University of Plymouth Library

Subject to status this item may be renewed
via your Voyager account

http://voyager.plymouth.ac.uk

Tel: (01752) 232323

GOD'S HOUSE AT EWELME
LIFE, DEVOTION AND ARCHITECTURE
IN A FIFTEENTH-CENTURY ALMSHOUSE

Frontispiece I. The almshouse passage connecting St Mary's Ewelme to the almshouse quadrangle was one of the principal thoroughfares for the community of God's House, allowing them to pass privately to and from their daily devotions in the church. The church font and its spectacular cover in the nave are visible through the far door.

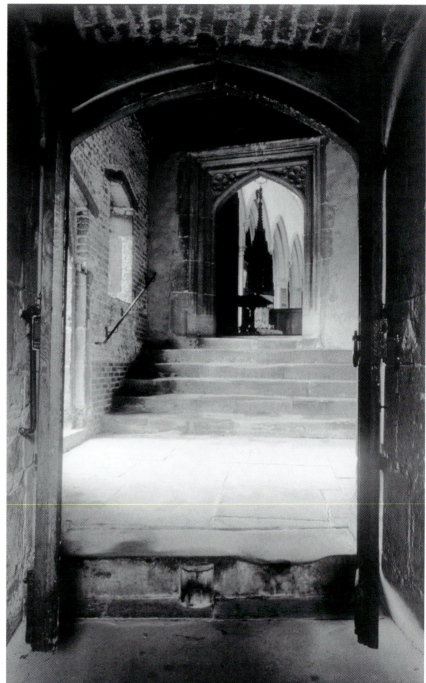

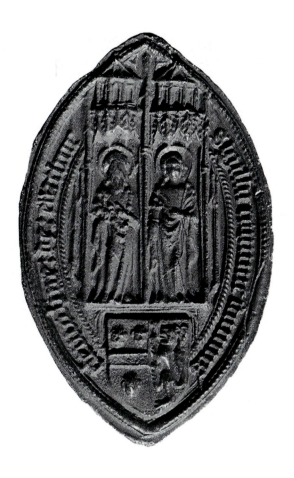

Frontispiece II
An imprint of 'the common seal of the house of alms of Ewelme'. The shape of the seal is typical of that used by ecclesiastical institutions in this period and shows St John the Baptist (left) and St Mary Magdalene (right) under architectural canopies. Both saints also appear painted above the cadaver on Alice's tomb at Ewelme. Beneath are the arms of de la Pole impaling Burghersh.

TO MY PARENTS, SISTER AND BROTHER

God's House at Ewelme

Life, devotion and architecture
in a fifteenth-century almshouse

John A. A. Goodall

ASHGATE

Published by
Ashgate Publishing Limited
Gower House
Croft Road
Aldershot
Hants GU11 3HR
England

Ashgate Publishing
Company
131 Main Street
Burlington
Vermont 05401-5600
USA

British Library Cataloguing-in-Publication data

Goodall, John A. A.
God's house at Ewelme: life, devotion and architecture in a fifteenth-century almshouse
1. Almshouses – England – Oxfordshire – History
2. Oxfordshire (England) – Religious life and customs
3. England – Social conditions – 1066–1485
I. Title
362.5'85-094257'09024

ISBN 0 7546 0047 5

Library of Congress Cataloging-in-Publication data

Goodall, John A. A.
God's House at Ewelme: life, devotion and architecture in a fifteenth-century almshouse / John A. A. Goodall.
p. cm.
Includes bibliographical references and index.
ISBN 0-7546-0047-5 (alk. paper)
1. God's House at Ewelme (Oxfordshire, England) – History. 2. Almshouses – England – Oxfordshire – History. 3. Religious institutions – England – Oxfordshire – History.

HV 63.G7 G66 2000
362.5'85'0942579–dc21 00–034851

ISBN 0 7546 0047 5

Printed on acid-free paper
Typeset in Palatino by Bournemouth Colour Press, Parkstone. Printed in Singapore.

Contents

List of illustrations

Where unacknowledged, photographs or line drawings are by the author.

Plates

xii GOD'S HOUSE AT EWELME

Preface

Notoriously, doctoral theses turn into dull books, but if this thesis does there can be no excuse. God's House at Ewelme is a most extraordinary survival from the Middle Ages. It was founded in 1437 by the Earl and Countess of Suffolk, William and Alice de la Pole, as an almshouse supporting a community of two priests and thirteen poor men in perpetuity. In return for the charity offered to it, this community was to serve a chantry chapel attached to the village parish church and offer prayers for the living and the dead. The foundation of God's House took more than twenty years to realize, and over that period it came to incorporate a school served by one of the community's priests. Almost 550 years later this institution still functions in the buildings originally erected to house it.

This book is a history of the foundation's establishment, its subsequent development and its daily life in the fifteenth century. It is based on an unusually complete body of medieval material, most of which has never been the subject of any scholarly discussion. This includes the foundation's original set of buildings, replete with a superbly preserved chantry chapel, and a miscellaneous collection of fifteenth-century documents relating to God's House which is preserved as part of the Ewelme Muniments in the Bodleian Library at Oxford (and see the Appendices in this volume).

Such a wealth of material is one justification for a monograph on Ewelme, but the subject merits detailed study in other ways too. In all their various forms chantry foundations, like God's House, were a mainstay of late-medieval society, involving, touching and shaping the lives of men and women from every walk of life. Yet, remarkably, no attempt has ever been made to integrate the documentary and physical evidence of an individual chantry foundation to create a detailed picture of its history and activities.

To do so in this case is to bring a lost world alive. At Ewelme we can still glean details of the complex devotional and political concerns that shaped the foundation of this institution by the powerful figures of William and Alice de la Pole. We can also catch a glimpse of the people who served the foundation

in the fifteenth century and of the life they led. These insights are valuable not only to our understanding of the late-medieval world in general – its outlook and the realities of life within it – but also for the picture they offer of the concerns and practice of Christianity in fifteenth-century England.

This book is divided into eight chapters, of which the first sets God's House in the context of other chantry foundations and introduces its importance as an object of study. The second gives brief biographies of the de la Poles and describes the history and architecture of Ewelme Manor (also later known as Ewelme Palace), the residence which formed the backdrop to the foundation. In the third chapter the circumstances surrounding the establishment of God's House are described and in the fourth the architecture of its buildings. The fifth, sixth and seventh chapters describe respectively the institutional life of the almshouse, the community up to 1524 and its devotional observances. The concluding eighth chapter looks at the Chapel of St John the Baptist in Ewelme Church, the focus of the community's devotional life and the burial-place of the Chaucer family.

A wide range of primary sources have been cited in this book and these require a brief introduction and explanation. Perhaps the single most important is the text of the foundation's Statutes, largely drawn up between 1448 and 1450 and written in Middle English. This is transcribed in full as Appendix I, along with an introduction and commentary. Quotations from the Ewelme Statutes in the text are given in modern English spelling, with my own punctuation, and are referred to in square brackets, either by their line number in the transcribed text (e.g. [l.606]) or by regulation number (e.g. [xxiv]) or both. Where their sense is hard to follow I have both inserted extra words or explanations in square brackets, and isolated superfluous words from the original text in parentheses.

Despite their fullness and detail the Statutes have to be treated with great care as an historical source. They follow a formula- or a model-text which was employed and adapted by contemporaries for similar institutions of their own. The resultant distinction between directions that belong to the formula and those that are specific to Ewelme is central to our understanding of them. The Statutes also have important limitations: amongst other things they are highly selective in their contents – so, for example, they contain very little information about the more mundane activities of the community, such as meals and recreation. Perhaps more important is the fact that while they admirably describe how the institution was intended to work they do not describe how it actually did.

These limitations should not, however, obscure the possibilities that the Statutes present. They may only provide a limited amount of information about the actual life of the foundation, but they say a great deal about the values and devotion that created and shaped it. Indeed the ideal of God's House is as fascinating and as revealing a subject as its reality. Moreover, the buildings were designed and furnished to reflect the ideal of life expressed in the Statutes, so in one sense it is the Statutes and the sentiments expressed in

them that best explain the buildings rather than an analysis of what actually went on within them.

In order to place the Ewelme foundation in a broader context it has been compared throughout the text with several other roughly contemporary and similar religious institutions. References to their statutes, with potted descriptions of the most important, are listed before the bibliography in the section entitled 'Hospital, college and guild statutes', where they are arranged in alphabetical order of place. In some chapters the text is extensively annotated with information about these foundations. This has been assembled with a view to indicating the full spectrum of the devotional life and the organization of chantry foundations in this period. An overview of the contents of a large number of statutes has never been attempted before and it is hoped that the reader will find much of interest and value in these notes without finding them a distraction.

The statutes and histories of these institutions may be used to give an impression of how Ewelme compared to other contemporary religious institutions in the circumstances of its foundation, its constitution and its activities. Collegiate statutes have been considered in this comparative discussion alongside those of almshouses for two reasons. First, colleges – which may be defined as foundations which supported a number of secular priests living together in community – often incorporated some provision for supporting the poor and the arrangements for this are often closely analogous to those of regular almshouses. Second, though the titles and duties of officers vary between almshouses and colleges, their hierarchies, devotional life and structures often bear striking resemblance to one another. By comparing Ewelme's Statutes with those of colleges it is possible to discern strong similarities in the conception and purpose of contemporary religious foundations, regardless of their particular form.

One feature of the comparisons among statutes that might require further explanation is the concern for the way in which statute regulations are phrased. Statutes not only share many points of similarity in their content, but also in the way in which they present that content. It is possible in fact to trace certain identically expressed ideas, and even whole regulations or blocks of text, through several sets of statutes. Only by recognizing and exploring these points of comparison is it possible to see how God's House at Ewelme fitted into the broader picture of contemporary foundations. The close similarities that exist between the statutes of every variety of religious institution in this period have so far scarcely been acknowledged, nor have the implications of this fact previously been examined.

Several other documentary sources have also been used to inform the picture of the foundation's early history and life. Principal amongst these are three sets of the foundation's accounts: the Master's Accounts, which include lists of petty expenses between 2 February 1455 and 1462; the Estate Accounts, which record the income of the almshouse from its lands; and the Audit Accounts for the years 1461–68, 1498–1508, 1511–14 and 1522–24. The Audit

Accounts are the annual financial statements of the foundation and their contents are tabulated in Appendix II. Aside from these there are several other useful documents in the Ewelme Muniments, amongst them the manorial accounts from the foundation's holdings and some extraneous documentation relating to other religious foundations established or patronized by the de la Poles. There are also large numbers of deeds and charters relating to the almshouse's holdings. In so far as these need explanation they will be discussed as and when they are referred to in the text.

In rewriting my doctoral thesis as a book I have taken some hard editorial decisions. My thesis included much material which, for reasons of length, has had to be jettisoned. Where I have cut material my policy has been to prune hard, on the principle that to do otherwise is potentially confusing and frustrating for the reader. Of the many transcriptions I made of accounts and documents I have kept the barest minimum, and I have tried to avoid laborious architectural and technical descriptions altogether. Finally, it should be noted that imperial rather than metric measurements have been used throughout. This is not because of conservatism on my part, but because the medieval artisans who created the buildings used these units of measurement, and some aspects of their design only make sense if represented in feet and inches.

Acknowledgements

Over the time that I have been working on God's House at Ewelme, with the kind permission of the Trustees of the Ewelme Foundation, I have become indebted to many people. Of those to whom I owe an academic debt I must particularly mention my fellow students at the Courtauld Institute, amongst them Tim Ayers, Achim Timmermann, Lucy Ormrod, Robert Maniura, Richard Plant, Freddie Law-Turner, Zoe Opacic, Loveday Gee, Beth Williamson, Alixe Bovey, Elizabeth Cleland, Alexandra Kennedy, Sue Byard, Erin Barret, Miriam Gill, Peter Kidd and John Hanson. Similarly, I would like to thank several other individuals outside the Institute: Stuart Hay, Carol Davidson, Duncan Givans, Rachel Moss, Aisling O'Donoghue and Linda Monckton.

This book has also been greatly improved by the help and specialist advice of several people: David Park and Helen Howard from the Courtauld Wall Paintings Department, and Fiona Kisby, Lisa Shekede, Henry Russell, Philip Lankester, John Blair, Claude Blair, my namesake John Goodall, David King, Clive Burgess, †Larry Hoey, John Kaye and Birkin Haward. Rowena E. Archer, who is currently working on a biography of Alice de la Pole, has kindly read some of the earlier chapters and purged them of a number of errors. In my work on the Ewelme inventories I have benefited greatly from the advice and suggestions of Jenny Stratford and Scot McKendrick. The examiners of my thesis, Christopher Wilson and Eamon Duffy, have also kindly helped correct several errors in the work. Members of my family and Mary Heimann, Harunaga Isaacson and Achim Timmermann have been very helpful in making suggestions, clarifications and corrections to typescripts. I must also thank Juergen Hanneder for saving my thesis and computer from a virus, as well as Mrs Turner, Mrs Wright, Mr and Mrs Gagg and Mr and Mrs Williams for other practical kindnesses. Many librarians have also been very helpful in my research and I would like particularly to thank the librarians at the Bodleian and Adrian James and Bernard Nurse at the Society of Antiquaries, as well Mrs Hatfield at Eton and Lindy Grant and Geoffrey

Fisher in the Conway Library at the Courtauld Institute. Nicholas Moore's archive on medieval brick architecture, which he bequeathed to me as the basis for a book on the subject, has been of great value in my research and both he and his widow, Dinah Moore, have been very generous to me.

At its final stage the text of this book has benefited from the attention of Maureen Street, whose patience and care as copy-editor have saved it from many errors. The kind loan of a camera by Carol Davidson has also helped improve the quality of its illustration.

Knowing how discouraging and difficult people can be about letting an unknown doctoral student into their houses, I am extremely grateful for the universal kindness with which I have been met at Ewelme. All the almsfolk at God's House have uncomplainingly allowed me into their cottages to take photographs, examine all the corners and crawl in the roof spaces. So too have the current leaseholders of the Manor House, Dr and Mrs E. Smith. Mr P. Bobby, the surveyor of the almshouse trust, has also been helpful in explaining details of the restoration of the buildings that he supervised.

I must further express two particular debts of gratitude for kindness and hospitality: firstly, to the Rector of Ewelme, Martin Garner, who has been exceptionally helpful in my work and also his wife and son John, and secondly, to Mr and Mrs George Cannon, who have fed me on every single occasion that I have been to Ewelme and driven me back to the bus stop in Benson when I needed to go back home. Their generosity and kindness have facilitated and added to the enjoyment of my work immeasurably.

But for all the other help I have received this book could not have been completed without that of my supervisor, Paul Crossley, and my family. Paul Crossley was assiduous in overseeing, correcting and advising me in my thesis. He introduced me to the study of medieval architecture and I hope that this book does justice to his care and kindness as a teacher. My parents, sister and brother have offered constant support, encouragement and much help.

Two trusts have very generously underwritten the production of this book. The Paul Mellon Centre for Studies in British Art provided for its thorough illustration and the Greening Lamborn Trust for the publication of the appendices, with their transcriptions of documents from the Ewelme Muniments.

List of abbreviations

BL	British Library, London
Bodl.	Bodleian Library, Oxford
BUS	*Breviarum ad Usum Insignis Ecclesiae Sarum* (3 vols), eds F. Procter and C. Wordsworth, Cambridge, 1882–86
CAD	*Catalogue of Ancient Deeds* (6 vols), London, 1890–1915
Cal. Pap. Reg.	*The Calendar of Papal Registers*, ed. W.H. Bliss, London, 1896
CCR	*Calendar of Close Rolls*, London 1892–1963
CFR	*Calendar of Fine Rolls*, London, 1911–62
CP	*The Complete Peerage* (13 vols), London, 1910–59
CPR	*Calendar of Patent Rolls, 1401–1509*, London, 1905–16
EM	The Ewelme Muniments, now in the Bodleian Library, Oxford (see the Bibliography)
Epist. Acad. Oxon.	*Epistolae Academicae Oxoniensis*, ed. H. Anstey (Oxford Historical Society, xxxv), 1898
MA	God's House at Ewelme Master's Accounts (Bodl. Ms. DD. Ewelme a. VI A 43 A)
Mon. Rit.	*Monumenta Ritualia Ecclesiae Anglicanae*, (4 vols), ed. W. Maskell, Oxford, 1882 (2nd edn)
ORO	Oxfordshire County Record Office
PL	*The Paston Letters* (6 vols), ed. J. Gardiner, London, 1986
PRO	Public Record Office, Kew
Rot. Parl.	*Rotuli Parliamentorum* (8 vols), n.d.
Univ. Oxf. Reg.	A.B. Emden, *A Biographical Register of the University of Oxford to 1500* (3 vols), Oxford, 1957–59
VCH	*Victoria County History*

The Ewelme Statutes are quoted referring to their line number or their

regulation number (in square brackets), as printed in the transcribed text in Appendix I. References in the text and notes to the statutes of foundations other than Ewelme are to the place name (or founder's name) of the institution and the page or statute number (in square brackets) of the cited detail, for example, Tattershall [182]; see the section 'Hospital, college and guild statutes', pp. 327–30 below.

Chantry foundations in fifteenth-century England

On a visit to Kempton Manor near London on 3 July 1437, Henry VI granted William and Alice de la Pole, the Earl and Countess of Suffolk, a royal licence to found an almshouse at Ewelme in Oxfordshire for two chaplains and thirteen poor men. According to the terms of the licence, the chaplains of the foundation were to celebrate Divine Service and, along with the poor men, to pray for the King and the Earl and Countess during their lives, and for their souls, the souls of the King's progenitors and of the parents, friends and benefactors of the Earl and Countess, after their death, and for the souls of all the faithful departed. This foundation was to be known as Ewelme Almshouse and was to be incorporated with the power to hold property up to the yearly value of 100 marks in perpetuity, to possess a seal, and to have the right to plead in court.[1]

About ten years later the founders, now raised to ducal estate, drew up a set of governing statutes for the almshouse at Ewelme. The prologue to these explains why the institution was established:

> We William de la Pole, Duke of Suffolk, and Alice my wife, Duchess of Suffolk, desire
> health in body, grace in soul, and everlasting joy … Because all Christian people,
> meekly and devoutly considering how, by the upholding and maintaining of Divine
> Service and by the exercise of works of mercy in the state of this deadly life [shall], in
> the last dreadful day of Doom, with the mercy of Our Lord, take their part and
> portion of joy and bliss with them that shall be saved; [therefore all Christians] ought
> of reason have a great and a fervent desire, and a busy charge in mind to uphold and
> maintain Divine Service, and to exercise, fulfil and do works of mercy before the end
> of their mortal life'. (ll.5–27).

It is in consideration of the need to discharge this dual obligation, incumbent on any Christian, to maintain Divine Service and perform works of mercy – so the preamble goes on to say – that William and Alice have built and founded an almshouse adjacent to the church on the west side of the churchyard at Ewelme. The foundation at Ewelme was to be called 'God's House or else the House of Alms' [v].[2] It was to support thirteen poor men

'with so great a penury of poverty that for lack of sustenance if they were not
by alms relieved they should lightly perish' [ll.32–6], and two priests in
perpetuity. This community, dedicated 'principally to God's worship to the
increase of our merits', was to pray every day for the living and for the dead
[ll.72–89]. The statutes also make mention of another feature of the foundation
which receives no mention in the royal licence: a school. This was to be run
by one of the foundation's priests and to provide an education free from 'the
exaction of any school-hire' for children from Ewelme manor and the manors
owned by the almshouse [11].

God's House at Ewelme was typical of hundreds of so-called perpetual
chantry foundations established in fifteenth-century England. Depending on
their pretensions, such foundations could take a wide variety of institutional
forms – from altars or small chapels served by a single priest to great secular
colleges with large communities of priests, chaplains, clerks, choristers,
scholars and almsmen. But the defining feature common to all chantries,
regardless of their particular form, was the requirement that Divine Service –
that is to say prayers, the Offices and the Mass – be offered for the good of
their founders during their lives and for their souls after death. Many, such as
Ewelme, were also concerned with undertaking works of mercy to the same
end, in particular sustaining the poor. England is still sown surprisingly
thickly with surviving institutions of this kind, although these represent only
a fraction of the numbers that formerly existed. Many Oxbridge colleges, as
well as several public schools and almshouses, are in origin chantry
foundations and have an unbroken institutional history which may be traced
back to the Middle Ages.[3]

The perpetual chantry foundations of the late Middle Ages were the
preserve of the very rich and, in purely financial terms, were probably the
single most important objects of patronage in the period. At their most
elaborate, the endowments to support them constituted great fortunes, and
their buildings, tombs, decoration and furnishings were executed in the
height of artistic fashion. Such physical remains, where they survive, are the
most eloquent testimony to the vast sums of money and energy invested in
them: the buildings of the greatest still dominate the cities and landscapes
they stand in, and the innumerable small chapels and tombs belonging to the
lesser ones continue to form a prominent part in the furnishings of churches
across the country, from cathedrals to parishes. This book is an attempt to
present a portrait of a particular foundation of this kind which is
exceptionally well preserved, well documented and important.

But although readers will, I hope, be quickly persuaded that God's House
is of especial interest in itself, they may require proof that this book is not a
piece of antiquarian or historical navel-gazing. Ewelme is not fifteenth-
century England nor does it entirely represent it. Nevertheless a case study of
God's House is of much wider interest than it might at first sound.

It had become common by the fifteenth century to associate chantries with

great palaces. The most ambitious form of such a foundation was a college of secular priests, which usually subsumed the existing local parish church and often supported a school and some provision for the poor. There are many examples of such institutions: Henry VI's college, school and almshouse of Eton College across the river from his residence at Windsor Castle; the college and *hospitium* for the poor beside the great Yorkist *caput* at Fotheringhay Castle; and the College of the Holy Trinity with its almshouse next to the family seat of the Lord Treasurer, Ralph, Lord Cromwell, at Tattershall Castle in Lincolnshire, to name just three examples.[4]

In the context of family residences these foundations were seen to perform several important and interrelated functions. In a world that readily acknowledged the intervention of God in its affairs and fortunes, the foremost of these was the celebration of Divine Service undertaken by their communities.[5] Prayer was not thought of as a passive exercise, but as an active and inherently valuable one in which praise, owed by mankind to God, might be harnessed and turned to use. Surviving statutes show a particular interest in the dedication of prayer towards speeding the progress of souls through the tortures of Purgatory to Heaven, and to supporting the living in their needs. From the perspective of their founders, therefore, such colleges served as a spiritual resource. As each generation buried its dead, Heaven was bombarded with the prayers that issued from them to release their souls from Purgatory, and, as the new generation grew up, it was bolstered by those same prayers.

Religious foundations associated with residences also served as symbols of power. The grandeur of their buildings advertised the importance of the founders and the collections of tombs within them the family's descent and alliances. Furthermore they provided an opportunity for the exercise of patronage, both through the salaried posts that could support members of a retinue and the provision of charitable care that might reward faithful servants.[6] The dispensing of charity was itself a public statement of the founder's social standing and Christianity. In every sense, therefore, these foundations were a natural extension of a nobleman's household: an institutional celebration of dynastic power that pointedly proclaimed status, wealth and Christian nobility. They were an institutionalized legacy to be supplemented by each generation of a family, and their fruits, both temporal and spiritual, were to be enjoyed and exploited by its members living and dead.

But despite their size and importance such chantry foundations should not be viewed as isolated or unusual institutions in the fifteenth-century world. As this study will show, they agree closely in details of constitution and devotional practice with quite different types of religious institution, such as guilds and even ordinary parishes.[7] In a contemporary's eyes they would also have seemed closely analogous to the institutions of the great peripatetic households of the period. The ordinances for the royal household of 1445, for example, record that Henry VI's chapel was served by a dean, twenty

chaplains and clerks, seven children and two vestry clerks, much the kind of community that might have served a chantry college. By Edward IV's reign, in 1471, this staff had increased to twenty-six chaplains and clerks and eight choristers and there was also a Teacher of Grammar to educate the boys.[8] The nobility too seem to have indulged in such lavish, quasi-collegiate household arrangements, although evidence for this is rather harder to come by. In the 1460s Sir Andrew Ogard 'kept his chapel in his house, of priests, clerks and choristers, of whom there were sixteen every day, with four priests, to a cost of £100 a year'.[9] Judging by the many liturgical and song books listed in the inventory of chapel goods from the de la Pole castle at Wingfield in Suffolk, this too must have been served by a similar number of priests and clerks.[10]

Great households also made considerable provision for the poor. In the royal household this took the form, amongst other things, of the charitable distribution of left-over food from the great hall, supervised by the King's almoner. This was known as the King's alms and it was one expression of a long-standing tradition of royal benefaction to the poor.[11] Again there is evidence that noble households also made similar doles and occasionally had more formal arrangements. In the early sixteenth century, for example, Lady Margaret Beaufort maintained almsfolk at the palaces she used at Croydon and Hatfield, and her will stipulated that these paupers were to be maintained at the charge of her estate after her death.[12] Research into the charitable bequests of the Hungerford family has shown that they also pensioned almsfolk and that by 1428 the head of the family, Walter Hungerford, was supporting thirteen paupers on his estates at 4d. each a week.[13] Viewed in such terms, chantry colleges were like parts of a household, but independently endowed and constituted in perpetuity.

And just as perpetual chantry foundations graduated into household institutions, so did their architecture. This is clearly illustrated in the domestic arrangements of grand collegiate institutions, which were in many ways ecclesiastical versions of secular households. The quadrangle of Henry VI's college at Eton, for example, is laid out with a great hall, accommodation and ancillary buildings in exactly the manner of a secular residence, the only difference being that a priest, the Provost, lived in the principal apartments rather than a nobleman. And the buildings at Eton were subsequently deeply influential in secular architecture.[14] Elements of everyday life in these foundations must also have been similar to those of great secular households. Both forms of institution were governed identically – by statute[15] – and their communities were formed into strict hierarchies which were defined by such things as dress and seating in the great hall during meals.[16]

Although not a collegiate foundation on the scale of the examples cited above, Ewelme was nevertheless a palatial foundation of this kind. It was established adjacent to an important residence, Ewelme Manor (or Palace), and closely associated with the family that owned it, one of the most powerful in fifteenth-century England. As such it is illustrative of other chantries of the nobility which, despite recent study, remain ill-understood.[17] Little has been

written about their religious observances, even though these are often minutely detailed in surviving documents and were undoubtedly conceived by contemporaries as their most important function. Similarly, the extraordinary buildings and furnishings of these institutions are all too often simply described admiringly by their historians rather than mined as sources of historical information.

By presenting a portrait of a particular institution, this book aims to show what an enormous wealth of information these foundations have to offer about every aspect of fifteenth-century life if they are studied holistically. Using the physical and documentary evidence available about God's House it is possible to reconstruct the religious practices of this institution in the fifteenth century, and to make informed guesses about the beliefs that underpinned them and the nature of the community that celebrated them. We can also improve our understanding of contemporary artistic developments, illustrate the exercise of political power and social authority, reveal the physical realities of life in the foundation and explore the mechanisms of fifteenth-century estate management, as well as a great diversity of other things besides. In short, we may peep through a keyhole into the fifteenth century, with all the excitements and maddening frustrations that that suggests.

As well as opening new fields of discussion, I hope also that this book will inform one well-established and ever-green field of debate. Perpetual chantries were the grandest manifestation of a central preoccupation of late-medieval religion: the desire of individuals to secure the benefits of Divine Service for themselves, particularly after death, to hurry their souls through, and to alleviate the pains of, Purgatory. The scale of interest in this desire during the late Middle Ages can scarcely be exaggerated. It was catered for and entwined within every aspect of religious practice in the period and is attested to in a variety of ways at almost every level of society.[18] While the importance of this interest to late-medieval religion has never been in question, its value and emphases have been very differently assessed by historians. In common with the subject of the late-medieval Church as a whole, there is a long-standing tradition of hostile criticism. This argues that much late-medieval devotion was a form of privatized religion whereby the Church served those alone who could pay for prayer, and that it reflects a society that was morbidly obsessed and engaged in running its living institutions for the benefit of the dead.

Using the evidence of Ewelme, this book contends that such an assessment of late-medieval religion, already discredited and challenged on many counts, fundamentally misunderstands its subject.[19] God's House not only furnishes specific evidence for such a refutation but is illustrative of wider beliefs and practices in fifteenth-century society. Just as palatial foundations were household chapels made permanent, so were the devotions they practised the devotions of the contemporary Church instituted in perpetuity. In other words, although chantries were founded by the richest section of society they

do allow us insights into the practice of religion in the widest sense. What the evidence of Ewelme suggests is that, far from constituting a privatized system of religious practice, chantries were endowments towards the public good from which the donor benefited privately.

Exactly what this meant in practical terms has been graphically illustrated in recent work on fifteenth-century parishes, nationally as well as in case studies of Bristol and London.[20] Chantry foundations in these cities appear to have been the very reverse of a private form of religion. Instead they seem to have been crucial in sustaining the public religious life of parishes with money and priests, and made possible the enrichment of their liturgy for the benefit of everyone.[21] This system of mutual benefaction – the dead benefiting the living and the living the dead – explains something of the attraction of chantries, beyond the fact that they celebrated the power and station of their founders. It certainly goes some way to explaining why they were not merely tolerated, but in some cases actively fostered and embraced by parishes. Of course, in the case of noble foundations parishes did not really have a choice about accommodating a chantry. But the evidence of Ewelme, and other chantries of the nobility, would suggest that their founders perceived them as a means of fulfilling their responsibilities towards dependents, not simply as a means of exploiting them.

In addition to reconsidering chantry devotion, through this study I hope also to make a contribution to the growing body of literature on medieval hospitals and almshouses.[22] Not only does the organization of these institutions inform us about the treatment of the aged and infirm in the Middle Ages, but also, as far as we can now know, of the lives and expectations of the poor. It is in fact one of the great interests of studying God's House at Ewelme that it illustrates the lives of people at the extremes of English medieval society, the greatest and the least.

With such a rich body of physical and documentary material, God's House at Ewelme offers an unparalleled opportunity for an exploration of the fifteenth-century world. It provides a full picture of a religious community in the period, its daily activities and the physical environment in which it lived. In doing so it adds materially to our knowledge of medieval hospitals. But beyond this it also offers insights into all sorts of wider social, political and religious issues. Throughout this book I have attempted to present the evidence I use as directly as possible and have self-consciously striven to navigate between the Scylla of apology and the Charybdis of unwarranted criticism.

The de la Poles and Ewelme Manor

The founders of God's House at Ewelme were prominent, not to say notorious, figures in fifteenth-century England, and the history of God's House at Ewelme directly reflects their remarkable careers and their piety. It is beyond the scope of this work to provide a detailed biography of either husband or wife, but without an appreciation of who they were it would be impossible to understand fully the physical form or development of the foundation they established.

Alice de la Pole was the granddaughter of Geoffrey Chaucer, whose successful literary and court career was the first step in bringing his family to the forefront of fifteenth-century English politics. Chaucer won the hand of Philippa Roet, an heiress and sister of Katherine Swynford, the mistress and later the wife of John of Gaunt.[1] By Philippa Chaucer had a son called Thomas who, at sometime before 1392, married Matilda Burghersh, the co-heiress of the family of Burghersh of Ewelme.[2] Alice was born to this couple about twelve years later, probably in 1404, and was their sole surviving issue.[3]

The circumstances of Alice's upbringing must have been remarkable: her father Thomas was an important political figure who served on five occasions as Speaker of the House of Commons and acted in several diplomatic missions. His family connections were of great importance in his career: he was first patronized by his uncle, John of Gaunt, and then, after Gaunt's death, he formed a close allegiance with one of Gaunt's illegitimate sons, Henry, later Cardinal Beaufort.[4] Apart from his political concerns Thomas was also interested in literature and, as his tomb records, was a patron of the church at Ewelme, responsible for rebuilding its surviving south aisle.[5]

At some stage in her early childhood, probably in 1414, Alice was married to a wealthy knight, Sir John Phelip.[6] He died in 1415 and afterwards the young widow was remarried to the Earl of Salisbury, the swashbuckling commander of the English army in France. The match took place before November 1424, when Alice attended a wedding feast in Paris at which she attracted the Duke of Burgundy's attentions, much to the jealous fury of her

husband.[7] Whether Alice's beauty was a factor in securing the match with Salisbury is not known, but in material terms the marriage was a great coup, raising her to noble estate. In 1428 Salisbury was killed at the siege of Orléans by a cannon ball – the first aristocratic English victim of gunpowder. An enriched and ennobled widow, Alice waited just two years before receiving licence on 11 November 1430 to marry William de la Pole, Earl of Suffolk.[8] William was born at Cotton in Suffolk on 16 October 1396, the second son of Michael de la Pole, Earl of Suffolk.[9]

The de la Poles were originally wealthy wool merchants from Kingston-upon-Hull in Yorkshire who had risen to prominence in the service of the Crown.[10] William's grandfather had gentled his condition with a marriage before 1361 to the heiress Katherine Wingfield, at whose patrimonial seat at Wingfield in Suffolk he later built a castle and helped found a college, endowed by the terms of his father-in-law's will.[11] In 1385 he was created Earl of Suffolk but shortly afterwards was disgraced, imprisoned and then forced into exile. He died abroad in 1389, stripped of his honours, and his body was returned home to be buried beside his wife in the Carthusian monastery of St Michael at Hull, which he had founded.[12]

His son Michael, William's father, inherited the title in 1398 and further increased the family estates with an advantageous marriage to Katherine Stafford. He died, along with his eldest son, in the course of Henry V's 1415 Agincourt campaign, leaving William the successor to the de la Pole inheritance. William spent his early manhood in France, where he acquired a number of French possessions and titles including that of Count of Dreux in or before 1425. He fought in several campaigns and succeeded the Earl of Salisbury as general of the English forces at Orléans after the latter's death. When Joan of Arc relieved the city he was forced to retreat and was captured at Jargeaux, whence he later claimed to have been ransomed for the fabulous sum of £20,000.[13]

Although William had resided almost exclusively in France during this period, he had received honours in England too, being made a Knight of the Garter during a brief visit in 1421. His marriage to Alice, however, roughly coincided with the first important steps he took on the English political scene. These began with his admission to the council of the boy-king Henry VI on 30 November 1431.[14] His marriage to Alice was very useful in the circumstances: she was a cousin of the royal uncles, Henry, Cardinal Beaufort and Humphrey, Duke of Gloucester, who led court politics during the King's minority, and through her father had particularly close ties with the former. As an only child she also came with a rich inheritance of estates. These were concentrated in the Thames Valley, but included land around the Wingfield estates in north-east Suffolk and south-west Norfolk.[15]

The subsequent development of William's career in the complex and continuously shifting sands of the English political scene can only be summarized here. He won the confidence of Henry VI and from the late 1430s began to amass offices, titles, perquisites and royal favours at an astonishing

rate.[16] Through such favours and by the judicious preferment of his supporters he put down deep roots into the political soil of England, maintaining his position at the head of an increasingly powerful faction through the 1440s.

In 1443 he was appointed chief ambassador to arrange a peace with France. Although reluctant to go, on the grounds that he was perceived in England as an ally of the French, he successfully negotiated a two-year truce and the marriage alliance between Henry VI and Margaret of Anjou. He received a series of grants in reward for his services in 1444, including the title of Marquis of Suffolk[17] and certain rights of wardship over his own heir.[18] Alice, who had shared many of the favours conferred upon her husband and even had the honour of receiving the robes of the Garter along with him,[19] now accompanied him to France to escort the new Queen to England. The party landed at Porchester on 9 April 1445 and proceeded, after a short delay, to the wedding at Titchfield, followed by a state entry into London on 28 May.[20]

The Suffolks were now at the zenith of their political success and William actively exploited this to secure a place for the de la Poles amongst the great noble lines of England. William acquired the wardship of the heiress Anne Beauchamp in 1446, almost certainly with the intention of organizing an important dynastic alliance for his son, John, who was born in 1442.[21] In the event, the match was frustrated by Anne's death at Ewelme on 3 January 1449, and another rich, aristocratic ward, Lady Margaret Beaufort, was substituted as the boy's bride.[22]

Amongst William's particular concerns during this period of political success was the patronage of architecture, and his building work at Ewelme – in particular the work on the Manor House, which he rebuilt from 1444 – is of the first importance in terms both of contemporary domestic design and brick architecture. His interests in this field may have been stimulated by his involvement in work on the King's pet foundation of St Mary's College, Eton, established in 1440.[23] From the first William was intimately concerned with overseeing the construction of the extraordinarily ambitious new college and in 1448 he made a gift of £666 13s. 4d. towards the rebuilding of Eton chapel.[24] There is evidence that William was interested in other arts too. He was a friend of the literary Charles, Duke of Orléans, whom he held in custody at Ewelme for several years;[25] wrote some surviving poetry in French and English; and is known to have met Dufay and rewarded him for his music in Paris.

By the late 1440s the foundations of the political hegemony that William had established began to come under pressure. It had been agreed under the terms of the 1444 truce that Henry VI would cede the province of Maine to the French monarchy and the blame for this deeply unpopular decision fell upon Suffolk.[26] The long process of surrendering Maine coincided with two events which, if not masterminded by William, none the less earned him further unpopularity and weakened his position. The first was the sudden death of his chief rival, Humphrey, Duke of Gloucester, at Bury St Edmunds on 23 February 1447 after he had been summoned there to attend a hostile

Parliament and arrested, a circumstance which was popularly represented as a political murder. The second was an attempted murder of the sometime Lord Treasurer, Ralph Cromwell, by an associate of Suffolk's, William Tailboys, in Westminster Palace. Cromwell certainly believed William to be responsible for this assault and was to prove a dangerous enemy.[27] Then in the spring of 1449 a gross diplomatic blunder – an assault on the Breton town of Fougères – led to the resumption of the war with France.

Meanwhile, however, William continued to be the pre-eminent object of royal favour. Not only did he receive the late Duke of Gloucester's title as Earl of Pembroke – which had been granted to him by reversion in 1443[28] – but the day after Humphrey's death William was also granted the office of Lord Chamberlain for life and the office of Constable of Dover Castle and Warden of the Cinque Ports. In the following months he was also appointed Admiral of England during the minority of the Earl of Exeter (9 August 1447); joint High Steward of the Duchy of Lancaster, South of Trent (11 December 1447); and Governor and Protector of the Staple of Calais (9 March 1448). Finally, on 2 June 1448, he was created Duke of Suffolk.

But even royal favour could not protect William from gathering popular hatred, which found expression, amongst other things, in ballads and art.[29] The effects of this unpopularity came to a sudden head early in 1450. On 9 January Adam Moleyns, Bishop of Salisbury and Keeper of the Privy Seal, was lynched by unpaid soldiers at Portsmouth. In his terror Moleyns denounced Suffolk to the crowd and on 28 January 1450 William was committed to the Tower of London pending his impeachment on various counts. These included complicity with the French, the misappropriation of money and designs on the English throne itself.[30] But the King, although under great pressure, refused to have Suffolk executed and sent him into exile instead. His enemies were not satisfied. While on his way to exile on 2 May 1450, he was intercepted by a ship called the *Nicholas of the Tower* and ignominiously beheaded at sea with a rusty sword in a mockery of a nobleman's execution.[31] The body was laid out at Dover and its head thrust on a pole. Nine years later his corpse was carried to the family Charterhouse in Hull for burial, as he had directed in his will.[32]

A wave of popular violence broke after the murder and Jack Cade entered London at the head of an army of rebels. Twenty prominent figures were indicted, amongst them Alice de la Pole.[33] Up to this point Alice remains something of a shadowy figure, but the presence of mind she exhibited in the aftermath of her husband's murder suggests that the rebels' implied accusation of her own culpability for political events was justified. Within six days of the murder she secured a royal grant of William's possessions until her son came of age to inherit them.[34] It is also possible that she took the oath of a vowess – a lay woman living under religious vows – at this date so as to secure her celibacy and independence.[35] Then, on 15 August, papal confirmation of her son's marriage to Margaret Beaufort, despite the degrees of consanguinity, was issued.[36]

But for all the remarkable speed with which she acted, some battles were eventually lost – her son's marriage to Lady Margaret, for example, was dissolved on 24 March 1453, and the loss of this wealthy heiress must have been a blow. In the main, however, her affairs seem to have settled down remarkably fast, and a surviving Receiver General's account roll of 1453–4 for her Essex, Norfolk and Suffolk estates is impressive testimony to the efficient running of her household by that date.[37] This recovery is all the more remarkable in the light of the worsening political situation of this period, which witnessed the first hostilities of the Wars of the Roses.

The family's allegiance in this civil war was determined in 1458 when Alice secured John de la Pole's marriage to Elizabeth Plantagenet.[38] This alliance to the sister of the future Edward IV eventually involved the de la Poles in active opposition to Henry VI and his Queen. But it also yielded rich rewards and, over the first reign of Edward IV, John and Alice appear to have enjoyed royal favour.[39] It is during this period that we gain the most detailed impression of Alice de la Pole. She is mentioned several times in the Paston letters of the 1460s and was evidently a formidable woman who worked closely with her son in turning the law to her own ends.[40] On one occasion in 1466 Margaret Paston was actually moved to warn her son, John, not to go to see Alice alone on business, 'For she [Alice] is sotill and hath sotill councell with here; and therfore it were wele do[ne] ye shuld have summe with you that shuld be of your councell.'[41]

Like her husband, Alice was an active and very capable patroness, as became apparent during her widowhood. Her patronage will be discussed in detail later, but she is documented as having given money towards the construction of the tower of Eye Church, in Suffolk, in 1454, and as issuing complex instructions for remodelling the church and de la Pole Chantry at Wingfield. It seems likely too that she devised the sophisticated devotional iconography of the Chaucer family chantry chapel at Ewelme as well as the design – unique for the period – of her own spectacular alabaster monument there. In 1459, at the time of her husband's interment at the Hull Charterhouse, she also commissioned a tomb, probably a brass, for him. The craftsmen involved were the finest that money could command: Henry VI had called on them to design his own tomb and they had previously worked on the monument of Richard Beauchamp, Earl of Warwick.

Nor was Alice de la Pole's patronage limited to chantries, tombs and ecclesiastical architecture. One other important building project in which she was involved was work on the Divinity School in Oxford. A letter of 1454 from Oxford University thanked her for books and gold as well as a grant of £20 towards the construction of the Divinity School. It also asked her to 'give credence to William Church, the supervisor of the said [Divinity School] works' – perhaps suggesting that she was consulted about the designs.[42] Later, in 1461, she received another letter, again thanking her for her generosity towards the work.[43]

Her connection with Oxford may well have resulted from her husband's

appointment as Protector of the University in 1447[44] and it certainly dated from before 1450, because she received a letter from the university four days after William's murder in which she was addressed as 'oure ryght especiall benefactrice and singuler lady'. It wished the speedy settlement of her affairs in London and her return and thanked her for 'the grete liberalite and tendyrnes in sondre wyse' which 'hit hath plesed youre noble ladyshippe but late ago to shew unto us'.[45]

As the granddaughter of Geoffrey Chaucer it is appropriate that Alice should also have pursued literary interests. While still Countess of Suffolk she commissioned the Benedictine poet John Lydgate to write a work on *The Virtues of the Mass*[46] and one inventory of her possessions from 1466 specifically mentions a number of her books, each bound according to subject in either red or black. She had a copy of John Lydgate's translation of *The Pilgrimage* (a work associated with her second husband the Earl of Salisbury),[47] part of a *Legend of Radegund*, a Latin book of 'the moral institution of a prince' as well as several French books: *Les Quatre Fils Aymond, Temps Pastoure, The Tales of Philosophers* and *La Cité des Dames* by Christine de Pizan.[48]

For Alice, the restoration of Henry VI in 1470 was only a brief political upset in what otherwise appears to have been a peaceful old age. It is symbolic of Alice's lifetime of political manoeuvring that after the King's murder Margaret of Anjou, the Lancastrian Queen she had first escorted to England in triumph thirty years before, was placed in captivity under her custodianship in Wallingford Castle.[49] Whether, after the events of the intervening years, this was intended as a reunion of old friends and a kindness on the part of Edward IV to Margaret, as some historians have assumed,[50] must remain an open question.

In 1471 Alice appears to have begun preparations for her own death and made over all her household goods, except those which she used daily, to her son and his wife.[51] One of the last recorded acts of her piety was the foundation of a guild dedicated to the Body of Our Lord Jesus Christ at the parish church of Leighton Buzzard in 1473, a manor she had aquired through her first husband.[52] On 13 March 1474 she was granted a papal indult permitting her to obtain special absolution because, as the document explains, she was 'broken with age'.[53] Her will does not survive but her tomb inscription records that she died on 20 May 1475. She was then probably in her seventy-first year.

Throughout their later lives, Ewelme was a particularly important centre of affairs for the de la Poles.[54] The manor had been the seat of Alice's father, Thomas Chaucer, and came into William de la Pole's possession in 1437, the year after the death of Thomas's widow, Maud.[55] As a patrimonial house in close proximity to Henry VI's favourite palace at Windsor it was adopted by the de la Poles as a principal residence and about seven years later, probably in response to his elevation to the marquisate on 14 September 1444, William de la Pole began work on a magnificent new residence there.[56] The new Manor House was commensurate with his new-found rank and Ewelme Palace, as it

later became known, was undoubtedly one of the great secular architectural commissions of the period. Its fabulously rich interiors commanded the awed respect of visitors into the seventeenth century, and its fine buildings incorporated brick, a building material which was in high fashion during the 1440s. Unfortunately it fell into disrepair in the sixteenth century, and the ruins were demolished in James I's reign. All that survives today is a single, much altered fragment of what was probably an accommodation range in the outer court.

But William de la Pole's lost Manor House merits examination both by virtue of its importance as a fashionable residence of the 1440s, and because the buildings of God's House – begun before it, probably in 1437 – were extended and adapted in 1444 to form part of its architectural landscape. To understand their form today, therefore, it is necessary to consider the lost Manor House in some detail. Comparatively little can be said with certainty about Ewelme Manor because its site has never been surveyed or excavated. Even so, the careful use of such documentary sources as survive can furnish some impression of this remarkable building.

The principal descriptions of Ewelme Manor date from the mid-sixteenth century onwards and at least two of them explicitly state that the residence had undergone changes since its first erection by William de la Pole. But in both cases there is good reason to doubt the veracity of the claim, and a combination of evidence, including records of internal decoration in the principal chambers as well as working descriptions of the buildings from inventories and accounts, prove that it was never fundamentally altered between its construction (from 1444) and its demolition.[57]

Ewelme Manor is first described by Leland in 1542:

The maner place of Ewelme is in the valley of the village: the base court of it is fair and is buildid of brike and tymbre. The inner part of the house is set with in a fair mote, and is buildid richly of brike and stone. The haul of it is fair and hath great barres of iren overthuart it instede of crosse beams. The parler by is exceeding fair and lightsum: and so be al the lodginges there.[58]

The details of Leland's description are confirmed and fleshed out by a survey of Ewelme Manor drawn up to establish the value of materials within the buildings prior to their demolition in 1612. This describes the buildings under three heads: the Manor House within the moat, then 'utterlie wasted and decayed'; the base court without the moat, comprising ancillary and service buildings; and a stable and barn remote from the house.

Judging by the evidence of the 1612 survey (transcribed below as Appendix VIII), the house within the moat was arranged around a courtyard – as was typical in contemporary domestic design – but according to an unusually coherent and regularized plan: the clerk consistently refers to the ruins as 'the building' and 'the house', as if they belonged to a single structure. Moreover, in contrast to his survey of the base court, in which each constituent building is individually treated, he also names chambers within this 'house' – such as the hall and parlour – without distinguishing them as

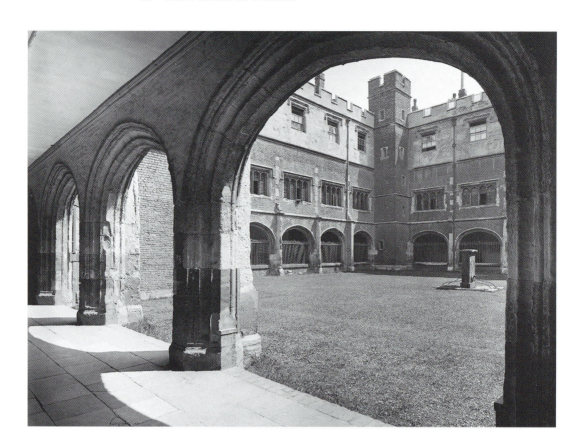

1 Cloister Court, Eton College (Bucks.), was begun in 1441. The upper storey is a modern addition to the original design, which explores the aesthetic possibilities of combining brick and stone.

individual structures. It seems reasonable to assume from this, therefore, that the elements of the house were integrated into a coherent ground plan. That the design was regularized is suggested by the consistency of the building's construction: as the survey records it, all the walls were two bricks thick; the stone buttresses were of the same height; and there were exactly matching lengths – 676 feet – of stone plinth and cresting for the base and parapet of the walls.

Three important and closely associated buildings from the 1440s have regularized courtyard designs and can be further compared in other particulars with the ruin described in the survey of Ewelme Manor. The most important of these three is the Cloister Court at Eton College, begun in 1441 by Henry VI and erected under the supervision of William de la Pole (see Fig.1). Closely related to Eton, both in terms of patronage and design, are the buildings of Queens' College, Cambridge (see Fig.2), largely built by Queen Margaret of Anjou between 1448 and 1449, and the third of the group, Herstmonceux Castle (see Fig.3), licensed for construction in 1441. Herstmonceux was built by Sir Roger Fiennes, the Treasurer of the King's Household, Keeper of the Wardrobe and a member of William de la Pole's political faction.[59]

All these buildings, including Ewelme, employed brick as a principal building material and this fact deserves consideration. Brick was a novelty in

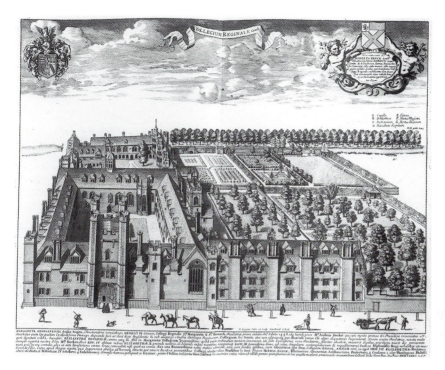

the south of England in the fifteenth century and its first known use in Oxfordshire is at Stonor Park in 1416 (not at Shirburn Castle, as is often asserted).[60] The use of the material in English fine architecture was probably pioneered in royal projects – by Henry V and his brothers – in the opening years of the fifteenth century, but none of their buildings survive. Over the 1430s, however, brick was also used in a number of prestigious building projects such as Caister Castle (Norfolk), under way in 1432; Tattershall Castle (Lincs.), documented from 1434; Faulkbourne Hall (Essex), erected from about 1439; and, possibly under construction at this time, Heron Hall (Essex).[61]

Securing the expertise for making and firing the huge quantities of regularly sized bricks necessary for such projects was not easy, and in this period many of the craftsmen who made bricks appear to have been foreigners.[62] It is doubtless a reflection of the workmen's extraction that the earliest important brick buildings, where they survive, appear to draw their architectural inspiration from the Continent. Characteristically, they make sparing use of stone, employ considerable quantities of carved or moulded brick decoration, and often incorporate distinctive, square-headed, transom windows.

But remarkably the Continental style of architecture was not adopted at Eton and instead the buildings are executed in a recognizably English architectural idiom. This character is bestowed to a great extent by the lavish use of ashlar masonry in the buildings: rather than having brick detailing, all the windows, doors and string courses have been finely cut in stone. These

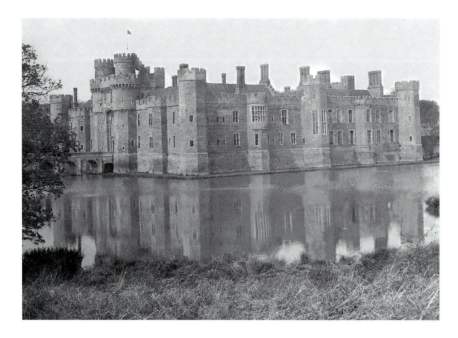

3 Herstmonceux Castle (Sussex), begun after 1441 by Sir Roger Fiennes. The modern inner buildings have replaced a complex fifteenth-century domestic plan incorporating four courtyards.

features are essentially English in inspiration although they do incorporate some remarkable details, including window tracery without decorative cusping. This simplified form, the cuspless window (visible in Fig. 1), was later to become a stock-in-trade of domestic architecture but it had never been systematically used before.

By this extensive use of stone, brick is reduced to the status of a walling material at Eton. But its possibilities as such have been exploited for maximum decorative effect. Much has been made of the contrasts in texture and colour between brick and stone. Not only are the two materials attractively blended in individual façades, but the hall, which originally dominated the quadrangle, is entirely built of stone. The walls are also inlaid with complex diaper designs, patterns laid in dark, vitrified bricks. Diaper decoration was common on the Continent but there are few surviving English examples prior to Eton, and most of the motifs at Eton were unprecedented in this country.[63]

The unusually rich diapering of Eton's brickwork is likely to have been created by foreign artisans and the surviving paybooks record many brickmen with foreign-sounding names, such as Pers Alyard, Cornelius Dauber and Egidius Wans. Through their involvement in this major building project the possibilites of brickwork were realized in an English architectural idiom for the first time and Eton stimulated a vigorous exchange of ideas between the brick and stone building traditions in England which was to outlast the Middle Ages.

Eton's subsequent influence was the result of several exceptional circumstances beyond the simple fact of its being a prestigious royal

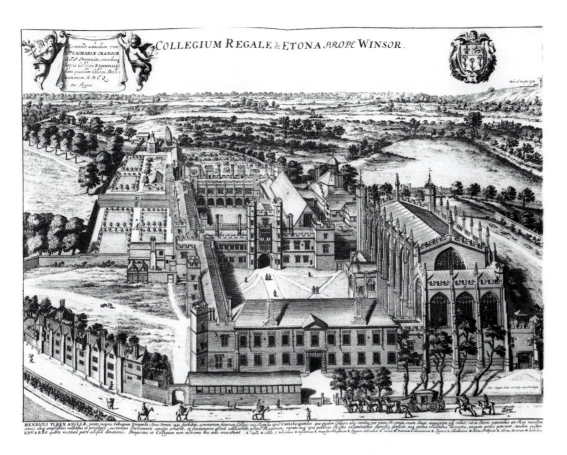

COLLEGIUM REGALE de ETONA PROPE WINSOR.

4 Eton College (Bucks.), from *Cantabrigia Illustrata* of 1688 by Loggan. The far courtyard with its distinctive towers belongs to the original college, begun in 1441.

foundation. Many of Henry VI's court favourites were closely involved in establishing the college and must have been familiar with the buildings.[64] In later life several of these men, in particular William Waynflete, Provost of Eton and then Bishop of Winchester, were outstanding patrons of architecture. On the other side of the equation, labour was impressed for the work and large numbers of artisans passed through the site. Amongst them was John Cowper, a young mason who became one of the most important designers of brick buildings in the later fifteenth century. There is evidence that important craftsmen from other major brick building projects visited the site too.

The architectural response to Eton was not one of slavish imitation, but one family of brick buildings directly related to it does emerge, of which Herstmonceux and Queens' College, Cambridge, are two important examples. Their debt to Eton is apparent in their use of stone detailing; their regularity of design, which integrates all the building elements within a coherent ground plan; and the use of projecting external turrets (see Fig.4). Such turrets are a curiosity of Eton's exterior design and were probably inspired by castle architecture, possibly by that of Windsor itself. More detailed points of comparison can also be made. Herstmonceux, like Eton,

possessed a glazed gallery above a cloisterwalk in one quadrangle and at Queens' there is a single range of a similar design. Both Queens' and Herstmonceux also have window tracery without decorative cusping.

There is powerful circumstantial evidence for supposing that Ewelme Manor belonged to this group of Eton-inspired buildings. William de la Pole's close association with the work and his supervision of the royal brickworks at Slough in particular would have given him easy access to the expertise necessary for brick building on a grand scale. Furthermore, the 1612 survey demonstrates that the brick buildings were detailed with stone buttresses windows and doors in the manner of Eton. It may also be significant that the survey describes all the brickwork of the inner court as belonging to the 'out walls' of the building. The quadrangles at Eton and Queens' are built as brick shells without internal masonry partition walls – in plan two squares set one within the other – and furnished internally with wood. If the Ewelme Manor courtyard only had 'out walls' this would suggest a similar method of construction. Finally, an early-nineteenth-century drawing of a surviving fragment of the base court shows that this building had cuspless window tracery (see below, Fig.6).

Of the internal arrangement of Ewelme Manor we know very little. Entrance into it was through a single large gateway, whose bolt, chain and lock are catalogued in the 1612 survey. Typically gateways were placed in the range opposite the great hall and were aligned with the screens passage. The private chambers and service rooms were then arranged in the ranges flanking the hall. Some of the principal rooms at Ewelme Manor are named in a set of inventories of goods drawn up in 1466. Their mention of a 'gentlewomen's closet', 'my lady's closet' and 'my lord's chamber' may suggest there were separate suites of apartments for the male and female sides of the household. Other rooms mentioned include the great chamber with its ceremonial bed, several bedchambers, the chapel, the great parlour, the 'Norserye' and the great wardrobe. The details and structure of certain inventories offer some hints as to the relative position of some of these rooms.[65]

The inventories also give an impression of the fabulously rich furnishing of the house in the mid-fifteenth century. They record tapestries, hangings, beds, carpets, heirlooms, chapel goods and even children's clothes and were possibly drawn up in preparation for a particular event at the Manor. William de la Pole had collected tapestries and the list here probably includes his purchases.[66] Amongst many other things the inventories demonstrate the medieval habit of hanging chambers with materials of different value according to their importance, from arras in the principal chambers to counterfeit arras in the lesser and worsted in some of the bedchambers. They also suggest that the decoration of the different chambers was themed. Of particular curiosity in this respect is the great chamber, hung with a tapestry of Hercules' tourney with the Amazons.[67] This subject is treated in Alice's book by Christine de Pizan, *La Cité des Dames*, where it is discussed as

emphasizing the martial power of women.[68] Can it be coincidence that the same room was hung with at least one other tapestry that took women as its theme – the arras of 'dame dehonore' – and was displayed in the great chamber of a dowager duchess? Might the three tapestries of 'locus perfeccionis' also in the room refer to a female world?

To judge from antiquarian descriptions, this opulence was matched in the permanent decoration of the rooms. The ironwork mentioned by Leland in the roof of the great hall is a case in point. The 1612 survey confirms the existence of two iron beams 'crossing' the room, although it states that they were of cast rather than wrought metal. This use of iron – employed as a dramatic decorative feature, to judge by Leland's observation of it – is quite exceptional. So too were other elements of the interior. Lee, a herald visiting Ewelme in 1574, wrote and drew:

Note that the roufes of all the principall romes in this house of the quer [sic] of New Elme be garnyshed with thes thynges forunder very riche with diverse other devyces so riche as I did never see the lyke.[69]

'Skeins of blew thrade' A 'wolpake' A 'box and color'

These symbols are of considerable interest individually. The last is almost certainly intended to represent the collar and block characteristically worn by pet monkeys, a so-called 'ape's clog'. This symbol was used by William de la Pole as a personal device and its depiction on the roof of Alice's closet in the house presumably bestowed upon it the name of the Chamber of Apeclogges.[70] The two other emblems, the skein of thread and the wool pack, were probably William's devices too and were also used in the decoration of furniture in the house: the inventories of 1466 record that one bed of blue satin was embroidered with 'carantynes [?], pakk and skeynes'.[71] These symbols of the wool trade may have been chosen to advertise either the source of the de la Pole family's wealth in the Hull wool trade or William's appointment as Governor of the Wool Staple at Calais on 9 March 1448.[72]

There are many examples of symbols of office or curious emblems being employed as personal badges to decorate architecture and furnishings in this period.[73] Nevertheless, the richness and diversity of those at Ewelme is remarkable and, as will become apparent, William and Alice de la Pole took the advertisement of family roots and connections through architecture and its decoration to extreme lengths. The de la Pole family was also celebrated in the heraldic glazing of the manor: their arms appeared quartered with those of other families and were prominently shown impaling the Burghersh lion that Alice had inherited from her mother.[74]

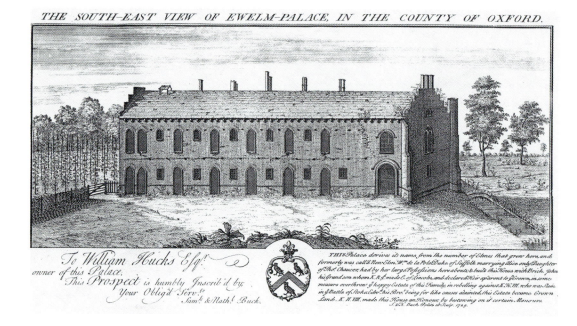

THE SOUTH-EAST VIEW OF EWELM-PALACE, IN THE COUNTY OF OXFORD.

To William Hucks Esqr
owner of this Palace.
This Prospect is humbly Inscrib'd by
Your Oblig'd Servt.
Saml. & Nathl. Buck.

5 The accommodation range of Ewelme Manor in 1729 by S. and N. Buck, actually viewed from the north-west. The sockets for the external gallery giving access to the first-floor rooms are visible.

The 1612 valuation describes three ranges of building outside the moat forming the base court to the house: one of timber-frame with brick nogging; a two-storey brick gatehouse, which apparently abutted another range on one side; and a double-storey brick range with five brick partitions and an external wooden gallery that stood 'beside' a house 'wherein the Honour Court is monethelie kept'.

This last range, which actually incorporated the courthouse, survived intact until the eighteenth century, and an engraving was made of it by the Buck brothers in 1729, as an illustration in one of their collections of topographical views of England's antiquities (see Fig.5). Their engraving shows a long two-storey building with stepped gables at either end. The absence of buttresses against the building's eastern (left) gable may suggest that a lost range stood at this end and, since the façade depicted probably faced into the courtyard, this would suggest that it formed the southern range of the base court. To the right of the engraving is a stream, and this may mark the line of the original moat, which has now disappeared.

The eastern section of the range appears to have been an accommodation block with lodging chambers arranged on two levels, each with its own door, window and fireplace. Those on the upper level were reached via the external wooden gallery, and the sockets for this are clearly visible in the engraving (Fig.5). Such rooms would have been used to lodge senior members of the household. There are good surviving examples of similar fifteenth-century buildings at South Wingfield, in Derbyshire, and Gainsborough Old Hall, in Lincolnshire. Much of the western end of the range has survived up to the present day but it has been extensively altered. This end of the range

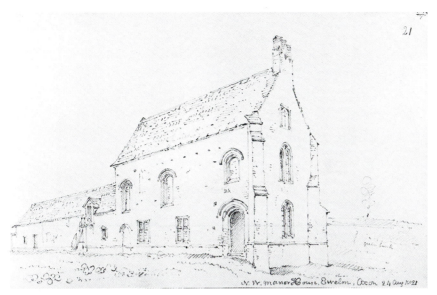

6 The accommodation range of Ewelme Manor in 1821 by J. C. Buckler. The doorway on the right matches that of the almshouse porch exactly, and the gable window tracery is without cusping.

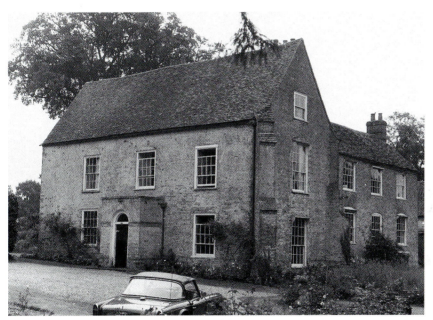

7 Ewelme Manor, the accommodation range, a modern view from the north-west. Very little evidence of the original design is now visible.

previously contained the courthouse mentioned in 1612 and was drawn before it was restored in 1821 by J.C. Buckler (Fig.6). Buckler's drawing confirms most of the details of the Buck engraving and indicates that the tracery in the west gable window was, in the manner of Eton and Queens', without decorative cusping.

As it stands today this surviving range of Ewelme Manor shows little external evidence of its antiquity other than the pair of buttresses at its western end (see Fig.7). Of these, that on the south-west corner of the building

8 Ewelme Manor, a conjectural elevation of the accommodation range in the base court from the north, showing bay divisions and roof-timbers and a section of the external wooden gallery.

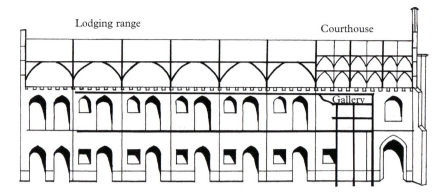

appears to have been integral with the lost hexagonal chimney or corner turret visible on the right of the Bucks' engraving.[75] The most impressive medieval element to survive is the five-bay section of the original roof, which has three elaborate bays decorated with tiers of wind-braces at its western end (see Fig. 8). These bays probably stood over the chamber which was later used as a courtroom. Its original use is not known.

From what we can learn of their patronage and glimpse of their personalities, it is apparent that William and Alice de la Pole were ambitious individuals with the determination and means to exercise power. Their careers brought fifteenth-century politics directly to Ewelme. After William inherited it in 1437 he adopted Ewelme Manor as a residence and, in response to his elevation to the marquisate in 1444, he rebuilt it in the most ostentatious fashion. As we shall see, God's House was conceived from the first as part of this de la Pole residence at Ewelme and both its institutional and architectural development reflect its close connections with the Manor.

3

The history of God's House

Founding an institution like God's House was something few could afford to undertake or organize. Financially, legally and logistically, the task of establishing a self-supporting and self-regulating community of men in perpetuity was immense. It was certainly not the work of a moment, as the royal licence for God's House, precisely dated to 3 July 1437, might lead us to suppose. Obtaining such a licence was simply a legal hurdle in a long process of foundation which might reasonably be expected to last years and even decades. Over this period it was common for all sorts of changes and adaptations to be made to an institution. Circumstances could change, plans go awry, patrons die, money run short or, in some circumstances, flood in in unexpected quantities.

Ewelme was no exception to this rule. But whereas we can only guess how most foundations were brought into being, in the case of God's House we can reconstruct a uniquely detailed picture of this process. There is evidence that the practical preparations for its establishment were under way as early as 1433, four years before the almshouse was formally 'founded' by royal licence and before the manor even came into the possession of William de la Pole. And God's House was not fully functional until at least 1454–55, over twenty years later. The changes which it underwent during this intervening period tell us a great deal about the forces and considerations which shaped its development and these shed an unexpected light on the conceived purpose of the foundation.

The logistical problems involved in founding a perpetual religious institution like the Ewelme almshouse demanded serious forethought.[1] Once a patron had decided to establish a foundation he needed to find an appropriate endowment which was both large enough to support the institution and sufficiently coherent to be manageable by it. The next problem was to get permission to make the endowment at all; the so-called Statute of Mortmain prevented all perpetual donations of land to the Church without explicit royal permission, which was difficult and expensive to obtain.[2]

Finally, a patron needed to build the institution and then staff it well, always a serious problem.

It is apparent that William de la Pole had given serious thought to most of these questions before he acquired the royal licence to found the almshouse in July 1437. The three manors the foundation was to draw its income from – Mersh in Buckinghamshire (now Marsh Gibbon), Ramridge in Hampshire and Connok (now spelt Conock) in Wiltshire – might seem far-flung, but they had a long history as part of an estate: an ideal endowment. This estate, which also included Norton-sub-Hamdon in Somerset and Grafton in Northamptonshire, had originally belonged to the Abbey of Grestens in Normandy. It had been bought by a member of the de la Pole family in the mid-fourteenth century and came into William's hands in 1430 through a complicated sequence of inheritance.[3] Shortly after he inherited them William began a series of conveyances of the manors, the documents relating to which survive in the Ewelme Muniments.

These documents essentially record the grant of the five manors to three men by William de la Pole and their return to William and Alice jointly. This exchange was actually effected twice: once incorporating the grant of a reversion of a third of the manors in the possession of a certain Anne Sackvylle, the widow of the previous owner, and once without. The whole process involved eight grants in all, and three documents survive from each grant, that is to say a grant and two powers of attorney, one for either party (in one case – EM A 12 – one of the latter appears to be lost). Several features of the documentation show that the legal procedure was carefully orchestrated: the grants are deliberately timed; their exchanges are precisely balanced; and William de la Pole signed the return grants to himself as if arranging and ratifying them.[4]

The body of documentation that these exchanges generated – twenty-four (originally twenty-five) documents including a royal pardon for one exchange, signed and witnessed in unimpeachable legal form – was clearly intended to create an unassailable title to the properties. Such exchanges are a feature of fifteenth-century legal wheeling and dealing and they might reflect any number of intentions on the part of William de la Pole. However, they do sometimes relate to the preparations for endowments and there are two features of these particular ones which strongly suggest that they were undertaken with this purpose in mind.[5]

The first is that the exchanges occurred three years after the properties came into William's possession. In other words it is very unlikely that they were drawn up in relation to an inheritance dispute – for example to counteract a rival inheritor's claims, or to substantiate a dubious appropriation of the property. But if William did not need to bolster his claim to the inheritance, why did he need these exchanges at all? The most likely answer is that he wanted to create written proof of his right to dispose of the property. These exchanges not only proved that he owned the property but, by extension, that it was his to give away – a very important and necessary

point to establish in the case of an endowment to a perpetual religious institution, which in the future might have no proof of this critical fact.[6] Secondly, the properties were conveyed back to William de la Pole and his wife Alice jointly. Alice had no prior claim to this property and her inclusion therefore is something of a curiosity. The most plausible explanation for it is that the exchanges were undertaken in preparation for the mutual endowment of a religious institution.

But although these exchanges show that preparations for the joint endowment of a religious foundation were under way, they do not necessarily prove that the terms or siting of that foundation had yet been determined. The latter question of the foundation's siting at Ewelme, if not planned from the first, was probably settled at the latest in 1434 when Alice's father, Thomas Chaucer, died on 18 November. As will be shown, God's House developed as a pointedly Chaucer foundation, incorporating as its focus a chantry chapel for Alice's parents decorated with an overtly self-aggrandizing heraldic display celebrating the family's connections with England's high nobility. It seems likely that this character was intended from the first: the Chaucers had no chantry of their own and, given the importance attached to these foundations in this period, Thomas's death would have demanded the creation of one. Such a foundation would most appropriately have been at Ewelme, the family's patrimonial seat.

Whether the form of the foundation as an almshouse was established at this date is not clear. It may be significant that, of the five manors involved in these exchanges, two – Grafton and Norton – were never actually incorporated into the endowment of God's House. It is a purely speculative suggestion, but this may imply that a rather grander institution, such as a college, was planned at first. Colleges were the most common form of palatial foundation in the period, and many circumstances – not least the prohibitive costs of such a grand project – might have prevented the establishment of one at Ewelme.

With the legal preparations apparently completed by 1435, the new foundation still had another two years to wait before it received its royal licence in 1437. This delay may have been caused by a decision to postpone the foundation until after the death of Thomas's widow, Maud, who held the manor in dower.[7] It may be evidence of this that after her death in April 1436 – and the completion of the legal procedures relating to it – preparations for the foundation went ahead very rapidly indeed, as if William had merely been waiting for an obstruction to be removed: a writ of *Diem Clausit Extremum* was issued on Maud's estates on 2 May 1437, and William and Alice entered into their inheritance on 22 June of that year.[8] Less than two weeks later, on 3 July 1437 at Kempton Manor, they secured a royal licence from the King to found God's House at what was now their own manor of Ewelme.[9] On the same day another pair of William's close political allies, William Phelipp, and Joan his wife, Lord and Lady Bardolf, were given a licence to found the so-called 'Phelippes chaunterie of Denyngton' at the altar

9 St Margaret's, Dennington, Suffolk, 'The Phelip's Chantry of Dennington', licensed on the same day in 1437 as God's House. The surviving loft to its surrounding screen gives some impression of how the lost rood loft at Ewelme was arranged.

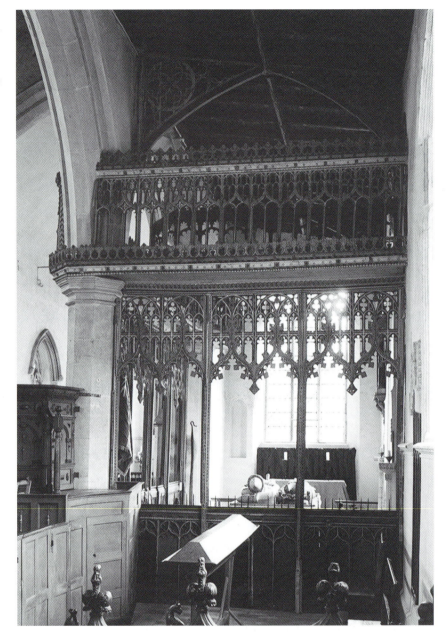

of St Margaret at Dennington in Suffolk, endowed with lands and rents worth £20 a year.[10] Coincidentally, this sister foundation – a screened enclosure in the south nave aisle with an altar and tomb – is one of the best-preserved chantry chapels in the country (see Fig.9).

Construction of the foundation must have begun almost immediately after the grant of the royal licence. The almsmen's chapel dedicated to St John the Baptist in Ewelme Church was completed by 1438, when the monument to

Thomas and Maud was moved into it and the tomb chest was inlaid with a new sequence of twenty-four enamel coats of arms. But there is no documentary evidence of activity on the foundation for almost another five years. Then, on 24 February 1442, a further royal licence was obtained, this time giving permission to endow the chaplains and poor men at Ewelme with the manors of Mersh, Connok and Ramridge, worth £59 a year, without their advowsons, in partial satisfaction of the 100 marks they were permitted to hold by the King's foundation licence of 1437.[11] A memorandum to the same effect was added as an endorsement to the reverse of the 1437 royal licence on the same day to confirm this grant.[12] Shortly afterwards, by an agreement dated Easter 1442, William and Alice granted the chaplain (note the use of the singular) and poor men the three manors.[13] The legal expenses of this exchange seem to have been defrayed from the income of the manors themselves and appear in the surviving manorial account from Ramridge that year.[14]

Four years later, on St Martin's Day, 10 or 11 November 1446, another agreement was drawn up on identical lines between the de la Poles and the almshouse, but this time endowing the chaplains (plural) and poor men with the same manors.[15] Curiously, it is only at the time of this second agreement of 1446 that we have evidence that the almshouse had become fully responsible for the management of its estates: the one surviving manorial account from this year, from the manor at Mersh dated Michaelmas 1445–46, is entitled 'The first account of the almshouse of Ewelme'.[16]

That the Ewelme almshouse was only auditing the Mersh accounts four years after it had been granted the manor seems odd. The most probable explanation for this is that until 1446 the estates had been managed for the almshouse by William's and Alice's own servants from Ewelme manor. There was probably a good practical reason for this: the 1442 agreement informs us that the almshouse was not fully staffed – there was only one priest and, though the wording obscures the reality, it seems likely that there were less than the full complement of thirteen poor men. By running the almshouse under the aegis of Ewelme Manor it would have been possible to oversee its development more easily and to support the community as it established itself. As we shall see, the almshouse was not fully staffed by 1446 either, but it was probably now large enough to be considered capable of running its own affairs. In these circumstances it is likely that the 1446 agreement signified formal recognition that the foundation had come of age and could meet the provisions of the royal licence. It was necessary to draw up this second agreement because the first agreement of 1442 had bequeathed the property but had only described one priest instead of the two in the royal licence. This was therefore a temporary measure superseded by the bequest of 1446, which finalized the endowment in accordance with the terms of the royal licence.

It is important to remember that these two agreements were no more than symbolically timed legal watersheds in the practical process of establishing

the foundation. Although we can deduce from the 1442 agreement that a community had certainly been established by then, its state and circumstances at that date remain obscure. The 1442 bequest may mark the first constitution of a community at Ewelme. But equally this could have happened some time before: if the almsmen's chapel with the tomb of Thomas and Maud Chaucer had already been erected by 1438 they would in all probability have been served by an embryonic community of almsmen from the earliest practicable date.[17] Whatever the case it seems likely that the deed was directly connected with the construction of the almshouse quadrangle and the settlement of the community – either newly established or moved from temporary quarters – in it for the first time. Given the completion of the chapel by 1438 and evidence, which will be discussed in the next chapter, that the almshouse quadrangle was completed before 1444, this would form a convincing tentative chronology.

The 1446 agreement is even more difficult to interpret as an indicator of the state of the community than that of 1442. It mentions two priests but, as will be demonstrated, no second priest was actually appointed to God's House until between 1454 and 1455. In other words the 1446 document was drafted so as to fulfil the terms of the royal licence but was not describing the reality. It was most likely timed to coincide with the foundation taking over the management of its estates – as the note on the 1446 Mersh manor account suggests. This was a labour-intensive undertaking, involving the dispatch of members of the community to the various manors as overseers and collectors. By 1446 the community was presumably large enough to be able to undertake this task. The 1446 agreement therefore proves that the community was growing, and considered capable of standing on its own feet.

Nothing further is known about the state of the community until the completion of the Statutes, and these may be securely dated to between 1448 and 1450. These confirm that the almshouse quadrangle had been built and that there were thirteen poor men and a Master in God's House.[18] They also include the first documentary reference to a school at Ewelme, describing the duties of the second priest – entitled the Teacher of Grammar – in running it. Practically everything we know about the school today derives from what the Statutes tell us. Its grand brick buildings – the second priest's house and the School House – are clearly appended as an afterthought to the almshouse complex and are closely analogous in details of design to the lost Palace buildings erected between 1444 and 1450. This evidence of their late construction is consistent with the fact that the second priest's post was still apparently vacant when the Statutes were written in 1448–50,[19] and also that the Statutes make no mention of the school building, perhaps suggesting that it was still in the process of construction at this date.

It seems curious that the school should have remained unfinished so long after the foundation was otherwise complete. It may be that it was put to one side as a secondary concern until the core of the foundation, the almshouse, had been established. But the Statutes seem to describe such a modest

institution – a grammar school for local children and children from the almshouse estates – that this scarcely seems probable. There were contemporary complaints about the lack of school masters in England, but when William de la Pole was at the zenith of his power and the almshouse was otherwise fully staffed it seems unlikely that such a difficulty would have stood in the way of a new appointment.[20]

Since the first mention of the school occurs in the Statutes, it is possible that the decision to found it was not taken until shortly before they were drawn up. The royal licence of 1437 may be cited as somewhat doubtful corroborative evidence for this suggestion.[21] It does not mention a school, and chantry foundations supporting two priests – apparently without schools – were common in this period, so there is no evidence that a school had been planned at the outset. If the decision to found a school had not been made until some time after 1437 that would explain why its buildings were an addition to the foundation complex and why the post of Teacher of Grammar remained vacant for so long.

Had the original plans for Ewelme in 1437 not provided for a school, it is easy to see how events in the 1440s could have led to the inclusion of one. In 1440 Henry VI announced his intention to found the College of St Mary at Eton, which incorporated its own school. Initially the college was planned as an isolated institution, but in 1443 it was linked with Henry VI's other new foundation, King's College, Cambridge, in imitation of William of Wykeham's earlier joint educational foundations of Winchester College and New College, Oxford.[22] The King's alliance of these two colleges is a reflection of a growing interest at court in education. Several prominent figures involved in Henry VI's project also founded or re-formed educational establishments of their own – amongst them Bishops Alnwick, Carpenter, Beckyngton and Waynflete.[23] Like these men, William de la Pole, himself closely involved with the work at Eton, might have been prompted to establish his own school beside his principal residence at Ewelme.

But the decision to found the school at Ewelme in imitation of the Eton project would only partly account for the circumstances of its foundation: if the decision to establish it was made by 1450, why did this modest institution only begin running between 1454 and 1455? The late date at which teaching commenced at Ewelme is one of two pieces of evidence which suggest that the early history of the school was not straightforward. The second is the disparity between the scale of its buildings and the type of institution which they apparently housed. To judge from the duties ascribed to the Teacher of Grammar in the Statutes, the school at Ewelme was typical of many small school foundations attached to chantries in this period.[24] Yet Ewelme differs from these foundations in the exceptional grandeur of its buildings. Contemporary statutes that describe schools often fail to mention the building where teaching was to take place and it seems clear, both from this and from the rare occasions when the site of the school is specified, that the provision was usually fairly casual.

Chantry schools seem most commonly to have been housed in chapels, as was the case at Higham Ferrers (Northants.) or North Leigh (Oxon.).[25] There are exceptions to this such as Heytesbury in Wiltshire, where, by contrast, the chaplains of the foundation were to teach in 'the place which is ordained and depute[d to] them to teach in within Heytesbury' [294] and at Sevenoaks in Kent, where the public grammar school, established in 1432, was to be held in a convenient house in the town.[26] A few contracts for purpose-built school buildings also survive, such as that at Stratford-upon-Avon erected in 1426 at a cost of just £10 5s. 3½d.[27] In view of this rather modest provision the question arises as to why the Ewelme buildings were so unusually ambitious for the kind of school the Statutes describe. One possible answer to this question, and an explanation for the late appointment of the first Teacher of Grammar, is that the school described in the Statutes is not the one which these buildings were originally planned to house.

The example set by William of Wykeham and Henry VI in their joint educational foundations was to influence the royal court right into the sixteenth century, as Wolsey's school at Ipswich and Cardinal College in Oxford (now Christ Church) show. One of William's contemporaries and colleagues who imitated the form was William Waynflete, sometime schoolmaster at Winchester and the principal administrator behind Eton's foundation and organization. Waynflete was granted a licence to found Magdalen Hall (and later College) in Oxford in 1448, which subsequently had two feeder schools.[28] It is not quite clear when these were established, but one at his birthplace (Wainfleet in Lincolnshire) was running in the 1460s, and a feeder school for the college in Oxford itself is first documented in 1480.[29]

With joint institutions as the obvious model for the greatest educational foundations of the day, William may not have been satisfied with founding an ordinary chantry school at Ewelme, such as the Statutes describe. He stood amongst the principal peers of the realm and moreover had shown considerable interest in the patronage of education both in the king's project at Eton and in the university at Oxford, which his wife patronized and which he served as Protector from 1447.[30] These circumstances might reasonably have called for some remarkable act of patronage, and one possibility is that it was decided to establish a feeder school for an existing Oxford college, in order to create a kind of joint foundation associated with himself. The plans for such a school might have been based on the original arrangements for Eton whereby, before it was allied with King's College, Cambridge, the boys were intended to pass on to established Oxford foundations.[31] Ewelme would have been ideally placed to function in this way and, as Protector of the University, William could doubtless have effected the arrangements with ease.

The intention to found a feeder school at Ewelme might explain the grandeur of the Ewelme buildings, which may be compared in scale to Waynflete's two-storey brick school building at Wainfleet in Lincolnshire. The latter was constructed in 1484 and incorporated a chapel and school room. A letter discussing its construction estimated that a building of the requisite size

for a school – twenty by seventy feet – would cost over £30, but in the event the carpentry alone cost nearly that sum.[32] There is unlikely to be any direct connection between the design of the school houses at Ewelme and Wainfleet, but in view of the possible similarity of their purpose as feeder schools the one forms a useful architectural yardstick with which to measure the other.

If this project was being realized in the late 1440s, William's murder in 1450 would have effectively killed it while the building and preparations were under way. His widow, perhaps finding that she was not in a position to complete the scheme, might then have decided to cut her losses and set up a more modest establishment in the splendid new buildings then under construction. It may be evidence of this that Alice revised the almshouse Statutes in 1456, just after she appointed the first Teacher of Grammar. Could one of the revisions have been to write out of the Statutes the regulations for the abortive project and insert instead the formulae for a run-of-the-mill local chantry grammar school?

As this narrative of the early history of the foundation vividly illustrates, God's House was not an institution that simply sprang into being in 1437, but one which was gradually brought to maturity over a considerable period of time and freely adapted to suit its patrons' wishes. William de la Pole took the first step to found God's House in 1433, when he began the legal process of securing a parcel of land that would form a suitable endowment. At that stage he may not have set his mind on any particular project, but he had probably decided to establish a Chaucer chantry at Ewelme with his wife by 1434 and determined that it would be an almshouse by 1437, when he obtained a royal licence for its foundation. Construction work went ahead rapidly and the almshouse chapel was complete by 1438 and the quadrangle probably by 1442. At this latter date the small community – which had perhaps already existed in embryo for several years – first received its endowment, but it only began to manage its own affairs in 1446. The Statutes, which constituted the final stage in its coming of age, were drawn up between 1448 and 1450. They include the first documentary reference to the school, which was a late addition to the almshouse, possibly inspired by William's involvement in the joint royal foundations at Eton and King's. It was not until 1454–55, twenty-four years after the first plans for God's House had been laid, that the school finally began to function, possibly on a less ambitious scale than was originally envisaged.

But to appreciate the specific circumstances of the foundation at Ewelme is to understand only one aspect of the story of its establishment. William and Alice de la Pole were exceptionally lavish patrons of religious foundations, and from the pattern of their patronage it is possible to see that Ewelme was part of a wider, loosely orchestrated campaign of nationwide endowments. One concern that underlay this campaign was political: William wanted to advertise the power and standing of the de la Pole family, and to use patronage as a means of consolidating and underpinning his rapidly expanding political hegemony in the 1430s and 1440s. This political concern

is a point of considerable interest and it underwrote many of his activities.

Amongst the articles of impeachment levelled at William in 1450 was the accusation that he intended to depose Henry VI and make his son, John de la Pole, King of England.[33] This accusation was undoubtedly false, but the fact that it was ever made at all highlights a contemporary concern with William's interest in establishing the de la Poles amongst the foremost noble houses in England. The marriages William organized for his son are the most obvious indications of this interest, but chantries were important too, as demonstrations of the family's status and advertisements of its antiquity, alliances and dynastic claims.

Ewelme was one of three chantry foundations associated with William's principal residences; the others were the Charterhouse of St Michael at Kingston-upon-Hull and the College of St Andrew at Wingfield in Suffolk. Both the Hull and Wingfield foundations had been established by William's forebears and had come to serve as de la Pole mausoleums.[34] That Ewelme developed as a foundation celebrating the Chaucer family would seem to indicate that it was conceived in direct counterpart to these. The collected tombs and the self-aggrandizing heraldic display of the foundation's chapel were intended to prove the Chaucer family's credentials as a noble line, and as a worthy match for the de la Poles. In this sense Ewelme is a piece of dynastic propaganda, and this influenced the form of the foundation in a number of surprising ways. For example, we shall see that when Ewelme Church was remodelled by the de la Poles to accommodate the foundation, the new fabric deliberately reproduced archaic architectural details and incorporated elements from an earlier church as if, in a bid for respectability, the building was pretending to be older than it was.

But the foundation of God's House was also an expression of William's growing local power. At the height of his career during the 1430s and 1440s, William was busy founding and endowing religious institutions, often in conjunction with political allies. These foundations were geographically focused in de la Pole home territory – a clear instance of patronage consolidating and expressing political control. Erecting buildings, beautifying churches with furnishings, liturgical utensils or vestments (often decorated with identifying coats of arms), being mentioned publicly in prayers, enriching the celebration of the Divine Offices with extra clergy, being recognized for and associated with the regular provision of charity – all were means of reminding a parochial populace of a patron's importance, wealth and power.

Between 1437 and William's death in 1450 there are royal licences recording the involvement of the de la Poles in founding three perpetual religious institutions in addition to Ewelme. The first, and most important, was granted on 20 October 1441 in return for maintaining the road 'which extends from Abingdon (Berks.) towards Dorchester (Oxon.), and over the Thames through Burford and Culhamford'. For this William and various of his political allies were given licence to found 'a guild in the parish church of

St Helen, Abingdon in Oxfordshire for thirteen poor weak and impotent men and women to pray for the good estate of the king, the brethren, sisters and benefactors aforesaid, after death and of their parents and for two chaplains to perform Divine Service in the church thereof in accordance to the ordinance of its founders aforesaid'. It was to be named the Guild of the Holy Cross, was to have its own seal, be capable of pleading in court and hold lands to the value of £40 – only £20 less than God's House itself.[35]

This licence was actually the means of incorporating an existing guild which controlled the principal trade bridges to and from Abingdon – one of the most important commercial centres in the region.[36] It has escaped comment that, through governing it, William and his associates were effectively commandeering the town's trade and that this fact was prominently demonstrated in two permanent ways. First, the same men also set up a famous market cross in Abingdon (which incidentally was sufficiently grand to serve as a model for Coventry's). This included a prominent display of heraldry, and although the original emblazons are not recorded they presumably included those of the de la Poles.[37] Second, the de la Poles must have become associated with all the guild's activities, including the refurnishing of St Helen's Church and the erection of a new almshouse.[38] The almshouse was built in 1446, and its regularized design and unusual architectural detailing ally it closely with both God's House and the new Manor House at Ewelme: facts, it will be argued, which may suggest that William was directly involved in its construction.

A year later, on 1 December 1442, William and Alice gave an endowment of over 800 acres of land to support two chaplains to say Divine Service in the chapel of St Mary le Bailley in Thetford for themselves and the Galyon family.[39] Then in 1447, along with the Archbishop of Canterbury and various others, William was again involved in establishing a chantry and hermitage in the neighbourhood of Ewelme. Licence was given 'to found a guild in the parish church of Thame of themselves and others' with permission to elect 'two or four wardens of the guild called St Christopher'. Associated with this there was to be a chantry of one priest to celebrate Divine Service at the altar of 'St John ys Ile', called the chantry of St Christopher, and an hermitage dedicated to St John the Baptist at Tettisworth. The hermit was to repair the highway between 'Stokenchirch and Hereford Brugge [bridge]' with his hands 'which has long been a nuisance for lack therof' and to pray in the chapel.[40]

In addition to these new foundations William was also involved in further endowing existing institutions. It seems significant that just two months after acquiring the Ewelme licence William got royal permission to make a further endowment to his own counterpart family chantry at Wingfield with lands and rents worth 100s. a year for two chaplains to say Mass at the altars of St Mary and St Nicholas for Lady Katherine, his mother, and at the altar of the Holy Trinity for Richard de la Pole, his uncle.[41] Then, only shortly afterwards in 1439, he made grants of land to the Charterhouse of St Michael at Hull, the other principal family foundation.[42]

In the 1440s William also became involved in two further concerns of particular importance in the locality of Ewelme. The largest single donation that William probably ever made to a religious foundation was the contribution of 1000 marks which he pledged towards the new College Chapel at Eton in 1448. He also became 'Protector' of Oxford University in 1447, a position that may have influenced the couple in insisting that the Masters of Ewelme were to be drawn from that university.[43]

Above and beyond such comparatively large concerns, the de la Poles were certainly involved in making substantial bequests to parish churches such as Eye in Suffolk[44] and Kidlington in Oxfordshire,[45] but for lack of information the extent of such patronage is difficult to assess. They were almost certainly also members of dozens of guilds, but references to this are again rare.[46]

God's House at Ewelme, then, was not an isolated undertaking. Over the years in which it was being established a number of de la Pole religious foundations sprang up in areas where William was intensifying his political control. Although it was the first of these foundations, and perhaps closer to the heart of William and Alice than many, Ewelme was, like the others, a statement of local power. As such its concerns were integrally bound up with the political world around it, and this demonstrably influenced its architecture and character. Amongst the manifestations of this which will be discussed are the use of brick at God's House and the East Anglian character of the design and furnishings of Ewelme Church – both exotic features (in a provincial sense) that were intended to reflect the de la Pole family's connections with East Anglia and the court.

But it would be a gross distortion to reduce a study of the circumstances of the foundation of God's House to an analysis of social and political motivation only. Devotion was also a vitally important driving force in its foundation, though its significance is easier to acknowledge than to measure. Its importance is witnessed by a number of details which will be discussed subsequently: in the carefully stipulated devotional obligations of the community, in the sophisticated iconography of the chantry chapel dedicated to St John in Ewelme Church and in Alice de la Pole's own tomb.

Alice's personal concern with chantry devotion is further reflected in her energetic organization of the family's spiritual affairs after her husband's murder in 1450. Amongst her documented activities are the remodelling of the de la Pole family church and chantry at Wingfield, including the reorganization of its tombs and perhaps also its college buildings in the 1460s;[47] an agreement with the Prior of the Charterhouse in Hull in 1462 that prayers and a commemorative distribution of food be made in the Charterhouse refectory beneath statues of herself and her husband;[48] the tomb she commissioned in 1459 for her husband at Hull; and the donation of 20 marks towards the construction of the tower of Eye Church for the good of her husband's soul and the good estate of her son in 1454.[49]

God's House, then, cannot be fully understood as an isolated fifteenth-century chantry foundation. It must be seen instead in the context of the de la

Poles' wider political, dynastic and devotional concerns, all of which played a part in its development and form. But the full complexity and importance of these concerns can only be glimpsed from the documentary evidence. Much more powerful testimony to them is apparent in the exceptional surviving architecture at Ewelme.

4

The architectural development of God's House

The fifteenth-century buildings of God's House, and such medieval furnishings as still exist within them, are amongst the most magnificent and complete ensembles of their kind to survive from the period (see Fig.10). As much as any documentation they offer invaluable evidence for the physical realities of life in an almshouse and chantry foundation in the late Middle Ages. But a detailed analysis of them is of more than narrowly archaeological interest. With such a rich body of supporting documentary material and a detailed knowledge of the foundation's circumstances in the fifteenth century it is possible to see the mechanics and values that forged this institution reflected in the buildings themselves. By extension we also receive an impression of the wider world in which God's House functioned and can read elements of its history in the fortunes of other foundations of the period.

God's House stands at the southern edge of Ewelme, a small village set in a shallow valley along the edge of the Chiltern Hills about thirteen miles south-east of Oxford. It takes its curious name from the Anglo-Saxon 'æwelme', meaning a fresh spring, a reference to the water source which still feeds a vigorous stream running parallel to the length of the main street. This stream was broadened and dammed to create watercress beds which were farmed into the last century but now stand disused. The foundation buildings are constructed on the valley slope immediately beneath the parish church of St Mary. At the bottom stands the School House, a handsome two-storey brick building (see Pl.i), and to the north of it a fifteenth-century gateway (Fig.11). In a line beyond this is a range of brick buildings incorporating the Grammar Master's House and the richly ornamented almshouse porch (see Fig.12). Passing through the porch, the visitor enters the almshouse cloister. Arranged around it are thirteen cottages for the community of poor men, the Master's Lodgings and a common hall (Pl.ii). This quadrangle is directly connected with the west tower of the church by an internal flight of steps and a covered brick passageway (see Fig.13). The church has an open internal plan but there

10 God's House, Ewelme: a plan of 1858 by F. T. Dollman. This shows that the medieval arrangement of the quadrangle was essentially preserved into the nineteenth century. It shows clearly the three principal component parts of the original foundation: the church and chantry chapel at the top; the almshouse quadrangle in the centre; and the school buildings at the bottom.

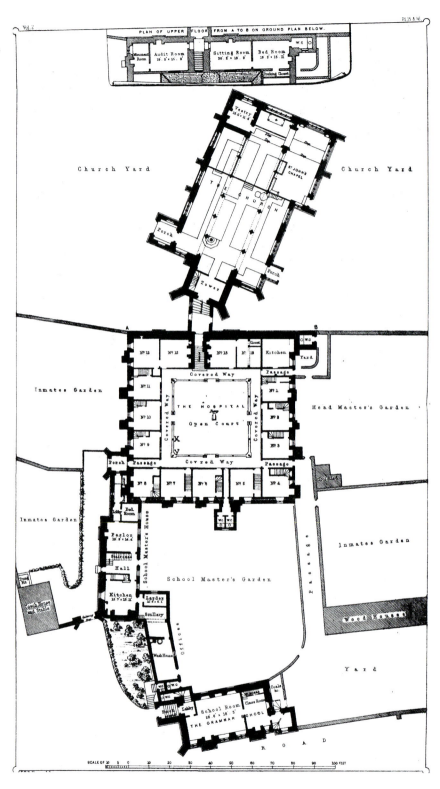

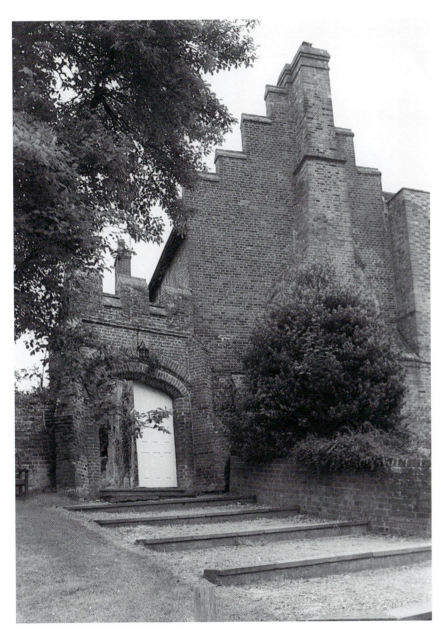

11 The west gable of the Grammar Master's House and the main gate at Ewelme, built after 1444. The fantastical castellations are characteristic of English brick architecture of the period.

12 A view of God's House at Ewelme from the north in 1941. The almshouse porch is at the centre of the photograph. To the right of this is the Grammar Master's House, and to the left the almshouse quadrangle and church.

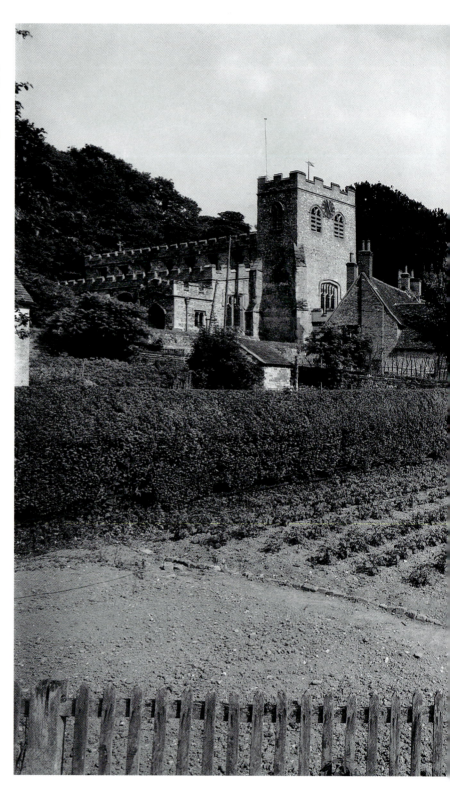

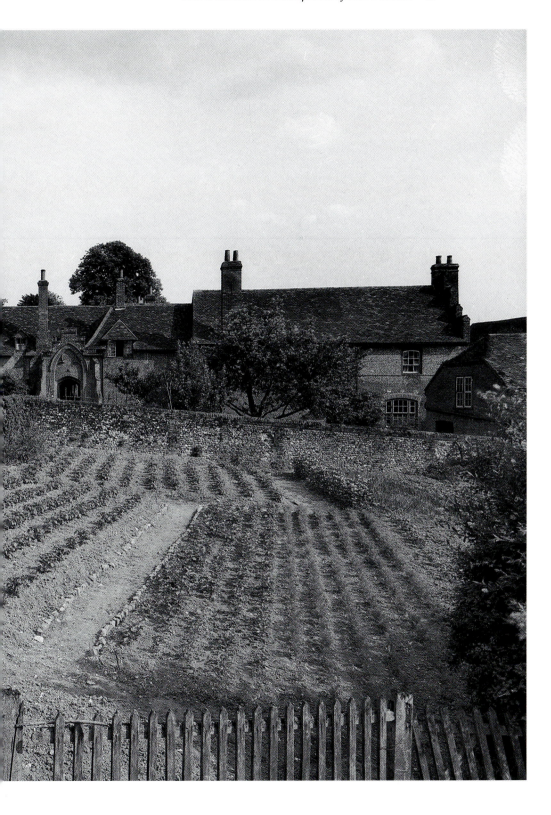

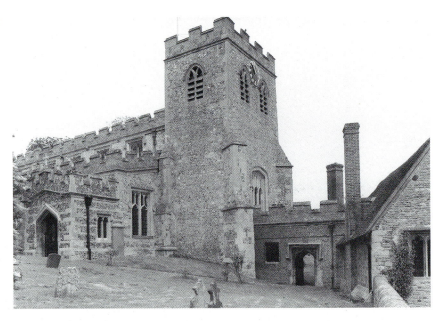

13 The west tower of Ewelme Church, the almshouse passage and the back of the almshouse common hall, decorated with herringbone brickwork. The church porch and upper sections of the tower have been rebuilt since the fifteenth century.

is a large chapel screened off within it at the east end of the south aisle. This is the burial place of the Chaucer family, the splendidly decorated chantry chapel of St John the Baptist, served by the almshouse community.

St Mary's Church, Ewelme

From the exterior, St Mary's Church at Ewelme is a small and undistinguished building with a squat, rectangular west tower. The body of the church comprises a central vessel, topped by a clerestory, which is flanked along its full length to either side by an aisle. This arrangement gives the church an unbroken outline and a distinctive, broad-headed east end (see Fig.14). The eastern façade and a section of the north aisle wall are decorated with a crude chequer pattern in knapped flint and cut stone, but otherwise the building is entirely constructed of rubble masonry. Crowning the church is a much restored stone string course set with gargoyles and a crenellated parapet of brick. There are two porches at the west end of the building: one in stone to the north and another in timber to the south (see Fig.15).

As it stands today the building is little changed from its state in the mid-fifteenth century, when it was remodelled by the de la Poles to accommodate God's House. The upper section of the tower was dismantled and reconstructed in 1792 – unfortunately before a record of its original appearance was made – and two new windows were inserted into the extremes of the north aisle: one in the west end of the church, probably in the eighteenth century, and the other in the vestry in 1849. Both porches have also been entirely rebuilt, but in each case they were apparently reconstructed in

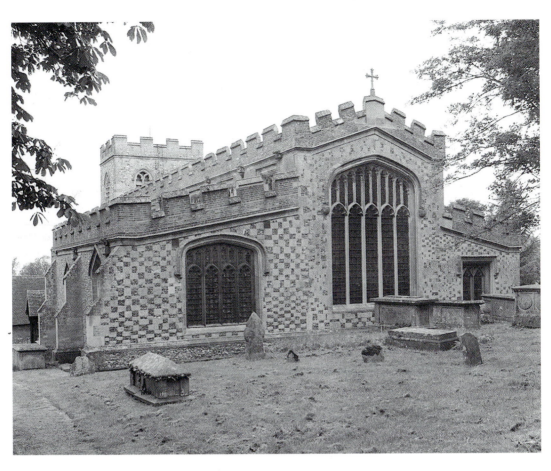

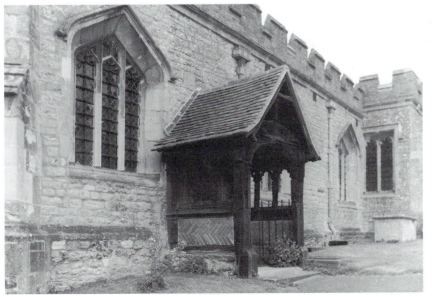

14 The knapped flint decoration of the broad-headed east end of St Mary's Church, Ewelme. Notice the disturbance of the pattern to the left of the main east window along the line of a masonry break.

15 St Mary's Church, Ewelme: exterior of the south aisle built by Thomas Chaucer c.1420. The timber porch cuts into the features of the aisle door it covers and is probably an addition of the 1440s.

reasonably faithful imitation of the structures they replaced, and the one to the south clearly incorporates most of its medieval timbers.

But although St Mary's is physically well preserved it requires an effort of mind to reconstruct its visual impact in the fifteenth century. The broad-headed east end and full-length clerestory of the church are unique in the parochial architecture of the region, and they were probably inspired by East Anglian designs. This use of East Anglian forms is also apparent in the furnishing and decoration of the building and was almost certainly intended by William and Alice as an advertisement of their titles as Earl and Countess of Suffolk. Whether most contemporary onlookers would have recognized this architectural allusion is an open question, but they would certainly have been struck by the oddity of the church's form. They would also have noticed its brick parapets. From the evidence of other buildings in the complex it would seem that it was the practice at Ewelme to cover rubble walls with render but to leave brickwork exposed for decorative effect. While the material was still prestigious and rare in Oxfordshire the inclusion of brick would have seemed unusual and ostentatious.

The interior of the church is impressive despite its small size (see Pl.III). There is no chancel arch to divide the nave from the choir and the central vessel of the church is uninterrupted through the whole length of the building; again, this is a feature strongly reminiscent of East Anglian architecture. Emphasis is given to this unified design by the low-pitched roof to the central vessel. This is of uniform height and design along the whole interior, and its heavy wall plates, purlins and ridge-piece give it a strong horizontal accent. The central vessel is divided from the aisles by arcades which run from the west end of the nave into the chancel and stop about fifteen feet short of the east end on both sides. To the south of the chancel the remaining stretch of wall is filled by Alice de la Pole's tomb, and to the north it forms one side of a vestry. This vestry occupies the eastern extreme of the north aisle. It is the only enclosed chamber in the church and is accessible through a fifteenth-century door on the sanctuary. As was often the practice, the vestry formerly had an internal upper storey, which probably served as a strongroom.

The church's open architectural plan is ordered by its fifteenth-century furnishings. These really make sense of the interior and their importance to the building has probably secured the survival of so many. Because the church lacks a chancel arch the only division between the nave and the choir is the rood screen. This runs across the whole width of the church dividing the aisles as well as the central vessel into eastern and western parts. Running east of the rood screen and infilling the arcades on either side of the central vessel are parclose screens. They divide the area east of the rood screen into three to create a chancel in the central vessel with a chapel on each side in the aisles. The chapel to the north is of the same width as the nave aisle and extends as far as the vestry. On the southern side, however, the aisle chapel has been made much higher and wider than the south nave aisle itself. This

chapel, which extends right up to the east end of the church, is the almshouse chapel and chantry of the Chaucer family dedicated to St John the Baptist.

Despite its impressive appearance, the architecture of St Mary's is confused. None of the windows in the church are aligned across the building and the elevation has been drawn together visually at clerestory level by the wall posts supporting the roof. These punctuate the wall at regular intervals and bestow an entirely illusory sense of ordered bay divisions on the interior. At ground level the regular march of the arcades serves the same visual purpose of ordering the architecture. Because the roof and arcades run at a single height through the length of the building they also distract from another irregularity of design. The church is built into a steep hill, but aside from the aisle windows, which are set progressively higher in the walls towards the chancel, the architecture does not acknowledge the change in ground level at all. Instead, the slope is accommodated internally as a single step two-thirds of the way along the building, and this is ingeniously concealed as the footing of the rood screen.

Such is the superficial impression of internal order in St Mary's, Ewelme, that, with the exception of the tower – to judge by its details a much altered fourteenth-century structure – it has long been described as the product of a coherent mid-fifteenth-century rebuilding. This has been attributed to the de la Poles after the establishment of God's House in 1437. But although the entire body of the church is fifteenth-century, its history is considerably more complex than has hitherto been supposed. In order to understand how the church actually developed it is necessary to consider its architecture in considerable detail. The extraordinary story that emerges more than repays the labour of the exercise.

Two periods of building work – here termed the first and second campaigns – are clearly visible in the fabric today (see Fig.16). The first building campaign comprised the south nave aisle with its arcade. This is constructed entirely out of coursed stone, in contrast to the various flint and stone mixtures used in the rest of the church. Its architectural details are extremely plain, and the only sculpted decoration it incorporates is a series of hood-stops carved as blank shields along the nave wall. The arcade piers are straightforwardly conceived as four shafts, each with its own capital and base, attached to a central column. All the windows and doors in the south aisle incorporate distinctively shaped over-arches in which the line of the arch runs straight from the shoulder to the apex of the opening without a curve. Each of the windows contains three tracery lights with a pair of small supermullion lights above the central one (see Fig.17). As we shall see, windows and a doorway of this design are also found in the southern wall of St John's Chapel, which is actually part of the second campaign.

There is good circumstantial evidence to suggest that Alice de la Pole's father, Sir Thomas Chaucer, was patron of the first building campaign. He is described on his tomb as 'a patron of this church' and certainly undertook building here because a surviving deposition of 1466 held in the Muniments

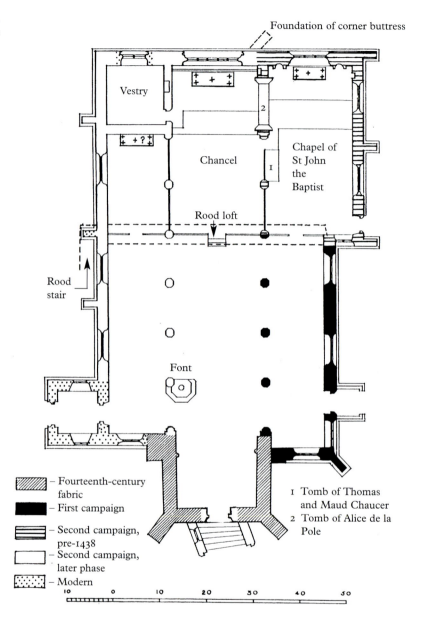

16 St Mary's Church, Ewelme, showing the building campaigns. Adapted from a plan drawn by L. Preston.

of God's House, and transcribed as Appendix VI, specifically asserts that he had used the stones of a great wall in the 'reperacion' of Ewelme Church. It seems significant in the light of this detail that the south aisle, in contrast to the rest of the building, is constructed purely out of stone. The dating of the first campaign before Thomas Chaucer's death in 1435 is further substantiated by the distinctive straight-sided arch used in the designs. This

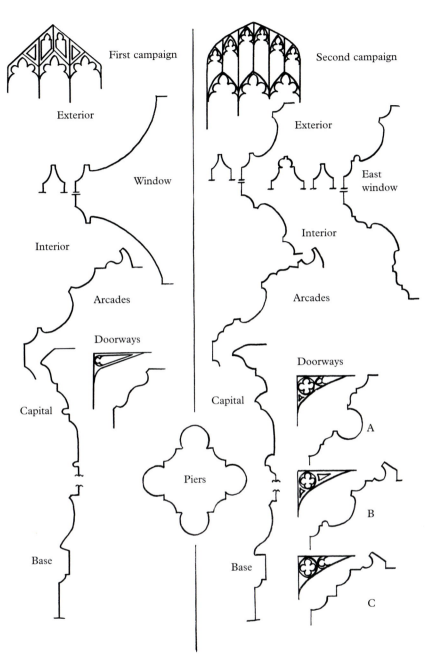

First campaign

Exterior

Window

Interior

Arcades

Doorways

Capital

Piers

Base

Second campaign

Exterior

East window

Interior

Arcades

Doorways

Capital

Base

A

B

C

17 St Mary's Church, Ewelme: comparative mouldings of the fifteenth-century building campaigns. Doorway A is in the west face of the church tower; B those to the north and south of the almshouse passage; and C the one at the west of the passage, at the head of the quadrangle stairs.

unusual form may be derived from the angular window designs used by the mason Richard Winchcombe in several important local buildings over the first quarter of the fifteenth century, for example the Divinity School at Oxford (begun in 1423), Adderbury chancel (1408–19), and other attributed works at Bloxham, Thame and Abingdon.[1] But the most compelling reason for

attributing the first campaign to Thomas Chaucer is the evidence of the second.

All the rest of the body of the church, including the parapets of the south aisle and both sides of the clerestory, belongs to a distinct, second building campaign. This was undoubtedly the work of William and Alice de la Pole and was undertaken in conjunction with the construction of God's House after 1437. The most remarkable feature of this campaign is the manner in which its details loosely echo those of Thomas Chaucer's aisle. Most strikingly the arcades of the second campaign are of identical size and pitch to those belonging to the south aisle. They are also very similarly moulded and detailed. In fact all the mouldings of the second campaign appear to be embellished versions of those found in the first (see Fig.17).

But there are several notable differences between the two campaigns. The window and door over-arches of the second campaign are all four-centred in design and the tracery follows a different pattern. This comprises a varying number of main lights – five in the chancel window, four in the east window of St John's Chapel and three in all the aisle windows (again an echo of the first campaign) – each with a pair of supermullion lights above it. All the supermullion lights have cinquefoil cusped heads with the curious exception of the east window in St John's Chapel, which has trefoil cusping. The second campaign also incorporates square-headed clerestory windows of two lights with cinquefoil heads. A larger window of this type stands in the west wall of St John's Chapel.

In contrast to the austere decoration of Thomas Chaucer's south aisle, the work of the second building campaign is enriched both inside and outside with large quantities of sculpture. Much of the external carving has perished or been replaced, but internally the quality of this work is still readily apparent. There is a superb set of figural roof corbels, which are cut as grotesques in the nave and as angels in the chancel. The hood-stops of the second-campaign arcades are similarly carved in a variety of forms to suit their location. A king's head, possibly representing God the Father, overlooks the font, and the arcade opening from the chancel onto the chantry chapel is decorated with Chaucer coats of arms on either side. Those facing the chancel are set beneath helmets, and those inside the chapel are held by busts of St Mary Magdalene and St Catherine (see Fig.73, below). Elsewhere the arcade hood-stops are cut as shield-bearing angels. The two set over the rood screen are modern copies.

There are several reasons for attributing the second building campaign to the de la Poles. Not only will the subsequent discussion of the almshouse quadrangle highlight similarities with the furnishing and architecture of the church which suggest that they were erected at the same time as each other, but the second campaign incorporated the chantry chapel of St John – a structure implicitly associated with the foundation. Work probably began on the new church therefore after the royal licence was issued in 1437. It was certainly finished by the time the Statutes were drawn up in 1450, because it

is remarked in them that a certain John Seynesbury was given the post of Master of God's House for the 'attendance that he had in the building of the said church and house also'[1].

The one secure date that we have for the remodelling of the church by the de la Poles between 1437 and 1450 is derived from the enamelled display of heraldry laid into the tomb of Thomas and Maud Chaucer in the Chapel of St John the Baptist. Its content and arrangement on the monument prove that the tomb was in place in the (presumably) completed chapel in 1438.[2] But although the chapel was completed by 1438, it is possible that the remainder of the building work to the chancel and nave was not undertaken immediately. There appears to be a masonry break running down the east wall of the church at the division between the chancel and the chapel and, at the point corresponding to this, there are footings for a corner buttress (see Figs.14 and 16). The coincidence of these two features suggests that the buttress was a temporary one, designed to support the old chancel while the chapel was being erected beside it.

Erecting the Chapel of St John against the existing church would have made practical sense in the remodelling work. Presumably the first priority of construction was to get the new burial chapel of the Chaucers completed and then to erect the foundation's buildings. By building the new chapel against the old chancel the parish church could continue to function while these two tasks went on. But although the chapel was probably erected in isolation by 1438 it seems likely from the physical and stylistic relationship between it and the rest of the rebuilding that the plans for the entire second campaign were already laid. Regardless of this staggered construction, therefore, the second campaign is of a single conception and design established by 1438.

To reiterate the proposed building chronology of St Mary's as it stands today: a church with a fourteenth-century tower was altered or rebuilt by Thomas Chaucer in the early fifteenth century. All that survives of his work is the south aisle, which was incorporated as part of a new church built by the de la Poles. They must have begun work on this new building very soon after the royal licence for the foundation of God's House was granted in 1437. It was executed in two stages: the first involved erecting the chantry chapel and the second the construction of the rest of the church around the south aisle.

The fabric of St John the Baptist's Chapel presents a particular problem in this proposed chronology of the church's development. In every other part of the building the distinctive features of the different campaigns appear in well-defined areas. But in St John's Chapel two windows and a door in the style of the first campaign appear in the south wall of a structure which, it has been suggested, actually belongs to the second (see Fig.18). The substantiating evidence for this assertion is complex and suggests that there were very particular reasons why this happened.

In physical terms the fabric of the chapel is both distinct from the work of the first campaign and physically integral with that of the second. Its distinction may be demonstrated on two counts. Not only are the south and

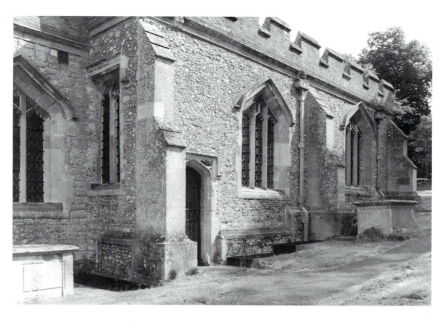

west walls of the chapel constructed entirely of flint (in contrast to the stone south aisle) but the change in material occurs at exactly the point where the chapel wall juts out beyond the line of the aisle. At this juncture the masonry of the aisle is disturbed and inlaid with flint; an arrangement which indicates that the flint wall was laid into the stone wall when the latter was already standing at its full height. In other words, the existing south aisle was truncated in order for the chapel to be laid out at its eastern end.

That the chapel is integral with the second campaign is evident from the physical evidence of its west wall. This contains a square-framed window which is identical in moulding and design to the clerestory windows of the second building campaign. It must have been specifically made for this position because its sill and mullions on the left-hand side have been cut so as to form part of the wall plane of the earlier south aisle. The tailoring of this second-campaign window would suggest that the wall it stands in is contemporary with it and, since the west wall determines the line of the chapel's south wall, that the plan of the chapel was established in the second campaign. This dating would be consistent with the fact that the arches which form the northern wall of the chapel belong to the second campaign. It would also correspond with the historical circumstances of the chapel's creation as a Chaucer chantry served by the new foundation.

But if this chapel really does belong to the second campaign, and the two fifteenth-century campaigns that have been described are genuinely distinct, what explains the occurrence of features like windows and a door in the style of Thomas Chaucer's aisle within its fabric? In order to answer this question, and to add authority to what may seem an unnecessarily convoluted interpretation of the fabric, it is necessary to look at the alterations Alice de la

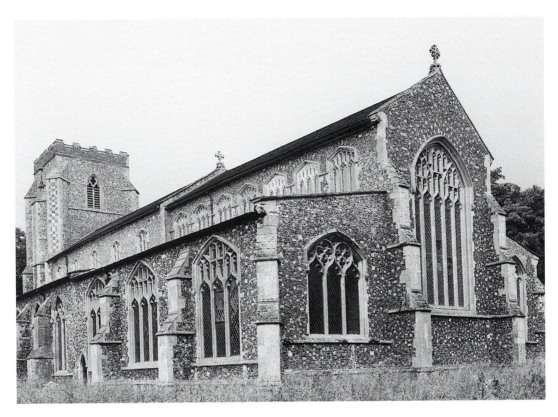

Pole undertook about thirty years later to a quite different building: the church and de la Pole chantry at Wingfield in Suffolk.

19 St Andrew's Church, Wingfield (Suffolk): view from the south-east showing the broad-headed east end and chancel clerestory built by Hawe, mason of Occold, for Alice de la Pole in the 1460s.

ST ANDREW'S CHURCH AT WINGFIELD, SUFFOLK

In reward for the vast loans he made to Richard II, William de la Pole's grandfather Michael received the title of Earl of Suffolk and the hand of the heiress of the veteran Sir John Wingfield in marriage. When Sir John died in 1361, Michael took over his seat at Wingfield and began to rebuild it as a castle. At the same time, under the terms of Sir John Wingfield's will, a college was founded to serve the parish church. According to the foundation charter, St Andrew's College at Wingfield was established in 1362 to support up to nine priests and a group of choristers.[3]

The collegiate church at Wingfield is altogether a much grander building than that at Ewelme, but it is almost identical to it in plan. It has a western tower, and the body of the building comprises a central vessel, topped by a clerestory and flanked along its whole length by aisles (see Fig.19). As at Ewelme, the only room in this open design is the vestry, which is tucked away in the eastern extreme of the north aisle. Otherwise the interior of the church is entirely open and its internal divisions are determined by furnishings. These are remarkably well preserved and, in the light of the church's

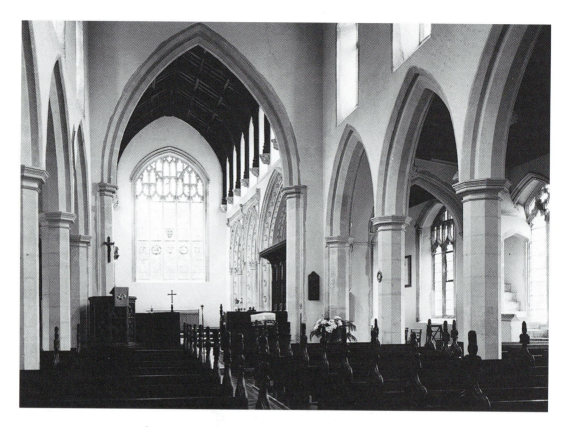

20 St Andrew's
Church, Wingfield:
interior view looking
east. One of the
flights of stairs to the
rood loft is visible on
the extreme right.

architecture, may be attributed to Alice de la Pole's alterations of the 1460s. Principal amongst them is the rood screen, which runs across the full width of the church. Only a small section of the lowest portion of this screen survives, but the stairs at either end giving access to the loft over it show that it must have been about fifteen feet high (see Fig.20).

The chancel to the east of this is very large by parochial standards – nearly the same dimensions again as the nave. It served as the choir for the college and preserves its medieval stalls, which return at their western end to form a U-shaped enclosure. On the north side of this there is a length of bench with desking which probably served to seat the choristers. The stalls are an unusual collection with high canopies and handrests carved with the de la Pole insignia of a Saracen's head (see Fig.21). There was also an organ in the choir.[4] The stalls subdivide the church east of the rood screen, marking off the aisles from the chancel itself. In an identical manner to Ewelme, the eastern ends of the aisles served as chapels, of which the most important was the Lady Chapel cum family chantry to the south. This latter chapel has defaced niches flanking its east window (see Fig.22), and the fragments of an Annunciation scene that are believed to have stood in them were discovered in the nineteenth century.[5]

Exceptionally for a medieval parish church, the vestry has an external medieval door as well as the usual sanctuary door, and is organized in a very

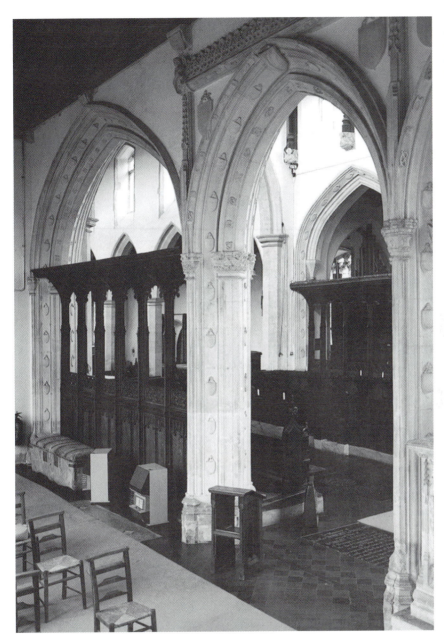

21 St Andrew's Church, Wingfield: view across the chancel. Note that the far (north) arcade arch has no capitals and seems tailored to accommodate the stall canopies.

remarkable manner. This long, narrow room is divided for three-quarters of its length by a fifteenth-century painted wooden gallery. The upper floor of this is lit by two little windows cut into the north vestry wall and, judging by the chimney-stack on the exterior, was once heated by a fire. Antiquarian accounts record that the vestry roof was decorated – probably with monograms of the name of Mary – and that the gallery was approached by a wooden stairway, though it is not known where this stood.[6] There are still considerable remains

22 A view of the Lady Chapel of St Andrew's Church, Wingfield, built by Michael de la Pole (ob.1415) and extended c.1460. The east window with its tracery florettes is probably late-fourteenth-century.

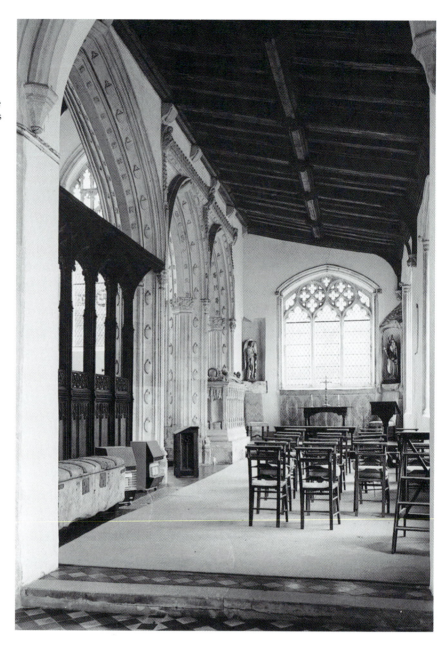

of painted decoration around the eastern extreme of the vestry and the east window contains *in situ* fragments of stained-glass canopies, which must formerly have stood over the figures of saints. Judging from these details, it seems likely that there was an altar at this end of the vestry, arranged so as to be visible to those in the gallery. There are also two low-set squints looking out from the gallery over the chancel. It was quite normal in this period for the devotions of the gentle or wealthy to be carried out in privacy, and these details

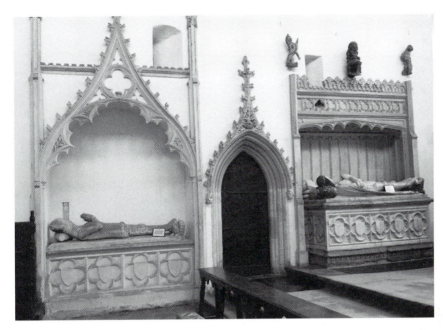

23 St Andrew's Church, Wingfield: north wall of the chancel with vestry door (centre), Sir John Wingfield's tomb (left) and John de la Pole's tomb (right). Note the parclose squints in the wall above.

probably identify this as a parclose or private watching loft with views over the two altars. Kneeling here viewers could see the consecrated host at the elevation of the Mass or as it hung suspended above the altar in a pyx. The care taken in organizing this loft with painting, lighting and exterior access would suggest that it was designed for use by the de la Poles. It may be no coincidence that in July 1465, at about the same time that it will be argued this parclose must have been built, Alice and her son John and daughter-in-law Elizabeth also sought a special licence to build a postern in the town wall at Hull so that they could attend Divine Service in the de la Pole Charterhouse there.[7]

The chancel contains three fine tombs. Set into the north wall are those of the founder of the college, Sir John Wingfield, and William and Alice de la Pole's son, John, with his wife Elizabeth Plantagenet (see Fig.23). On the south side of the choir is the tomb of Michael, 2nd Earl of Suffolk, and Katherine de la Pole, William's father and mother. This tomb stands under one of a pair of arcade arches which are richly decorated with angel capitals and small pairs of wings, lion's heads and knots (see Fig.24). These motifs are the heraldic badges of the Wingfield, de la Pole and Stafford families respectively and they celebrate Michael's family connections: his wife was a Stafford and his mother a Wingfield. In the early nineteenth century one of the spandrel shields also had the remains of a painted emblazon of de la Pole quartering Wingfield.[8] The tomb itself has a sedilia built into it – a very unusual arrangement – and the surrounding niches were once filled with labelled statues of the couple's children.[9]

As it stands today, the church is the product of three principal periods of construction. The earliest parts of the existing building all probably belong to an entirely new church that was built at Wingfield when the college was

24 St Andrew's
Church, Wingfield:
the tomb of Michael
and Katherine de la
Pole and its canopy
arches decorated
with heraldic
devices. View from
the chancel.

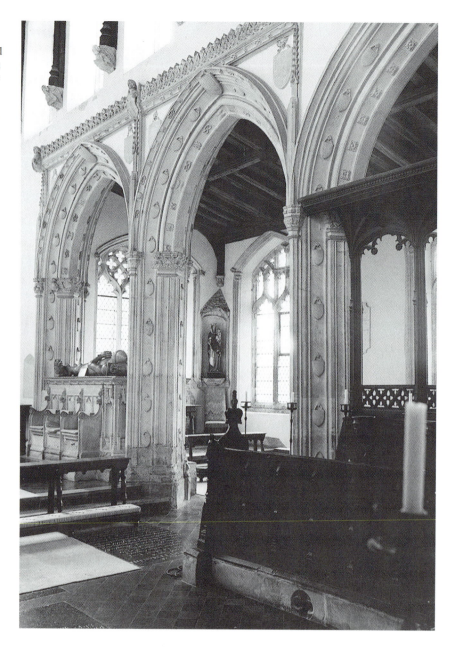

founded in 1362. According to the foundation charter, the executors 'having
built most of the church afresh, with an increased sum of money had made …
all things necessary to a sumptuous work'.[10] The architectural details of the
nave, the nave aisles (the northern has been remodelled subsequently on its
original footings),[11] the tower and the chancel arch would all be consistent
with the 1360s, and their regularity of layout suggests they were executed as
part of a single plan.

Features in other parts of the church also closely match the details of this work. The east window of the Lady Chapel has the distinctive four-petalled window-tracery patterns found in the nave aisle windows. It also shares the mouldings of the 1360s work, as do two windows in the vestry;[12] the sanctuary door to the vestry and the priest's door in the south wall of the Lady Chapel. It will become apparent that some of these features have been moved from their original positions and incorporated into later additions to the building. But it can be assumed that the sanctuary door is in its original place. This stands next to Sir John Wingfield's tomb which, being integral with the wall, is likely to be fixed in the original fabric of his church.

On the grounds of this evidence we can reconstruct the church erected by the executors of Sir John Wingfield as comprising the present tower and nave with two aisles, a chancel and a vestry. This building formed the basis of two subsequent sets of changes (see Fig.25). The first was the addition of the Lady Chapel on the south side of the chancel. Aside from the east window and priest's door the architecture of this chapel is quite different from the 1360s work: the arcades are intricately moulded and the window tracery is without four-petalled designs. The heraldic carving on the easternmost arches of this chapel leaves no doubt that Michael de la Pole, whose tomb stands here, was responsible for this work. It was presumably complete by his death because it is specified in his will of 1415 that he be buried on the north side of Our Lady's Altar at Wingfield.[13]

The church, as it existed in 1415, was next altered in the early 1460s by Alice de la Pole. Details of her proposed alterations, undertaken by a mason called Hawe of Occold in Suffolk, are recorded in an estimate for the projected work preserved in the Ewelme Muniments. This document (dated and transcribed in Appendix IV) deserves very close analysis for the remarkable light it sheds on the thinking behind the alterations it outlines. It contains a description of the intended architectural changes to the church, costings for materials and an *aide-mémoire* list of other necessaries.[14]

According to the estimate, the chancel was to be extended fourteen feet, and a new arch, 'of the same workmanship' as that over Michael and Katherine de la Pole's tomb, was to be built in the extended space on the south side of the church. Today it is possible to identify a masonry break running down the middle of the central pier of the pair of decorated arches over this tomb at a point fourteen feet from the east wall. The type of stone used, the coursing of the masonry and even the detailing of the sculpted decoration in each arch is slightly, but distinctly, different. In the light of Hawe's estimate, these differences prove beyond doubt that the eastern arch of this pair is an accomplished 1460s imitation of an early-fifteenth-century design (see Fig.26).

But not all the changes described in the estimate were executed so exactly and this document actually allows us to construct two sets of alterations – those that were proposed and those that were effected. The differences between the executed and the envisaged buildings are not always great, but

25 St Andrew's
Church, Wingfield:
the development of
the building.

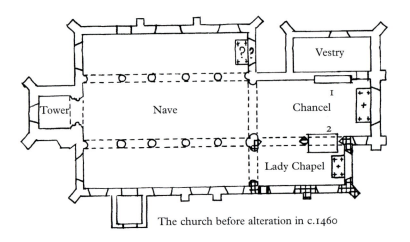

The church before alteration in c.1460

1 – Sir John Wingfield's tomb
2 – Michael and Katherine de
la Pole's tomb

Alterations described in Hawe's estimate

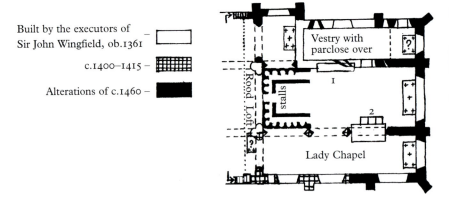

Built by the executors of
Sir John Wingfield, ob.1361

c.1400–1415 –

Alterations of c.1460 –

The alterations as they were probably executed

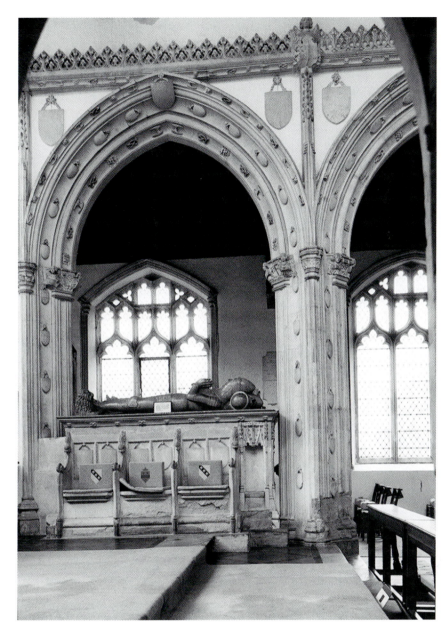

26 St Andrew's Church, Wingfield: the 1460s canopy arch over the tomb of Michael and Katherine de la Pole. It is constructed in imitation of the original canopy to the right. The masonry break between the two canopies runs down the centre of the right-hand pier.

some are important. The other points of alteration listed in the estimate are as follows:

(1) The tomb of Michael and Katherine de la Pole was to be moved and re-erected in its existing form under the new 1460s arcade arch.

(2) Our Lady's Chapel was to be lengthened so as to stand level with the chancel's east wall and a new window and buttress made for it in the south wall opposite the new arch.

27 St Andrew's Church, Wingfield: reconstructed elevations of the existing church in 1460 and the proposed alterations to it.

South elevation

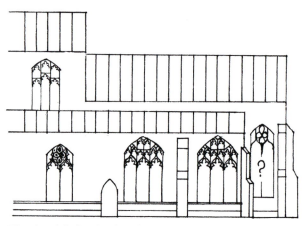

The church before its alteration c.1460

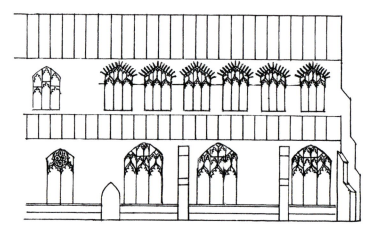

The alterations proposed in Hawe's estimate of c.1460

(3) It is explicitly stated that the existing east window of the chapel was to be reused in the new east end of the Lady Chapel.

(4) The chancel itself was to be heightened level with the nave and to have a clerestory with six windows built on each side.

(5) This enlarged chancel was also to be provided with two new windows – a gable window of five lights in the east end and a north window of 'the same sort and form' as the existing window on the south side of the chancel (see Fig.27).

East elevation North elevation

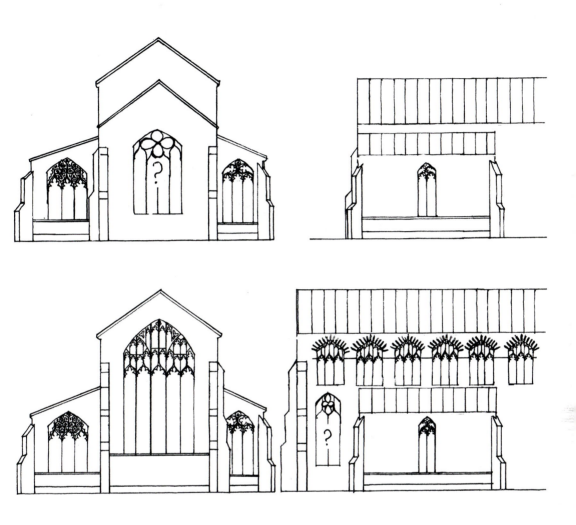

The majority of the work described in this estimate was executed and can be seen today: the chancel with its five-light east window and clerestory; the extended Lady Chapel with an added south window – also apparently a 1460s imitation of the c.1415 work – and the moved tomb. It is worth noting that if the present Lady Chapel east window is re-used from Michael de la Pole's pre-1460s Lady Chapel – as the estimate directs – it must actually have been recycled once previously by him in the construction of that chapel: the mouldings and tracery identify the window as belonging to the 1360s church

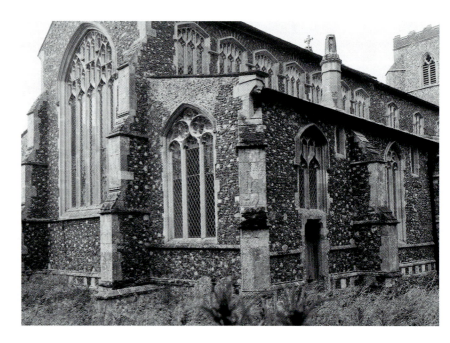

28 St Andrew's
Church, Wingfield:
exterior view of the
vestry showing the
consistency of the
masonry across the
east end. Note the
coarser 1360s
masonry to the
extreme right of the
picture.

erected by Sir John Wingfield's executors. But the proposed alterations also contrast in a number of interesting ways with the fabric of the church today. The clerestory has seven and not six windows a side and Michael de la Pole's tomb is not likely to be in its original form. This is suggested both by its obvious untidinesses, and because its existing plinth is too wide to fit between the plinth mouldings of its original canopy. Presumably, therefore, the tomb chest, decorated with figures of the couple's children and fitted with a sedilia, was actually built or rearranged in the 1460s by Alice de la Pole.

Most important, however, are the contrasts between the proposed and existing ground plans of the church. We know that the church as it stood previous to the proposed alterations did not have a broad-headed east end. This is apparent because the estimate tells us that the chancel extended beyond the south-aisle Lady Chapel sufficiently for there to be a window set in its south wall. Interestingly, the estimate also proves that there was no intention to create one, because the vestry was 'to remain as it doth' and a window, described as being 'of the same sort and form' as the south chancel window, was to be made and fitted into the extended north-chancel wall.

But although the estimate does not describe a broad-headed east end there is good reason to suppose that the existing plan was the product of Alice de la Pole's remodelling. Looking at the vestry today it is possible to see that it incorporates two patterns of masonry (see Fig.28). To judge by the window that stands in it, the rubble in the western half of the vestry probably belongs to the 1360s church. The mixture of stone and knapped flint of the remainder, however, extends throughout Hawe's other documented additions to the church and its regularity across the whole east end would suggest that it was

Wingfield, must remain an open question. Her husband was a prominent patron of architecture and it seems quite likely that the design of Ewelme Church owed much to William. If this was the case, it is conceivable that Wingfield was similarly arranged to Ewelme in memory of her husband, to whose family the church truly belonged.

THE FURNISHINGS OF ST MARY'S, EWELME

The fifteenth-century furnishings of St Mary's, Ewelme, are remarkably fine and well-preserved. In combination with the evidence of antiquarian records, they offer good evidence for the appearance of this church in the fifteenth century. The most remarkable interior in the building has always been the chantry chapel of St John, but this requires individual discussion, and what follows is effectively an attempt to reconstruct what parishioners might have seen when they entered the body of the church in the century before the Reformation.

One of the most important decorative elements in the medieval interior of St Mary's was the stained glass. Most of this has long disappeared, and all that survived into the early nineteenth century was moved into the east window of St John's Chapel, where it now remains.[17] Little may be said with confidence about this window's collage of fourteenth- and fifteenth-century fragments.[18] The former, if they originally belonged to the church, were presumably salvaged by William and Alice de la Pole from the older parts of the building during their remodelling work. The fifteenth-century glass may also include fragments from Thomas Chaucer's church but, if it does, it is impossible to identify these with security. What can be said, however, is that, as the de la Poles left it, the glass would appear to have formed a coherent decorative scheme with two themes: heraldic and devotional.

Antiquarian accounts help us to reconstruct a great deal of the heraldic glass. In particular they record a large number of coats of arms, most of which formed part of a complex heraldic display in St John's Chapel. The surviving glass also contains a number of roundels depicting heraldic beasts including yales and lions, the supporters of William and Alice's impaled coats of arms (see Fig.29).[19] These originally filled the supermullion lights of the south aisle windows and were set in panels of lightly patterned, diamond-shaped quarries, as is shown by a surviving fragment of *in situ* leading in the easternmost north-aisle window and by various early drawings (see Fig.67, below).

A drawing by Buckler of 1821 also shows a figure in the glass of one of the principal window lights of the south aisle.[20] This probably indicates that there were full-length figures of saints set beneath architectural canopies in each of the main lights. Such an arrangement is a commonplace of fifteenth-century glazing schemes, and a number of canopy fragments and heads from large fifteenth-century figures – all of unidentified female saints – survive. As a whole the scheme at Ewelme and the style of the painting compare closely with the extant glass at the Wilcote Chantry at North Leigh in Oxfordshire, founded in 1438.[21]

29 Glass fragments in St John the Baptist's Chapel, Ewelme. Above the lion and yale roundels, supporters of William and Alice's arms, are the remains of two cherubim originally from the supermullion lights of the chapel's east window.

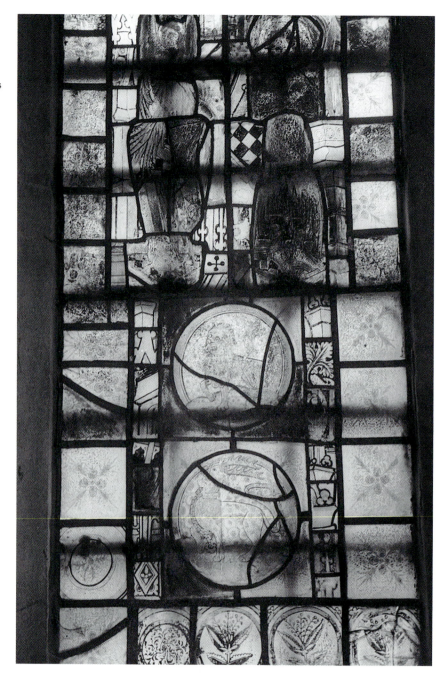

There is particular record of only one religious subject in the glazing at Ewelme. In the late seventeenth century the Herald Anthony à Wood noted: 'In a south window of the church are the pictures of two men talking – tu quis es? christus es tu? non sum ego christus.'[22] It is extremely unusual for Wood to record anything but heraldry in his church notes and this implies that the

scene in question was particularly prominent or noteworthy. The entry stands
in the manuscript under a separate head from the description of the chancel
and the Chapel of St John, a detail which might indicate that the scene filled
a window in the south nave aisle. It must have represented the passage in St
John's Gospel in which priests and Levites were sent from Jerusalem to John
the Baptist to discover who he was. In response he exhorted them to prepare
for the coming of the Lord.[23] It seems significant that this scene probably stood
in the aisle leading to the almsmen's chapel, dedicated to this saint, and this
fact will be further discussed in Chapter 8, below.

The Font and its Cover

The font stands on an octagonal platform of two steps at the west end of the
church, against the first free-standing pier of the north nave arcade (see Pl.III).
It is octagonal and cut with decoration: blind tracery patterns around the base
and blank shields set in quatrefoils on the bowl. On the arcade immediately
above it there is a carved head wearing a beard and crown, perhaps an image
of God the Father presiding over the spiritual threshold of the Church.
Suspended over the font is a spectacular cover, a wooden pinnacle about 10
feet six inches high. Such font covers were a feature of many late-medieval
English parish churches and they reflect the widespread medieval convention
of using elaborate canopies to identify important objects within a church
interior. As well as appearing over fonts, similar structures may be found
incorporated in many kinds of furnishing including tombs, stalls and pulpits.
In the case of fonts such canopies were more than merely decorative
structures: it was required that baptismal water be covered and kept locked
away.

The Ewelme cover is hung from the ceiling and counterbalanced by a
weighted wooden block carved as a triple rose (see Fig.30). It is formed of four
concentric circles of ogee arches of diminishing proportions stacked one
above the other. They are attached to a hollow wooden core by radiating
boards. Each of these boards is decorated along its outward edge by crockets
and curves inwards towards the apex in four stages to create a five-stage
structure (see Fig.31). Articulating each stage is the stylized outline of a
buttress surmounted by a notional pinnacle and coping stone. On the inner
edge of the upper stage there are a series of wooden cusps. The boards and
core are pierced by four ranks of narrow lancets with cusped heads and
castellated ledges. Around the rim of the base there is a band of ornamental
foliage, and at the apex is the feathered figure of an angel (see Fig.32). To
judge by his posture this is almost certainly St Michael the Archangel: his
hands have sockets for lost objects and he stands in the conventional attitude
to clasp a sword in one and the scales for weighing souls at the Last
Judgement in the other. The inclusion of St Michael on the font might be
intended as a symbolic reference to a Christian's course of life from Baptism
to judgement. Passing through the centre of the whole cover and holding it
together is a long iron rod.

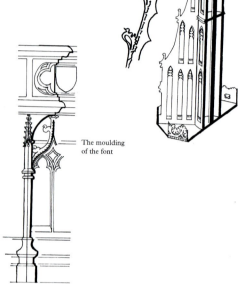

A cross-section of the font cover, with a detail of the upper stage

The moulding of the font

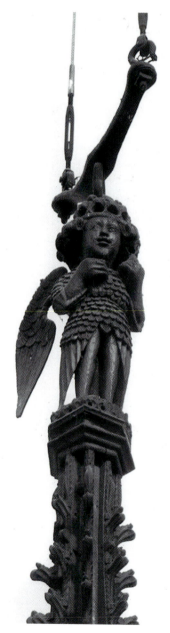

30 The multiple-rose counterbalance to the font cover at St Mary's Church, Ewelme, probably made in the 1440s. This common decorative motif was also the device on Alice de la Pole's signet ring.

31 St Mary's Church, Ewelme: details of the font and its cover.

32 St Mary's Church, Ewelme: the finial of the font cover. This probably represents St Michael, formerly holding the sword and scales of judgement in his hands. The wings attached to the figure are modern.

The cover is essentially medieval, but a close inspection of its timbers reveals that the circles of ogee arches are a nineteenth-century invention, added when the cover was restored after a fall between 1825 and about 1850. The original form of the font is depicted in an engraving made by Skelton in 1825 (Fig.33). This shows that it originally comprised only the wooden core and radiating boards.

The crocketing of the original radiating boards on the upper stage of the font follows a very unusual pattern which suggests an East Anglian provenance for the work. In this stage the crockets are conventionally cut as curling leaves with the exception of the uppermost – which is pressed flat against the finial – and the next leaf but one below it – which is cut as a bud (see Fig.31). This sequence of forms finds a parallel in an undated pyx cover at Dennington, Suffolk,[24] and, even more closely, in the font cover of St Peter's, Salle in Norfolk. Salle's font was built by the Luce family and is datable to the mid-fifteenth century (see Fig.34).[25] The correspondence of this minute detail on these two covers in the context of what are otherwise virtually identical designs may identify them as having been made by the same craftsmen. Salle's cover preserves fragments of paint on its boards and this suggests that the woodwork of the Ewelme cover was also once coloured.

It has long been supposed that the Ewelme font cover is Tudor on account of the counterbalance being cut as a 'Tudor Rose'. But multiple roses are a commonplace of late-medieval design and two details, apart from the comparison with the mid-fifteenth-century font cover at Salle, would suggest that it belongs to the de la Poles' remodelling of the church before 1450. The first is that the rose on the counterbalance, although otherwise a common decorative form, was also used by Alice de la Pole on her signet ring and may therefore be used here as an identifying mark of patronage.[26] Second, the pedestal for the figure of St Michael shares a distinctive moulding – a slightly distorted roll and fillet cut just off the perpendicular – with the screen behind the Chaucer tomb and the rood screen in the church. These are integral with the architecture and this shared detail probably points to common authorship.

The Rood Screen

The rood screen was the visual centrepiece of every medieval parish church. It divided the sacred space of the chancel from the public nave and took its name from the crucifix, or rood, flanked by figures of Mary and St John, which always hung above it. It is a common misconception that the rood screen was principally important as a means of removing the Mass beyond the reach and sight of the laity. Judging by surviving examples, rood screens were often easy to look through and usually enclosed just the high altar of the church. Other altars could be located almost anywhere in the building, sometimes with complete disregard to the architecture. Indeed the rood screen itself could have altars built against its public side.[27]

In practice the rood screen was less a means of exclusion than a window-frame through which the congregation watched the principal Masses

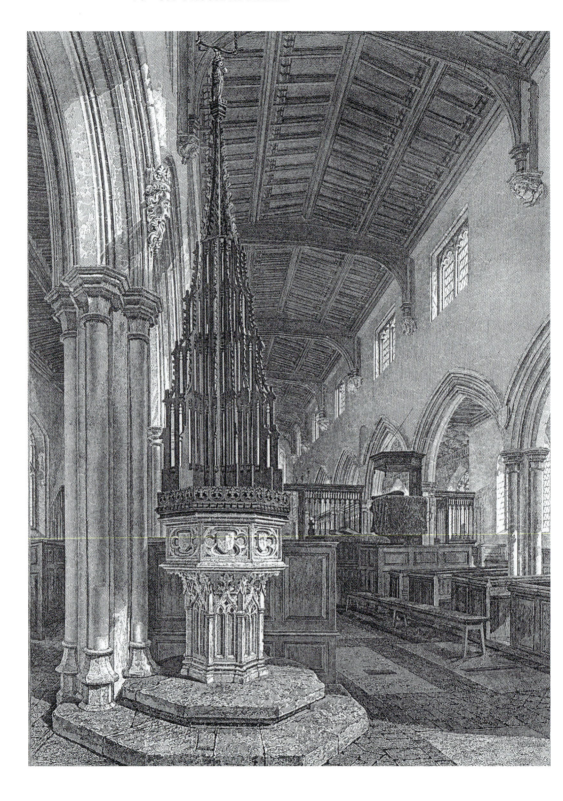

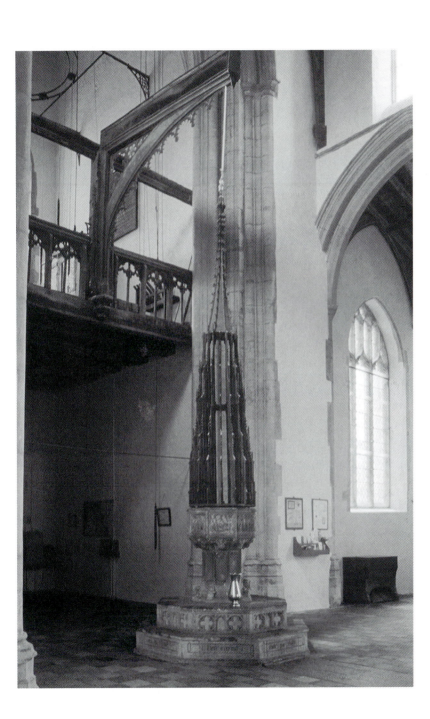

33 Skelton's view of the interior of St Mary's Church, Ewelme, published in 1825. This shows the font cover in its original form and also evidence of the coving of the lost rood loft above the south arcade.

34 St Peter's Church, Salle, Norfolk: view of the mid-fifteenth-century font and cover, possibly built by the same craftsmen as that at Ewelme. There are still considerable traces of colour on the woodwork of this.

celebrated in the church and the most important elements in the parish liturgy. Appropriate to this function, many of the grander surviving examples bear complex iconographies emphasizing Catholic theology and the heavenly hierarchy.[28] The screen also served as a liturgical furnishing in its own right by virtue of the gallery that ran along the top of it, called the rood loft. Depending on the locality and wealth of a parish the form of the rood loft might vary considerably. There are instances of rood lofts incorporating musicians' galleries, organs and even chapels.[29]

At Ewelme the rood screen is integral with the fabric of the present church and must have been built by the de la Poles as part of their remodelling of the building. It forms a partition across the full width of the interior and is divided into three separate sections by the piers of the arcades (see Fig.35). Those sections partitioning the aisles are both narrower and lower than the central part of the screen but all three contain a centrally placed, inward-opening pair of doors. These were secured by an identical system of locks and bolts and the original ironwork still survives on the doors leading to the Chapel of St John the Baptist.

The different sections of the screen are of uniform design, with a plainly panelled lower section and openwork tracery above it. This tracery imitates the pattern of the second campaign's window tracery with two supermullion lights set above each main ogee light. The pattern is a hallmark of the second campaign work, although in the screen the supermullion lights have trefoil rather than cinquefoil cusping. As is sometimes the case in medieval screens, the uprights of the tracery designs are made from wrought-iron bars, but unusually these have wooden capitals and bases fitted over them.[30] Above the tracery there is a moulded cornice which originally supported the rood loft. Nearly all traces of the loft have disappeared and there is no record of its design. A few details of it can, however, be rescued. As Skelton's engraving of 1825 shows (see Fig.33), previous to their restoration the aisle walls above the screen were smoothed back to accommodate the loft. The doorways communicating between the loft in the aisles and nave also survive, as does a square corbel which supported one end of its footwalk in the south aisle.

It is not clear how high the rood-loft parapet was but it must have substantially altered the interior appearance of the building, obscuring the view of the side chapels from the nave and interrupting the fine view down the main vessel that the modern visitor has today (see Pl.iii and compare Fig.9). The rood and its associated figures were probably hung from the double principal rafter in the roof, which is set about two feet behind the line of the screen. Presumably the loft projected as far forwards as it did backwards and must therefore have been approximately four feet wide. Access to the loft was provided by an external stairway built up against the outside of the north aisle. The doorway to it is now blocked by a buttress.

The rood screen has passed through various vicissitudes. Apart from losing its rood loft at the Reformation the screen appears to have remained untouched until 1844. In that year two feet of panelling were sawn off the

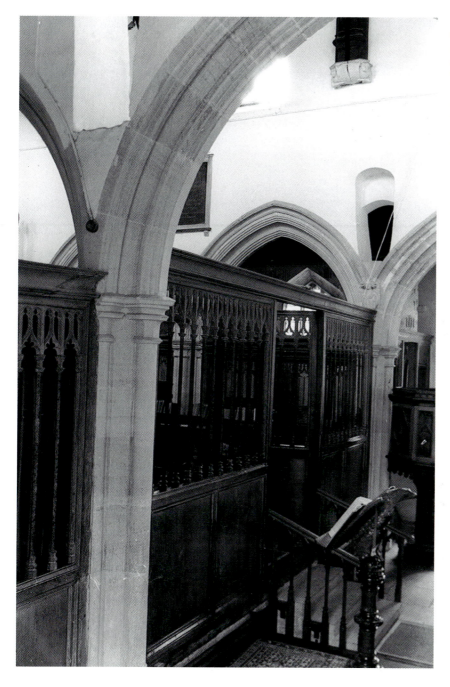

35 St Mary's Church, Ewelme: the rood screen and doorways to the rood loft. Note the double angel corbel and principal rafter above the screen in the nave. The rood figures were probably suspended from this.

bottom of the central section, apparently in order to help the Rector quell disturbances in the congregation while he preached from the nave pulpit.[31] At the same time the screen was painted with brown paint, 'where as before it had been purple and gold'.[32] In 1924 F. E. Howard brought the woodwork of

the screen back to what he considered to be its pre-1844 condition and it remains as he left it.[33] Shortly before this work began it was also decided to remove the brown paint on the screen. The first stage in this process was undertaken by the screen scholar Aylmer Vallance, who stripped the central section in about 1909.[34]

It has been assumed that Vallance found no traces of paint because when the other sections of screen were stripped in subsequent decades only the barest fragments were exposed. But this is not the case. There is a surviving letter from a daughter of Mr Dodd, the Rector of Ewelme from 1911, which makes reference to a lost drawing she had made of the paint exposed by Vallance.[35] The surviving correspondence with Vallance also makes mention of drawings made by him of the screen and amongst the collection of papers in which these letters have been preserved are a damaged tracing and painting of it. The painting is initialled by an artist who also made drawings for Vallance's books and it was therefore presumably drawn up under his direction and records the details of the coloration as he discovered it (Pl.IV).[36] Fragments of all the colours identified in this painting can be traced on the screen today, with the exception of the gold and the panel decoration with its gold and black IHS symbols on a blue ground. It is possible that this latter design was supplied by Vallance to replace lost decoration, but if it is based on original traces of paint it would explain the nineteenth-century description of the screen as being blue and gold. It would also convincingly echo the iconography of St John's Chapel.[37]

The Parclose Screens
There are sections of screen filling the pair of arcade arches on either side of the chancel (see Figs.36 and 37). They are all constructed in oak and have remained essentially unaltered since they were first erected – even details like the medieval plumb-line marks are still visible on the cornice planks. Each section of screen has open-work tracery above a plain panelled base. In contrast with the other screens, which are identical in design, the south-eastern parclose has richer mouldings and more elaborate tracery patterns than its neighbours (see Fig.38). This distinction in design reflects its importance as the backdrop to the Chaucer tomb in St John's Chapel.

There is a medieval means of access through the parcloses on each side of the chancel. On the north side this takes the form of a door cut as a section of screen, and on the south of an opening. The wooden jamb of this opening is elaborately moulded on all its exposed faces, and this fact proves that there was never a door at this point. One of Skelton's 1825 engravings also shows that the tracery design of the screen once continued through this opening (see Fig.67, below). There is no record or trace of any medieval paintwork on any of these screens and those to the north are still partly covered by brown paint, which was presumably added in 1844 when the rood screen was daubed with this. The nineteenth-century stalls and panelling in the chancel have obscured evidence for any medieval seating. Early engravings show that there was a

decorative crest of foliage along the top of each section of the parclose and this may have been original. Like the rood screen, these parcloses are integral with the architecture of the second campaign and are presumably contemporary with it. Moreover, their mouldings are closely comparable to those of the rood screen and font cover, suggesting that all were constructed by the same craftsmen (see also Fig.31 and Pl.IV).

36 St Mary's Church, Ewelme: the north side of the chancel showing the vestry door and north parclose screens. There is a heavy door to the aisle chapel in the near end of the far screen.

THE ALMSHOUSE PASSAGE

Before turning to the domestic complex of the foundation itself, it is appropriate briefly to consider the architectural ligature which connects it to the church. This is a covered passage constructed of brick with stone details running between the church tower and the almshouse quadrangle (see Fig.13). The church doorway opening onto this passage formerly had an elaborate medieval door, but this is now fitted to the School House and a reproduction of it stands in its place.[38] There are also two archways – formerly secured with doors – facing each other across the passageway. This arrangement was probably intended to allow feast-day processions, such as that held on Palm Sunday, to circumambulate the church, as custom demanded. Set above the door opening onto the graveyard to the south there is a defaced sculpture, possibly a devotional image (see Fig.39). The passage is undoubtedly contemporary with the second building campaign of the church: its four doorways are comparable in design to other features of the

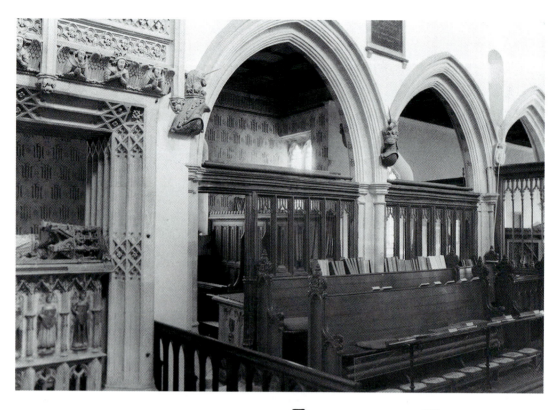

37 St Mary's Church, Ewelme: the south side of the chancel. The heraldic hood-stops in the arcade and the richly finished parclose (on the left) relate to the Chaucer tomb visible beyond.

38 St Mary's Church, Ewelme: the mouldings of the parclose screens.

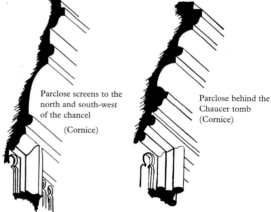

Parclose screens to the north and south-west of the chancel

(Cornice)

Parclose behind the Chaucer tomb

(Cornice)

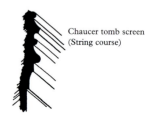

Chaucer tomb screen

(String course)

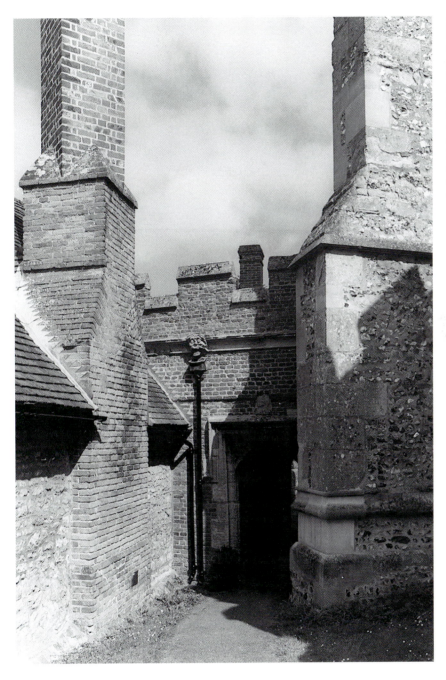

39 God's House, Ewelme: south side of the almshouse passage. The archways facing one another across the passage were formerly secured with doors and were designed to allow liturgical circumambulations of the church on feast days.

second campaign (see Fig.17) and the roof is identical to those in the nave aisles.

Two lost pieces of sculpture inside the church were possibly associated with the passage. On the western piers of the arcades flanking the tower arch are two statue brackets cut into busts of beardless figures (Figs.40 and 41), and

40 St Mary's Church, Ewelme: a statue corbel in the westernmost pier of the south arcade. Almsmen sometimes wore their beads around the neck and this is possibly intended to represent one.

41 St Mary's Church, Ewelme: a statue corbel, possibly representing an almsman, on the westernmost pier of the north arcade. One of a pair that may formerly have supported donor figures of William and Alice de la Pole.

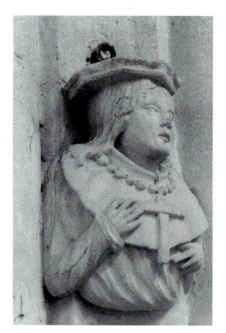
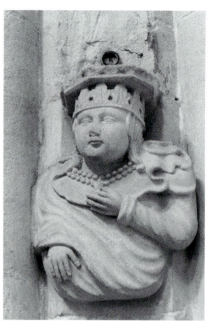

it may be conjectured that the sculptures formerly set on these were figures of William and Alice de la Pole. Preserved in the Ewelme Muniments is a surviving draft of an agreement made by Alice de la Pole with the Prior of the de la Pole Charterhouse at Kingston-upon-Hull in Yorkshire in 1462. This is of particular interest because it made perpetual and institutionalized a devotion which Alice is likely to have exercised personally towards the poor on a regular basis (see Appendix v). By the terms of this the Prior agreed to make and erect statues of William and Alice in a prominent place in the conventual refectory. These figures were to be shown holding a loaf or platter and a jug in their hands as symbols of bread, fish and oil. The Prior also agreed to distribute food daily to a poor man and a poor women from before these figures and, in return, the paupers were to pray for the de la Poles and all the faithful departed.

There is no evidence for any similar practice at Ewelme, but portrait images were often associated with the distribution of charity, for the obvious reason that they personified the benefactor. And if the directions for the location of the Hull effigies reflect the de la Poles' preferences for the placement of their donor statues then there are two good reasons for suggesting that these corbels supported images of them. First, this particular location in the nave, which is otherwise a very odd position for devotional sculpture, would have been an ideally prominent position for their figures. Not only is it in the public part of the church but it flanked the almsmen's exit from the building through the passage and would be seen by them on every occasion they passed into the almshouse. Second, the beardless corbel figures are almost certainly intended to represent almsmen. They are identified as

such by the beads they wear around their necks, a practice stipulated, for example, in the Eton statutes when the almsmen walked abroad [LVII]. The depiction of patrons with bedesmen or priests at their feet is a topos of contemporary tomb sculpture and this arrangement beneath the tower would echo the idea.

The domestic buildings of God's House

The existing arrangement of fifteenth-century domestic buildings at Ewelme is one of the most perfect and picturesque examples of almshouse architecture to survive from the Middle Ages in England. It developed in two distinct stages. First the quadrangle was constructed. This was erected according to a regularized design with a coherent underlying system of unit measurements. Then, after its completion, the school and its associated buildings – the almshouse porch, the Grammar Master's House, the main gateway and the School House – were appended in a line beneath its south-western corner. Of these buildings the School House was probably the last to be completed and this fact may help explain some oddities in its design. The break in construction between the two parts of the complex is reflected not only in their awkward physical juncture – evident both in the plan as well as in the fabric – but in their contrasting building materials and detailing. The explanation for this two-stage development probably lies in the late decision to incorporate a school within the almshouse and the ambitious architectural development of Ewelme Manor by William de la Pole after 1444.

THE ALMSHOUSE QUADRANGLE

Leland, describing Ewelme in 1542, wrote:

The pratie hospitale of xiij poore men is hard joynid to the west end of Ewelm paroche chirche: and much after the building of the vicars houses at Windesore yn a circle. In the middle of the area of the hospitale is a very fair welle.[39]

The almshouse quadrangle probably appears today much as Leland saw it in the sixteenth century, except that the fine well in its centre has disappeared without record and is now replaced by a Victorian water-pump (see Pl.II). The quadrangle stands on a platform cut deep into the hill and is skewed off the true axis of the church above by the lie of the land. The cloister within it is enclosed by four timber-frame ranges, two long ones to the east and west connected by two short ones to the north and south (see Fig.42). These are erected within an encircling rubble stone wall that is punctuated by high brick chimney-stacks and pierced by plain stone-framed windows. In the fifteenth century the quadrangle contained thirteen almsmen's cottages, the Master's Lodgings and the community's common hall. The latter two were incorporated within the eastern range, which, as a result, stands considerably higher than the rest. A pentice runs along the internal face of every range to create a continuous cloister walk around it. Set in the centre of each walk is a

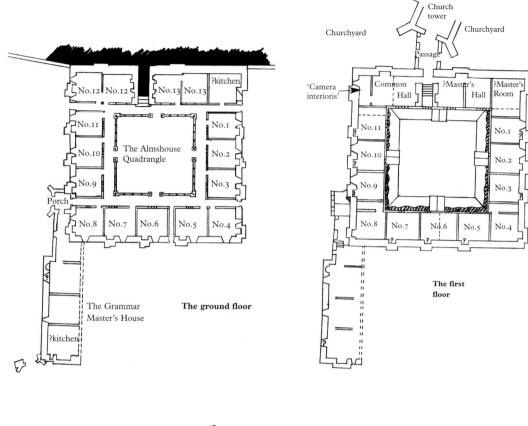

42 God's House at Ewelme: plan of the fifteenth-century buildings as they were originally arranged.

doorway with a high decorative timber-frame gable. Five passages originally led from the cloister walk to the outside world and a sixth housed the stairwell leading to the church.

The modern quadrangle is essentially a medieval building but it has been much restored over the centuries and in its present state is the product of a major renovation in 1970. This was undertaken with a view to creating a set of six modern flats in place of the thirteen original almsmen's cottages. During the course of the work the quadrangle was largely rebuilt and, in some respects, significantly altered. Several fifteenth-century chimney-stacks were dismantled, many new windows inserted and nearly all the existing ones enlarged. Much of the original fabric was stripped away and replaced and the timber-frame cut away or altered in many places.[40] The south-eastern

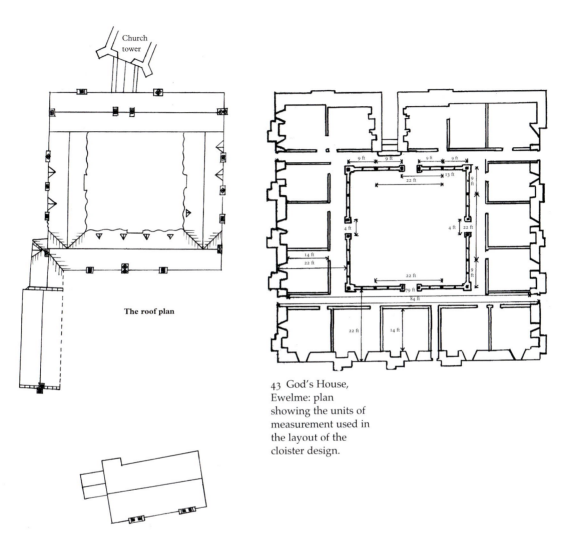

The roof plan

43 God's House, Ewelme: plan showing the units of measurement used in the layout of the cloister design.

corner of the quadrangle was the worst affected of all. Its existing plan was destroyed to create a new ground floor flat and, above it, an extension to the Master's flat. Unfortunately, it has not been possible to locate the photographic record that was made before the work began in 1970 and, as a result, the only evidence which we have of the original fabric is the existing timber-frame (where it is visible) and such drawings and photographs of the buildings as precede the restoration. We also have evidence of some features of the quadrangle's medieval form from the Master's Accounts of 1455–68.

Ewelme's quadrangle follows an unusually coherent design in which all the chief elements of the medieval buildings are regularly disposed (see Fig.43). The outer stone wall forms a square with an exterior measurement of eighty-four feet and an interior measurement of seventy-nine feet. These

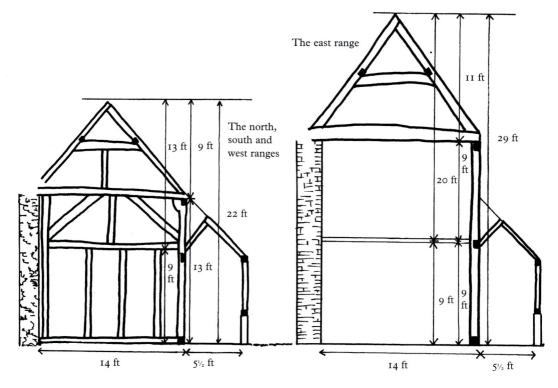

The east range

11 ft

29 ft

9 ft

20 ft

9 ft 9 ft

14 ft

5½ ft

The north, south and west ranges

13 ft 9 ft

22 ft

9 ft 13 ft

14 ft

5½ ft

44 God's House, Ewelme: elevation showing the approximate proportions of the cloister ranges (not to scale).

lengths are divisible by combinations of the principal units of the quadrangle's design – nine feet, thirteen feet, and the sum of these measurements, twenty-two feet. The former length of eighty-four feet is also divisible by units of fourteen feet – a common carpentry measure in the period, which has also been employed in determining the plan.

Within this stone shell the timber-frame has been laid out as follows: the wall of the cloister walk is positioned twenty-two feet from the outer face of the quadrangle's external rubble wall and the ranges are built out towards this to a distance of fourteen feet from the inner face of the same wall. The elements in the faces of the cloister walks have been disposed in plan according to nine feet and twenty-two feet measures. Each range of the roof of the cloister walk is supported on six principal upright posts, which have been positioned at nine-foot intervals measured from the corners of the walk: three from one and three from the other, so that the innermost pair are only four feet apart. These innermost uprights form the sides of the gabled doorways in the centre of each walk. The central upright of each group of three is twenty-two feet from its counterpart upright in the adjoining half of the walk, and this fact is registered in the architecture by the insertion of a roof collar-beam that springs from above each intermediary upright into the adjacent range (see Fig.49, below). Positioned midway between each principal cloister upright there are secondary posts. As will be discussed, these could be a modern addition to the medieval design but they do fit within it perfectly happily.

In internal plan each of the four ranges is divided up into a series of bays. Most of the bays are about thirteen feet long but the need for passages and

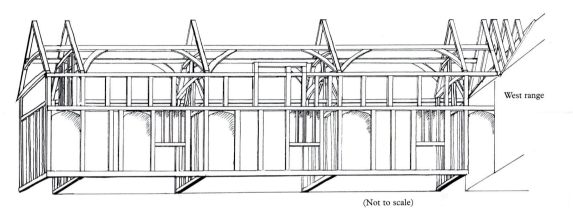

West range

(Not to scale)

45 God's House,
Ewelme: isometric
view of the timbers
of the south cloister
range as they
originally appeared.
The common rafters
of the roof are not
shown.

large rooms introduced irregularities which have been accommodated by botches and variations in size. Where variations in thirteen-foot bays became otherwise unmanageable – as in the northern end of the eastern range and the central pair of bays in the western range – the carpenters adopted bays approximately nine feet in length (see Fig.42, first-floor plan).

Nine-, thirteen- and twenty-two-foot measurements also occur in some elements of the cloister elevation (see Fig.44). The three low ranges all stand twenty-two feet high and the dimensions of their elevations appear to be derived from nine- and thirteen-feet measures: the distance from the ground to the first-floor beams is approximately nine feet; from the ground to the wall plate thirteen feet, and from the first floor to the apex of the roof thirteen feet. In the eastern range the first floor is also nine feet from the ground, and the wall plate another nine feet above that. Neither the cloisters nor the gabled doorways seem to conform in elevation to this system of measurements.

As in most timber-frame structures, all the medieval architectural features in the cloister are integral with the main frame of the buildings and it is possible therefore to identify or reconstruct these with certainty (see Fig.45). The original almshouse cottage doors have plain four-centred arch heads and the framing timbers around them have had their inner corners chamfered off. There are two grander doorways than these in the quadrangle. One opens onto the passage leading to the almshouse porch (at the north-western corner of the quadrangle) and the other onto the stairwell leading to the church. Their spandrels are decorated with carved tracery patterns and the eastern

46 God's House, Ewelme: the stairwell from the cloister to the church. The wooden door-frame is cut in imitation of stone. Both handrails are fifteenth-century.

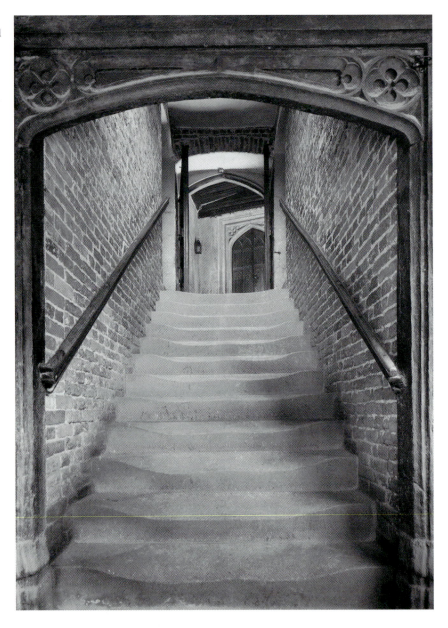

range doorway also stands on deep plinths (see Fig.46). In these details, as well as in their plain mouldings, they are identical to the doorway at the head of the almshouse stair to the church (see Fig.17, door C). Their features also compare with those of second-campaign doorways in the church.

A number of the original windows facing into the cloister walk in the north, south and west ranges also survive. It is still possible to see the sockets for the lost timber mullions in some places and these show that they were

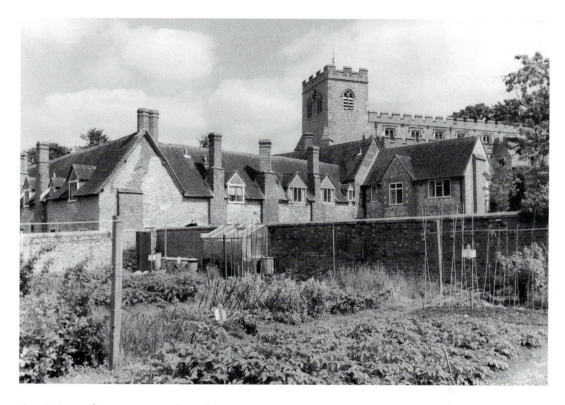

divided into three vertical lights. The windows in the east range have all been enlarged and, because the timber-frame on this side of the building is almost entirely lost, there is no evidence of their original form. Only the window above the stairwell probably maintains its original dimensions. Some of these eastern-range windows were certainly glazed in the fifteenth century, because the Master's Accounts record the repair to the leading of windows in the common hall and to a 'hanging window' – perhaps that above the stairwell. Reference to the repair of 'a glass window in the cloister' may also suggest that the almsmen's cottages were similarly treated.[41]

The doors and windows set in the external rubble wall to the quadrangle are all of stone and, with the exception of the door at the head of the church passage stair, were without decoration or moulding. All but one of the windows were widened in 1970, but an 1821 drawing by J.C. Buckler shows their original appearance (see Fig.61, below). The doorways are apparently unchanged. More prominent on the exterior than either the doors or the windows are the tall, brick chimney-stacks (see Fig.47). These have been much restored but, from both the evidence of drawings and the fabric itself it is clear that they accurately reflect the design of the medieval originals. They are built in a rough English bond with queen closers and incorporate a variety of flue shapes including polygonal and diamond forms. The use of chimney-stacks to articulate an exterior façade is characteristic of English architectural design, but the finish of these is distinctively Flemish-inspired: in several

47 God's House, Ewelme: view from the south-west across the almsmen's gardens. The garden walls probably follow the lines of medieval predecessors.

48 God's House,
Ewelme: detail of a
chimney kneeler.
Kneelers are the only
specially shaped
bricks in the cloister
ranges.

cases the juncture between the flue and the stack is decorated with stepped
gables supported on projecting corbels or kneelers which have been cut or
moulded into shape. These are the only shaped bricks in the quadrangle (see
Fig.48). Similar contemporary designs of chimney-stacks are found in several
important brick buildings of the 1440s such as the guardhouse at Tattershall

Castle in Lincolnshire (also with queen closers) and the kitchen of Queens' College, Cambridge (1448–49).

In 1970 the filling of the frames throughout the quadrangle was entirely stripped out, but there is some evidence of its original forms. In the roof space above the Master's Lodgings there are remains of several filling panels composed of woven oak staves covered in plaster. This stave-and-plaster filling was probably found throughout the almshouses and, even where it has been removed, it is often still possible to see the distinctive sockets and grooves cut to receive the upright oak staves in the main frame. The only part of the frame that was not filled in this manner were the panels facing onto the covered walks of the cloister. These are filled today with bricks laid in herringbone and other patterns (see Fig.49). It is clear from drawings that these panels reproduce the patterns which formerly existed and there is good reason to suppose that this brickwork was part of the quadrangle's medieval decorative finish.

Brick has been used throughout the quadrangle sparingly but for maximum visual effect: doubtless a reflection of its comparative rarity and the prestige attached to it in this period. This self-conscious usage of the material is most readily apparent on the exterior. Climbing into the roof space of the annexe to the Grammar Master's house, a structure added against the north-western corner of the quadrangle after its first completion, it is possible to see the remains of what must have been the fifteenth-century finish of the buildings. The roof conceals a section of the quadrangle's rubble wall and the stump of a demolished chimney-stack. In this area the rubble wall is concealed by render while the brick of the stack itself stands exposed. This simple cosmetic trick of covering the rubble, if extended over the whole exterior, would have given the illusion that the almshouse was built entirely of brick. It would also have served to integrate the quadrangle visually with the rebuilt church, which was also finished externally with rendered rubble walls and brick castellations.

That brick was being used consciously as an object of display is further suggested by one touch. The exterior almshouse wall is constructed entirely of rubble, with the curious exception of the north end of the east range (see Fig.13, above). This section of wall, which faces onto the churchyard and towards the village, is covered in a herringbone pattern of brick: a detail which can only be explained if it was to be left exposed and, in the context of this public façade, was being used for show. The occurrence of brick patterns in the cloister panels would make perfect sense if, as on the exterior, there was a conscious effort being made to display this material. Doubtless they were intended to make the cloister enclosure look rich and unusual.

Only one element of the fifteenth-century quadrangle presents problems of reconstruction. In essentials the present cloister pentice has probably changed little since the Middle Ages: many of its roof timbers look medieval and the disposition of the supporting uprights in the plan accords with the regular design of the cloister as a whole. But the pentice has been much restored and

49 God's House,
Ewelme: view of the
north cloister walk
showing the original
window openings
and the patterned
brickwork, relaid in
1970 according to the
medieval designs.
Note the two collars
in the roof. They are
set 22 feet apart, a
measurement
underlying the
design of the whole
quadrangle.

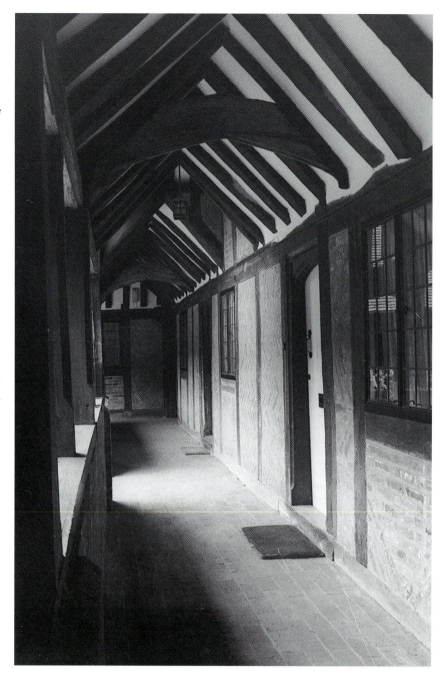

it is not clear today how it was originally finished. The cloister is first
represented in a Buckler drawing of 1821 (see Fig.50). In this the walks are
depicted in much the same form as they exist today, with the roof of each walk
supported on ten uprights. The only differences are that the uprights rest on

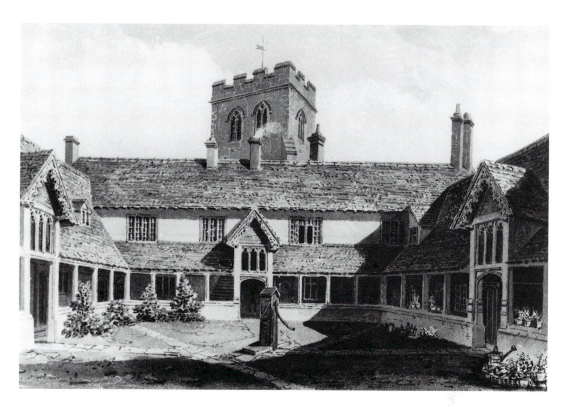

a rather lower footing wall than at present with coping stones or bricks set over it.

Buckler's drawing may record the fifteenth-century design of the cloister but a later alteration has confused matters. In the mid-nineteenth century the footing he drew was replaced with modern bricks and the cloister was left with only six principal uprights in each walk (see Fig.51). One engraving of the cloister in this state – by Dollman in 1858, part of a volume on medieval domestic architecture – also records that at least two of these uprights were elaborately moulded (see Fig.52). To judge from early photographs, the cloister was then remodelled again in the 1860s. At this time the walks were reconstituted in their present form with ten uprights each. All the uprights, with the exception of the much-patched medieval jambs to the gable doors, were then replaced with plainly moulded timbers set on a Victorian brick footing.

Without the uprights themselves to look at it is impossible to know whether Dollman's richly moulded posts were surviving details from the medieval quadrangle or more modern insertions. Buckler's drawing does not suggest that there were richly moulded uprights in the cloister when he drew it and the medieval jambs to the gabled doorways would further argue for a plain medieval finish to the originals. On the face of it, therefore, it would seem likely that Dollman's moulded uprights were part of the mid-nineteenth-century restoration. But if they were, why did Dollman record

50 God's House, Ewelme: 1821 view of cloister by J. C. Buckler. Note the extra chimneys, the lower footings of the cloister walks and the fenestration, which is possibly medieval.

51 God's House, Ewelme: views by Dollman (1858). It shows only six upright timbers in each walk and a modern brick footing.

52 God's House, Ewelme: details by Dollman (1858) of the porch and the cloister. The mouldings of the lost upright posts from the cloister are shown in the bottom right-hand corner and stood in the south-west corner at points X and Y on Figure 10.

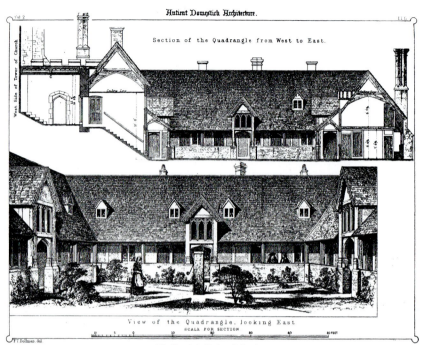

The Hospital, Ewelme, Oxfordshire.
Section and View of the Quadrangle.

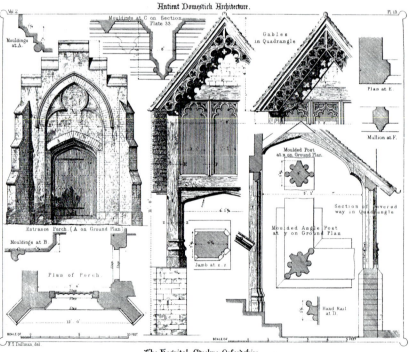

The Hospital, Ewelme, Oxfordshire.
Various Details.

them, and why does the drawing they form part of not show any complex mouldings in the remainder of the restored cloister? Added to these facts, the recorded uprights convincingly echo the mouldings found on other fifteenth-century furnishings at Ewelme, such as the screens in the church, as well as the handrail of the quadrangle stair and a moulded beam in an adjacent chamber (see Fig.52). Since the timber-frame of the pentice could easily have been altered at some stage prior to 1821, the possibility must remain that these uprights were a surviving medieval feature. And if they were, then perhaps the walks were originally more richly decorated than at present.

Like the walks they stand in, the decorative gabled doorways of the cloister have been very heavily restored. But as far as it is possible to judge from drawings and the surviving medieval timbers within them, their restoration has been faithful to the original detailing. They are all designed with a doorway set beneath a three-light window. That to the west has a distinct tracery pattern from the others and is also the only gable to preserve its original bargeboards, elaborately cut with tracery designs (see Fig.53).

As today, the quadrangle was roofed with tiles in the Middle Ages, and the Master's Accounts contain several references to these – for example the purchase of 'crestys' or crest tiles for the roof ridge and the payment of various 'tegulatori' (tilemen) in 1456 for some unspecified work.[42] These accounts also refer to the well or water-pump which, according to Leland, formed an important centrepiece to the cloister. It was periodically repaired and buckets for it were regularly made and mended.[43] There was a long-standing tradition of ornamented wells set in cloisters, and it is unfortunate therefore that we have no information about its form.

THE INTERIOR ARRANGEMENTS OF THE ALMSHOUSE QUADRANGLE

The Almsmen's 'Cottages'

As was often the case in fifteenth-century almshouses, each poor man at Ewelme was to receive 'a certain place by them self within the said house of alms. That is to say a little house, a cell or a chamber with a chimney and other necessaries in the same, in the which each of them may by himself eat and drink and rest and sometimes attend to contemplation and prayer.' [x][44] At Ewelme the almsmen were provided with a little house or 'cottage', comprising two rooms.

Eleven of the cottages were arranged around the north, south and west ranges of the quadrangle with front doors opening onto either the cloister walk or the passages leading off it (see Fig.42). Each bay of these ranges appears to have formed a single house with an upper and a lower room. The upper room was open to the apex of the roof. In the case of cottage no.6 two shorter bays were so adapted. The modern plastering in the ranges conceals the fabric of the walls, but there are some exposed fireplaces in both upper and lower chambers, so it is possible that all the cottages had two fires. These are all of brick and have flattened arch heads. Several of the fireplaces on the

53 God's House, Ewelme: west gable door of the cloister. This is more elaborately decorated than its neighbours.

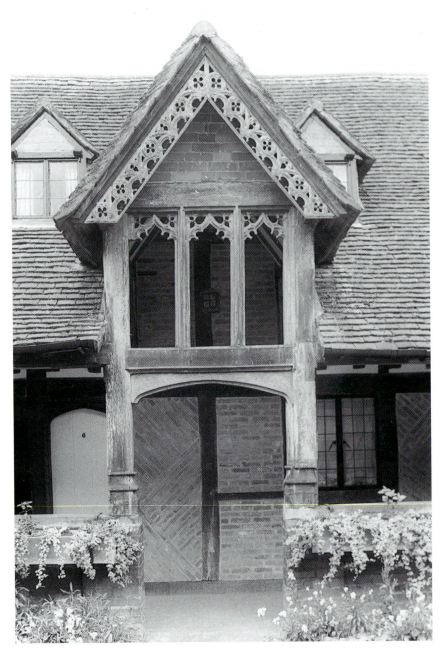

ground floor also have small arched niches above them, perhaps intended to hold lights (see Fig.54).

Both chambers were lit by windows: two on the ground floor – a wooden-framed one in the cloister wall and a stone-framed one in the outer wall – and a dormer on the upper floor, set either on the inner or the outer side of the

range.[45] It is not clear what the original means of access between the two floors was. The earliest plans depict small staircases against the partition walls of each bay but photographs of these show they were not medieval. One possibility is that ladders or narrow wooden spiral stairs were fixed into deep semi-circular recesses that previously existed from ground to ceiling in the external rubble walls of certain of the ground-floor rooms (see Fig.55).

There were also two other almsmen's cottages in the eastern range on either side of the stairwell leading to the church. These both comprised two ground-floor rooms lit solely by windows facing into the cloister. There were three fireplaces heating the four rooms – one set in the thickness of the wall on either side of the stairwell leading to the church and one in the northern gable of the range.

The Master's Lodgings

According to the Statutes, each Master was to 'have and hold for their habitations and dwelling places such chambers, hall, kitchen and gardens with all other assigns as at this time is edified for him within the precinct of the said house of alms' [VIII]. These chambers were situated in the east range of the almshouse quadrangle and the garden immediately to the south of it.[46]

The single piece of evidence indicating where these appointed lodgings were is an entry in the Master's Account of 1458 which records that a paviour and his servant undertook one day's work in the cemetery next to 'William Marton's room'.[47] This would seem to prove that his chambers were in the eastern range next to the churchyard. The bays above the almsman's cottage at the northern end of the range were occupied by the common hall, so the Master's Lodgings presumably comprised a suite of rooms in its southern end (see Fig.42). It is not really clear how these rooms were organized in the fifteenth century. The chamber on the ground floor at the southernmost extreme of the range may have been the Master's kitchen. This room was entirely destroyed in the 1970 restoration, but nineteenth-century plans show that it possessed a large fireplace and served this function at that time (see Fig.10, above).

The Master's rooms on the upper floor were presumably entered, as today, through the door on the landing at the top of the staircase leading to the church. Today all the rooms have inserted ceilings but the main frames of the roof were formerly infilled with plaster and oak panelling to the apex of the gable, which suggests that they stood open in the fifteenth century. The disposition of two extant fifteenth-century fireplaces may give some clues as to their original arrangement. One fireplace is set in the staircase wall. This is of the same design and size as the cottage fireplaces and in like manner to these has a blind niche above it. The second is much larger and stands in the east wall of the room directly beneath the main frame of the roof above. Because of its location there can have been no wall at this point corresponding to the roof divisions, so the northern two bays presumably formed a single room. This might have been divided up by wooden screens to create a smaller

54 God's House, Ewelme: detail of a fireplace in an almsman's cottage with a niche, possibly for a light, above it.

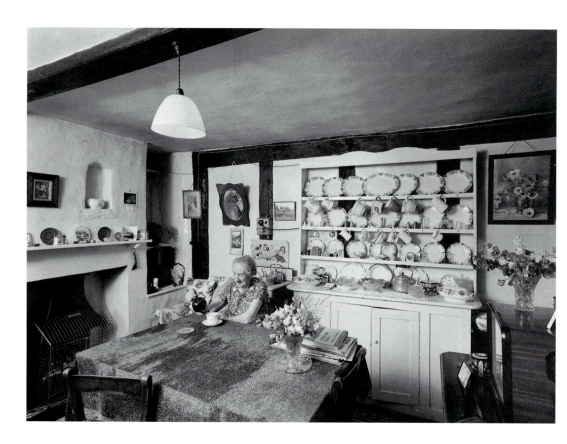

55 A pre-restoration view of cloister cottage 6 at Ewelme, taken from the south-east. Note the deep recess, possibly the medieval stairwell, in the corner of the room.

and a larger chamber, each served by its own fire. It is not possible to reconstruct the arrangement of the third bay. The external wall of the Master's Lodgings was originally pierced by several windows. Only one of these now survives, in the southernmost bay of the range, but the others have been infilled. It was also lit by two windows opening into the cloister.

The Common Hall

The Statutes mention a common hall in the almshouse as a formal point of assembly for the community [LXII, LXXXII and LXXXV], and purchases for a chamber of this name – the *aula communis* – occur repeatedly in the Master's Accounts. Sixpence was expended on rushes to cover the floor in 1456 and a muniment chest was bought for it in 1459. In 1459–60 the 'inner door' of the hall was furnished with two padlocks and keys.[48] This door may have belonged to an inner chamber adjacent to the common hall, which is also spoken of in the accounts. The *camera interioris*, so-called, was extensively altered in 1459–60. At that time timber was bought for the operation and a carpenter employed for several days to make changes to it. When it was completed, the common hall was painted, a door mended and a set of three keys bought for it.[49]

The common hall was situated on the upper floor of the northern end of the eastern range and is the only extant medieval interior space in the

quadrangle (see Fig.42, above). It must have been entered, as today, through the existing brick doorway facing the entrance to the Master's Lodgings on the landing at the top of the stair to the church. This section of the range is divided into three bays, of which the southernmost pair still form a single hall with a centrally placed fire (see Fig.56). The third bay must be the *camera interioris* referred to in the Master's Accounts. The wall which separates this chamber from the hall is medieval and the exposed beams show clear evidence of having been altered subsequent to their erection: a floor (that has now been removed) was keyed into the timbers at the level of the tie-beam. This alteration is probably that documented in the Master's Accounts of 1460 and it may have been undertaken to create a safe chamber for the 'common huch' or chest demanded by the Statutes [LII]. If it was used as such this might explain the purchase of two padlocks for its door and also the 1460s alterations immediately following the purchase of a new chest for the muniments in 1459.

Light was provided for the common hall by a single large window facing into the cloister. This was originally glazed and the leading was repaired in 1459.[50] The internal room was lit by a small, stone-framed window in the external wall. This latter window appears in Buckler's 1821 painting (see Fig.61, below) and was replaced in the nineteenth century by the present one. There is no evidence that the common hall at Ewelme was ever used for communal eating, as was the case in some almshouses.[51]

The Almshouse Gardens
Amongst their day-to-day tasks, the almsmen had to 'keep clean the cloister and the quadrate about the well from weeds and all other uncleanness and their gardens and alleys' [XLV].[52] The gardens must have lain, as they still do, to the north and south of the cloister quadrangle (see Figs.10 and 47, above). Their layout as four walled gardens is perhaps medieval[53] with three enclosed plots to the south of the quadrangle and one to the north. The Master and the Teacher of Grammar owned one of these each [VIII, IX], the former most likely that immediately to the south of the quadrangle and the latter that to the south of his chambers. The remaining two must either have been divided into plots or communally farmed by the almsmen. Presumably they were meant to grow vegetables and this fact, like their private eating arrangements, suggests a degree of self-sufficiency.[54]

The Design and Dating of the Almsmen's Quadrangle
With so few comparable buildings surviving, it is difficult to judge how unusual the Ewelme quadrangle was architecturally in its own day. A few surviving almshouse complexes do have quadrangles, such as Wynard's Almshouse at Exeter, but none have such a regularized plan as Ewelme. This is not to say that none existed, however, and the indication from statutes that certain lost almshouse complexes incorporated cloisters makes the existence of parallel designs a likelihood.[55] But whether or not Ewelme was unusual

56 God's House, Ewelme: roof of the common hall. The farthest bay of the room, described as the Camera Interioris, probably served as a strongroom after it was altered in 1459–60.

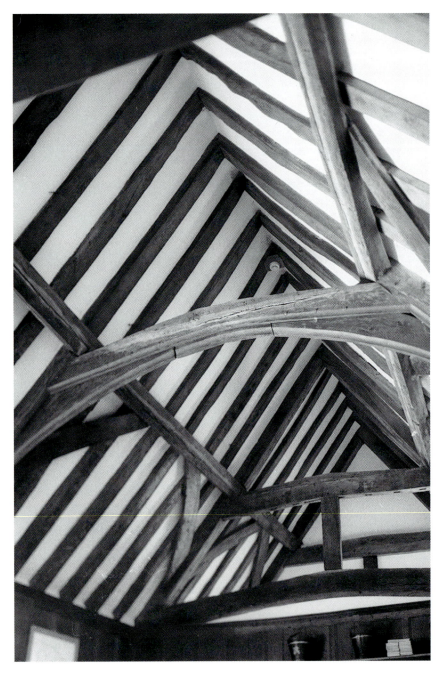

amongst almshouses of the period, its architecture can only be properly understood in the context of a much broader spectrum of buildings. As Leland's comparison of the almshouses quadrangle with the Vicar's Close at Windsor (actually built much later, in 1478–81) makes apparent, there may have been good ecclesiastical parallels for the design. But equally the Ewelme

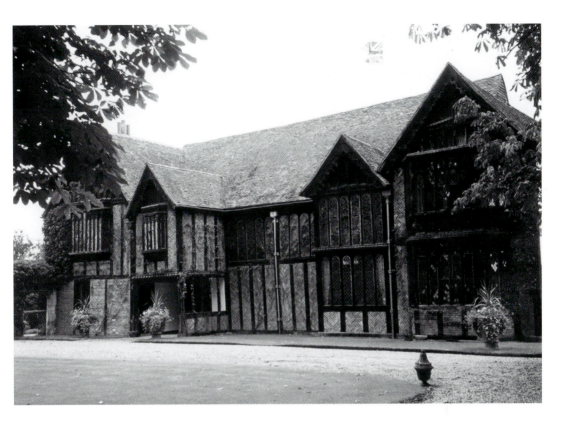

57 Ockwells Manor (Berks.) was built by John Norreys, probably in the 1440s, and is a rare surviving example of fine timber-frame architecture from the period.

quadrangle was also probably informed by secular architecture and one particular building makes this clear.

Ockwells Manor, in Berkshire (see Fig.57), is a rare surviving example of fine timber-frame architecture from the mid-fifteenth century. The house was built by Sir John Norreys, an intimate of both Henry VI and William de la Pole, and its hall was probably finished around 1450.[56] Like Ewelme, Ockwells incorporates herringbone brick panels, has prominent façade gables with richly carved bargeboards and is laid out according to a coherent system of measurements. It is also clearly connected with the royal College of St Mary at Eton by ties of patronage; its use of brick; the inclusion of a regular double-storied cloister; and windows designed without decorative cusping. Amongst other things, this comparison with Ockwells emphasizes just how ostentatious the architecture of Ewelme was.

One other building also deserves special mention in relation to the design of the Ewelme quadrangle: the almshouse of the Guild of the Holy Cross at Abingdon. In 1442 William was amongst a group of men who incorporated the Guild of the Holy Cross attached to St Helen's Church in Abingdon. By the terms of their licence the guild was to support thirteen poor men and women, and in 1446 a hospital was erected adjacent to the parish church to support them.[57] This building, now known as Christ's Hospital, has survived and is a regularized version of an almshouse design popular in the fifteenth

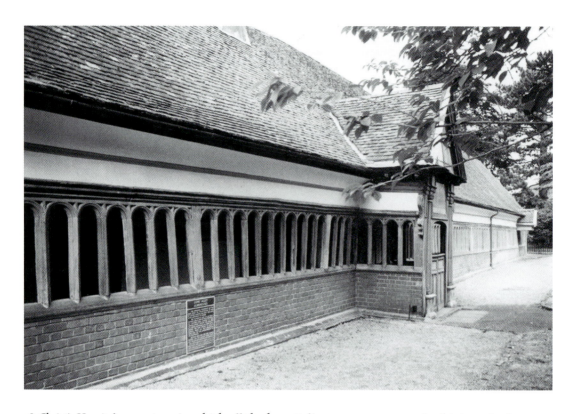

58 Christ's Hospital
(Berks.), formerly the
almshouse of the
Guild of the Holy
Cross, built in 1446
to house thirteen
poor men and
women. Like
Ewelme it is
regularly planned
with a cloister walk
and gabled doors.

century in which all the hospital's rooms were organized into a single range
(see Fig.58).[58] At Abingdon the range contains thirteen lodgings and a hall
with a pentice cloister walk along one side of the building. This cloister walk
is entered through three gabled doorways and has cuspless tracery lights. The
use of cuspless tracery here, William's involvement with the foundation, its
regular design with a cloister walk, its date and its proximity to Ewelme
make a powerful, but entirely circumstantial, case that its buildings were
executed under his direction and were directly related to those of God's
House.

There are no documents which can help us date the quadrangle at Ewelme,
but it was presumably begun after the issue of the foundation's licence in 1437
and was probably completed when the almshouse was first endowed in
February 1442. This dating would agree with one particular detail of the
architecture: the sparing use of brick in the fabric. As we shall see, this
material was used freely in the later medieval foundation buildings, most
probably because local brickworks were established when Ewelme Manor
was rebuilt from 1444 and these made it abundantly available. By implication,
therefore, the quadrangle was certainly complete before work to the Manor
began in 1444. If the quadrangle's bricks were not made locally, it is
interesting to speculate where they may have come from. One obvious source
would have been the royal brickworks at Slough. William was directly
overseeing these as part of his duties in the construction of Eton.[59]

One feature of the quadrangle's design which is intriguing in the light of this dating is that it appears to be arranged for the accommodation of only a single priest, whereas the royal licence of 1437 specified that two should serve the foundation. This might suggest that there was an intention to expand God's House almost from the first. Alternatively, it is possible that the two priests were at first intended to share the Master's Lodgings.

The school and its associated buildings

The remaining fifteenth-century buildings at Ewelme – what is termed here the Grammar Master's House (from the fact that the Teacher of Grammar had his lodgings here), the almshouse porch, the almshouse gateway and the school – all have brick as their principal building material. The bricks they use are made to a fractionally smaller size than those found in the quadrangle.[60] These buildings were certainly an afterthought added to the quadrangle, probably in response to the mid-1440s decision to incorporate a school within the foundation. They also seem to have been intended to orientate the almshouse architecturally in a south-westerly direction, towards the new Manor House. Work to them may have been interrupted by the fall of William de la Pole in 1450, because the School House is not as consistent in quality and finish as the Grammar Master's House, the gate and the porch. This fact might reasonably be explained in terms of a hurried or interrupted construction to this building caused by William's murder.

THE ALMSHOUSE PORCH

The almshouse porch is roughly butted up against the north wall of the quadrangle and served as the main entrance both to the cloister and the Grammar Master's House. The porch is an elaborate piece of brickwork which shows the rich effects that this new material could create (see Fig.59). Its façade takes the form of a castellated gable flanked by corner buttresses. Filling the gable façade is a tall, blind arch decorated with trefoil cusping and a moulded hood. Set inside the blind arch is a doorway with a depressed head moulded with a roll that dies into the jambs of the door. A doorway of exactly this type was recorded by Buckler in 1821 as part of the surviving Manor House at Ewelme (see Fig.6, above).

In design the porch at Ewelme is of markedly Flemish character; both the trefoil cusping of the blind arch and the decorative castellations may be closely paralleled in contemporary buildings throughout the Low Countries. A number of similar designs exist,[61] but one detail makes this association with Continental work particularly compelling: the tips of the cusping to the blind over-arch are of stone and this particular feature can be seen in several Flemish examples of the form.[62] Quite why this was done is not clear, because bricks could easily have been carved to fill these spaces and the brick masons at Ewelme were certainly not shy of cutting bricks, as is indicated by some of

59 The porch of God's House, Ewelme, built 1444–50. The design is closely paralleled in Continental brick architecture. Notice the stone tips to the cusping of the blind over-arch.

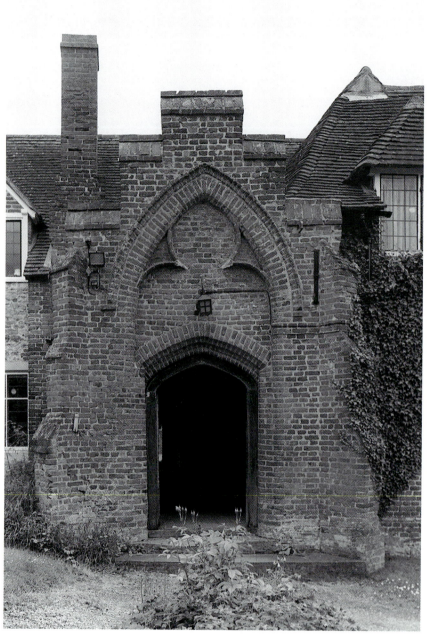

the detailing in the Grammar Master's House. Indeed, to judge by the tool marks on several bricks and irregularities in the mouldings it is possible that the principal details of this porch were carved rather than moulded.

THE GRAMMAR MASTER'S HOUSE

Like the Master, the Teacher of Grammar was to have 'such chambers, hall,

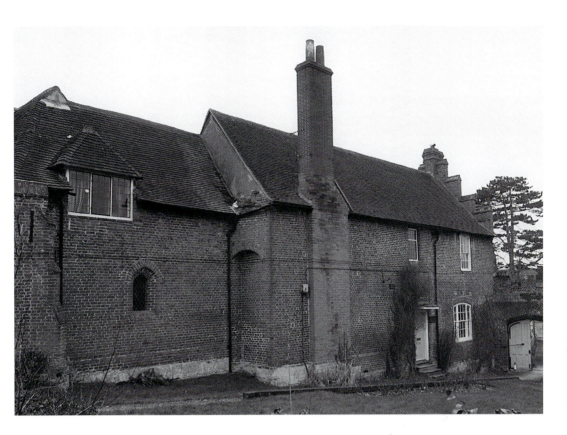

kitchen and garden with other assigns as at this time is edified for him within the precinct of the said house of alms …' [IX]. There is no explicit reference to the situation of these chambers but the available evidence would strongly suggest that they were located in the range adjoining the north-west corner of the quadrangle, which has certainly served as the Grammar Master's House since at least the late seventeenth century (see Fig.60).[63] This house is a timber-frame building constructed within a brick shell somewhat irregularly laid in English bond. The shell is of a piece, but the framing within it has two structurally distinct sections: a three-bay building – the house proper – and, at its eastern end, an L-shaped annexe constructed around the north-western corner of the almshouse to the almshouse porch (see Fig.42, above).

The annexe to the Grammar Master's House has survived almost intact structurally to the present day. Part of its ground floor served as a corridor between the house and the almshouse porch and is lit by a four-centred brick window. Some of the bricks forming the sill of this window seem to have been carved into shape *in situ*. The doorways at either end of the corridor still preserve their fifteenth-century doors and the wooden frame of that into the house has identically cut spandrels and mouldings to those of the principal doors in the almshouse, a detail which suggests that this was the main entrance to the building. Above the corridor there is a small chamber. This is

60 God's House, Ewelme: the Grammar Master's House (right) and annexe (left). The front door and chimney are modern insertions.

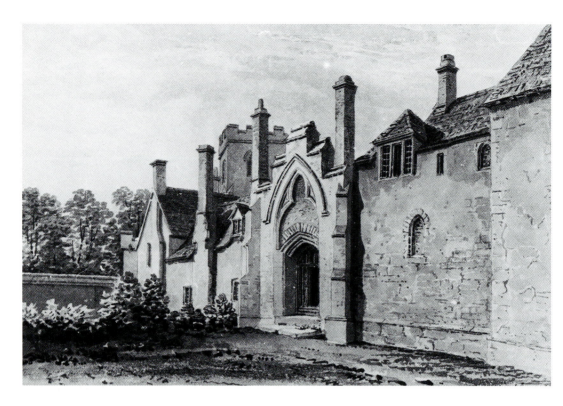

61 God's House, Ewelme: 1821 view of porch and annexe by J. C. Buckler. Notice the original arrangement and dimensions of the external windows.

approached from the adjacent first-floor chamber up a medieval stair of three steps, cut from solid oak blocks. It is lit by a large window which, to judge by its gable timbers, is a refenestrated medieval opening. One of Buckler's 1821 drawings also shows two other windows in the annexe, but both have been blocked (see Fig.61).

Throughout the annexe the timber frame is haphazardly arranged and erected without regular bays. It is apparent from the evidence of the roof that this is the result of the awkwardnesses of constructing it around the existing quadrangle. To the west of the annexe there is a regular sequence of rafters, but where the roof meets that of the quadrangle range there is a confused transition to a clumsily constructed lean-to structure. The lean-to is supported by a single lateral beam. At one end this rests on a timber that has been slipped under the structure of the quadrangle's west-range roof, and at the other by a second beam jammed into the northern wall of the same range (see Fig.62). The makeshift manner in which the annexe roof is worked around the fabric of the quadrangle indicates that the almshouse was structurally complete when the annexe was built up against it. That the almshouse was actually finished altogether is further indicated by two additional details. First, there are still some tile laths on the now-enclosed quadrangle roof, evidence that this area was once tiled and exposed to the elements. Second, the quadrangle wall in the roof space is rendered, and this only makes sense as the remains of an external finish to the quadrangle predating the erection

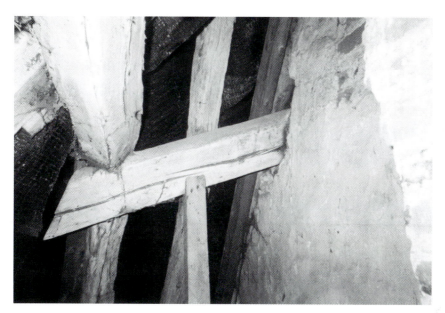

62 God's House, Ewelme: roof space of annexe showing the original exterior render of the cloister quadrangle. A roof timber of the late-1440s annexe is crudely jammed into this once-external wall.

of the annexe: not only has the render clearly been chipped away to receive the supporting timber at the east end of the annexe roof – and therefore necessarily predates it – but the roof space is far too untidy to have been left internally exposed and this finish is therefore senseless in its present context.

The house is both wider and higher than the adjacent annexe and was extended and refaced on its southern side in 1774.[64] In its fifteenth-century form the building simply comprised three regular timber-frame bays, each fourteen feet long and arranged on two floors. Very little of the timber-framing is visible today and the original design is only apparent from the surviving roof, which was formerly open internally to the apex. The timbers of this are well finished with chamfered edges, a detail also found in the surviving Manor House roof. During repairs in 1996 part of one frame on the first floor of the building was also exposed. This revealed the original upper-floor level and also some early-sixteenth-century wall paintings of strapwork patterns.[65]

Three of the external walls of the house – those to the east, north and west – are fifteenth-century and they give some clues as to the original internal arrangements of the building. The stepped western gable compares in overall form with the gable of the porch and with the gables of Ewelme Manor as they were depicted by Buck in 1729 (see Figs.5 and 11, above). There are moulded kneelers corbelling out the corners of the gable and their details are more elaborate than those found on the almshouse chimneys (see Figs.63 and 48). A chimney-stack rises in diminishing stages up the gable. It is served by a massive fireplace on the ground floor – nine feet deep from the inner face of the wall – and this feature may identify this room as the kitchen.[66] There is also a second chimney-stack which emerges through the roof behind the

63 God's House, Ewelme: Dollman's 1858 drawings of the School House. The projecting block at the rear formerly housed the spiral stair to the upper floor. Notice the gable of the Grammar Master's House and the details of its moulded brickwork in the top left-hand corner.

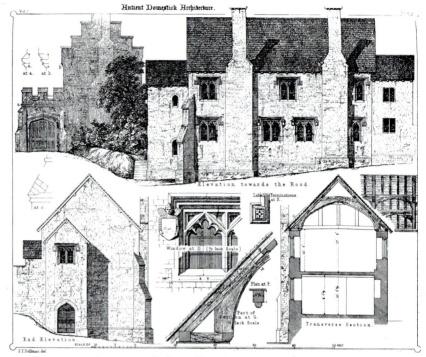

The Grammar School, Ewelme, Oxfordshire.
Elevations, Section, and Details.

castellated parapet. This presumably served a now-concealed fireplace in a chamber on the first floor. A small window that formerly lit this upper room is visible in Buckler's 1821 drawing of the building (see Fig.64).

The northern façade of the house has been extensively altered and the only fifteenth-century feature that is still recognizable is a blocked window on the ground floor. This would appear to be of the same form as the surviving window in the annexe corridor. Another arched window of this kind was also discovered in 1996 in the upper, eastern chamber of the house. The other existing windows in the building probably stand in the position of older openings, but it is not clear what form these originally took. One internal feature of this wall which may be fifteenth-century is a semi-circular recess in the eastern bay of the house. This has been convincingly transformed into a display niche but it looks very similar to the niches found in some of the almshouse cottages and, like them, may have served as a stairwell.

There are no architectural features in the eastern return wall which connects the house to the annexe, but there is an external arch at first-floor level connecting the two parts of the building (see Fig.60). The function of this arch is unclear, but it must have supported some decorative feature and corresponds to a gap in the timber-framing of the building. On this wall, just above the level of the annexe roof, there are fragments of moulded brickwork and what may perhaps be the base of a parapet or window. This whole house

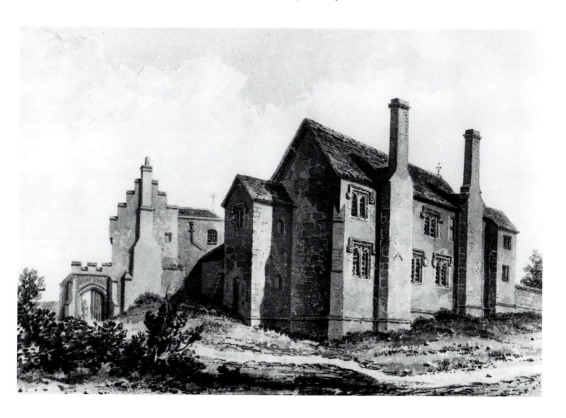

64 God's House, Ewelme: 1821 view of the school and main gate by J. C. Buckler. The window in the gable end of the Grammar Master's House is now blocked.

is considerably larger than the Master's apartments in the quadrangle and it seems likely that it originally included rooms for guests and entertainment.[67]

THE MAIN GATEWAY

The main gate of the almshouse is built against the north-west corner of the Grammar Master's House and compares very closely in detailing with the almshouse porch and the house itself (see Figs.11 and 63). It is square in outline, flanked by corner buttresses and topped by a row of castellations which sit on a moulded-brick string course. The archway is four-centred and has a hood of identical form, but not size, to that of the almshouse porch over-arch, a detail which may suggest that its elements were carved rather than moulded. This gateway may be mentioned in the Master's Accounts of 1462 when a gutter was mended 'infra le Gross dores'.[68]

THE SCHOOL HOUSE

The imposing two-storey brick School House was a free-standing building in the fifteenth century but is now connected to the other buildings by a low stone-built range (see Pl.1). It has had a chequered history. By the early nineteenth century the post of school master had become a sinecure and the building was in disrepair. In 1890 the childhood reminiscences of one almsman about it were summarized by the Rector:

The door of the school was bricked up, the windows were all broken; the floors of the rooms were gone; the ground of the lower room was covered with stones which boys had thrown in through the window holes. No school had been held there within the memory of living man, and the common talk of the village was that there had been a Roman Catholic school held there years ago.[69]

In 1830 the school was re-established and its building restored. Further major, but unspecified, repairs were also undertaken in 1848 and 1861.[70] Nevertheless a child was killed falling down the worn medieval brick staircase of the building in 1872 and afterwards the steps were replaced in stone and the floor perhaps renewed. Unfortunately the new stair proved too narrow for desks to be carried up to the completed schoolroom and it was necessary to cut a hole in the floor to raise them. Unfortunately (again) the design of the school was promptly condemned by Her Majesty's Inspectors and a new staircase had to be built at the south end of the building.[71] A number of changes were also made in the twentieth century, including the excavation of the ground floor around 1910 to heighten the room, and the resetting of the first floor and the addition of a classroom extension to the south of the building in the 1960s. As a consequence of all these changes the original interior arrangements are impossible to reconstruct. The only fifteenth-century element of it which probably does survive is the roof, a massive arch-brace structure of six bays (see Fig.63). But this is evidently much restored and without a scaffold it is not possible to determine how much of the timber is original.

The exterior has been remodelled quite as much as the interior, but nineteenth-century drawings and the evidence of the fabric itself make some aspects of the medieval building discernible. In its original form the school was rectangular in plan with two massive chimney-stacks rising up its western façade and a gabled porch on two floors set at its northern end (see Fig.42, above). Today the principal entrance to the school is set in the porch, but the present doorway is a nineteenth-century enlargement of an earlier opening and the arrangement does not reflect the medieval design (see Fig.64). The upper storey of the building was formerly entered up a spiral stair housed in a lean-to structure built against the east wall (see Fig.63). This has been destroyed but it is shown in some drawings and a section of the renewed spiral stair belonging to it can still be seen today. There is also a structure depicted at the southern end of the building by Buckler and Dollman but this is certainly post-medieval – its fenestration certainly looks modern, and it concealed one of the fifteenth-century corner buttresses which stand at either end of this façade. It was demolished early last century and all trace of it has been effaced today by the 1960s extension to this end of the building. The south and east faces of this building have been so much altered that it is not clear that any of their details or windows are original.

The west façade of the school is intended as an architectural showpiece: one of the chimneys bears a decorative diaper pattern in vitrified bricks and the principal windows – all of one or two lights and with cusped and angular

65 Ewelme: detail of west façade of the School House with its rough brickwork. The diamond-shaped diaper pattern is faintly visible on the chimney stack at the level of the window heads.

arch heads – are of stone. Both these features are typical of fine brick architecture in the period (see Fig.65). Two of the ground-floor windows also have prominent hood-stops cut as shield-bearing angels. The figures in place today are modern, but they replace medieval figures which stand today in the passageway between the almshouse and the church. But this seemingly impressive architectural display is clumsily executed. The brickwork of the School House makes no attempt at regular bonding; the diaper pattern on the chimney is crude; and the stone windows are very untidily coursed into the masonry. These windows are also of different designs in the body of the building and the porch, and in neither case are there medieval parallels for the forms they take in any of the other foundation buildings.

DATING THE SCHOOL BUILDINGS

The Grammar Master's House, the almshouse porch and the gate share a common and distinctive architectural vocabulary. They are built entirely in brick and include angle buttresses, castellated gables and closely comparable moulded or cut detailing. All these features distinguish them from the architecture of the quadrangle, which was evidently completed before they were begun. Their common features may be paralleled, however, in the recorded remains of Ewelme Manor and this makes a strong case for associating them directly with William de la Pole's work to his residence after 1444. It seems probable that the brick for these buildings was supplied from the same source as that for the Manor and that the same craftsmen were employed on both.

The School House is not as closely comparable to these structures as they are to each other, but there are still strong physical similarities which suggest

that it is to be associated with them. It is also constructed of brick, albeit this is not laid in bond, and it possesses angle buttresses and four-centred brick windows. The absence of castellated gables and moulded brick in the school might be explained either in terms of its partial ruin in the nineteenth century or the circumstances of its establishment. It has already been suggested that the very late appointment of the first Teacher of Grammar, John Clifford, after 1454 or 1455 and the incongruously ambitious (for a chantry foundation) design of the school may indicate that a plan to form a joint school and college foundation was frustrated by William de la Pole's murder in 1450. If this was the case, it might be that the building was in the course of construction at that date and was hurriedly finished off.

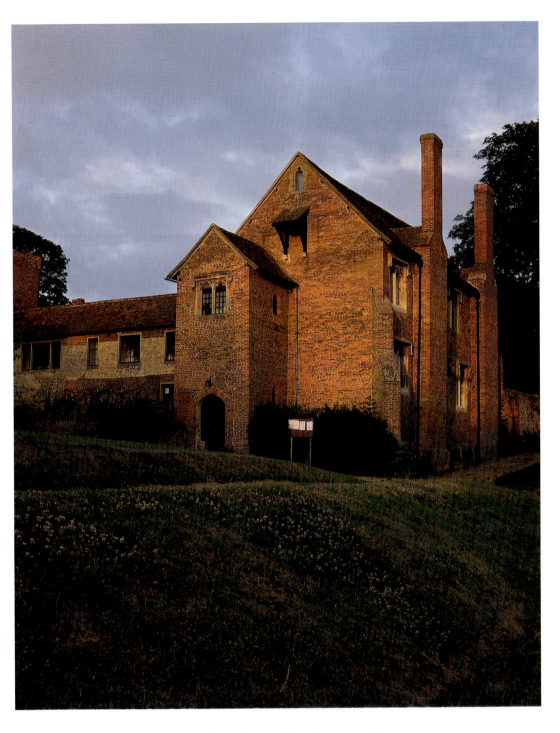

1 God's House, Ewelme: the School from the north-west. This is the most roughly constructed of the brick buildings at Ewelme and its erection may have been interrupted by Suffolk's murder in 1450.

II God's House, Ewelme: the almshouse quadrangle. Many of the original chimneys have been dismantled and the cloister walks are thoroughly restored. The medieval well, formerly in the centre of the garth, has been lost.

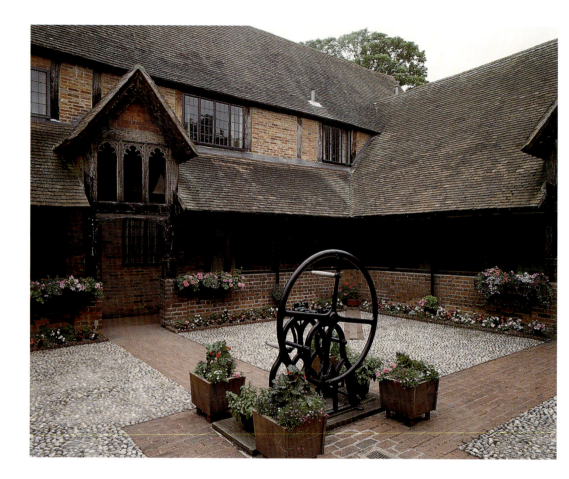

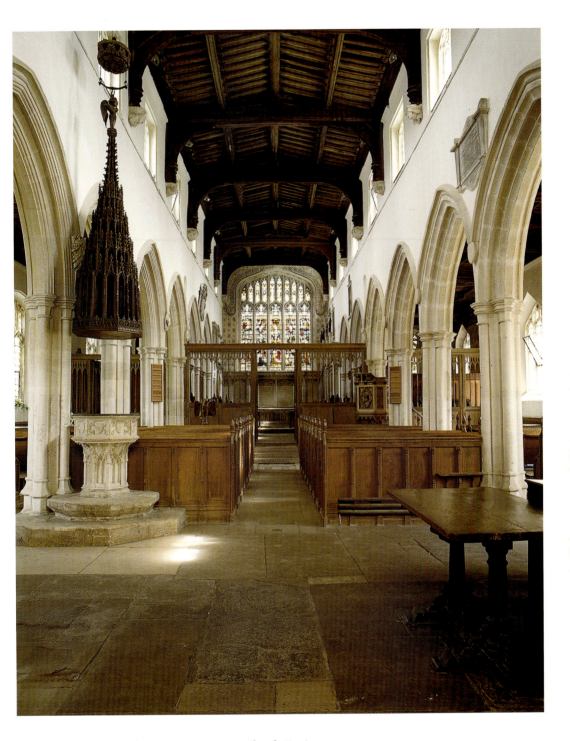

III This open view down the interior of St Mary's Church, Ewelme, would have been interrupted by the lost rood loft. The contrasting designs of the north and south sides to the building are clearly visible.

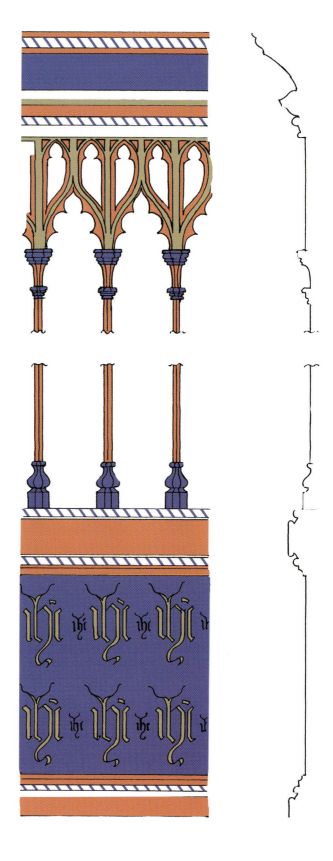

IV St Mary's Church, Ewelme: reconstruction of the rood screen decoration, based on Vallance. All the colouring, apart from the gold and the decoration of the panelling, is confirmed by surviving fragments of paint on the screen and the whole is probably reliable.

V (*opposite*) The spectacular c.1438 interior of St John the Baptist's Chapel, Ewelme, looking eastwards. The painted decoration is a faithful Victorian reproduction of the medieval scheme.

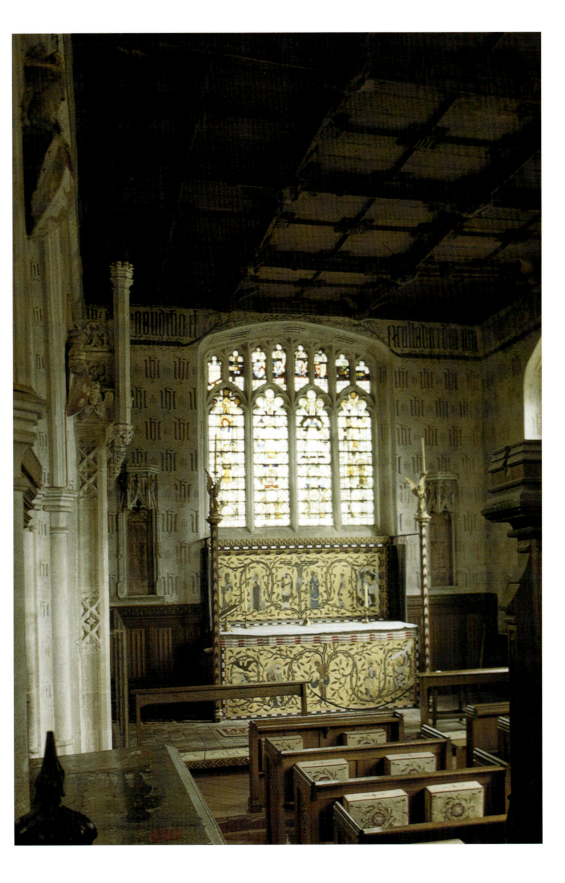

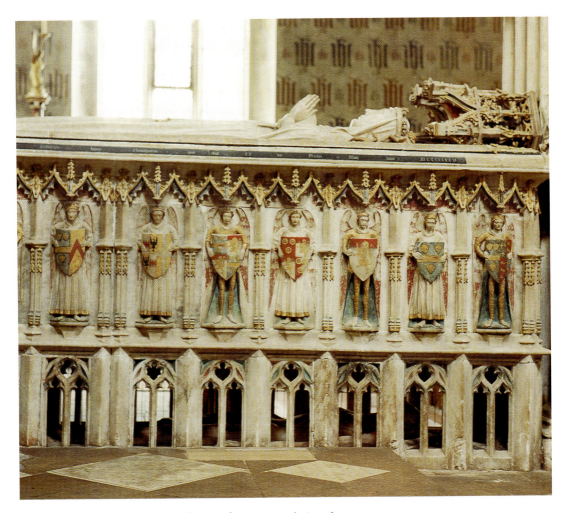

VI Alice de la Pole's tomb, Ewelme, showing the two-story design of
the chest and the faithfully restored coloration. The alternating
pattern of chest figures is broken on each side and the hidden angels
at the ends are half-painted and smashed away.

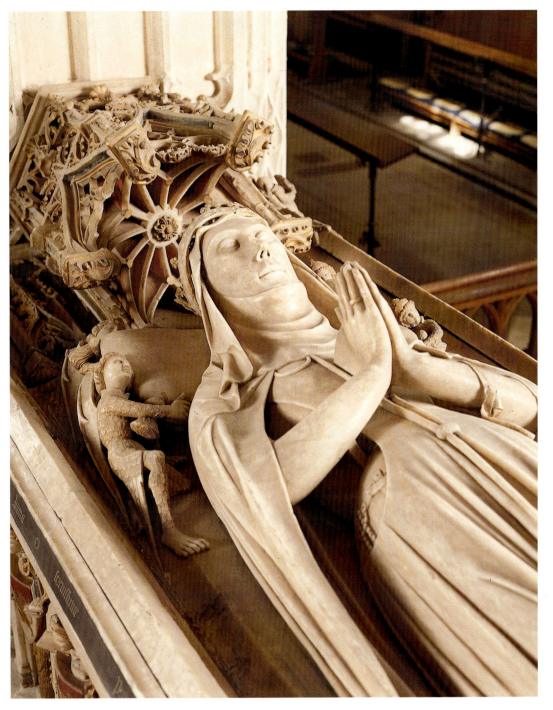

VII Upper effigy of Alice de la Pole's tomb, Ewelme, built 1470–75 and
now stripped of colour. Alice is portrayed wearing her ducal coronet
and the Order of the Garter, twisted around her left arm. Notice also
her rosary, wound over her belt.

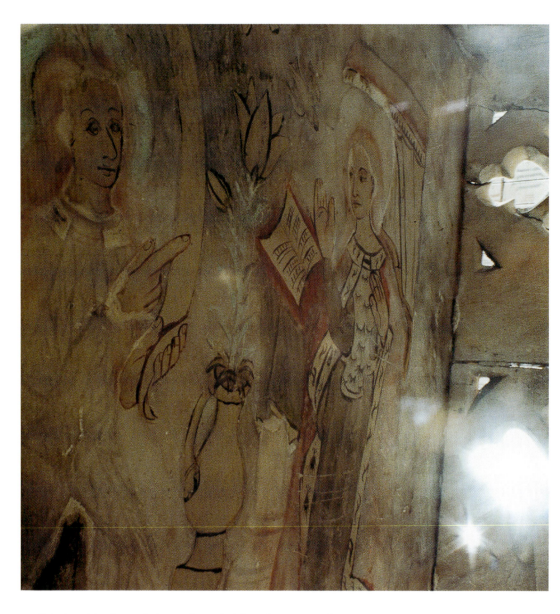

VIII Painting of the Annunciation on the roof of the cadaver space of
Alice de la Pole's tomb, Ewelme, of 1470–75. Gabriel's features are
retouched in pencil, but these paintings are otherwise unrestored.

5

Institutional life in the almshouse

Having discussed the development of the buildings at Ewelme and the physical environment in which the foundation functioned we are now faced with the question as to what actually happened in the course of day-to-day life at God's House in the Middle Ages. For an answer to this it is necessary to turn to the evidence of the Ewelme Muniments. Particularly important in this respect are the Statutes, which set out a portrait of the foundation as it was intended to run and provide the basic information essential for an understanding of the often confused and fragmentary documentation that records the real, living history of the community. The Statutes are of particular value in reconstructing both the constitution of the community and the manner in which it administered itself. From them emerges not only an impression of how God's House was conceived as a working religious foundation but a fascinating picture of contemporary institutional life.

The community and its duties

The first part of the Statutes is concerned with establishing a hierarchy of authority in the community and with outlining the duties of its various members, each one 'funded in good and staid living in himself, and endued with godly and spiritual occupation of very true, trusty and devout daily prayer; in the which we have great trust and hope to our great relief and increase of our merit and joy finally' [XVI]. The right of appointing to God's House was (and still is) the privilege of the holders of the lordship of Ewelme [LXVII].

God's House at Ewelme had three officers. The two most senior were priests: the Master, who was the head of the community, and the Teacher of Grammar, his deputy. There was also a senior almsman called the Minister. No sets of statutes survive from a contemporary almshouse that was identically constituted, but several probably existed.[1] Instead surviving

statutes describe either almshouses incorporated within the hierarchy of a college (as at Eton, Whittington's Hospital in London, Tong, Sherbourne, Caister and so on), or independent foundations with only a single officer. This was usually a priest (as at Westminster, Ludlow,[2] Heytesbury or Wynard's Hospital at Exeter), but in one instance – Ellis Davy's Almshouse at Croydon – it was an almsman entitled 'Tutor'.[3]

But despite their different forms these various institutions actually shared much in common with each other. In fact, all statutes of this period tend to rehearse an identical canon of duties and personal characteristics, which they apportion differently depending on how the particular institution was staffed and constituted: for example, the Master's duties and personal characteristics at Ewelme, as they are described in the Statutes, are closely analogous to those of other heads of chantry institutions such as the poor-man 'Tutor' at Whittington's Hospital or the Warden of Tattershall College.

This detail is one instance of the manner in which contemporary chantry institutions – colleges, almshouses and even guilds – could vary significantly in form while still having much in common. In order to illustrate and explore this fact, this chapter has been thoroughly annotated with information about the constitutions and administration of other foundations and it is hoped that the reader will occasionally be beguiled into referring to the relevant notes and to the section 'Hospital, college and guild statutes' below for further discussion of a particular subject. The notes show how the Ewelme Statutes relate to what appears to be a common contemporary ideal of the structure and nature of a religious institution. They also illustrate how the formulae employed in the different statutes relate to one another.

The first priest was to be 'preferred in power and reverence' above the rest of the community and to be called the Master [ll.89–92]. It is laid down that 'in all things pertaining to the honest worship and profit of the said house ... they [the rest of the community] truly obey and intend [the Master] as it seems in any manner that it is lawful and expedient' (ll.115–120). He was to be responsible both for the temporal possessions of the almshouse and for its good living, ensuring 'that charity, peace and rest be had and kept among the brethren'. The Master was to be a man 'able and well disposed ... in body and soul, firmly to counsel and exhort to virtuous living the said poor men to their comfort and salvation'[LXIX].[4] Apart from his duties in governing the almshouse the Master was also enjoined to lead the spiritual observances of the poor men. These will be described in detail in Chapter 7, but essentially comprised a daily Mass and the Offices, which under no circumstances were 'to be left unsaid ... before the said poor men in the said work days and holy days in the said due and behoveful times' [XIX].[5]

Ideally the Master was to be a 'learned man of the University of Oxford passed thirty winters of age'.[6] However, if such a 'degreed' man could not be found, another suitable priest was to be appointed instead [LXIX]. His annual salary was £10[7] – that is to say 50s. termly – to be paid from the almshouse's income [XI] – and expenses incurred by him or his servants in almshouse

business were to be paid out of the foundation's funds [xv].[8] So that the office would be more attractive to 'worshipful and well learned men' the Master was also permitted to increment his income with that of another benefice, as long as 'the said almshouse be not hurt nor let; so that by no manner of colour, fraud nor deceit the residence in the foresaid almshouse be lessened or diminished' [LXX].[9]

According to the Statutes, the second priest attached to the foundation was to be 'apt and able to teach grammar'.[10] He was to teach grammar to 'all the children of our chapel of the tenants of our lordship of Ewelme and of the lordships pertaining to the said almshouse, now and at all times to come … without exaction of any *scolehire*' [II].[11] This obligation is accompanied by the instruction later in the Statutes that he must 'so sadly and discretely rule his scholars that none of them be tedious, noisome or troublesome to the said place or any of the inhabitants therein' [LXIV] – a direction apparently unique to Ewelme.[12]

Like the Master, the Teacher of Grammar was to receive the salary of £10 a year [XII] and was allowed to hold another benefice 'because he shall give the more due and better attendance to daily information and the increase of cunning of his scholars'; the extra benefice, however, was likewise given on the condition that 'his residence at, and keeping of his school be not hurt nor let' [LXXI].[13] During the Master's absence the Teacher was to take over his responsibilities in running the almshouse: saying the daily Mass and reciting prayers and the Offices before the almsmen [III].[14] Normally, however, teaching was expected to engage all his time, and apart from his attendance in the chancel for Divine Office on holy days [xx] he was exempt from the formal recitation of Offices and prayers in the church demanded by the Statutes of the poor men and the Master.[15] However, the Statutes also say that if there were ever less than 'four children that actually learn grammar beside *pettetes* and *reders*, then he shall say Matins and Evensong daily in the said church of Ewelme with the said Master before the said poor men' [XXI].[16]

The mention of 'pettetes and reders' throws some light on the kind of education the school provided. The elementary level of medieval schooling included reading, song and elementary grammar for boys of seven to ten years of age, and it was only after this that they passed into the more advanced study in grammar schools.[17] The 'pettetes and reders' referred to in this passage must refer to children at this elementary stage, and their mention demonstrates that Ewelme's school was intended to supply both elementary and advanced tuition.[18]

It is stated in the Statutes that the community at Ewelme was to include thirteen poor men,[19] each 'meek in spirit, poor in temporal goods, and in such a state that without other relief than his own goods he shall not more competently live; chaste in body and of good conversation named; and tried and broken in age; or else by other manner of feebleness to get his living' [LXXVIII]. This is a standard contemporary description of an ideal almsman, found in many sets of statutes, and it relates to the dual purpose of the

foundation: the worthiness of the poor men made them suitable to celebrate Divine Service and their genuine poverty made them appropriate objects for works of mercy.[20] Constituting an all-male community was by no means universal practice in the period and women were admitted in several other almshouses.[21] Though it is not expressly stated, the tenor of the Ewelme Statutes makes it clear that the almsmen were to be celibate.[22]

The poor men were to receive a weekly wage of 14d., which was to be paid to them by their Minister [XIV].[23] According to one seventeenth-century antiquarian the wages were paid to the poor men every Friday morning upon 'Chaucer's stone'.[24] This almost certainly reflects the medieval practice, although it is not detailed in the Statutes: wages seem normally to have been distributed at the end of the week and were often given out around a benefactor's tomb – the 'stone' here probably refers to Thomas and Maud Chaucer's monument in the Chapel of St John the Baptist.[25]

This charity was intended to form the sole income of the almsmen and, as is common in such institutions, they are expressly forbidden to supplement their wages with paid work or begging [XLIII].[26] It is further stipulated that should an individual receive an occasional sum of more than five marks it should be divided into two: one half going to the man who received it, and one half counted among the general income of the almshouse [LVI]. Should any of them acquire an income of over six marks a year it is instructed that he should be removed from the almshouse and another man put in his place [LV].[27] When they died they had to give to the almshouse 'such goods as they have in time of their said death: their duties and debts paid' [LX].[28]

Although poverty and worthiness were the only necessary titles to a place in the almshouse, preference in new appointments was to be shown to

tenants of our lordship above said [of Ewelme] and other lordships and manors within the Counties of Oxford and Berkshire pertaining to the said lordship of Ewelme; and such also as have been broken in our service, impotent to labour for their sustenance, and those poor men in special that be found dwelling tenants to the lordships or manors of the which shall rise and grow to be the livelihood [of the almshouse] [LXXIX].

Similar directions are ubiquitous in contemporary statutes.[29]

There is no description in the Statutes of the practical process by which new almsmen were appointed to God's House, but one document in the Muniments may give clues as to what actually happened. Scribbled on the back of the Hull Charterhouse agreement of 1462 is a list of the poor men and women in the community of the de la Poles' 'New Hospital' in Kingston-upon-Hull (see Appendix V), to which Alice de la Pole then had right of presentation. The names of the men are listed with a note of their physical health – 'sturdy and powerful' or 'young but ill' or 'poor and old' – and the name of what appears to be a sponsor. So the 'able and powerful' Richard Grawngby was appointed at the 'instance' of a certain John Hastmore; two men were appointed 'by the will' of the Prior of the Charterhouse; one 'by' the late Master Peter of the foundation; and the 'powerful' William Malyard at

the 'instance' of G. Crysto and the present Master. Two men apparently have no proposers – the 'poor and old' John Beanghorn, who heads the list, and John Hadelsey, who ends it. The women are not individually named – there were eleven, five 'debilitated' and six 'young and strong'. Beneath is a sentence reading 'none of these are tenants of my Lady and one, called Joanna Mayre, was lately received without the licence of my lady'. A note under this list reads: memorandum of John Campyon *'comorante per le North feyre* [?ferry] in Hull, faithful tenant of my lady for twenty-five years, old and debilitated'.

This list clearly illustrates the mechanics of appointments to this de la Pole hospital. As at Ewelme, there was interest in whether the almsfolk were family retainers, though evidently this was not an essential qualification. To take a place it was not sufficient just to turn up when a vacancy arose; one had to be proposed by some prominent figure – such as the Master or a de la Pole servant, as John Hastmore presumably was – or be appointed by the Prior of the adjacent Charterhouse. The appointment was then normally ratified by Alice de la Pole herself, hence the special note that Joanna Mayre was at the house without 'my lady's licence'. The fact that she had taken her place without licence, however, would suggest that ratification was something of a formality. John Campyon was probably a candidate whose place was awaiting ratification. The clerk who wrote out this list would presumably have presented his name and qualifications to Alice, who would then have agreed – or not – to the appointment.

It is also worth noting that the Statutes place one important restriction on entry to God's House at Ewelme: 'Also we will and ordain that no leper, madman nor any other infected and in the grip of any intolerable sickness be admitted into the said house' [LXXVI]. In order that the foundation should not be encumbered with ill men the same regulation continues:

And if at any time to come any person of the said house after his admission to the same be infected with leprosy or any other intolerable sickness we will that he be moved so that he infect not his fellowship, provoking them to horror. And that he [having been] so moved and translated to any behoveful place, receive during his life for his sustenance, of the provenance of the said almshouse, the portion of the poor man afore assigned, so that notwithstanding such said sickness we will that he be taken and counted one of the number of the said poor men, and of the said almshouse, during his life.[30]

This regulation also applied to the Master and the Teacher of Grammar [LXXVII].

Such a restriction throws light on the emphasis of the foundation: it was not designed to look after the diseased, as was the case with many hospital foundations up to the fourteenth century. Instead, while God's House did not exclude the sick, it really wanted to attract the worthy poor and particularly those who had outlived their useful working lives. By implication such men were not to be dotardly either; rather they were to be capable of leading a demanding life of contemplation and prayer. All that the Statutes actually say about catering for illness is that the more able-bodied amongst the almsmen

were to 'favour and succour and diligently minister to them that be sick and feeble in all behoveful time' [XLVI].[31]

As has been described, the almsmen were – ideally at least – to be devout and pious. Little more is said of their personal qualities but that they must not be incontinent, 'commonly drunk, a glutton, an idler, a chider surly among his fellowship, a tavern haunter or of any other suspect or unlawful place' [XLI].[32] Also none of the community should 'have drawing to his chamber any manner of woman by the which likely suspicion or slander might fall to the said house of alms' [XLVII]. This injunction can be read as either a complete prohibition of women or a restriction on unsuitable women. The latter is most probable because so many almshouses supported women either as servants or even as inmates.[33]

The life of the poor men was structured around an intense timetable of formal prayer which is described in considerable detail in the Statutes and which must have taken up most of the hours of the day. They did not apparently eat or prepare food communally, as was the case in several other almshouses.[34] In their free time they were to be

restful and peaceable without noise or trouble to their fellowship: without crying and great noise making [but] attending to prayers or to reading or to hearing of virtuous living or else occupied with honest labour of their hands, keeping themselves from wrangling, chiding and in special from foul boastful and ribald talking of things done in their days then afore passed [XL].[35]

It was also forbidden for almsmen to gossip with outsiders about the affairs of the house or spread slander about it [XLII].

In the outside world the almsmen were to be easily distinguishable by their dress: according to the Statutes, each of the poor men was to wear an identifying red cross sewn on his gown [XXXVIII]. He was also to have 'a tabard of his own with a red cross on the breast. And a hood according to the same, without the which habit he shall not enter the church in time of prayers or Divine Service' [XXXVII], a clear allusion to monastic practice.[36] If the sculptures under the tower of Ewelme Church are intended to represent almsmen,[37] it would seem that they were clean-shaven.

All transgressions of the regulations were to be punished by the docking of wages. In the case of absence from or late attendance at the timetable of prayer the Statutes lay down the precise sums that were to be to be deducted, all between 1d. and 2d. [XXXII]. In all other cases, however, the Master acted entirely at his own discretion [XXXIII, XXXVII, XI and so on].[38]

Of the thirteen poor men, one was to be chosen by the 'assent and nomination of the Master, the Teacher of Grammar and the more part of the said poor men' as Minister [LXXIV].[39] If none of the existing poor men were suitable, the patrons of the almshouse could appoint someone from outside [LXXV].[40] The Minister was to be 'well disposed in wisdom and discretion' and had the duties both of presenting the 'errors and defaults of the foresaid poor men to the Master without fraud or guile'[41] and of performing certain practical duties in the almshouse: ringing the 'common bell' to services [IV]

and locking the doors and gates of the almshouse at night at the times stipulated by the Master [v].[42] The Minister was to be paid 16d. each week, 2d. more than his brethren [xiii].[43]

The administration

As well as describing the hierarchy of God's House the Statutes are also concerned with prescribing the formal administrative procedures that the foundation was to adopt in the management of its endowment and affairs. The detailed treatment of administrative procedure is a common feature of statutes for every variety of contemporary institution from secular households to colleges or guilds and was obviously considered a very important means of ensuring that they regulated themselves properly. In common with those of other institutions, the procedures that the Ewelme Statutes outline are largely directed towards ensuring that the foundation's income was honestly and openly – within the community – accounted for and spent.[44] In what follows, the information provided by the Statutes about administration is set out and, in relation to it, the surviving administrative documentation in the Ewelme Muniments is briefly discussed.

The royal licence of 1437 gave permission for the priests and poor men of God's House to hold land and rents to the value of 100 marks a year. This endowment is described under two heads in the Statutes. First described are the almshouse buildings, their furnishings and the land on which they stood:

however the said house lie or be edified at this time with its gardens, walls, gutters and sewers; lying or being up on any part of the ground belonging or pertaining to our manor and lordship above said [of Ewelme], we give ... in pure and perpetual alms [v].

Second come the three manors (without the advowsons of their churches), which were given in perpetual alms for the sustenance of the house:

Of the which three manors one is called Ramridge in Hampshire, the second Connok [now Conock] in Wiltshire, the third is called Mersh [now Marsh Gibbon] in the shire of Buckingham, as appears in the deeds, muniments and grants openly made of the said three manors with their appurtenances to the said Master and Teacher of Grammar and poor men to their successors in perpetuity ... [vi].

The instructions in the Statutes for maintaining the first part of the endowment – the buildings of the foundation – are straightforward: 'Also we will and ordain that all manner of housing, walls and buildings pertaining unto the said almshouse be repaired and upheld of the common costs of the same' [lxi].[45] Administering the estates and protecting them and their income for the foundation was an altogether more complex business. As a corporate body the endowment was held in common by the whole community and the Statutes sought to make this as real as was practically possible by directing that all charters, papers and treasure should be placed in a common chest under three different locks.[46] Keys for these were to be held respectively by the

Master, the Teacher of Grammar and the Minister [LII].[47] The Statutes go on to say that 'no person of the said house shall presume to keep together at one time of the said keys two or three, neither presume to seal with the common seal without foreknowledge and assent of the more part of the said persons and brothers of the said house'[LIII].

But though the possessions were to be kept in common, it was the Master who was made principally responsible for administering them:

[the Master], to whose office shall belong and pertain the goods of the said house, the which shall come unto his hands, is well and truly to minister in such wise that [if] the said goods be in any manner dispersed, he shall gather [them] together; and those goods that be gotten and gathered together he shall to the profit of the said house safely keep [ll.93–104].[48]

The Statutes direct that the foundation will bear all 'necessary costs and expenses; and for their servants in their company or by the said Masters to be sent at all times needful for surveying, improving, letting to farm, arrearing and receiving of the livelihood of the same house, or for any other occupation doing for the well of the said house'[xv].

With this responsibility came the obligation to manage the accounts and documentation of the foundation. In the first month of a new Master's arrival he was to 'associate unto him the Teacher of Grammar and two other fellows, more discreet of the said house, [and] they shall make a full and a true inventory, indented in two parts of all the common goods notable of the said house such wise: that the second part of the said inventory shall remain with the said Master; that other part remaining in the common treasury to be built for that purpose or in the common coffer under three keys' [xLIX].[49]

The Master was made responsible for establishing the financial state of the foundation in subsequent years 'by a true reckoning and account yearly to be had in the end of every year: in some day thereto apt and opportune between Saint Luke's Day [18 October] and Christmas next following' [xLIX]. The Statutes go on to say that 'within eight days after the ending and finishing of the said accounts that they be rehearsed openly before the brethren' [L]. Also any 'money and treasure or else jewels of the said house [are] to be brought forth yearly after the account of the said Master' [LIV]. In having an annual account God's House was following an universal model of contemporary institutional financial practice. The Statutes also require that there 'yearly be made a pair of indentures in the which shall be written duly and truly all the parcels of the receipts of the lordship and livelihood that pertains to the said almshouse. Of the which indentures one part shall be kept in the common chest and the other part shall remain with the Master' [LI].

These, then, were the basic administrative demands made on the Master: that he draw up a witnessed and indented inventory of the almshouse's possessions on his first arrival; that he subsequently produce an annual account, which was to be presented to the whole community; that he draw up an indented account of the almshouse's receipts each year; and that he manage the estates. Documents fulfilling and relating to all these obligations

survive in the Ewelme Muniments and they demonstrate that the system of administration outlined in the Statutes was followed to the letter. The principal of these fragmentary survivals require brief and, for the sake of clarity, individual description.

INVENTORIES

One of the earliest administrative documents to survive in the Muniments is an inventory taken in February 1455 on the arrival of a new Master, William Marton. This is indented and witnessed as the Statutes direct, and simply lists the sum of money in the common purse. Marton is described in it as taking 'delyveraunce of the kay of the comyn cheste leying in the comyn halle loken under .iij. lokys'.[50] Curiously, the common chest, which this inventory also proves existed in 1455, must have been considered inadequate for some reason, because three years later there is a record for the purchase of a new chest with three keys for the custody of muniments and, two years after that, for a chest for jewels that was presumably to be locked within it.[51] This is the only pre-Reformation inventory of its kind to survive, although there is also a list of the contents of the common chest taken in 1504 which, since no new Master was appointed at this time and the paper is not indented, must be regarded as an occasional document. Nevertheless the practice of taking an inventory at the accession of a new Master probably persisted and there is another indented list of 'the common goods notable of this almshouse', which was drawn up in 1681. This tersely records a long table and cupboard in the common hall, 2s. 9d. in 'the treasurie' and 'nothing more, whether jewels or anything else'.[52]

THE ANNUAL AUDIT ACCOUNTS

As we have seen, under the terms of the Statutes the financial affairs of the foundation had to be scrutinized by the entire community between St Luke's Day (18 October) and Christmas every year. It was in fulfilment of this injunction that the annual Audit Account – a summation of all the year's accounts – was drawn up. A large number of these survive and the contents of those predating the Reformation are tabulated as Appendix II, in a manner reflecting the layout of the originals. Although the day on which these accounts were presented shifted from year to year, all were drawn up between the dates specified in the Statutes. On occasion there are two surviving copies of a particular account: one written on paper, and a second written on parchment. In these cases, the paper copy was evidently a rough draft for that on parchment and often contains corrections and alterations.

The Audit Accounts were a simplified overview of the foundation's dealings for the year and, as is apparent from their phrasing, were derived from a number of detailed working accounts. It was evidently the practice of the clerk to copy the totals from each of these working accounts into the audit under a single heading. Occasionally he does so with the briefest of commentaries, but usually the reader is simply referred to the working

account for any information about the total sum. So, for example, there is an entry each year in the Audit Accounts recording fines levied on the almsmen. This entry comprises a total and, next to it, a note reading something like 'received from fines and for the misdemeanours of various people of the said almshouse over the said time of this account, as appears in the booklet of paper displayed above this account and which is in the keeping of the said Master of the house of alms'.[53] In other words there was a working account of fines kept throughout the year which contained the details of misdemeanours and the sconces levied for them. Sadly, not even a fragment of this booklet survives, nor does the vast body of documentation which the annual Audit Accounts draw from. As a result it is difficult to know how many of these contributory documents there were. But fragments survive of two: the Master's Accounts and the Estate Accounts.

THE MASTER'S ACCOUNTS

One quire of the Master's Accounts, with entries dating to between 1455 and 1462, survives. The Master's Accounts are a record of everyday expenses including the upkeep of the buildings, official entertainment and business travel, all costs which the Statutes specifically state were to be met out of the common purse. Their function as a working source for the annual Audit Account is easily demonstrated. The last pages of the quire cover the same period as the surviving audit closing in December 1462. In the latter there is a total of 102s. 2½d. recorded for 'Other Expenses' over the year and a brief note of the various contributory costs. All of these may be traced in the Master's Accounts: the horses for travel; money paid to tilers; and the purchase of iron. The Audit Account also mentions that the cost of underpinning a wall was included in its total of 'Other Expenses'.[54] In the Master's Account for the previous year there is a note that a separate quire of paper was used to serve as an account book for this large undertaking.[55] This supplementary working account relating to the repair of the wall is lost but probably explains the shortfall of 17s. 9½d. between the total of the surviving Master's Accounts for that year – £0 84s. 5d. – and the total of miscellaneous expenses in the annual Audit Account – 102s 2½d.

THE ESTATE ACCOUNTS

The other important body of surviving documentation used in compiling the annual audit is a set of accounts which describe themselves as recording 'the receipts, payments and dues of the almshouse of Ewelme'. These were drawn up in fulfilment of regulation LI in the Statutes, which require that an indenture of two parts be drawn up every year recording the parcels and receipts of the almshouse. That this actually happened is shown by the fact that two indented copies of some of these accounts still survive, and many are labelled 'cista', presumably identifying the copy that was to go into the common chest. By the sixteenth century all the information they contain relates to the almshouse estates, and, although this is not true of the earlier

accounts, they are here termed – with a degree of licence – the Estate Accounts.

The receipts from the estates constituted the vast bulk of the house's income and these accounts were principally intended to keep an accurate record of the dues paid to the foundation in instalments by its manors. This account was closed at the audit each year and the total income received from each manor copied into the Audit Account. The estates and their records present a potentially enormous subject for exploration which is not germane to this discussion.[56] But in order to understand these accounts it is necessary to explain, in a simplified way, something of how the estates were run.

As is apparent from the documentation, the almshouse estates generated income in various ways. Mersh and Ramridge each had a reeve, who ran the estate for the foundation. He farmed and managed some of the land directly, but a lot was also leased, some of it to private individuals, such as a certain John Northfolke, the Rector of Lannton, and Thomas Hauly, who came to Ewelme to seal an indenture relating to holdings at Mersh in 1457 or 1458.[57] There were other lease-holders with direct ties to the almshouse too: Sir Edmund Rede, described as 'a knight and our seneschal', who paid rent to the almshouse for land in Mersh from 1465[58] and Walter Lympeas, *firmarius* (farmer) of Ramridge,[59] who received a livery from the foundation in 1456 and 1459 or 1460.[60] The entire Connok estate appears to have been in the hands of a certain William Pope, described as *firmarius* throughout the 1460s.

Nearly all the regular rents and profits from these estates were due twice a year: at the feasts of the Annunciation (25 March) and Michaelmas (29 September). But although Connok usually seems to have made termly payments, profits from the other estates were paid in instalments throughout the year. These instalments were carried to Ewelme in different ways. Sometimes the Master would visit an estate and collect the money himself, sometimes the reeve or farmer would deliver it, and sometimes a servant of any of these parties would make the journey, or leave it at a third place to be collected. The Estate Accounts record the payment of each of these instalments, keeping note of the person who had paid it, the hand that conveyed the sum, the address to which it had been delivered and – if necessary – the term, Michaelmas or Annunciation, for which it was owed.

This system of delivery can be illustrated, for example, from the various accounts of the year 1461. The first entry in the Estate Account records the delivery of 51s., by the hand of a certain Humfrey Forster, to Wallingford Castle – then in the possession of the de la Poles – on 14 January 1462. It is stated that this payment was made on behalf of John Redehede, the reeve of Mersh. This money was then collected by a servant of the almshouse, as is shown by the entry in the Master's Accounts for the payment of 12d. for the collection of money from Wallingford Castle (2nd entry p.29). The second entry in the Estate Accounts notes the visit of Redehede to Ewelme to deliver £0 22s. 4d. His visit is also recorded in the Master's Accounts, which describe him as bringing 'the profits of his office' and which state his expenses for the

journey to Ewelme as 6d. (5th entry p.29). An almsman, William Chamberleyn, collected the £0 11s. 8d. from Mersh in the next instalment from Mersh noted in the Estate Accounts, and was given 12d. by the Master to cover the costs of his journey (11th entry p.29). Redehede then came to Ewelme on 15 April and delivered £0 18s. 8d. to the counting house at Ewelme Manor. This last journey is probably recorded in the ninth entry on page 30 of the Master's Accounts, which notes the expenses of 4d. for the *prepositus* (reeve) of Mersh coming on the house's business. It is possible to marry most of the entries in these two documents, and they make it apparent how busy the traffic between the various estates and Ewelme was. Incidentally, these entries can also be married with the surviving manorial accounts rendered by the respective *prepositi* of Mersh and Ramridge to the almshouse.

There are two important features of almshouse life that these administrative procedures highlight: first, that almsmen were being regularly employed to run errands for the almshouse, and second, that the administration of the foundation was integrally involved with that of the de la Pole family: the counting-house of Ewelme Manor and, to a lesser extent, that of Wallingford Castle regularly feature in its financial dealings.

It also deserves note that the Estate Accounts were probably also based on working accounts in the manner of the annual Audit Accounts: there survives a quire of paper recording the instalment payments from the estates for the years 1456 and 1467. Its entries are in two distinct hands and the document would appear, for this reason, to have been written as the various payments actually came in. Unfortunately, no parallel Estate or Audit Account survives from this period.

This elaborate system of accounting was only one means of securing the financial operation of the foundation in perpetuity. A richly endowed institution such as God's House also had to be protected from people who would try – as indeed they have at various periods – deliberately to strip it of its assets or embezzle its funds. As regards embezzlement, the principal deterrent would seem to have been the open treatment of accounts, but the Statutes also make a single mention of 'auditors', who were to agree to the Master's expenses claims [xv]. From this isolated reference it is not clear who these men were or what they did, but there are two other references to auditors in the Muniments which might help answer these questions.

When Henry VII gained possession of the patronage of the almshouse through the confiscation of de la Pole property, he appointed the Bishop of Hereford visitor of the almshouse. The Bishop's signature appears on a number of Audit Accounts between 1504 and 1508, along with the statement that he had been appointed by the King and that the Master had shown him the accounts and represented that they were true.[61] Two of these accounts – those for 1506 and 1508 – also refer to the Bishop's auditor, who had looked over the accounts and verified them. In 1506 the auditor is named as John

Ardern, a Fellow of Magdalen College, Oxford.[62] From this it seems that the auditor described in the Statutes was a representative of the patron, in the sense of the current living owner of the manor of Ewelme.

The embezzlement of money was a relatively small threat to the long-term welfare of the foundation. Much more serious was the possibility that the endowment would be stripped away. As we have seen, William de la Pole went to considerable lengths to establish an unassailable legal title to the properties before he bequeathed them to God's House, and this was in itself a defence. He also provided a formidable collection of other deeds; and in the Muniments today there are not only title deeds which trace the ownership of the endowment back to the fourteenth century, but two deeds of gift of the property by the de la Poles to the almshouse (with copies), and a detailed reiteration of them in the Statutes, again a document with legal weight.

With such strong legal defence the only serious external threat to the foundation's endowment came from the future lords and ladies of the manor. Each generation of owners was to have the position of 'provisor' or 'founder'[63] of the almshouse, that is to say that they were to be the beneficiaries of its prayers and were to have the power of visitation [LXXXI]. Given their local position as enforcers of the law, they could bring considerable pressure to bear on the foundation to relinquish its property. To prevent this, the Statutes instruct that if any future lord or lady of Ewelme should try to strip the almshouse of its endowment then the Chancellor and Treasurer of England should have full power to restore the property. In return the Chancellor and Treasurer were to be joint beneficiaries of the prayers of the foundation [VII].

There was, however, also an internal threat: members of the foundation might decide to close the institution down and take over the property themselves. To frustrate this, the Statutes effectually preclude the foundation, an independent institution in every other way, from shutting itself down:

we forbid and charge in all manners, that no person by the will and the assent of the said Master and his successors; the said Teacher of Grammar and his successors; the said Minister and his successors; of the said poor men and their successors [at] any time to come presume to disperse, consume, give away and lay to weed the common goods of the said house. But we will that every of them do his diligence to keep, augment or make them better. [LIX][64]

The evidence for re-creating a portrait of God's House in the fifteenth century answers all the elements of a piece of theatre. The surviving buildings are the stage set and, thanks to their excellent state of preservation, with some careful thought it is still possible to imagine their appearance in the fifteenth century. In place of the script of the play there stand the Statutes – a minute description of what was meant to happen here. But the production really depended on the actors themselves, the cast of men who lived here and played their parts in the community. They determined what life was really like and it is to the subject of who was who in fifteenth-century Ewelme that we must turn next.

The community

For the individual patient enough to piece the fragments of evidence together it is possible to gather a considerable quantity of biographical information about the priests and poor men who formed the medieval community of God's House. Very little is known about chantry priests and almsfolk in the late Middle Ages and Ewelme's documentation presents a rare opportunity of revealing something of their careers and lives. Nor has any attempt previously been made to chart the history of a foundation through the lives of its community. To do so involves some narrowly focused discussion, but the rarity and the interest of the rewards more than justify this. In what follows all the biographical information relating to the members of the community up to the Reformation – Masters, Teachers of Grammar and poor men – is assembled. Ideally this survey would have carried through beyond the Reformation but, because of changes in the form of the accounts and the loss of documents, there is little to be said about the individuals in the community after 1524. Nevertheless this should not be allowed to detract from the value of the earlier information we do have or the characterful pre-Reformation history of the foundation that emerges.

The Masters

MASTER JOHN SEYNESBURY (1437–54)
Sir John Seynesbury is named as the first Master of the almshouse in the Statutes, where he is described as the 'late parson, by long continuance of time of the said parish of Ewelme' [ll.131–43]. He was not a graduate, but it is explained that his appointment was the result of 'his long continued service and attendance that he had in the building of the said church and [alms] house also'. Recovering details of Sir John Seynesbury's career is a difficult task. He is first recorded shortly after the death of Alice's father, Thomas Chaucer, in 1435. As is apparent from the legal documentation relating to the

settlement of Chaucer's property, Seynesbury was enfeoffed of some land conjointly with him[1] and involved in distribution of his property by the terms of Chaucer's will.[2] Both these facts suggest that by this date he was closely connected with Thomas Chaucer, though unfortunately the length and nature of the association are impossible to trace, and it is not known when he became Rector of Ewelme.

Because the Statutes place special emphasis on the separation that was to exist between the affairs of the foundation and the parish at Ewelme [LXXII] it is likely that Seynesbury had to relinquish his post as Rector when he assumed the new office of Master of the almshouse. Quite when this happened, however, is not clear. Given the early circumstances of the foundation he may actually have served for a while both as Rector and as nominal Master to the embryonic community, perhaps only resigning his living at the time of the endowment agreements in 1442 or 1446.[3] He had certainly ceased to be Rector by 1450, however, because the Statutes describe him as 'late parson' of Ewelme and in 1453 another man is known to have held that living.[4] No almshouse accounts relating to Seynesbury's mastership survive and it has not proved possible to rescue further details of his career.

John Seynesbury's surviving brass in the church at Ewelme records that he died on 27 August 1454, and it would seem likely that a Certificate of Absolution in the Muniments endorsed by a certain John Gautier and dated the 33rd year of Henry VI (1 September 1454 – 31 August 1455) was written out for him in the days following his death.[5] After Seynesbury's death no new appointment was made for five months. This might be a reflection of the political chaos of England at this time and the personal dangers which faced Alice de la Pole and her thirteen-year-old son John: in August of 1453 Henry VI had lapsed into a mental stupor that was to last for sixteen months. The struggle for power which this precipitated turned in favour of the Yorkist party, many of whose leaders were active enemies of the family. Without the royal protection that had shielded Alice de la Pole after her husband's murder in 1450 the family's affairs may have been in difficulty. Whatever the circumstances, a candidate was finally chosen and William Marton took up his appointment as Master of God's House on 1 February 1455.[6]

MASTER WILLIAM MARTON (1455 TO BETWEEN 1495 AND 1498)

William Marton was from the diocese of Carlisle and had come to Oxford where he took his Bachelor of Arts degree in 1443–44. In March 1444 he was ordained deacon to the title of Osney Abbey and in the same year became a chaplain of Queen's College, Oxford, a post which he held until 1451. By 1449 he was Master of Arts and in 1451 was made fellow of his college, which he served as Treasurer between 1453 and 1454. His vacant fellowship in the college in 1455 marks his departure from Queen's to serve at Ewelme.[7]

It is with Marton's appointment that the documentation of the almshouse really begins, and considering his previous appointment in what must have been a bureaucratized and efficient treasury at Queen's this is perhaps not

surprising. The appointment of an experienced financier may in itself have been a deliberate choice by Alice de la Pole. An inventory of the house's goods made at his arrival on 1 February 1455 records that the common chest contained a mere £3 12s. 4d.[8] For a foundation with an annual income in the 1460s of over £60 this is a surprisingly small sum. It seems quite possible therefore that the almshouse was in financial difficulties – perhaps as the result of the building work – and that with his experience William Marton was chosen to put it on a secure footing. In this respect at least his mastership was a success: his last surviving Audit Account, which closed in December 1468, records that £74 9s. 10½d. were placed in the common chest, nearly twenty-five times what he had found in it thirteen years previously.[9]

The surviving gathering of the Master's Accounts, a working account of petty expenses, was opened the day after Marton took up residence, on the feast of the Purification (2 February). Unfortunately, neither this nor the other records of his mastership provide any personal information about him. But they do make clear that he drew his £10 salary annually, and that he travelled regularly on almshouse business.[10] The six-year period (1455–61) covered by the surviving quire of Master's Accounts makes the extent of his travel apparent. In this time he visited the almshouse's principal holdings at Ramridge (Hants.), Connok (Wilts.) and Mersh (Berks.) no less than twenty-two times, in journeys varying between one and a half to five days in length. Of these, fourteen journeys were made to hold courts[11] and eight to undertake unspecified business.[12] On top of this are what seem to have been six extraordinary journeys: visits to Oxford, London, Watlington, Thame, Boarstall and Abingdon.[13]

It is perhaps an indication of his assiduous attention to duty that, over these seven years, there is only one piece of almshouse business that he deputed to the second priest, the Teacher of Grammar: a court held at Mersh in 1458.[14] Even during the period for which we lack the detailed evidence of the Master's Accounts it is apparent that Marton continued to travel extensively, because the surviving annual Audit Accounts covering the period 1461–68 note his considerable expenses on this count, though they give no itemized details of them.

Marton was evidently also closely associated with Alice de la Pole's household and in 1469 he was a witness and beneficiary of the will of Simon Brailles, her chaplain.[15] He was probably also a beneficiary of Alice's own will, because seven years later, just after her death, he and the then Rector of Ewelme, Dr Thomas Lee,[16] received the release of rights in the manor of Ewelme which had been seised in fee to the use of Alice de la Pole.[17] This release is likely to have been a reward for service and it was accompanied by a pledge of future good faith and allegiance to the family: shortly afterwards, Lee and Marton also received seisin from John de la Pole of land in Suffolk and Norfolk.[18]

Marton continued in his post as Master after Alice's death and four years later in 1480 he took the Statutes of the almshouse to be ratified by the

Archbishop of Canterbury. As the preamble to this surviving ratification charter explains, Marton did this to fulfil the request of the Duke and Duchess in their wills.[19] After this point he disappears from all but one set of records. The Muniments preserve a fragmentary series of accounts from the Mersh estate and Marton continues to be mentioned in these as receiver of income in his capacity as the Master up until the last surviving account, dated 29 September 1495. The next mention of a Master is on a brass in Ewelme Church commemorating Master William Branwhait, who died on 5 November 1498, so Marton must have died between 1495 and 1498.

MASTER THOMAS REVE (1488–94)

Curiously, it seems that Marton's mastership was not unbroken up to his death, as one would naturally assume. The Mersh accounts also suggest that another man, a certain Master Thomas Reve, had temporarily enjoyed the mastership for some period between Michaelmas (29 September) 1488 and 25 March 1494. The Mersh accounts do not form a complete sequence, but their evidence is as follows. In the account closing Michaelmas 1488 all the receipts went, as they always had, to William Marton, but in the subsequent surviving account, dated Michaelmas 1492–3, all went to a certain Master Thomas Reve. In the next account of the series, dated Michaelmas 1493–4, both men received money from the manor[20] and by the final pair of surviving accounts, ending Michaelmas 1495 and 1496, all the money was again passing to William Marton.[21]

Before discussing these accounts, it is necessary to introduce Thomas Reve. Like Marton he was closely connected with Oxford, and had served as a bursar at Magdalen between 1483 and 1485, a college he had entered as a Sir John Fastolf Scholar in 1476, and as a fellow in 1482. He resigned his fellowship in 1485, shortly after his presentation by the college to the rectory of Bramber in Sussex, to which he was admitted on 20 June 1484. In 1488 he resigned this in turn.[22] Judging by the evidence, this was almost certainly in order to go to Ewelme, where he must have taken up residence after Michaelmas that year, the closing date of the Mersh account in which Marton is sole receiver of the receipts.

Reve's appearance as a collector in these Mersh accounts would seem to prove that he was acting as Master of the foundation for a period after 1488. 'Why?' and 'In what capacity?' are impossible questions to answer satisfactorily on the strength of the accounts alone. His resignation of Bramber suggests that his move was planned and that it was undertaken for a permanent job, although the mastership evidently did not turn out to be that. Marton's own movements are equally unaccountable: why would he have left Ewelme and, if he did, why and how did he come back?

The accounts are problematic to interpret. Theoretically all the receipts recorded in them were meant to pass into the common coffer of the foundation. The Master was, by virtue of his post, collector, but he was not meant to benefit directly from what he received. This creates a potential

ambiguity: the fact that Marton or Reve collected the money does not prove that either of them actually enjoyed it: it merely shows that they were in office. Given the difficulties of the evidence, any explanations of events based on it must necessarily be tentative. But there are features of the 1493–94 account – when both men shared the receipts from Mersh – that are so curious that they require some attempt at speculative interpretation. To paraphrase and arrange in chronological sequence, the entries read as follows:

February 1493 'Magistro William Marton' received 13s. 4d.
21 May 1493 'Magistro Thome Reve' received 53s. 4d.
29 August 1493 'Magistro William Marton' received 53s. 4d., which the document states he was paid ('solut', a word used nowhere else in this context in the accounts).
25 November 1493 'Domino Willo Dawson' (the almshouse's second priest) received 103s. 4d.
For Annunciation Term (ending 25 March 1494) Reve received 26s. 8d.
For Annunciation Term Marton received 26s. 8d.
For Michaelmas Term (ending 29 Sept 1494) Marton received 53s. 4d.[23]

Leaving aside the collection made by William Dawson for the moment, let us look at those made by Reve and Marton. The first payment to Marton derives from the previous financial year, but otherwise the payments received by the two men balance exactly up to the end of the Annunciation term. This seems remarkable for two reasons. Firstly, if William Marton returned to Ewelme after a period of absence, one would expect his collections to recommence after the date of his return and at that same point Reve's collections to cease. This is not what happened: there were in fact two Masters actively collecting receipts at the same time, and Marton collecting money from the previous financial year. Secondly, if the receipts were passing to the almshouse coffers, why are they divided so carefully between these two men – for example the two equal payments made for the Annunciation term – and why is the payment made to Marton on 29 August actually owed to him?

Dawson's collection is also a curiosity. As Marton's deputy there is no reason why he should not have collected money; but of the twenty-three surviving Mersh accounts, the second priest acted as collector in only five instances, and the first of these occurred in the account ending Michaelmas 1484. That year, in contrast to every previous year, in which Marton was the sole named collector, the second priest received all the monies from the estate. Rather curiously, Marton's name appears instead in this 1484 account in an address added to the reverse of the document: 'To Mast. Willm Martyn of Ewelme. Mast of the almeshouse of Ewelme be this delyverd.'[24] As described, Marton is again the sole recipient in the next surviving account, ending Michaelmas 1488, and then in 1493 there follows the sequence of accounts mentioning Reve outlined above. In the last two accounts after Reve left (ending Michaelmas 1495 and 1496) both Dawson and Marton are mentioned as collectors.

It is curious that William Marton should have changed the usual practice of his mastership in 1484 and allowed his deputy to act as collector, and also that the account should need to be addressed and sent to him. Was he at Ewelme? Then it is odd that in 1488 another Master should appear, and apparently act alone for at least one year (in the year up to Michaelmas 1493), serve parallel with Marton for the first half of the following year and then disappear, and that subsequently Dawson should act alongside Marton as collector until records disappear.

The implication is that Marton was periodically absent. There are many possible reasons for this, but two in particular might suit the circumstances. The first is that Marton was entering his dotage and could no longer perform all his duties. Certainly he must have been approaching at least the age of sixty by the late 1480s. If this was the case, Reve might have come to Ewelme to act as Master in what was expected to be Marton's last illness and resigned his benefice on the understanding that he would receive the post subsequently; as we shall see, in 1498 a succeeding Master arrived before the death of his predecessor. But Marton then recovered and the settlement of the dispute over the mastership involved the apportioning of revenues.

Alternatively, Marton may have become involved in contemporary political events and been either drawn away or ousted from his post. In 1483 the accession of the Yorkist King Richard III thrust the de la Poles into the forefront of English politics. John de la Pole's son, John, Earl of Lincoln, became President of the Council of the North, and after the death of the Prince of Wales in April 1484, heir-apparent to the English throne. This stroke of good fortune then turned to the family's disadvantage after the Yorkist defeat at Bosworth in August 1485. Henry VII could only be deeply suspicious of a family that had such good claims to the English throne. Initially he was conciliatory, but John thirsted after the crown and two years later, in 1487, he was killed in the act of rebellion at the battle of Stoke and all his property was appropriated by the king.

How the foundation at Ewelme was affected by these events is impossible to say without further evidence, but as a long-standing family servant Marton may have become caught up in them. One fact which might suggest this is that in the sixteenth-century accounts there is reference made to two large debts owed to the foundation by members of the de la Pole family. The larger of the two is a debt of £20 owed by the late John, Earl of Lincoln, which is described as having been made 'in the time of a recent master', and given that John was killed in 1487 this must refer to Marton.[25] This loan and Marton's possible absence in 1484, when John's political fortunes were waxing, might suggest that he was closely involved with the Earl's household and affairs. After the failed rebellion Marton's services to the Earl may have landed him in political difficulties. The post at Ewelme would have been an easy and suitable target for a takeover, particularly since there may have been some confusion over the seizure of the Earl's property, as distinct from that of his father. This series of accounts from Mersh may, therefore, record Marton's

successful attempts to regain a living which was hazarded by John's ambition.

MASTER WILLIAM BRANWHAIT (BETWEEN 1495 AND 1498)

There is very little information about the three Masters who succeeded William Marton. The first was Master William Branwhait. No documentation from Branwhait's mastership survives, so the date of his appointment is not known. The only references to him are to be found in his surviving will and in the accounts of his successor. In his will, dated 1 January 1498, Branwhait asked to be buried in the church 'next to the almshouse' and donated 6s. 8d. to the nave for the burial.[26] His brass, with a half-figure of a priest, still survives, probably in its original position, at the east end of the south aisle. The inscription on it records the date of his death as 5 January 1498. It is significant that not even a Master could squeeze a monument into St John's Chapel itself. This was reserved for the Chaucers and their successors alone.

To judge from his will Branwhait was a wealthy man, bequeathing £6, along with various possessions, to his family and about £30 in other gifts, including 10s. to the almshouse. There are a number of bequests to religious houses, as well as stipends for priests to pray for his soul. Principal amongst these were £4 to a certain Adam Fawcett to celebrate Mass at Sudbury (Gloucs.) for a year and £16 to John Spence, his successor as Master, 'to celebrate Masses for my soul and the souls of the faithful departed' for three years. In doing this Branwhait was presumably buying into the devotions of God's House itself. Spence both witnessed Branwhait's will – along with Dr Thomas Lee, the then Rector of Ewelme Church – and proved it. This suggests that he was heir-apparent to the mastership and present at Ewelme when the will was written, just before Branwhait died.

Branwhait is mentioned posthumously several times in the annual Audit Accounts: in the first account of Master Spence, dated December 1498–9, as the donor, by his will, of 10s. to the foundation. Subsequently he appears in the sixteenth-century accounts as the creditor of a bad debt made from the almshouse common chest. This was a sum of £13 lent to Elizabeth, Duchess of Suffolk, widow of John de la Pole, at an unspecified date, and it joined the sum of £20 lent to John, Earl of Lincoln, by William Marton. Both these debts recur on and off in the account calculations until they finally disappear – probably unpaid – in the accounts of Spence's successor, Master William Umpton.[27]

MASTER JOHN SPENCE (1498–1516)

Spence's mastership, which began in 1498, is well documented, with twelve surviving annual Audit Accounts, covering the period between his accession to the post and December 1514. But despite these he remains a shadowy figure. He was actively connected with Oxford University during his tenure of the mastership, supplicating as an M.A. for a B.Th. at Oxford in 1506 – a

degree to which he was admitted on 27 March 1512. In 1512 he also acted as University Preacher. He died four years later in 1516.[28]

MASTER WILLIAM UMPTON (*fl.* 1522–24)
The last documented pre-Reformation Master is William Umpton, who was in his post by November 1522, the opening date of the earlier of two surviving Master's Accounts written during his mastership. He has no documented connection with Oxford.

The Teachers of Grammar

SIR JOHN CLIFFORD (1454/55–62)
A certain John Clifford is the first documented figure to have held the post of Teacher of Grammar. The earliest reference to him occurs in William Marton's inventory of 1 February 1455, which he witnessed.[29] Three years later, in the Master's Accounts of 1458, there is a note recording the payment of his expenses for attending a court in Mersh – apparently in place of the Master, William Marton.[30] In 1460 his ruined garden wall was mended and in 1461 a brick wall in his house was repaired.[31] His name is also included alongside William Marton's and 'the thirteen poor men of Ewelme almshouse' in a deed of 1460 making over land to the foundation.[32] The annual Audit Accounts show that he died in 1462 – seemingly half-way through the year, because he had collected his salary up to the feast of the birth of John the Baptist (24 June).[33]

Nothing further is known of Clifford from the Muniments, but this man must be the same John Clyfford, a determiner, who rented a school from University College, Oxford, in 1448–49 and was ordained priest as a Bachelor of Arts on 15 June 1454.[34] The evidence for this identification is circumstantial, but cumulatively convincing: first, there is a school master of the same name in Oxford, a town closely associated with the foundation. Second, he appears at exactly the right time to take up the Ewelme post: if the identification is correct, Clifford's appointment as Teacher of Grammar must have been made between his ordination on 15 June 1454 and the inventory that he witnessed at Ewelme in February 1455. This circumstance agrees exactly with the evidence for the early history of the foundation.

As has been discussed, the endowment documentation proves that no second priest had been appointed at Ewelme by 1442 and the Statutes show that the post remained open at least up to the date they were ratified between June 1448 and May 1450.[35] This latter fact is clear for two reasons: first, the Statutes make no mention of an appointee to the office – an odd omission since they name the first appointees of the others (a common habit in medieval statutes);[36] and second, though they express the other appointments unequivocally – 'we put into the same house … Sir John Seynesbury' [ll.131–4] or 'we actually provide and put into the said house thirteen poor men' [ll.207–9] – in the case of the Teacher of Grammar it simply says 'we will

and ordain, as for the second priest, that there be provided a well disposed man' [ll.151–3]. This is surely an expression of a future intention and it proves that the second priest was still to be appointed. In other words, John Clyfford was ordained priest in the same five-year period when the first appointment to the post of Teacher of Grammar was made.

SIR WILLIAM GRENE (*fl.* 1462–78)

John Clyfford's successor was a man called William Grene. He was appointed in the latter part of 1462, receiving for that year a quarter of the annual salary appointed to his office.[37] Grene died in 1478, when the indented Estate Accounts record the payment of 3s. 4d. to the foundation by his executor, the then Rector of Ewelme, Dr Lee.[38]

SIR ROGER MAKENEY (1483–87)

The next documented Teacher of Grammar was a certain Roger Makeney, who is mentioned as 'magister scole de Ewelme' in an account from the Mersh estate dated Michaelmas 1483–84.[39] That he died in 1486 is demonstrated by the Estate Account of that year, which records that his executors left 3s. 4d. to the foundation, a sum identical to that left by Grene.[40]

SIR WILLIAM DAWSON (*fl.* 1493–1503)

Makeney was presumably replaced in turn by William Dawson, who first appears as a collector of money in the Mersh accounts between Michaelmas 1493 and Michaelmas 1494 and again in 1494–96.[41] He collected his whole salary of £10 in the surviving annual Audit Accounts of John Spence up to and including that for the year closing December 1502.[42] He must have been replaced over the course of the following year because by the time of the next surviving account, closing December 1504, a certain 'Dominus Stele' held the post. He is mentioned again in the Estate Account for the year beginning December 1505 for paying back a 6d. debt to the house.[43] This reference is interesting in that it proves that Dawson did not die in office but found another, perhaps more attractive, post, to which he moved.

STELE (*fl.* 1503–06), MASTER GREGORY (*fl.* 1506–14) AND SIR JACOB MILES (*fl.* 1522–24)

There is no record of these last three Teachers of Grammar other than that they may be shown to have received their full salaries in the surviving annual Audit Accounts: Stele in the three accounts covering the period between December 1503 and December 1506; Master Gregory in five accounts covering the period between December 1506 (he took straight over from Stele) and December 1514; and Jacob Miles in the two accounts covering the period from December 1522 up to December 1524. That the full salary of £10 was paid to the Teacher of Grammar in both 1506 and 1507 implies that the transition from Stele to Master Gregory was planned and that the former did not die but moved on to another job, as his predecessor had done.

The school and its children

The Statutes give no details about the everyday running of the school, which is otherwise scarcely documented. No names of pupils are recorded, nor is there any indication of their numbers. The one tiny fragment of information about the school occurs in a curious page of accounts in a gathering of estate receipts which refer to expenses incurred during the visits of a certain Edward Quarton to Ewelme in 1465.[44] Amongst them are entries apparently referring to the school: for schoolhire (appropriately, for a free school, no sum is entered), for a set of 'writings' (the title is illegible), for straw for the floor of the school and for ink. Why these expenses should occur in such an account is mysterious. There is no evidence that the children at Ewelme acted as choristers or partook in any devotions.

The poor men up to 1524

There is a certain amount of information to be gleaned from the Ewelme Muniments about the almsmen of God's House themselves. Information about almsmen in this period is very hard to come by and for this reason it deserves reproducing in full, despite the aridity of bare details. The names of those who died each year, along with the value of their effects, are noted both in the annual Audit Accounts and, during the fifteenth century, in the Estate Accounts. These entries constitute the bulk of our knowledge about the community of poor men at Ewelme and what follows first is a list of their contents arranged by year and interpolated with any further information from the Muniments about the individuals they mention. Together the two fragmentary sequences of surviving accounts provide details about almsmen for the years 1461–68, 1472–74, 1475–78, 1482–87[45], 1493–94, 1497–1508, 1511–14 and 1522–24. In some years there were apparently no deaths and, for the sake of completeness, the list also indicates these. On such occasions the clerk writing the accounts usually noted that there were no mortalities, but sometimes the item recording deaths is tacitly omitted from the account. Where this happened the list below states the fact.[46]

Obit between December 1461 and December 1462:
Simon the Labourer – 20s. *'ex mero dono'*
John Saundesey – 8s. 10d.
Thomas Wellington – '*Aliquo profic[io] proven[iente] de camera Thome Welyngton ?…? in onera q' pecuni[a]e su[a]e dispositum fuerit secundum voluntatem d[omi]ne fundatric[is]'*. The meaning of this is obscure.

Thomas Wellington must actually have died early in the previous year because the second entry in the Master's Accounts beginning 19 December 1460 describes him as a 'late' poor man of the house.[47] The Master's Accounts

record the expenses incurred in receiving his gift to the foundation of two acres of land near Bensyngton: 4d. for making two deeds and 2d. for taking seisin. Various earlier deeds relating to the land also survive in the Muniments, presumably passed on with the gift. From these it emerges that Wellington had originally received the property as part of a larger four-acre parcel of land, along with his wife Agnes and various others, on 1 August 1428.[48] His wife was evidently dead by 1461 because, when he passed his two-acre portion to the almshouse on 23 January that year, she was not mentioned in the deed.[49] The income from the rent of this land (8d. every year) appears occasionally in the *Vadia Pauperum* section of the annual Audit Account, showing that it was remembered as an almsman's bequest. Perhaps the curious note in the Audit Account records the fact that the income from the land was taken this year by Alice de la Pole to cover the legal costs of securing this gift, which she might have had to oversee.

Thomas Wellington must have been one of the more senior members of the community because he witnessed the inventory made by William Marton on his arrival in the almshouse in 1455 along with the Minister, John Bostok.[50]

Obit between December 1462 and December 1463:
John Pury – 7s. 9½d. There was a family of Purys who were tenants at Ramridge from at least 1434, to which this man might belong.[51]

Obit between December 1463 and December 1464:
Thomas Smyth – 4s. 1½d. The Audit Accounts say this sum is 'of the goods in the room of Thomas Smith, a pauper, sold this year'.

Obit between December 1464 and December 1465:
William Curteys –10s. 1½d. William Curtes is also mentioned in a Ramridge Estate Account dated September 1462–63: '*Et solut' pro reperacione unius tenenti in Peynton nuper Walti Eston factus pro Willm Curteys unum pauperum de Ewelme in gronfel stodand et walland[?] de la enterteys dicti tenenti in toto – xij d.*'[52]
Nicholas Webb – 12s. 11d.
Walter Maynword – 10s. 10d.
Gerard Vespilan – 10s. 1½d.

Obit between December 1465 and December 1466:
John Martyn – 22s.
Thomas Pek – 12s. 7d.

Obit between December 1466 and December 1467:
William Chaumerleyn (Chamberlain) – 29s. 5½d. The Master's Accounts contain six references to this man. He first appears claiming 6d. expenses for going to Mersh to receive money on 28 February 1461 (p.25). Later that year he visited various estate officers on the house's business (p.27) for which 6d. was paid. In 1462 he again travelled to Mersh to receive money (p.29),

claimed 1½d. undertaking various duties of the house (p.31) and went to two courts with Master William Marton, one at Mersh and later on 1 June one at Ramridge (bis p.30).
John Wodeward – 6s. 3d.
Richard Laurence – 22d.

Obit between December 1467 and December 1468:
William Payce – 13s. 11d.

Obit between December 1472 and December 1473:
John Newport – 19s. 1½d. The Master's Accounts record that Newport travelled with William Marton to Ramridge and Connok to see the manor and hold a court in 1460 (p.21).

Obit between December 1473 and December 1474:
Richard Malpasse – 12s.
Nicholas Well – 12d.

Obit between December 1475 and December 1476:
NO DEATHS

Obit between December 1476 and December 1477:
Thomas Taylor – 3s. 6½d.

Obit between December 1477 and December 1478:
Thomas Forde – 3s. 11d.
Simon Almsman – £10 2s. 3½d. 'in money and goods'.

Obit between March 1482 and March 1483:
Richard Golburn – 47s. 3d.

Obit between 9 April and 25 June 1483:
NO DEATHS

Obit from 26 June 1483:
Sampson Vicars – £3 13s. 2½d.
William Gilham – 9s. 5d.

Obit between December 1484 and December 1485:
NO DEATHS

Obit in 1487:
Richard Lewes – 12s. 1d.
John Mandevylde – 3s. 3d. There is a John Maundevylde who appears in the Mersh accounts as a tenant from 1446 up to 1470.[53] The name is sufficiently

unusual for it to be possible that this is that same man, or at least a member of the same family.

Robert Crokelyn – 8s. 9d.
Nicholas Spyre – 8s. 5d.

Obit between December 1493 and December 1494:
William Elys – 33s. 11d.

Obit between December 1497 and December 1498:
NO DEATHS

Obit between December 1498 and December 1499:
John Tommys – 4s. 10d.

Obit between December 1499 and 17 December 1500:
Thomas Raynolds – 12s. 11d.
John Rose – £4 13s. 2d.
John Okelay – 14d.
John Eternate – 22d.

Obit between December 1500 and December 1501:
Richard Tailor – 10s. 11d.
John Crue – 4s. 9¹/₂d.

Obit between December 1501 and December 1502:
Richard Bolte – 26s. 7d.
William Clerke – 11s. 11d.

Obit between December 1503 and December 1504:
Edmund Sampson – 27s. 5d.

Obit between December 1504 and December 1505:
NO ENTRY IN THE ACCOUNT

Obit between December 1505 and December 1506:
NO ENTRY IN THE ACCOUNT

Obit between December 1506 and December 1507:
Thomas Cowper – 21s. 6d.

Obit between December 1507 and December 1508:
NO ENTRY IN THE ACCOUNT

Obit between December 1511 and December 1512:
NO DEATHS

Obit between December 1512 and December 1513:
NO DEATHS

Obit between December 1513 and December 1514:
Thomas Coton
Galfridi Welshman ⎱ between them 19d.

Obit between December 1522 and December 1523:
NO ENTRY IN THE ACCOUNT

Obit between December 1523 and December 1524:
John Delaby – £6 13s. 5d.

The names of some other almsmen are mentioned independently in the Muniments and to complete the list of all the documented members of the community these should briefly be set down. John Bostok is described in the Statutes as the first Minister and he witnessed the inventory taken by William Marton on his arrival at Ewelme in February 1455.[54] He was presumably a founder-member of the community but unfortunately there is no further information about him and it is not known when he died. The Master's Accounts make reference to two other almsmen. In February 1455 there is a partially obliterated entry in them referring to a certain Thomas Stevynson and a building account.[55] This must refer to the expenses of 'Thomas Stevens, a pauper of Ewelme' who appears in the Ramridge manorial account closing Michaelmas 1455 as paying several workmen for repairs to buildings including the Manor House. Thomas Stevyns or Stevynson is not mentioned again and he presumably died shortly afterwards.

Another entry in the Master's Accounts between June and October 1456 reads 'Item barbitonsori pro camera iacobi vacant.' Presumably this Jacob was either an absent or dead almsman. The mention of a 'barbitonsori' is curious. Several almshouse and college statutes in this period include instructions that barbers be employed to shave the brethren.[56] Perhaps Ewelme also employed one, although the Statutes do not mention the fact: in sixteenth- and seventeenth-century accounts there are regular references to such a post. In this period barbers also acted as surgeons and it is also possible that this entry refers to the provision of medical care for an almsman.[57]

The Estate Account closing December 1473 records the 12d. rent from an acre of pasture at Garsington given to the foundation by another late almsman called Richard Wellys.[58] He must have died between the previous surviving account (closing December 1468) and December 1472, the opening date of the first account that records the income of his gift.

Altogether the Muniments provide us with the names of twenty-two almsmen who died between the establishment of the almshouse and Alice de la Pole's death in 1475; and of a further twenty-five up to 1524 – a total of

forty-seven. It is tempting to make an educated guess as to what proportion of the total number of almsmen who joined the foundation between 1437 and the Reformation – say 1538 – this represents. There are two sets of consecutively dated accounts which might be used roughly to calculate the death rate in the community: that of the 1460s gives an average of 2.1 deaths a year; that between 1497 and 1508 an average of 1.1 a year.[59] To judge from these averages, there must have been between about 111 and 212 almsmen over this period, so there is record of perhaps only a third.

As well as calculating the overall numbers of almsmen from the accounts it is also possible to use their information to get an impression of the size of the community from year to year. The annual Audit Accounts list the total sum of wages paid to the almsmen over the year and the shortfall between this sum and the amount which the foundation would have paid if there had been thirteen almsmen fully resident for the whole year – £39 17s. 4d. – gives an idea of the size of the community. It also permits us to judge the speed with which replacements were appointed.

The surviving Audit Accounts, whose contents are tabulated in Appendix II, essentially fall into two groups, one covering the period 1461 to 1468 and the second, the period 1498 to 1524. From these accounts it would appear that in the 1460s, when Alice de la Pole was still alive to supervise its affairs, there was a shortage of almsmen at Ewelme. Indeed in some years – 1467 and 1468 – there must actually have been vacancies standing open for the whole year. Interestingly, this circumstance agrees precisely with the contemporary state of affairs at the de la Pole Hospital at Hull. The list of the community there – written on the back of the 1462 Charterhouse agreement – records that only seven out of the twelve men and eleven out of the twelve sisters that the foundation was meant to support were in residence.[60] This raises the question as to whether, at this date, almshouses were difficult to fill. In the case of Ewelme this is unlikely because the foundation was actually sustaining a relatively large community in the face of extraordinarily high mortality rates: fifteen almsmen, more than the total supported by the house, died in the seven-year period between 1461 and 1468.

This situation appears to have changed in some way by the turn of the century. Except for two years in 1499 and 1502, the almshouse not only had its complement of thirteen almsmen, but in 1514 and 1524 was able to fill its vacancies immediately. This change may in turn relate to what appears to be a fall in the mortality rate. With so many gaps in the accounts we must be cautious in drawing conclusions, but it is remarkable that, in contrast to the 1460s accounts, only fourteen deaths are recorded in the fifteen accounts which survive for the years from 1497 to 1524. These figures may suggest that whereas in the 1460s vacancies were immediately available for men desirous to join, because of the many deaths amongst the brethren, by the second decade of the sixteenth century men were actually waiting for a space. Without knowing the dates at which the almsmen died it is impossible to know exactly how long it took to fill vacancies but, at a rough estimate, it

would seem that in the 1460s it took an average of about 200 days to find a replacement for a dead almsman compared with about 100 days between 1497 and 1524.

As well as providing information about the size of the community, the accounts also illuminate one particularly fascinating feature of daily life in the foundation. Amongst the items listed in each Audit Account is a total of the fines deducted from the wages of the poor men over the year. In the 1460s this sum is entered under the heading 'In correction of the poor men', but in the early sixteenth century the title changes to 'From sconces and absence'.[61] Unfortunately these fines are presented as a lump sum and no indication is given for either the amounts of individual fines or the misdemeanours they were levied for. But some idea of how large fines were likely to be, and therefore an impression of the stringency with which discipline was enforced, can be gathered from a passage in the Statutes. This describes fines of a penny or tuppence for late attendance at Divine Service [XXXII]. If similar sums were levied for other offences – rebelliousness, breaking the rules and so on (the Master could fine at his own discretion [XXXIII, XXXVII, XLV et cetera]) – it would seem that fining was comparatively common, though there are significant discrepancies between the 1460s and the figures from 1498 onwards.

In the 1460s the largest sum levied in fines in one year was the 22s. recorded in 1463. On the reckoning that most fines were either a penny or tuppence this must represent something between 132 and 264 individual fines. The average of fines in this period is in fact considerably lower: 14s. 6d. a year (between 87 and 174 fines) but it even sank as low as 9s. 9d. (between 59 and 117 fines) in 1467. The later group of accounts presents a slightly different picture. Apart from a freak year in 1499 when only 17d. was levied in fines – a circumstance doubtless connected with either the leniency of the new Master or the incapacity of the old – the 1460s average carries over into John Spence's mastership. Then suddenly, in the five accounts of 1508, 1512, 1513, 1514 and 1523 the total shoots up to more than £2 before dropping back again to 18s. 9d. in 1524. It is possible that this reflects a period of particularly harsh discipline – involving in the worst year (1508) between 252 and 503 fines. More likely, however, it indicates the docking of wages for the absence of almsmen from the foundation. Almsmen were allowed to leave the foundation with permission but they did lose their wages for the period they were away [XXXVI, XXXIX]. Absences would naturally drive up the figures much higher than disciplinary fining alone; moreover the change of the title under which the sum of fines is entered in the accounts of this period suggests that men were going away.

But it should also be observed that the Master was not the only person in a position to impose fines. On St Swithin's Day, 15 July 1458, it was noted at the back of the Master's Accounts that the poor men were owed 7s. Immediately below there is an entry which reads 'And no more since this week my lady our foundress visited and punished certain persons as will be

related in a convenient place in this book.'[62] If it ever was related the narrative has sadly not survived. All that is clear is that Alice de la Pole arrived and threw her weight around. This occurrence must serve as a reminder that the foundress lived next door to the almshouse for nearly forty years after its establishment. This is the only evidence of her direct involvement in its everyday affairs but it suggests that she kept a close eye on it and ensured that it ran properly.

Of the almsmen's backgrounds very little can be said with the evidence available, but in a few cases one may guess at details. For example, Simon the labourer's name is presumably an indication of his livelihood. The small holdings owned by Thomas Wellington and Richard Wellys suggest that they were cottiers, and certainly show that they were locals. That four men – Thomas Stevyns, William Curteys, William Chamberleyn and John Newport – are documented as being employed in almshouse business is intriguing. Stevyns and Curteys were certainly almsmen when they ran these errands for the foundation and there is no reason to suppose that Chamberleyn and Newport were not also. Their almshouse duties must have been neglected while they were away and their absences demonstrate that the life of an almsman was not necessarily as eremitical as the Statutes suggest. Their employment also raises a question. Did they travel as servants, or did they have some kind of practical experience which made them useful in the work of courts and estate management? Were they literate? Indeed might two of the other men mentioned on similar errands in the Master's Accounts – Thomas Latoner[63] and John Walshman[64] – also have been almsmen?

It is further possible to say something about the individual wealth of almsmen. Indeed, since the Statutes place such an emphasis on poverty this is a point of considerable interest. There are difficulties in evaluating the worth of the almsmen's effects as they are recorded in the accounts, not least because in some cases they evidently include sold property, presumably such things as furniture and tools. But if the annual salary of £3 0s. 8d. may be considered a reasonable living wage, it is surely a sign of genuine poverty that only four men of the forty-three for whom we have valuations of effects had more than that sum to their name at their death and that thirty-one had less than a third of it. Only four men seem to have been unusually rich: the richest was Simon the Almsman who died in 1478 with £10 2s. 3½d. in money and goods; but there was also Sampson Vicars who died in 1483 with £3 13s. 2½d. ; John Rose with £4 13s. 2d. in 1500; and John Delaby with £6 13s. 5d. in 1524. Apart from Simon the Almsman's, these sums are not large and on the whole the figures would seem to prove that the almsmen were genuinely needy. One interesting figure in this respect is a certain Thomas Alwyn. He appears in the fines section of the annual Audit Account of 1504 as being expelled and sconced 43s. 4d. for having had more than six marks income a year at the time of his admission to the almshouse.[65] The fact that this man was actually brought to account for his breach of the Statutes suggests that the question of income and poverty was taken seriously.

There is little more that can be said with any certainty about the almsmen. All that these figures and names make clear is that a very large number of men must have passed through God's House and that, in the main, they were genuinely poor. The surviving evidence still leaves unanswered many fascinating questions: where they came from, what their professions were, whether they came there out of choice or under the duress of poverty, whether they were young or old, whether they sought the religious life that was planned for them or simply desired the creature comforts of an almsman's cottage.

7

Devotion

Up to now the subject of the devotional life of perpetual chantry foundations has not attracted the serious attention of many scholars. But this is certainly not for lack of information on the subject. From about 1400 onwards foundation statutes begin to describe the religious obligations of their particular communities in exhaustive detail. In the case of Ewelme, the devotional directions constitute nearly one-fifth of the Statutes, and this is by no means an unusual proportion. Such directions are a mine of information about the life of chantry foundations and the concerns which lay behind the practice of religion in fifteenth-century England.

The subject of late-medieval devotion is still something of an English scholarly neuralgia and recent assessments of its practices and value still vary hugely. At heart the debate about it remains focused on the Reformation and, perhaps unfashionably, I have deliberately striven to avoid engaging directly with this subject. But since so much English scholarship has been bewildered by, or frankly hostile to, the values of chantry devotion,[1] a case study of Ewelme is an opportunity to examine it afresh, without apology, in its own terms. The picture that emerges is quite at odds with the religious Slough of Despond which is often wished on the late Middle Ages.

Like all chantry foundations, God's House at Ewelme was established for the purpose of bringing its founders to salvation, and this point is made explicitly in the opening passage of the Statutes:

We William de la Pole, Duke of Suffolk, and Alice my wife, Duchess of Suffolk, desire health in body, grace in soul, and everlasting joy … Because all Christian people, meekly and devoutly considering how by the upholding and maintaining of Divine Service, and by the exercise of works of mercy in the state of this mortal life [shall], in the last dreadful day of Doom with the mercy of Our Lord take their part and portion of joy and bliss with them that shall be saved; [therefore all Christians] ought of reason [to] have a great and a fervent desire, and a busy charge in mind to uphold and maintain Divine Service, and to exercise, fulfil and do works of mercy before the end of their mortal life … [ll.5–27].[2]

They go on to explain that the foundation was to discharge these two duties of maintaining Divine Service and performing works of mercy on behalf of the de la Poles. The terms of these duties are subsequently made clear: God's House maintained Divine Service by supporting two priests and an attendant congregation of almsmen 'which daily shall pray after due opportunity of time for quick and dead' [ll.84–7]. And it performed works of mercy by providing food, clothing and shelter for thirteen poor men who had no other means of support.

The passage to paradise

Since the stated aim of God's House was to bring its founders to salvation, it is essential to provide an outline of the medieval theology of salvation by way of introduction to a discussion of its devotional life. This subject has of course been extensively treated both in the vernacular and scholarly literature of the period, and by modern scholars. What follows is a necessarily brief and mechanistic rendering of a very complex subject.[3]

Man was a divine creation that had gone wrong. When Adam ate the apple in the Garden of Eden he wilfully estranged himself from God and rejected the paradise that had been created as his home. In his justice, God had to resent Adam's sin until reparation had been made for it, but mankind, which owned nothing that did not come from God, had no means of making satisfaction for it. God, however, was determined to redeem his poisoned creation and overcame this difficulty by becoming a man himself and, as Christ, was sacrificed on Calvary to atone for the Fall.

The Crucifixion, however, could only atone for, and not undo, the effects of the Fall, and Adam's sin was inherited by all his progeny. This inherited flaw of Original Sin was the agency of death, so despite Christ's atonement for Adam's failing man remained a fallen creature who had to die in a spoiled world.[4] Paradise had therefore to be offered on different terms: since death was the product of the Fall, at death man paid the debt inherited from Adam's sin. This sin was atoned for by the Crucifixion; so after man's death, God could again bring him to paradise in Heaven.

This was the foundation of Christian belief in salvation as it was then understood: God had created man to live in paradise and, even when Adam frustrated that plan, God changed the rules so as to make it possible for everyone to be saved after their death. Adam had in other words turned paradise into a passage to paradise.

This relatively straightforward state of affairs was complicated by the element of individual responsibility for sin. Though man was, in a sense, conditioned to commit sin as a result of the Fall, he exercised his free will when he actually did so. Each person's sin therefore constituted a personal rejection of God's new passage to salvation, and satisfaction had to be made for this before a sinner could be brought to Heaven. Because this sin was

fundamentally the result of the Fall, the foundation for its satisfaction was already laid by the Crucifixion, but actual responsibility lay with the perpetrator. The process of individual satisfaction involved firstly the recognition of, and penitence for, sin, and secondly reparation for it.[5]

These two stages of penitence and satisfaction for sin were absolutely interdependent. Without penitence the actions of satisfaction were considered to be useless and meaningless. Indeed if a man or woman did not repent of their sins, the barrier they created to salvation, despite the Crucifixion, was insuperable – they were irrevocably damned. Furthermore, they had to repent before they died because there was no opportunity of repentance after death.

Satisfaction was a slightly different matter. Once sins had been recognized and repented, satisfaction might be made for them either in life or after death. Satisfaction after death took place in Purgatory. The agonies of Purgatory represented the most fearful form of satisfaction: satisfaction of an individual's sins exacted from them in proportion to their enormity. Once they had died and were in Purgatory, souls could do nothing to help themselves; they simply suffered for the misdeeds of their lives until satisfaction had been made.[6]

Purgatory represented one possible means of satisfaction, a passive one, but there was also a variety of active means which could be undertaken by the living. In all its forms active satisfaction had the vital quality of being transferable: it could be performed by any living person on behalf of anyone whether alive or in Purgatory. By this quality of transference chantries could make satisfaction for other people's (and particularly their founders') sins. Active satisfaction may be crudely categorized under one of two heads: practical and spiritual.[7] Practical satisfaction involved good deeds and works, on the principle that good actions cancelled bad ones. Spiritual satisfaction involved the invocation of God himself – either directly or through the intercession of saints – in the satisfaction for sins and could be secured through prayer, spiritual exercises and, most potently of all, in the Mass, itself a re-enactment of Christ's atonement on Calvary.[8]

These spiritual activities were also vitally important in facilitating man's passage to salvation in a quite different way. Because salvation ultimately depended on how a man or woman had lived, the living world was the real battleground over which God and the Devil fought for human souls. Prayer was a critical element in that struggle and could be used to influence events, thwart evil, inspire grace and prompt good deeds – amongst many other things.

Evidence of the interest in prayer for the living is ubiquitous. John Lydgate's devotional poem on the Mass written for Alice de la Pole, for example, lists the benefits of hearing it in a lengthy section of sixteen verses. Amongst other things, he asserts that the Mass fends off sickness, engenders physical well-being, invokes the protection of a litany of saints, inspires fervent devotion, instils religious feeling, brings good fortune and directs a man to grace and virtue. Rather lost amidst this panoply of benefits is the

acknowledgement of the Mass's value in helping souls in Purgatory.[9]

Prayer could, in other words, be harnessed to prevent sin, protect men from evil and inspire them to lead a Christian life. In so doing not only did men and women become less estranged from God during their earthly existence (and therefore culpable for less suffering in Purgatory), but also worthier objects of God's mercy at the Last Judgement. In this sense the pursuit of salvation was an active task which was integrally bound up with living concerns and not just a remedial treatment undertaken to make satisfaction for sins.

In the light of these beliefs about salvation, the dual activities of God's House – the celebration of Divine Service and the performance of works of mercy – become readily comprehensible. Both prayer and good works were means of satisfaction, and the former could also actively facilitate the passage to paradise for the living. By these activities God's House could promise its founders the health in body, grace in soul and prospect of everlasting joy that they call for in the opening lines of the Statutes.

But although the logic behind creating an institution charged with performing these two activities as a means to salvation is obvious on a superficial level, it is also important to understand that a number of other devotional considerations were at play too. Although the celebration of Divine Service was valued as a means of making satisfaction, it was principally considered to be important for a different reason. In whatever form it was offered, prayer was first and foremost a means of praising God. Such other benefits as it offered were derived from its central value as worship. The Statutes themselves make this point directly when they explain that the foundation is to be established for its members to pray 'principally to the worship of God, to the increase of our merits' [ll.72–3]. And by combining the celebration of Divine Service with the works of mercy, William and Alice de la Pole were undertaking this praise in a manner particularly calculated to redound to their credit.

Since it was only 'with the mercy of Our Lord' that William and Alice would see salvation [ll.18–21], their performance of works of mercy at Ewelme was intended to show their worthiness to be recipients of clemency at the Last Judgement.[10] Moreover, the poor were considered to be especially powerful supplicators in prayer, untainted by the sins of the rich and close to Christ in suffering and in their poverty.[11] By engaging the poor – and the Statutes repeatedly emphasize the importance of the genuine poverty of the community – to pray at Ewelme, the de la Poles not only ensured that their charity was meritorious (and therefore effective in making satisfaction for sin) but also that the prayers offered by the institution were especially potent.

To ensure the efficacy of the almshouse as a spiritual agency acting on their behalf, William and Alice formally rehearse the states of mind necessary for the satisfaction of their sins in the opening passage of the Statutes: they admit their sinfulness by acknowledging their need for divine mercy at the Last Judgement and underline their state of repentance by emphasizing that the

establishment of the foundation was undertaken 'in the state of their mortal lives' [ll.17–27]. Such statements are a commonplace of preambles to late-medieval wills for precisely the same reason.

The form of the foundation as an almshouse might itself be represented as a statement of another attribute vital for its efficacy in securing the founders' salvation. As John Lydgate described in his poem on the Mass, the state of charity was essential in prayer:

Without Charyte availeth noone almesse,
To clothe nakyd or hongry folk to fede,
Vysyte the seke or prysoner in theyre nede …
Your Pater-Noster, your Ave, nor your Crede,
Where Charitye fayleth, profyteth lytyll or nought.[12]

The prayers at Ewelme, as an almshouse, were to be offered in an institutionalized statement of William and Alice de la Pole's charity.

But because the foundation offered praise to God in a manner peculiarly suited to help the de la Poles, it is important that these devotions are not misunderstood as being necessarily selfish or private. Divine Service was of inherent value to everyone who took part in it. By creating an institution attached to a parish church charged with offering potent Divine Service in perpetuity, the de la Poles were making a valuable and tangible gift to the village, to its community and their own successors. That they made certain of its value to themselves in no sense diminished the public worth of the foundation.

The daily timetable of devotion

As described in the Statutes, Divine Service at Ewelme was to be celebrated by the two priests with an attendant congregation of almsmen, whose prayers were to give the foundation's devotions an added spiritual ballast. To perform their devotional obligations the almsmen required a knowledge of just three prayers: the *Pater Noster*, the *Ave*[13] and Creed – the common man's devotional bread and butter.[14] These prayers were used in two ways at Ewelme – either as devotions in themselves or else as supplementary devotions, to be recited when something occurred that the almsmen would not necessarily understand, but which the founders desired they be actively involved in.[15]

The daily routine of prayer and Divine Service at the almshouses was structured around the Canonical Hours or Divine Office – Matins, Lauds, Prime, Terce, Sext, Nones, Vespers (or Evensong) and Compline. Such was the central importance of Divine Office to the medieval church that the Statutes do not bother to say much on the subject. It may be inferred from references and directions, however, that they were to be recited before the almsmen every single day in their entirety and at the correct hours [XVII, XVIII, XIX,

xxiv and xxxii]. The exact timing of the Offices was left to the Master's discretion, with the proviso that, though they might be moved for convenience, they should normally be held at the 'customable' moments long established for these offices by the Church [xviii].[16]

In the Statutes the duties of the priests, poor men and Minister are all outlined separately, but in what follows the various directions have been integrated to form a single chronological description of what is described as a 'ferial and work day' [l.474].

* * *

The daily round of prayer began when the brethren first rose in the morning. It is explained that, because God wanted man to desire above all else 'to be so demeanoured in his living' that he might be saved, when they got up the almsmen were to kneel at their beds and, before they did anything else, say three Our Fathers, three Hail Marys and a Creed, 'desiring inwardly in their souls' that the demeanour of the King, William and Alice and all other Christian people should bring them to see the Kingdom of Heaven. Meanwhile the priests were to recite the *Deus Misereatur* with the same intent [xvi]. This psalm is most fitting in this morning context: God is called to have mercy on the world and bless it so that it may in return praise his name and acknowledge his justice, generosity and righteousness.

Soon after 6 o'clock the common bell rang to warn the almsmen to prepare themselves for Matins [xvii]. They were to clothe themselves in their habits – a tabard and hood worn over their gowns, each item with a red cross sewn on to it [xxxvii and xxxviii] – and then proceed to the church by the second tolling of the bell, when the Master began his Office. Matins was followed by Lauds and Prime and then, shortly before nine, by Terce [xvii].

At 9 o'clock the bell was to be rung again and the Master began his Mass in the almshouse Chapel of St John the Baptist, on the north side of the chancel of the parish church [xviii]. If the Master was absent, his place was to be taken by the Teacher of Grammar [iii]. During the Mass the celebrating priest was to pray for the good estates of the King, Alice and William during their lives, and to include special collects for their souls, and for the living and the dead – provided that they were appropriate according to the Sarum Ordinal [xxv]. After Mass was said, the Master and the poor men were to gather round the tomb of Thomas and Maud Chaucer where the *Deus Misereatur* (Psalm 67; see above) was to be said, followed by the collect *Deus qui caritatis*:

God that by the grace of the Holy Ghost doth infuse gifts of charity into the hearts of thy faithful servants, give health of body and soul to thy servant men and women, brethren and sisters, for which we pray thy meekness, that they love thee with all virtue and with all love fulfil those things that be pleasing to thee, by Christ Our Lord. Amen[17]

This was to be accompanied with the suffrages – intercessory prayers – for the living. Those who could not recite these prayers were to say three Our Fathers, three Hail Marys and a Creed. Then the following prayer was to be

clearly recited in English:

God save in body and soul our sovereign lord the King, my lord William Duke of Suffolk, my lady Alice Duchess of Suffolk his wife, our founders, my lord John their son and all Christian people

to which the brethren would reply 'Amen' [xxiii]. After the death of the de la Poles the same prayer was to 'be said for them that shall succeed unto us as founders [i.e. the subsequent lords of the manor as described in Statute lxviii] of the foresaid house for [the] time of their mortal life and for all Christian people' [xxiii].

It was probably around twelve o'clock that the office of Sext was recited, and then about two hours later, Nones. The sounding of the common bell at 2 o'clock called the almsmen back to the church where the Minister said such prayers as the Master had dictated. They were to be offered for the good estate and welfare of the spiritual and temporal parts of the Church, and for the de la Poles and their successors. The Minister probably recited these aloud before the other almsmen. Afterwards all the brethren were to kneel and say fifteen Our Fathers, fifteen Hail Marys and three Creeds in praise of the Passion of Our Lord and the Joyful Mysteries of Our Lady. These prayers were to be offered for the 'spiritual relief and succour' of the de la Poles and their successors [xxix].

At 3 o'clock, 'after meat', two peals were to be rung on the almshouse bell, after which the Master was to proceed with Evensong. He was to continue in the church until Compline was said, except during Lent, when the rule of the Church stipulated that evensong be said before Nones [xviii].

At six o'clock in the summer or after Evensong in the winter the almsmen were again to gather in the church and repeat a service similar to that held by the Minister at 2 o'clock, with the difference that the appointed prayers were to be intentioned for the de la Poles' souls, those of their progenitors, successors and all Christians after their decease. Then the kneeling brethren were also to say fifteen *Aves* for the repose and rest of all souls [xxx].

After Compline the almsmen were again to gather around the tomb of Thomas and Maud Chaucer. On this occasion they were to recite the *De Profundis* along with its common suffrages or, if they could not say it, three *Pater Nosters*, three *Aves* and a Creed. The *De Profundis* is most apposite for this moment in the evening: the psalmist calls 'from the depths' for God to hear him. No one, he explains, should survive the Judgement of the Lord if he did not forgive their sins. But since he has promised to do so, the soul shall trust in the Lord for that forgiveness as the watchman for the coming of day.

After the recitation of the *De Profundis* someone was to say aloud in English:

'God have mercy on the soul of the noble prince Harry the sext, and on the souls of my lord William, some time Duke of Suffolk, and my lady Alice Duchess of Suffolk his wife, our first founders, and on their fathers' and mothers' souls and all Christian souls.' And it shall be answered openly Amen.

All those that succeeded Alice and William as founders – that is the later lords of the manor – were also to 'be rehearsed by name in the foresaid beads' after their deaths [xxiv].

In addition to observing this formal timetable of prayer, the poor men were also expected to go to the church at a convenient time and recite the Our Lady Psalter containing 150 *Aves*, fifteen *Pater Nosters* and three Creeds three times. These additional prayers were to be offered for the good estates of the King, for his soul after he died, and for William and Alice and all the living, William and Alice's parents, and all Christian souls. Alternatively – presumably if they were literate – the poor men might say the Our Lady's Matins with the Seven Psalms and Litany, or say Placebo and Dirge with Commendations, or several Nocturnes of the Psalter, or undertake reading approved by the Master [xxii].

It is apparent that this timetable drew an analogy between the cycle of each day and the cycle of life. In the morning, as the community prepared for the day's activity, prayers were directed towards the living and their needs – that they should act well and live in good estate – and in the evening, as everyone prepared for sleep, for the dead and their needs. The psalmist's final plea in the *De Profundis*, recited at the end of the last ceremony of the day – that his soul shall trust in the Lord as the watchman on daybreak – was being literally enacted: the almsmen went to bed in anticipation of the next daily cycle of prayers while the souls of their beneficiaries waited for God's mercy.

There were apparently very few variations to this timetable. On special feast days the Master had to say Matins and Evensong in the chancel of the church with the parson, and he was to be joined by the Teacher of Grammar, who otherwise seems normally to have been exempt from regular attendance at the Offices [xix and xx]. The Teacher of Grammar was also to attend the prayers around the tomb on such days [xxiii].

Each year the almshouse also had to celebrate the anniversaries of William and Alice [xxvi], and of Thomas and Maud Chaucer [xxvii] with Placebo and Dirge, Commendations and with a Requiem Mass, at which all the almsmen had to be present. Placebo and Dirge constituted the Office of the Dead and comprised Vespers (which began with the word Placebo) together with Matins and Lauds recited as one office and called Dirge. Commendations referred to the Psalms of Commendation – Psalms 119 and 139 – that were usually recited with them. Placebo, Dirge and Commendations were also to be recited at Ewelme as often as the Sarum Missal directed [xxviii].

The devotional observances of God's House at Ewelme have many points of close similarity with those described in the statutes of other contemporary religious institutions including colleges, chantry chapels and, of course, almshouses. That there should be similarities is not surprising considering the common purpose of these different forms of chantry foundation. But the degree of their consistency is nevertheless striking and has never been analysed in any detail.

As their statutes describe them, no two almshouses observed identical devotions. But all almshouse statutes, including those of Ewelme, made

similar devotional demands on their brethren. One universal requirement was the daily celebration of the Mass, which in almshouses was attended by the entire community.[18] Some institutions, such as Westminster [151] and Wynard's [405–6], demanded the almsmen's attendance at more than one Mass, but this seems to have been comparatively unusual. In many cases the respective statutes minutely detail the collects to be inserted into the Mass.[19] As at Ewelme [xxv], these invariably included mention of the founders, their kin, their associates and the souls of all the dead.

Other aspects of the timetable at Ewelme were widely, but not universally, paralleled. It was nearly always required for example that – as at Ewelme – the almsmen hear all the Offices every day.[20] There are, however, a few examples of almshouses where attendance at all the Offices was not demanded. At Tattershall the almsmen apparently only had to attend Matins and Vespers every day [181] and at Heytesbury and Ludlow no attendance at the Offices seems to have been required by the almsmen at all. In these latter two places, instead, the foundation priests had to say certain Offices on Sundays and holidays while they were being publicly recited in the parish church – a practice which is also described at Ewelme.[21] The almsmen at Eton simply had to say prayers in the church, cemetery or cloister while certain of the Offices were celebrated, but there is no evidence that they had to attend them [lvi].

Three other elements of the daily timetable of prayer at Ewelme are commonly found described in almshouse statutes of this period. Firstly, there were prayers that were to be said by almsmen on their knees when they first got out of bed.[22] Secondly, there was the private recitation of the Psalter of Our Lady by the poor men [ll.569–71].[23] The third feature of the timetable that Ewelme shares with other almshouse foundations is a ceremony in which the almsmen gathered together, recited the *De Profundis* with its common suffrages (or, if they were unable, three *Pater Nosters*, three *Aves* and a Creed) and then responded to a prayer in English spoken by a senior member of the community, invoking God's mercy on the souls of the founders. Almost identical ceremonies are encountered in all almshouse statutes, bar those of Eton, where the choristers performed an analogous ceremony.[24] When the founder's tomb stood in the church, as at Westminster, it was always specifically directed that this ceremony should happen around it.

Ewelme was exceptional in having a second version of this ceremony performed in the morning on behalf of the living, but the evening ceremony accords in all respects with the normal form described elsewhere. In most almshouses the ceremony concerned the dead alone and was performed just once a day,[25] and usually – as is appropriate for such petitions – in the evening after Compline as the last service of the day.[26] Analogous ceremonies are also described in the statutes of different kinds of chantry foundation, such as chapels and colleges, where they were performed with greater or lesser degrees of elaboration. The common features of all were the recitation of the *De Profundis* with its suffrages and a public prayer, which was to be clearly

understood by those present. In some instances this was included as part of the chantry priest's daily Mass.[27] Perhaps the most remarkable examples are to be found at Fotheringhay and Eton, where there were several solemn services of this kind each day performed by the college community as a whole.[28]

Morning prayers, Offices, recitations of the Psalter of Our Lady (or certain recognized alternative devotions) and ceremonies around founders' tombs are common features in the daily devotional observances of contemporary almshouses. One occasional devotional obligation found at Ewelme that is also almost universally stipulated in other statutes is the celebration of founders' anniversaries, in this case those of the Chaucers and of William and Alice on the days of their deaths [xxvi and xxviii].

Anniversaries were a common feature of fifteenth-century devotions for the dead. They involved re-enactments of the funeral exequies of the deceased and were celebrated each year on a particular feast or on the day of their death. At their simplest they comprised Placebo – the Vespers celebrated on the evening before the 'funeral'; and Dirge with Commendations – Matins, Lauds and the Commendatory Psalms – performed the next morning; and, later in the day, a Requiem Mass. But often such ceremonies were much more elaborate. A draped hearse stood in place of the coffin and many of the trappings of a funeral, such as candles burning at the head and foot of this, were introduced. Anniversaries were also often accompanied by distributions of bread and bell-ringing – acts of charity and publicity (prompting prayers) meant to benefit the soul of the deceased.[29] The Statutes at Ewelme do not mention any of these elaborations but simply the Requiem Mass and Placebo and Dirge with Commendations. Whether the service was actually intended to be more elaborate it is impossible to know, but the surviving accounts do not record the expenses one might expect if they were. Other college and almshouse foundations certainly did make more demands.[30]

The similarities between the observances of different almshouses show that Ewelme's devotions followed a recognizable pattern. This is in itself an important fact: William and Alice de la Pole did not aim to create a chantry foundation that functioned in a unique way; quite the reverse. But this is not to say that Ewelme was indistinguishable in its devotions from other foundations. It is possible to demonstrate that the de la Poles went to considerable lengths to tailor the activities of God's House to answer their particular devotional needs. This tailoring included the addition of observances not encountered in other foundations. In order to identify these interpolated details it is necessary to consider the textual complexities of the Statutes.

As is explained in the Introduction to Appendix I of this book, the Ewelme Statutes were modelled around a formula text which is also reproduced in the Croydon and Whittington statutes. In both these latter cases the description of the timetable of devotion adheres closely to a recognizable structure in which identically phrased statutes are presented in the same order: the

almsmen must hear the Offices; they must pray at their uprising; they must say Psalters of Our Lady; and they must pray round the tombs of their founders. Both the Croydon and Whittington statutes then immediately go on to talk about meal times and the clothing of the almsmen, the next elements in this formula's overall structure.

The very close similarities between the sections of text dealing with the devotional timetable in the Whittington and Croydon statutes suggests that the model formula followed by both had simply been transcribed in each case. The Ewelme document seems also to have followed this formula closely: these same subjects are described using identical phrases and, with the exception of the first two elements (which have been reversed), appear listed in the same order in the overall structure of the document: the almsmen must pray at their uprising; the almsmen must hear the Offices; they must say the Psalters of Our Lady; they must pray round the tombs; and, some lines later, they must wear a habit (there was no communal eating at Ewelme, so the regulation about meal times has been removed).

But, as has been mentioned, although the Ewelme Statutes clearly follow the formula, they also elaborate on it. The extent to which they do so is apparent if the passages in the Ewelme Statutes which also appear in the Whittington and Croydon statutes – that is, the elements derived from the model formula text – are removed. Presumably the residue comprises regulations and details which William and Alice de la Pole were personally responsible for inserting. Given the nature of the evidence it is impossible to be absolutely certain about the exact distinctions between the formula's text and the Suffolks' additions to it. But on the basis of this contrast the following parts of the Ewelme text did not appear in the model formula it followed: Statute xvi [ll.432–46 and ll.459–67] and Statutes xvii, xviii, xx, xxi, xxiii, xxv–xxx.

This very substantial body of inserted text falls into three categories. The first, and largest, category includes elements which describe details of life that are found in other almshouse statutes but not at Ellis Davy's at Croydon or Whittington's Hospital. Such directions include summoning the almsmen by the tolling of the bell to the morning Offices [xvii],[31] and also the obligations of the priests to celebrate Mass every day [xviii][32] and to recite certain Offices publicly on holy days [xix and xx] (see above). These two latter details, as well as the regulation that the priests recite the *Deus Misereatur* when they rose from their beds, may in fact belong to the formula, but would have been redundant at Croydon and Whittington's, where there were no priests in the almshouse community.

The second category includes two observances which do not find exact contemporary parallels in other surviving almshouse statutes, but which probably reflect known practices. The first is the morning ceremony of prayer around the tombs when the priests and community were to recite the *Deus Misereatur* and pray for the living patrons of the foundation, and for all the living [xxiii]. This ceremony is clearly modelled on the ubiquitous practice of

gathering the almsmen round the tomb and reciting the *De Profundis* for the dead. The closest comparable observance that I am aware of is described at Westminster where the almsmen also gathered round the tomb twice every day. On the first occasion this was during the High Mass, the third chantry Mass of the morning. When it had finished one man was to say, 'Sires, ye shall ... pray for the good and prosperous estate of the king our Sovereign Lord King Henry VII, founder ... of us thirteen poor men in his almshouse within this monastery and of other observances and diverse works of alms and charity.' Afterwards the *De Profundis* was recited.

Then in the evening after the final service in the chapel the Westminster almsmen were again to gather round the tomb and offer a prayer aloud in English: 'God save the king our sovereign and have mercy on the soul of his most excellent princess, Elizabeth, the late Queen of England, his wife and the souls of his children and of their issue, and of their progenitors, and ancestors of the same king our said sovereign lord and all Christian souls' [151–2]. Again this prayer was followed by the *De Profundis*.

There are clear distinctions between the directions for the Westminster and Ewelme ceremonies – notably that at Westminster there is no indication that the prayers are to be modified for the benefit of the King's successors after his death, and the *De Profundis*, not the *Deus Misereatur*, is to be employed. They do, however, show an identical concern to engage the spiritual life of the almshouse explicitly with the living and their interests.

Because of the intrinsic value of prayer it is common to find chantries offering it for living founders – as at Westminster. It is much rarer, however, to discover instances where, as at Ewelme, the prayers of chantries were to include the good estate of subsequent living generations of a family. The only other explicit example of this practice is to be found in the devotions of the choristers at Eton. The sixteen boys were to process into the church every evening wearing their surplices and, after saying prayers and singing an antiphon to the Virgin, were to pray for the good estate of the living King and other benefactors of the college. This, it is explained, was intended to make subsequent kings of England see that they were supported by the prayers of the college and to encourage them, therefore, to be good patrons of it [xxx]. On occasion there is also evidence that chantry priests had to time their Mass and devotions for the convenience of the founder's successors, in other words to act as both chaplains and chantry priests.[33]

The third and final category of additions at Ewelme to the model text of the statutes are details that were of William and Alice's own conception. Any identification of these is necessarily tentative but I would suggest that the prayers which were to be recited by almsmen under the guidance of the Minister at 2 and 6 o'clock each day [xxix and xxx] were probably such. There is no documented parallel for these practices. Moreover, the dedication of the prayers to the Joyful Mysteries of the Virgin and the Passion closely echoes elements which will be discussed in the iconography of the almsmen's Chapel of St John the Baptist. These facts, together with the extreme awkwardness

with which the regulations outlining them have been fitted into the structure of the text – literally appended to the timetable – would suggest that they were unique to Ewelme.

But perhaps more important, and certainly more striking, than any individual observances inserted by the de la Poles are a number of the interpolations into the text of the Statutes which direct how the devotion of the almshouse community is to be framed. This subject will be more fully discussed below, but there is one illustration of this kind of addition in the regulations outlining the daily timetable of prayer which deserves notice in the present context. It concerns the prayers said by the almsmen when they got up [xvi]. As already mentioned, prayers of this kind are commonly detailed in statutes of this period, and indeed are a feature of the formula employed in the Ewelme text. The Ewelme regulation is exceptional, however, in that it is introduced with a short preamble emphasizing that the prayers are to be directed for the good demeanour of the King, the founders and all Christians and explaining why.

From such details it would appear that while the instructions for the daily timetable of prayer at Ewelme echo those described in other almshouses, William and Alice de la Pole carefully tailored them. Not only did they insert extra observances, but they also prescribed the particular emphasis of the devotions to be offered. The result was a timetable which exceeded that described in all other surviving almshouse statutes both in its fullness of detail and in its devotional intensity.

The quality of life in God's House

This timetable of prayer was only one aspect of the Christian life that the founders intended to be led within the almshouse. Indeed, in one sense it was a subject of secondary importance. The real problem for William and Alice was to establish an appropriately Christian quality of life which would imbue the prayers and ceremonies which the almsmen and priests undertook with meaning and potency. Without this the celebration of Divine Service would be mere form.

The Ewelme Statutes reflect a particular concern with this problem and, while rehearsing the standard directions by which the almshouse was to govern itself, incorporate observations that not only cast light on the founders' conception of this particular institution, but also give an impression of why other almshouses were organized and ran as they did. In a passage unique to Ewelme it is desired that every member of the foundation 'be funded in good and steadfast living in himself, and endued with godly and spiritual occupation of very true, trusty and devout daily prayer, in the which we have great trust and hope to our great relief and increase of our merit and joy finally' [xvi]. This quality of prayer, on which the de la Poles placed such emphasis, was to be ensured in two practical ways: by the enforcement of a

set of statutes enshrining a rule for a Christian life, and by constructing an enclosed and artificial world within the almshouse in which Christian values and piety could be fostered.

In relation to the first of these aims the Statutes explain:

> Diverse places of alms have been founded out of great piety and devotion, to be ruled by many right and reasonable rules and statutes which tend to the increase of virtue in the inhabitants of the same and to exclude vices from the same. Yet for failure to execute the same statutes and rules ... such said houses have been, by misliving and negligence, brought to great heaviness, and at the last to great desolation [LXXXI].

This passage, again particular to Ewelme, shows that the Statutes were more than just a set of regulations: they were a rule of life with a spiritual purpose. And so it was intended that the Statutes be regularly read and thoroughly understood. In a passage, this time lifted from the formula text, it is instructed that the Ewelme Statutes be 'distinctly read' and 'understandingly expounded' before the poor men every three months, and that every month a 'few rules be taken out of this whole ordinance' and read to them. Also that the priests and brethren have 'a true copy of this present ordinance and of the said rules ... to be read amongst them as often as they will, that the contents and the chapters of the same may the more inwardly be commended to their minds' [LXXXVII].[34] The Rule of St Benedict was, of course, treated in a similar way in monastic houses, and it is worth noting that the reading of household statutes also occurred in secular houses.[35]

As well as exhorting the community to a Christian way of life, the Statutes were designed as a readily enforceable set of regulations: a yardstick by which the quality of life could be measured and against which it could be corrected. It was to this end that the admission oath, a universal undertaking demanded in the period of new entrants both to religious foundations and secular households alike, was instituted:

> Also we will and ordain that every Master, Teacher of Grammar, Minister and poor man of the said house of alms, on his first being received to the said house, be sworn before the said poor men in their common hall that he shall truly keep and observe these present statutes and rules pertaining to him after our present ordinance to his cunning and power so that he shall not be contemptuous of them, nor despise them after knowledge be had of them [LXXXV].

A copy of what is probably the fifteenth-century text of this oath is written into the book copy of the Statutes and is transcribed on p.223. By taking this oath an almsman bound himself to pursue the Christian life which the Statutes enshrined, and to be punished for infringements of it. He also had to swear that he would not try to mitigate his punishments when they were decreed [LXXXV].[36]

Through the efficient enforcement of statutes meant to encourage virtue and exclude vice William and Alice de la Pole were trying to create an artificial environment which was beneficial to the almsmen and their devotion. This notion of God's House as an artificial – and correspondingly

fragile – haven from the evil of the outside world is alluded to several times in the Statutes, and it is apparent that there was a desire to make the life as inward-looking and enclosed as possible. Injunctions against intercourse with the outside world are a feature of other contemporary statutes, but the restrictions they rehearse are usually concerned with preventing vagrancy or inappropriate behaviour. The Ewelme Statutes go much further than this, setting out a substantial list of restrictions under a section of the Statutes which claims to offer the means by which 'the inhabitants and dwellers of the said almshouse (by us founded) [may] flee and avoid evil, slander, dishonesty, and the occasions thereof' [XLVIII].

In this section, alongside a series of directions instructing the almsmen not to roam about the parish [XXXIV], to gossip with outsiders [XLII] or to frequent taverns [XLI], which are common to several sets of statutes, there are a number of regulations particular to Ewelme which are clearly designed to restrict the almsmen's contact with the outside world. They were not to leave the almshouse for above an hour at a stretch [XXXV]; there were financial disincentives for going away even with good cause, including on pilgrimage or to visit friends [XXXVI];[37] and they were not to take service, especially from a lord or lady of Ewelme or their servants [XLIII].[38] Any man who left the almshouse for more than a quarter of a year without license of the then patron and Master was to 'lose the privilege, liberties and exhibition of the said almshouse for ever more' [XXXIX].[39] Within the almshouse itself, the poor men were to have separate chambers where they could 'attend to contemplation and prayer' [X] and were to live in a peaceable atmosphere involved in devotion or honest labour [XL]. This description of the living quarters is itself drawn verbatim from the statutes' formula,[40] but at Ewelme the ideas of enclosure were underscored by the claustral design of the buildings.

To help guarantee the seclusion of the almsmen, responsibility for all the almshouse's external concerns was vested in the Master [ll.92–104]. Like the almsmen, he was explicitly forbidden to undertake other local commitments – he was to have no agreements with the parish priest of Ewelme involving him in the performance of parish duties [LXXII] and there is an allusion to the dangers of lords or ladies from the Manor interfering with his devotional responsibilities [XIX].

At Ewelme, the world was not to be excluded merely in order to create a conducive environment for prayer. It appears from the Statutes that exposure to the world was thought actually to contaminate spiritual life. In the regulation which explains that the almsmen will not receive wages while on leave – even if they have good reason to be away – absence is represented as undesirable not simply because the timetable of prayer could not be observed, nor just because the vacant seats brought dishonour on the almshouse, but also because '[an almsman's] devotion … would be lessened by outward acquaintance and worldly occupation' [XXXVI].

Discipline

As has been seen, responsibility for day-to-day discipline lay with the Master and Minister, the latter bringing the faults of the poor men to the attention of the former, who dispensed punishment through the docking of wages [IV].[41] But if this system began to break down, the very isolation and self-dependence of the almshouse might make it collapse entirely. For more serious offences, therefore, a different disciplinary mechanism came into action which, in its culmination, drew in outsiders who had both the power and, it was hoped, the vested interest – by way of the prayers offered for them – to reform the almshouse and enforce its Statutes. This disciplinary system is found with small variations of detail in statutes of every type of religious institution in the period.

Incorrigible almsmen were to be publicly admonished on three occasions, in a system of warnings which would seem to be based on Christ's words in Matthew XVIII:15-17 [LXII]. This method of reproof was widely advocated and is described as a means of correcting neighbours in sermons, as well as in almshouse and collegiate statutes.[42] If the poor man persisted in his behaviour he was to be expelled. At Ewelme such expulsions were to take place at so-called visitations, regularly held external enquiries into the life of the almshouse [LXXXIV]. It is specified that the current owners of the lordship of the manor of Ewelme, described in the Statutes variously as 'provisours' ('guardians') or 'founders', were to attend these and that they might be held every year if necessary [LXXXI].[43]

On such occasions, it was instructed that the:

> Master, and Teacher of Grammar and poor men be obedient to appear before him [the visitor] in their common hall; and to his inquisition and diligent examination of the manners and conditions of every person pertaining to the said house they shall truly answer and witness the truth; and in all other matters pertaining to the said house of the which they shall be examined after their cunning and power' [LXXXII].

The behaviour of the Master and Teacher of Grammar also came under scrutiny on these occasions. Like the almsmen they could be expelled from the almshouse for persisting in a fault after three corrections in visitation [LXIII].

To prevent men who were a threat to the almshouse using exterior force to get themselves re-admitted after being expelled, the Statutes prescribe that whenever a new member of the community was received at a swearing-in ceremony in the common hall, he was to state in his oath that he would never try to re-enter the almshouse if he were expelled, or attempt to plot against it [LXXXV]. This injunction is a universal feature of statutes and, where the texts of oaths survive, is always included.

In the end this system of discipline depended on the probity of the 'provisours'; and it is to them that Alice and William finally address themselves. Their message is apparently personalized but belongs to the formula of the statutes:

Therefore [to] all of them to whom of our present ordinance after our decease it shall pertain to the said house to provide any Master, Teacher of Grammar, Minister or poor man in any time to come, we pray and beseech them most meekly and devoutly, and with all reverence as we may, we charge before God, as they will answer at the dreadful Day of Doom all affection and inordinate love, all corruption of prayer, and temporal reward ceasing, and put away no priest but chaste and discreet, no Minister but apt and disposed to his office aforesaid, no feigned poor man but verily poor and devout [Lxxx].[44]

God's House at Ewelme was a religious foundation whose purpose was to help its founders through their lives, Purgatory and the Last Judgement to salvation. Its functions – the celebration of Divine Service and the performance of works of mercy – which were offered for the worship of God, were intended materially to affect every stage of that journey, maintaining the couple in good temporal and spiritual estate, making satisfaction for their sins and exemplifying the mercy that they needed at the Last Judgement.

In order that it might fulfil these purposes effectively, William and Alice also sought to establish through the Statutes an enclosed and disciplined atmosphere in which the almsmen were to live. This rule of government ensured that the foundation's activities were of value: that the alms were offered to genuine paupers and that its devotions were observed by a pious community. By doing this the de la Poles ensured not only that their own interests, but also the interests of the living community who generation after generation discharged these duties, were served. Significantly it is this theme of mutual benefit that the concluding appeal of the Ewelme Statutes emphasizes:

Finally to speak in this matter, we pray and heartily beseech [the] Master, Teacher of Grammar, Minister and poor men now present in the same house, and all afterwards to come, that they have and keep amongst themselves continual charity, serving, praising (and truly to) God, and for the persons and souls foresaid, after this present ordinance. So [by] living poorly and meekly, especially in spirit, in their conversation in the said house, that after the state of this mortal life they may come and inhabit the house of the Kingdom of Heaven, the which with our Lord's mouth is promised to all them the which be poor in spirit. So be it [xxxviii].[45]

It was only by getting the almsmen of God's House to Heaven that the de la Poles could ever hope to follow.

The Chapel of St John the Baptist

The almsmen's chapel in St Mary's Church at Ewelme, dedicated to St John the Baptist, was the heart of the foundation, where the priests and poor men gathered each day for the celebration of Divine Service around the tombs of Alice and her parents. Cut off from the nave and chancel by screens, it was a clearly defined and sumptuously decorated private chapel. Few churches can rival the extraordinary collection of fifteenth-century furnishings and decoration that this chapel still preserves. They are of the highest quality and are remarkable surviving examples of fifteenth-century art at its most sophisticated. But this chapel is also of special interest as the self-consciously conceived theatre for the community's praise of God and, as much as the Statutes, this chapel can tell us a great deal about the devotion of the de la Poles.

St John's Chapel is rectangular in plan, with its altar set beneath the east window on a dais of two steps (see Pl.v). Its reredos probably stood in a recess beneath the window – now concealed behind a modern altar – and was flanked on either side by large statues set in the canopied niches in the wall. Covering the whole chapel is a magnificent roof divided into greater and lesser panels by moulded beams decorated with the busts of angels (see Fig.66). Two types are represented: around the side of the roof are angels with coronets bearing shields and in the centre are angels emerging from balls of flame wearing high crowns and bearing scrolls. Applied to the beams at regular points are wooden shields carved with the Sacred Monogram, IHS: the first three letters of the name Jesus in Greek. The figures, scrolls and panels were presumably painted, but no record or trace of colour survives.

A regular diaper pattern of IHS monograms in two sizes is painted in red and black across the white walls of the chapel. Around the cornice, and separated from this diaper by a stylized border of twisted foliage, is a series of quotations from the Vulgate painted in black, with abbreviated biblical references in red. From the west end of the north wall they read:

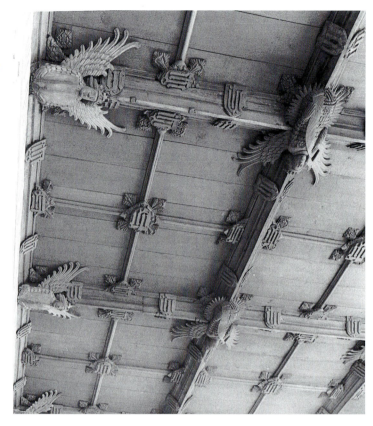

66 The angel roof of St John the Baptist's Chapel, Ewelme, c.1438. Two kinds of angel are represented and the whole was probably painted (see Fig.72).

ET DONAVIT ILLI NOMEN QUOD EST SUPRA OMNE NOMEN, UT IN NOMINE IESU OMNE GENU FLECATUR COELESTIUM TERRESTRIUM ET INFERNORUM. PHILIPANS IJ. EGO AUTEM IN DOMINO GAUDEBO ET EXULTABO IN DEO IESU MEO. ABOUCUC III. ENIM NON EST ALIUD NOMEN SUB COELUM DATUM HOMINIBUS IN QUO OPORTEAT NOS SALVOS FIERI. ACT IIIJ. OMNIS QUI INVOCAVERIT NOMEN DOMINI SALVUS ERIT. JOHEL IJ.

The Douay translation of these passages is as follows:

'and hath given him a name which is above all names. That in the name of Jesus every knee should bow, of those that are in heaven, on earth and under earth.' Philippians II. 'But I will rejoice in the Lord: I will joy in God my Jesus.' Habakkuk III. 'For there is no other name under heaven given to men whereby we may be saved.' Acts IV.[1] '... everyone that shall call upon the name of the Lord shall be saved.' Joel II.

The chapel has been heavily restored in the last 150 years. In 1843 the walls were entirely repainted,[2] and in 1938 the roof was dismantled and six figures of angels from it were replaced.[3] But judging from earlier depictions of the interior, this work was remarkably faithful to the medieval designs (see Fig.67).[4] Two important fifteenth-century features of the interior have, however, disappeared: there was an elaborate encaustic tile floor decorated with Chaucer roets (wheels) and Burghersh lions (see Fig.68)[5] and the windows were filled with stained glass. This included a heraldic programme,

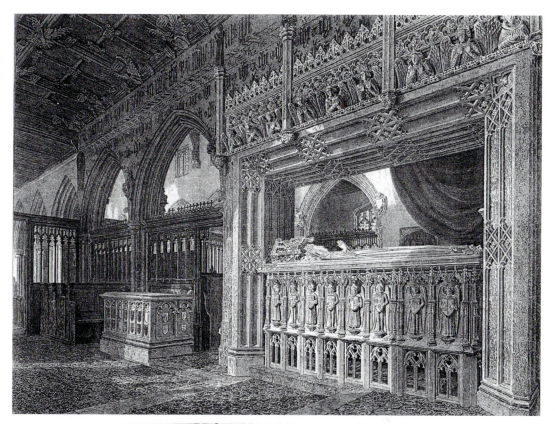

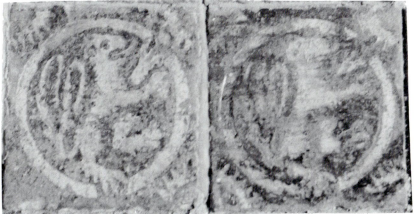

67 View of St John the Baptist's Chapel, Ewelme, published by Skelton in 1825. Notice the heraldic tile floor and, in the north aisle window (visible through the tomb canopy), the arrangement of glass roundels.

68 Relaid tiles depicting the Burghersh lion from St John the Baptist's Chapel, Ewelme. Some tiles with Chaucer roets also survive.

thoroughly recorded in antiquarian sources, but also a religious one, of which only one element can be securely reconstructed. A Buckler drawing of 1821 shows three figures of cherubim in the upper lights of the east window, and fragments of these still survive (see Fig.29, above).[6] It is also possible that a panel of an IHS monogram, cut in the shape of an upper light from one of the first-campaign windows, also stood in the chapel, repeating, like the cherubim in the east window, the two principal features of its surviving iconography.

This fifteenth-century decorative scheme can be closely dated. Given its iconographical coherence, and the fact that the roof is integral with the structure of the building, it must have been executed when the chapel was first erected. Since the Chaucer tomb was moved into its present position and inlaid with a new set of enamelled shields in 1438, this display was probably completed by then.[7]

Given its dating, the celebration of the Name of Christ in the decoration of the chapel is remarkable. Devotion to the Name of Jesus had first taken liturgical form in the mid-fourteenth century, when a votive Mass to the Holy Name was established. It grew in popularity over the next century, but it was only by the 1480s and 1490s that it was becoming widely established as a feast with an Octave and Office of its own.[8] Ewelme's iconography predates this general acceptance of the feast by at least forty years, and this raises questions about how the devotional theme of the chapel came to be chosen.

The nature of medieval iconographies as starting points for a potentially limitless series of associations makes a formalized analysis of them a complex business. This chapel presents a particularly difficult study because the Name of God is an ubiquitous biblical subject, encountered in numberless contexts. In what follows, the potential fecundity of association inherent in the chapel's display is taken for granted, and only its central themes are explored. A useful starting point for an analysis of the iconography is the liturgy of the Feast of the Holy Name. Though it was a later creation than the chapel itself, the central themes of the liturgy of the Feast and Octave of the Holy Name must stem from ideas that were current previously and that underwrote this precocious 1430s decorative scheme.[9]

In tone, the liturgy of the feast is resoundingly triumphant. It celebrates the glories of Jesus, his power and heavenly majesty, and emphasizes the salvation of mankind through his incarnation. One of its recurrent themes, of interest in the context of this chapel, is the pronouncement of the name of Jesus. This is treated in a variety of ways – as an invocation of God, as an object of rejoicing and praise, as a word of power, as a means of healing and as a means to salvation.[10] The triumphal tone of the feast is reflected in the decoration of the chapel itself, with its angels emerging from balls of fire. This is a representation of a heavenly choir, whose songs of praise have crystallized around them in the surrounding texts and IHS monograms.[11] In the context of a chantry these figures might be understood to represent the saved, who were believed to be raised to the status of angels in heaven.[12] The chapel is in fact a glorious celestial vision whose sights and sounds have been rendered in paint and wood.

The painted quotations around the cornice of the chapel are a gloss to the patterned IHS monograms on the walls and ceiling, the chorus of the angels' praise. With the exception of that from Habakkuk, all the quotations speak explicitly about the name of Jesus: at Jesus' name all shall bow and, in the last pair, that his name shall bring salvation. The Habakkuk quotation, however, alludes to it in another way: the Hebrew name Joshua also means 'saviour',

so this too emphasizes the saving power of the Holy Name and the reasons for exulting in it. Thus far we have a good explanation for the iconography of the chapel, but it is worth speculating whether other ideas are being more subtly expressed here too.

There is evidence that some fifteenth-century iconographies made use of the textual context of the quotations they incorporate to give them added resonance and meaning. The fifteenth-century chantry chapel of the Chudleigh family at Ashton in Devon, for example, contains a sequence of biblical quotations, whose grouping, arrangement and devotional significance are apparent only if they are viewed in the light of liturgical texts.[13] At Ewelme, each quotation is prominently provided with its biblical reference and if onlookers accept this implied invitation to open a Bible they are provided with an interesting context for each. The quotations are taken alternately from the New and the Old Testaments. Perhaps significantly in the context of a chantry, those from the Old Testament both come from descriptions of the end of the world. Looking at them individually and in the order in which they must be read, the passages in which they stand are as follows (the painted text is highlighted in bold):

6　'[Jesus] Who, being in the form of God, thought it not robbery to be equal with God;

7　But emptied himself, taking the form of a servant, being made in the likeness of men, and in habit found as a man.

8　He humbled himself, becoming obedient unto death, even to the death of the cross.

9　For which cause, God also hath exalted him **and hath given him a name which is above all names:**

10　**That in the name of Jesus every knee should bow, of those that are in heaven, on earth and under earth;**

11　And that every tongue should confess that the Lord Jesus Christ is in the glory of God the Father.' (Philippians II)

The power and majesty of the name of Jesus celebrated in the first quotation is given an interesting twist in its textual context: it is Jesus' humility and his preparedness to stoop to becoming a man, and enduring a degrading death, that has exalted him above everything else.

The second quotation from Habakkuk III:18, '**But I will rejoice in the Lord: I will joy in God my Jesus**', comes from a passage in which the prophet promises to pray to God despite his misfortunes and the evils of the world. The theme of the text may explain its position over the altar: the Mass was the central element of the community's devotions, by which the poor men and priests actually enacted the promise of the prophet to praise God in the misfortune and evil of earthly existence. When the bread and wine were consecrated during the Mass the community also witnessed a re-enactment of the Incarnation and it is possible that this particular quotation was understood to refer to this fact as well.

The moment of the Incarnation is treated repeatedly in the antiphons, readings and other prayers of the entire Octave of the Feast of the Holy Name.[14] Jesus was conceived when Gabriel spoke his name at the Annunciation.[15] It may be no coincidence, therefore, that the particular quotation above the altar is incorporated twice into the liturgy and Octave of the Feast of the Name of Jesus in relation to this theme, once in the context of Isaiah's prophecy of Christ's birth: 'Behold, a Virgin shall conceive and bear a son, and shall call his Name Immanuel' (Isaiah VII:14)[16] and once joined to a quotation from the Magnificat, the Virgin's hymn of exultation as the handmaid of the Lord, to form an antiphon to that prayer: 'I will exult and rejoice in the name of Jesus: for he who is powerful makes me great, and holy is his name'.[17] The allusion to the conception of Christ by the Virgin in this quotation might have been intended to complement the probable iconography of the centrepiece to the chapel, its altar reredos.

There is no evidence for the subject of the reredos, but in the context of this iconography it seems more than likely to have been a scene of the Passion. The central emphasis of the Feast of the Holy Name was on the salvation Jesus brought through the Crucifixion, and in consequence the Passion was a common subject for Jesus Altars.[18] If this was the case, the quotation and reredos would have celebrated the Incarnation as a whole – both the Annunciation and the Crucifixion – and they would have done so at the place in the chapel where these events were re-enacted every day. As the first quotation in the chapel celebrates Christ's humility in his preparedness to become man and to suffer, this second one might therefore relate, along with the reredos, to the Incarnation – a second stage in the history of Salvation.

The third quotation from Acts IV is drawn from a disputation with the Pharisees over the cure of a cripple:

10 'Be it known to you all and to all the people of Israel, that by the name of our Lord Jesus Christ of Nazareth, whom you crucified, whom God hath raised from the dead, even by him, this man standeth here before you, whole.

11 This is the stone which was rejected by you, the builders, which is become the head of the corner.

12 Neither is there salvation in any other. **For there is no other name under heaven given to men whereby we may be saved.**'

Having treated in chronological sequence the importance of Jesus' humility as a preparation for his majesty, followed by his Incarnation, this third quotation would seem to celebrate the fulfilment of that act – Christ's Resurrection and the power which he now effectually wields. The explicit theme of the quotation – salvation by the Name of Jesus – is also apposite in the context of a chantry. This chapel, patterned with IHS monograms, becomes a statement of faith in this quotation – those who are buried within it and those who built it both acknowledge the potency of that name and intend to be saved by it. It may be significant, in fact, that in Revelations XXII:3–4, the Saved are

described as having the name of God on their foreheads.

The fourth quotation, from Joel II, would fit into the iconography as a celebration of the ultimate destiny of creation and the culmination of Christ's sacrifice in the Last Judgement. It is drawn from a description of the Apocalypse:

31 'The sun shall be turned into darkness and the moon into blood: before the great and dreadful day of the Lord doth come

32 And it shall come to pass, that **everyone that shall call upon the name of the Lord shall be saved**: for in mount Sion, and in Jerusalem shall be salvation, as the Lord hath said, and in the residue, whom the Lord shall call.'

Thus far, the decoration of the chapel might be interpreted as a sophisticated intellectual construction containing a vision of heaven, and a celebration of the history of salvation, from Christ's preparedness to become incarnate to the Apocalypse. But the aspect of the iconography which lifted it beyond the intellectual was its living element. The life of prayer conducted within it might be considered to have animated the wood and paint, and during the daily celebrations of Mass, when Christ became present, he also became a physical part of the euphony of the angels' praise.

In the context of the Mass the angel roof of the chapel also takes on another significance. The importance of angels as attendants in the liturgy is well recognized, but a devotional poem written for Alice de la Pole in the 1430s by John Lydgate, called *The Virtues of the Mass*, underlines one significance of their presence here rather nicely:

Aungelys reioyce with lawde, honour, and glory,
From the heuynly court by grace they ar sent
and at the Masse abyde and be present
All our prayers deuowtly to report
To hym that syt aboue the firmament
Sowlys in peyne they refresshe and comfort.[19]

Are the hovering wooden figures in the roof these very angels waiting to carry the prayers of remembrance offered in the chantry chapel to the throne of God itself, as the poem says, bringing comfort to souls in Purgatory?[20]

It is possible that the dedication of this chapel to John the Baptist – though it is really a Jesus chapel by its iconography – is simply a matter of devotional preference on the part of the de la Poles. John was an immensely popular saint in England at this time, particularly as a patron of hospitals, and indeed he appears with Mary Magdalene on the seal of God's House at Ewelme. Alice may also have had a personal devotion to him, because she kept an image of his head amongst her books.[21] She also chose him, along with Mary Magdalene, as one of the two saints to grace her tomb.

But it should not escape notice that John the Baptist was a particularly appropriate figure to act as patron to this chapel on three counts. First, he was

the prophet of Christ and this fact was alluded to in the lost stained glass of a south window to the chapel or aisle. In this John was portrayed as being questioned by the priests and Levites and there was a dialogue in the glass which ran 'Who are you? Are you the Christ? No, I am not the Christ.' Antony à Wood, who recorded this scene in the seventeenth century, did not habitually note the religious imagery of the churches he visited and this fact suggests that it was prominently set. What it must have been intended to underline was John's role as the herald of the real Christ, celebrated in his majesty within the chapel. Second, John was identified by Christ himself as the prophet Elijah, who was to return before the Last Judgement (Matthew XI:14 and Malachi III:24). The medieval understanding of the association between these two figures was complex, but in consequence of it John the Baptist was connected with the Second Coming of Christ and, for obvious reasons, this also made him a suitable patron of a chantry.

Finally, the life of John the Baptist paralleled that of Jesus in several ways, some of which seem significant in the context of this chapel and its celebration of the Holy Name. The birth of John was also announced by Gabriel with the same words that he used to the Virgin: 'and you shall call his name John' (Luke 1:13 and 1:31 respectively), a parallel circumstance treated in the liturgy of the Feast of the Birth of St John the Baptist. It is worthy of remark too that John's name subsequently worked miracles: Zachariah was struck dumb for his incredulity at Gabriel's promise of a son until, at the child's circumcision, he wrote on a tablet 'His name is John' (Luke 1:60–4). John was also celebrated for his humility and was understood to have performed the offices of all the nine orders of angels, an interesting association in the context of the chapel's angelic display.[22]

The iconography of this chapel is a powerful statement of Christian belief and piety. Its quotations seem to trace the progress of Christ's struggle to bring man to salvation and are physically organized around the altar. This might be understood as underlining the transcendence of the Mass in the history of salvation as a re-enactment of Christ's atonement. The iconography also celebrates the Christian's hope of salvation and represents the celestial vision to which the Saved will be raised.

This iconographic scheme to the Name of Jesus, some forty years before the feast was established, begs the question of how the Ewelme chapel was conceived in artistic terms. The wall paintings are likely to derive from textile design and there are extant examples of diaper decoration on tapestries which compare well with it.[23] But this generic similarity is hardly an adequate explanation for the remarkable interior as a whole. Since so much English medieval religious art has been destroyed (and even what survives is often not properly dated), any discussion of the sources for the Ewelme iconography is necessarily speculative, but this display may tentatively be connected with East Anglian artistic developments from the 1420s to the 1440s.

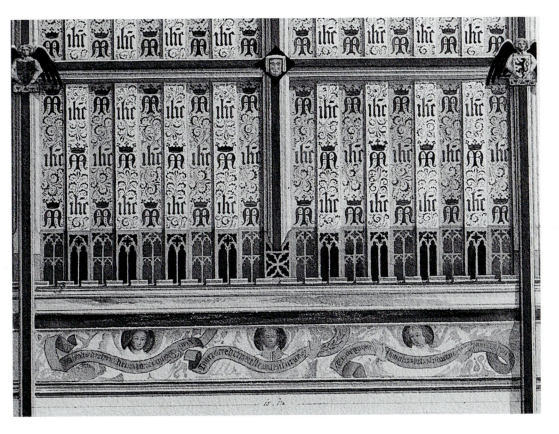

Although the forms and motifs employed in St John's Chapel – such as the coffered roof, cornice inscriptions and IHS symbols – enjoyed almost universal popularity in the later fifteenth century, they also appear in similarly conceived iconographies in East Anglia from much earlier in the century. Given that the furnishings and design of the church at Ewelme look towards that region, it is these which are likely to have inspired the iconography of St John's Chapel. The nave of St Peter's, Salle, in Norfolk (c.1400–20), for example, preserves fragments of a cornice inscription of the *Te Deum* and the 150th Psalm, held on scrolls by the painted figures of angels. The roof above this is decorated with monograms of the names of the Virgin and Christ, and has bosses carved as the busts of angels (see Fig.69). These may presumably be understood, like the cornice angels, to be singing the texts and monograms around them in a representation of celestial glory.

Patterning of roofs with monograms as a depiction of heaven remained common throughout the century in East Anglia, often in conjunction with angel iconographies (as at Blythburgh and Ufford), and occasionally with cornice quotations (as at Edwardstone). But the Ewelme iconography, although comparable to these examples, perhaps looks to another related furnishing which employs the same artistic conventions, and more precisely echoes its devotional themes, the celure of the rood. These celures were

69 The painted decoration of the nave roof and cornice at St Peter's Church, Salle, c.1420. In a cartoon-like convention similar to that at Ewelme, the angels bear the text of the *Te Deum* that they sing.

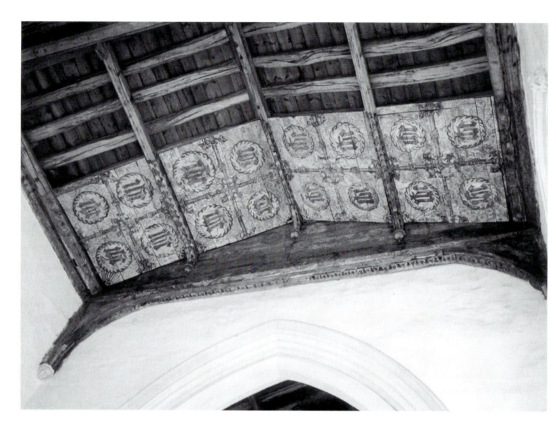

70 The late fifteenth-century celure at Stowlangtoft, Suffolk. This type of furnishing, associated with the rood, may have been the source for the decorative scheme of the Chapel of St John the Baptist at Ewelme.

special ceilings built over the Crucifixion scene on the rood screen to highlight its importance. They could take a variety of forms, from wooden vaults to panelling.

IHS monograms are often found painted onto rood canopies in East Anglia. No surviving examples are closely dated, but two in particular, at Stowlangtoft (see Fig.70) and Metfield in Suffolk (which bears both the monograms of Jesus and Mary), are similar to the Ewelme paintings in the style of their script and vine foliage, and there are other examples of the form at Medlesham, Cratfield and, perhaps based on an original design, a renewed celure at Eye (Suffolk). A celure decorated with IHS symbols is also documented as having existed at Wingfield, and that might actually have been commissioned by Alice de la Pole in the 1460s.[24]

None of these celures bear cornice quotations, but examples of this do exist, such as the mid-fifteenth-century celure of St Edmund's, Southwold in Suffolk.[25] It bears quotations from the *Benedictus* and is painted with figures of angels carrying the instruments of the Passion and scrolls with further verses of praise.[26] Angels also appear alongside the Sacred Monogram in the celure at Pulham in another celebration of the glory of the Crucifixion.[27] The position of these celures in proximity to, and in celebration of, the Crucifixion might possibly connect them with the Ewelme chapel's iconography, in which the

presence and Passion of Christ are such important themes. The decorative scheme might, in other words, have been conceived as a rood-screen iconography arranged in a chapel where the Crucifixion was daily re-enacted in the Mass.

The association of the chapel iconography with East Anglia is further substantiated by a stylistic comparison between the design of its roof and that over the chancel at Salle in Norfolk, which was completed at almost exactly the same time as Ewelme, in 1440.[28] This is pitched but its faces are decorated with panels in a manner closely reminiscent of the decoration of the chapel ceiling at Ewelme. The intersections of rafters, purlins and secondary beams are all decorated with small figures of angels in a variety of attitudes of praise (see Fig.71). Several other similar and roughly contemporary roofs survive in the locality and some of them still preserve their original painted decoration, for example that at East Dereham in Norfolk (see Fig.72).

The Chaucer monument

Standing within the chapel and a focus for the devotion of the community that prayed there are two magnificent tombs, those of Alice de la Pole and her parents, the Chaucers. The monument of Thomas and Maud Chaucer stands lengthwise against the eastern parclose screen of the chapel (see Fig.73). It is encased in Purbeck marble, with the plinth and table-top cut from a darker coloured stone than the chest. The three exposed sides of the chest are panelled with blind arches, and all but one of these arches – that sandwiched between the screen and the pier of the arcade – contains a pair of enamelled shields, arranged one above the other. The fourth face of this tomb has been roughly shaved off and it stands hard against the screen.

Laid into the table-top are two brass effigies (see Fig.74). That on the left depicts Thomas Chaucer in plate armour and that on the right Maud. She is dressed in a long, flowing gown under a cloak secured by a cord and clasps, and wears a wimple and veil. Both figures have at their feet the respective heraldic animals of their families: Thomas a unicorn, and Maud the double-tailed Burghersh lion. In the four corners of the slab are a further four enamelled shields, and around the rim of the tomb on three sides is an inscription:

Hic jacet Thomas Chaucer armiger, quondam dominus istius villae, & Patronus istius ecclesiae: qui obiit 18 die mensis Novembr: anno D[omini]. 1434. Et Matildis uxor ejus, quae obiit 28. die mensis Aprilis Anno D[omini]. 1436.[29]

Here lies Thomas Chaucer, knight, sometime lord of this manor and patron of this church, who died on the 18th day of the month of November, the year of Our Lord 1434. And Matilda his wife, who died the 28th day of the month of April, the year of Our Lord 1436.

This tomb was extensively restored in 1843–44. At this time a new inscription, reproducing the text of the old, was added to the monument, and the inlaid

71 The chancel roof of St Peter's Church, Salle, in Norfolk, c.1440. This panelled roof, with angel figures decorating the intersections of rafters and purlins, closely resembles that of the chapel at Ewelme.

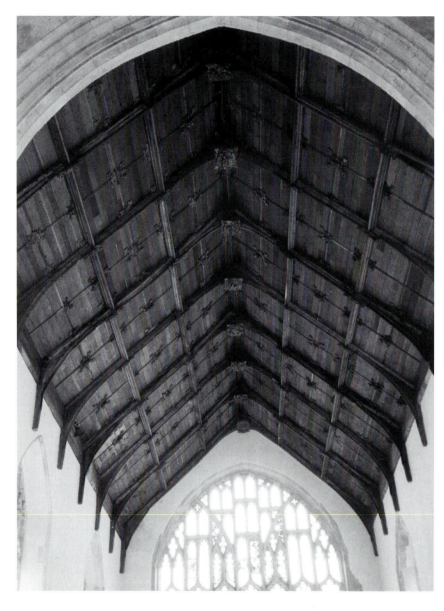

sequence of enamelled shields was entirely renewed.[30] Various heraldic errors were committed in this restoration, but the original sequence of emblazons has been reconstructed from antiquarian evidence by Greening-Lamborn. These emblazons are listed below as part of the discussion of the heraldic display in the chapel. Greening-Lamborn also argued convincingly that the tomb was moved from elsewhere in the church into its current position in 1438.[31]

That the tomb has been moved, or was at least first intended to be placed elsewhere, is suggested by the shaving of its northern face. Evidently, the

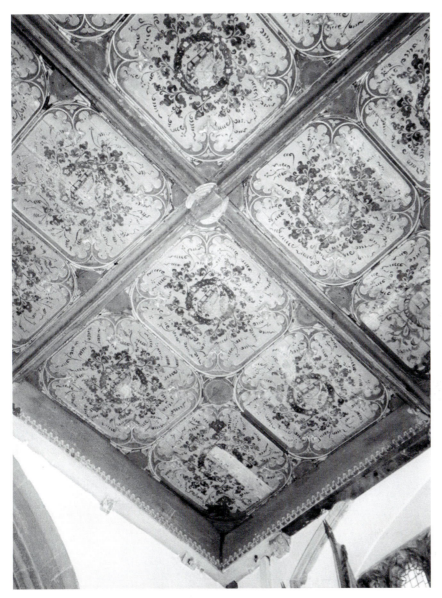

72 The south-chapel roof of the church at East Dereham, Norfolk, preserves its fifteenth-century painted panels depicting the Lamb of God. Small busts of angels have been removed from the intersections of the beams.

monument was originally designed as a free-standing structure with a fourth decorated side, and this had to be cut off before it could be placed flush against the screen. That it was put in its present position in 1438 is suggested by the content and arrangement of the heraldic display that now decorates it. The omission of inlaid shields in the blind panel at the north-west corner of the chest presupposes that the monument was standing in its present awkward position when the heraldic decoration was added (see Fig.75) and two of the emblazons (numbers 8 and 12 in the list below, this chapter) may be used to date the display precisely. The first celebrates the alliance of

73 The Chaucer tomb in St John the Baptist's Chapel, Ewelme. The arcade arch, decorated with the sculpted busts of saints Catherine (left) and Mary Magdalene (right), serves as its canopy.

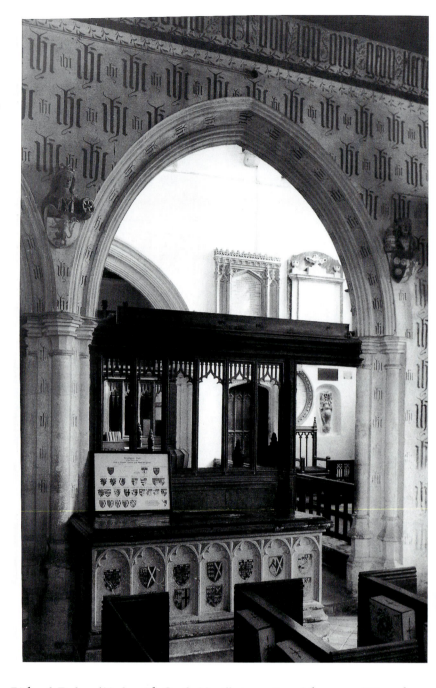

Richard, Duke of York, with Cecily Neville in 1438, and the second Humphrey Stafford. Stafford assumed the title of the Earl of Buckingham and quartered his arms with those of Woodstock after the death of his mother in October 1438. Since the shield on the tomb is unquartered it must predate this event.

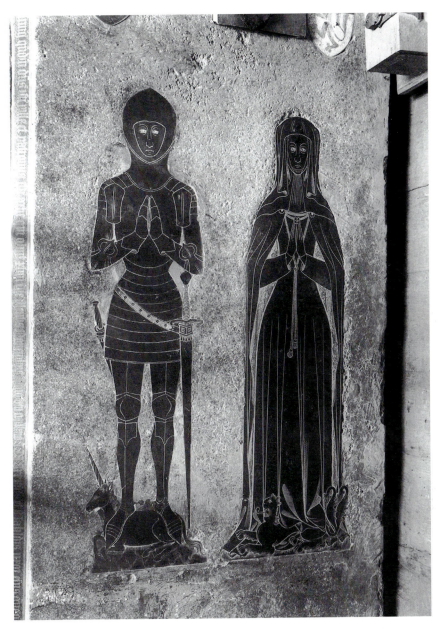

74 The brasses of Thomas and Maud Chaucer in St John the Baptist's Chapel, Ewelme. In 1438, when the monument was re-erected here, one edge of the tomb (pictured here to the right) was roughly cut away to fit it against the chapel parclose screen.

The inclusion of these emblazons in the applied heraldic decoration on the tomb, therefore, demonstrates that it had been re-erected in its present position in the chapel by the third quarter of 1438.

It may be added to these observations that two details of the chapel's arrangement actually seem to demand that the Chaucer tomb stand in its present position. First, as has been described, the screen behind the tomb has quite different, and richer, details from those of the other parcloses. This fact

itself would logically be explained if it was intended to be the backdrop to this monument. Second, the arcade arch under which the tomb stands has been treated as a canopy, with ornamental head-stops. On the chancel side there are two coats of arms – Chaucer and Chaucer quartering Burghersh – beneath the helms with the Chaucer crest, a unicorn (see Fig.37, above). On the chapel side

are two saints: St Catherine carrying her wheel and the Burghersh coat of arms, and Mary Magdalene with her jar of nard and the arms of Chaucer impaling Burghersh (see Fig.73). The paint on these carvings is modern but it follows the coloration noted in 1574.[32] Not only are these shields identical to the four chosen to decorate the corners of the tomb slab – a detail which itself suggests that the heraldic tomb decoration is coeval with the architecture – but the Saints appear to relate to the two dead figures. Mary Magdalene is the namesake of Maud and St Catherine holds her wheel, which was the heraldic device of the Chaucers.

From the physical evidence, therefore, it seems likely that the Chaucer tomb was first erected as a free-standing monument somewhere in Ewelme Church. When St John's Chapel was newly completed in around 1438, however, it was dismantled and reassembled in the position in which it stands today. At this time a new heraldic display was also added to it. Similar reworkings of parental tombs are documented during this period and Alice de la Pole may later have undertaken a similar operation on her parents-in-law's tomb at Wingfield.[33] Presumably the tomb inscription was also renewed at this date for it to fit on the newly arranged monument.

The monument of Alice, Duchess of Suffolk

Alice de la Pole's magnificent alabaster tomb stands beneath a richly ornamented canopy in the eastern extreme of the wall that divides the chancel and St John's Chapel (see Fig.76). It was probably carved in London between 1470 and 1475 and ranks amongst the most important surviving late-medieval funerary monuments in England, remarkable for both its rich detail and unique design.

THE TOMB CANOPY

The canopy over the monument is built right through the wall between St John's Chapel and the chancel so that, if the tomb were to be removed, it would form a wide doorway between the two about nine feet square. Its polygonal faces are decorated with a distinctive, angular panelling design and there is a statue plinth on the inner face of the eastern upright. It was common practice in contemporary tomb design for the praying effigy on a monument to face a devotional image, and in this case the image may have been the Annunciation: the scene appears elsewhere on the tomb itself and the plinth would naturally accommodate two figures, with one panel to frame Gabriel and the other Our Lady. A series of iron hooks and eyes is arranged on both sides of the canopy opening and these would appear to have secured hangings around the tomb, a rare piece of evidence for the medieval practice of covering important monuments.[34]

The canopy is not a load-bearing structure but has been inserted into a roughly finished arch which supports the wall and clerestory above it.

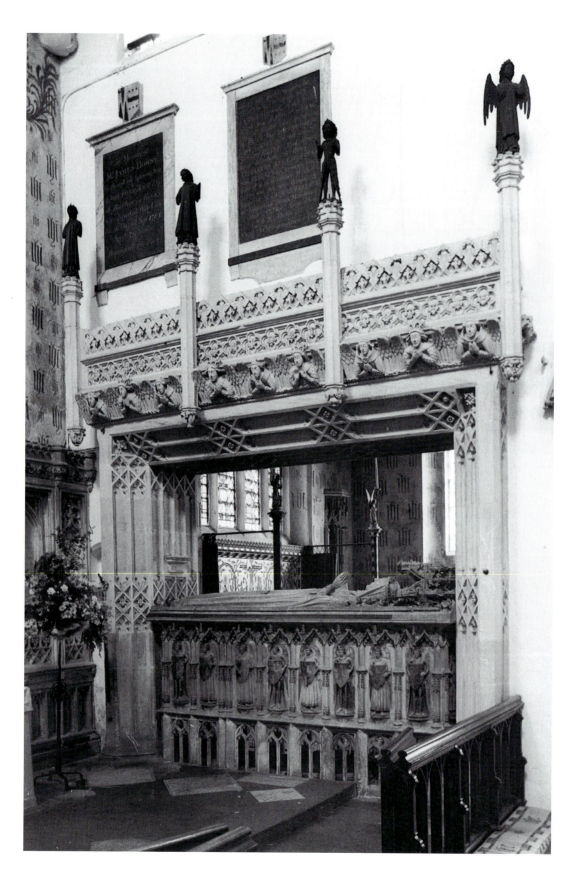

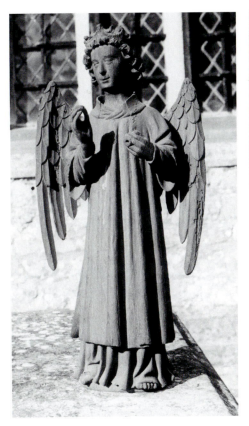

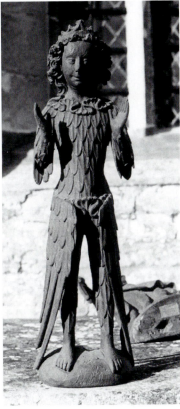

76 A view of Alice de la Pole's tomb from the chancel, Ewelme Church. The iron eyes for attaching hangings are visible up the sides of the canopy and the tomb may normally have been covered.

77 St John the Baptist's Chapel, Ewelme: vestmented angel from the canopy over the tomb of Alice de la Pole. The figure formerly held some object.

78 St John the Baptist's Chapel, Ewelme: a feathered angel in a conventional attitude of praise from the canopy over the tomb of Alice de la Pole.

Running along the top of its lintel is a carved stone parapet decorated with angels, quatrefoils and foliage patterns. The angels are dressed alternately in costumes of feathers and vestments. Eight pinnacles rise through this parapet and each is surmounted by the wooden figure of an angel, some of which formerly held objects in their hands. Most of these figures were hollowed out at the back to reduce their weight and their wings are carved from separate blocks of wood nailed into place (see Figs.77 and 78). There are no traces of any paint remaining on the canopy or its statuary.

Plain lintel canopies of this type remain comparatively unusual throughout the fifteenth century, and while general comparisons may be drawn with those over other tombs from this period, such as Archbishop Chichele's at Canterbury (see Fig.80), completed by 1426,[35] or the monument of Richard Willoughby (ob.1471) and his wife at Wollaton in Nottinghamshire, the similarities are not sufficient to provide a basis for dating the Ewelme design. Nevertheless, two other unusual features of the decoration on the Ewelme canopy would serve to date it to the 1470s.

Friezes of angels have a long pedigree in church fittings, but the depiction of alternately dressed figures only occurs from the mid-fifteenth century onwards: for example, there are full-length figures of angels in different dress

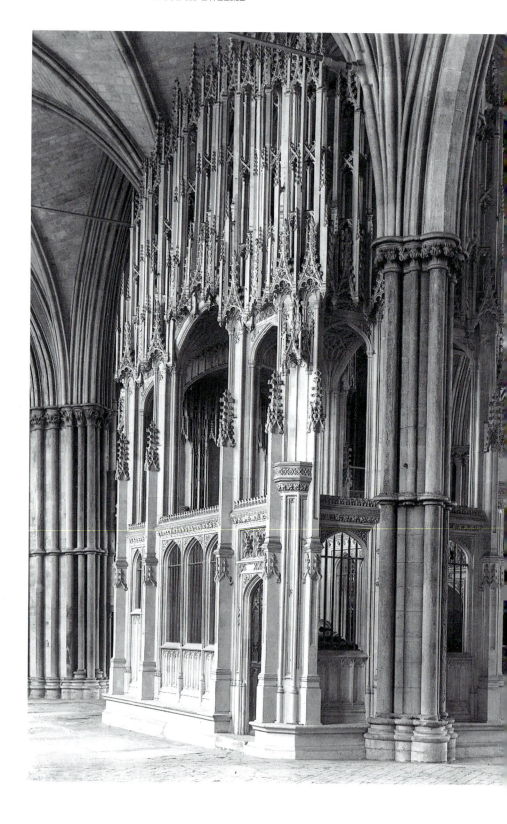

on the 1430s tomb canopies of Bishops Stafford and Branscombe at Exeter. Ewelme's particular motif – of differently dressed figures represented from the torso upwards – is best paralleled, however, in much later designs, such as the frieze at St George's, Windsor (begun in 1473)[36] and, early the next century, in Henry VII's Chapel, Westminster (begun c.1503).

The association of the Ewelme canopy with designs of the late fifteenth century is strengthened by parallels for the distinctive panelling design found on it. This pattern appears to have been first used at Eton College Chapel, where the windows of the north vestibule are panelled and formed in an identical manner to the Ewelme canopy. Unfortunately it is not clear exactly when these were built, but the panelling design alone also appears around the east window (finished in 1460) and around the roughly contemporary doorways to the ante-chapel. Both were completed under the patronage of William Waynflete, Bishop of Winchester.[37] The design appears after this in two further important commissions by Waynflete in the mid-1470s. First, around the door and in the canopy-work of his chantry at Winchester, probably built in the middle of the decade (Fig.80),[38] and second, around the west door of the tower of Tattershall College church, which was begun in 1479 but probably designed rather earlier.[39]

An association of the Ewelme canopy with Waynflete's work of the 1470s is also suggested by the wooden figures of angels on the top of it. These are very finely carved in a naturalistic style, with smiling faces and tightly curled hair that falls in thick locks. The drapery on the figures is elegantly disposed in flowing but restrained folds (see Fig.77). This style is reminiscent of that of some figures in the great screen at Winchester, which was probably erected during the episcopacy of William Waynflete and completed by 1476.[40]

These stylistic comparisons of the wooden angel figures, angel frieze and panelling suggest that the canopy was designed in the 1470s, a dating further confirmed by the details of the tomb itself. That too shows close affinities with work patronized by William Waynflete in this decade, and was therefore certainly designed of a piece with the canopy.

THE TOMB

Alice de la Pole's tomb is cut entirely in alabaster and is of a unique design (see Pl.VI). Its upper section is a conventional, solid tomb chest, decorated around the sides with the figures of angels set under canopies. Supported on this is a full-length effigy of the Duchess lying beneath a complex canopy, or gablette. But this chest tomb has been raised above the level of the floor and in the space beneath it is another portrait of Alice, this time as a desiccated corpse, loosely wrapped in a shroud. There are several surviving contemporary double-effigy monuments with cadavers, but in every other case the tomb chest has been reduced to a table-like structure which allows the cadaver beneath to be clearly viewed (see for example Fig.80).[41]

The tomb has undergone only one major documented restoration[42] and still preserves traces of its original colouring. Much of this is buried beneath later

79 Winchester Cathedral: Bishop Waynflete's Chantry, probably built in the 1470s. One of several commissions by Waynflete which uses the distinctive panelling pattern found on Alice's tomb canopy. Here it appears around the chantry door and in the rich pinnacle crown of the structure.

80 Archbishop Chichele's tomb at Canterbury Cathedral, built by 1426. The cadaver on this tomb is designed to be seen, and there are inscriptions around both effigies to drive home the striking message of man's mortality conveyed by the monument.

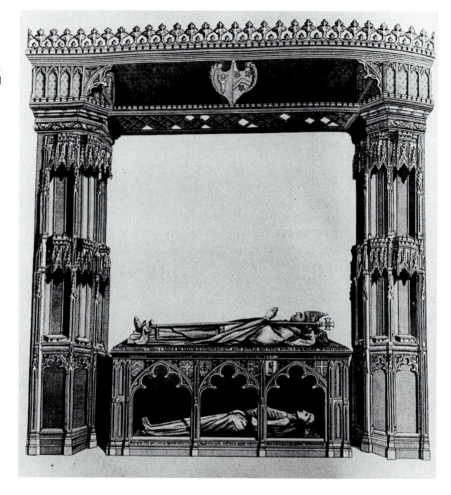

paint layers, but these demonstrably reproduce the original colour scheme and – with the exception of the upper effigy, which has been scraped clean – it is still possible to appreciate the original appearance of this monument.[43] The practice of painting alabaster was well established in the fifteenth century, on both tombs and altar panels, and in some cases it could cost more to have an image coloured than to have it carved.[44]

The faces of the tomb are divided from top to bottom into eight vertical sections by mullions surmounted with pinnacles. At the level of the cadaver the spaces between the mullions are infilled with panels of alabaster cut through with tracery, but around the tomb chest they form the sides of miniature canopies. In each canopy there is the figure of a crowned angel carrying a shield emblazoned in paint. The angels appear dressed in two different ways: half are vested in albs and the remainder in costumes of feathers. The differently dressed figures are placed alternately along the faces of the tomb chest, but this pattern is broken in two places: the second and third angels from the east on both sides of the tomb are identically dressed (on

the north side there are two vestmented figures, and on the south two feathered figures side by side). Between these duplicated angels two mullions are also placed together. At the ends of the tomb the canopies and angels which decorate the chest have been smashed. As will be discussed, this was probably done deliberately when the tomb was first erected because of an error made in constructing it.

Figures of angels or mourners set under canopies are a common feature of fifteenth-century English alabaster monuments.[45] In some instances the details of such decoration are sufficiently distinctive to permit the attribution of tombs to different workshops.[46] But the Ewelme tomb does not obviously fall into such a category, and the characteristic features of the angels on the chest – such as their bulbous eyes and chubby faces – are so widely paralleled in fifteenth-century alabasters as to be useless for dating or attributing the design. The detail of angels dressed in feathers is noteworthy, however. Although such figures are common throughout the fifteenth century in painting, glass and alabaster altar panels, their appearance on tombs is rare.[47] So too is the alternation of dress on the figures along the chest. This latter detail suggests a connection with another monument, the alabaster tomb of Bishop Stanbury at Hereford Cathedral (see Fig.81).

Stanbury was a prominent ecclesiastic with strong Lancastrian connections who had served as a confessor to Henry VI and was involved in the foundation of Eton.[48] His monument was probably built by his executors immediately after his death on 11 May 1474 and, significantly in the circumstances, these included William Waynflete, who may therefore have been directly associated with its design.[49] There are several points of close similarity between this c.1474 alabaster monument and Alice de la Pole's tomb at Ewelme and the first of these relates to the figures on the tomb chest. On Stanbury's tomb, as at Ewelme, these alternate along the sides of the chest, though in this instance the alternation is between figures of saints and shield-bearing angels.[50] There are no canopies over the Stanbury chest figures, and the angels have been cut to a different pattern from those at Ewelme, but, as will be shown, these tombs are certainly directly related.

Forming a rim along the sides of the Ewelme tomb are two pinnacles set on long mullions. Beneath these is a brass inscription. What is in place today is a nineteenth-century recreation of the original, which read:

Orate pro anima Serenissimae Principessae Aliciae Ducissae Suffolchiae, huius ecclesiae patronae, & primae fundatricis huijus elemosynariae quae obiit 20 die mensis Maij; anno Di. 1475. litera Dominicali A.[51]

Pray for the soul of the most serene princess Alice, Duchess of Suffolk, patron of this church and first founder of this almshouse, who died on 20th day of May in the year of Our Lord 1475. Dominical letter A.

This inscription is not merely remarkable for the inflated titles it rehearses. There is grandiloquence too in the manner in which it describes Alice as patron of the church – a conscious echo perhaps of the inscription on her parents' tomb – and also identifies her specifically (and without reference to

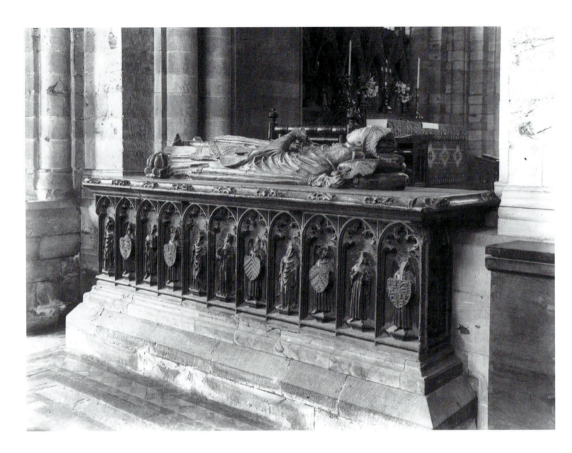

81 Hereford
Cathedral, Bishop
Stanbury's alabaster
tomb, probably
commissioned by
Waynflete c.1474. The
tomb has been badly
damaged and
clumsily rebuilt. It
may formerly have
included a gablette
above the effigy.

her husband) as the first foundress of the almshouse. It is a curiosity, though of what significance is not clear, that the Dominical letter – a means by which the church calendar is determined – of the year of death is noted.

The upper effigy is a magnificent full-length figure of the Duchess in an attitude of prayer (see Fig.82). She wears her ducal coronet and what Leland described in the sixteenth century as the robes of a vowess, a member of the laity living under religious vows: a scapula, joined at the sides from the waist downwards, worn over a loose undergarment that is fastened at the waist by a leather belt.[52] Twisted round the belt is a rosary (see Pl. VII), quite a rare accoutrement on funerary images of women and one which seems first to appear in the 1470s.[53] A wimple (or 'barbe') and veil are worn under the crown and fastened below the wimple is an heavy body-length cloak. The cord fastenings for this fall down below the effigy's knees. Unusually, Alice is portrayed also wearing the Order of the Garter round her left forearm.[54] Apparently both Queen Mary and Queen Victoria consulted this tomb when pondering the problem of how to wear the insignia of the order without compromising their feminine modesty or dignity. In both instances Alice's example was accepted as a seemly solution. There is also a ring worn round the third finger of the effigy's right hand.

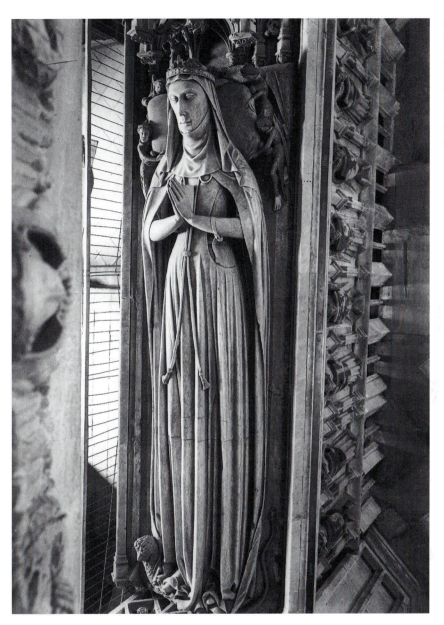

82 The upper effigy of Alice de la Pole's tomb, Ewelme. Note the stub for an intended return rim to the tomb by the feet of the effigy – one indication of the botched erection of the monument.

This costume worn by Alice appears indistinguishable in essential detail from that of many widow effigies. Though weeds do vary on tombs – for example, in the shape and detailing of the barbe and the form of the undergarment – there are apparently no distinctive features which justify Leland's identification of the Duchess specifically as a vowess. Moreover it has been suggested, from the evidence of brasses, that the clothes of vowesses were indistinguishable from widow's weeds.[55] But Leland, although providing the only evidence of Alice being a vowess, is a sufficiently early

and experienced observer for his word to be taken seriously, and it is possible that his identification was based on the lost coloration of the effigy.

That the coloration of otherwise identical clothes could distinguish the status of a widow is well illustrated by the alabaster effigy of Alice's daughter-in-law, Elizabeth, at Wingfield. Stothard's 1812 tinted drawing of this shows that her weeds were distinctively coloured and trimmed with ermine in a manner befitting her rank. Yet without this detail the effigy would, like Alice's, be indistinguishable in dress from scores of other widow-figures on monuments. The presence of scrubbing marks on the Ewelme effigy probably indicates that its present finish is the result of systematic cleaning and it is possible therefore that Alice's robes were formerly coloured in some manner that identified her specifically as a vowess. Perhaps she wore the garments of a religious order.

The head of the Ewelme effigy rests on an oblong pillow supported at the sides by four – rather than the usual two – angels, who all wear costumes of feathers (see Pl.vii). Only one of these angels preserves its original head, that on Alice's lower right side, and its features are more rotund than those of the tomb-chest figures. The face of the effigy is pronouncedly pear-shaped with unnaturally elongated features. It is dominated by a long straight nose and two absolutely symmetrical, tear-shaped eyes with heavy lids and arching eyebrows. The nub of the chin is prominent enough to be visible above the barbe, and the mouth is straight-set, with thick lips. In comparison with the bloated features typical of good contemporary alabaster effigies this face is distinctive and it may possibly be an attempted portrait.[56]

At the feet of the effigy is a couchant lion with a tightly curled mane (see Fig.82). Its body curves right round the end of the Duchess's figure, the head on her right-hand side and the tail on her left. On the edge of the tomb to either side of this animal it is possible to see the stumps for an intended return rim across the end of the chest. Above Alice's head is a hexagonal canopy or 'gablette'. It has been carved with great virtuosity from a single block of alabaster and its details are immensely rich, sophisticated and unusual.

The gablette is cut into three concentric decorative layers and would appear to be conceived as a three-tier pinnacle telescoped into one tier (see Fig.83). Its outer faces are each carved with a traceried ogee arch, and the surviving details of the uppermost outer face show that these were all formerly filled with curving tracery forms growing into leaves. The arches are set under high hoods with busily frilled foliage decoration and oblong leaf crocketing. At each corner of the hexagon there is a miniature flying buttress complete with plinth, coping stone, finial pinnacle and crocketed ogee quadrant arch springing to the next layer of the gablette behind. One unusual and subtle conceit of design is discernible in these buttresses. The finial pinnacles are set at 45° to the plane of the buttresses on which they stand and their mullions notionally extended right down to the base of the gablette. There the plinth mouldings of the pinnacle mullions interpenetrate and protrude through those of the buttresses and through the springs of the flanking arches.

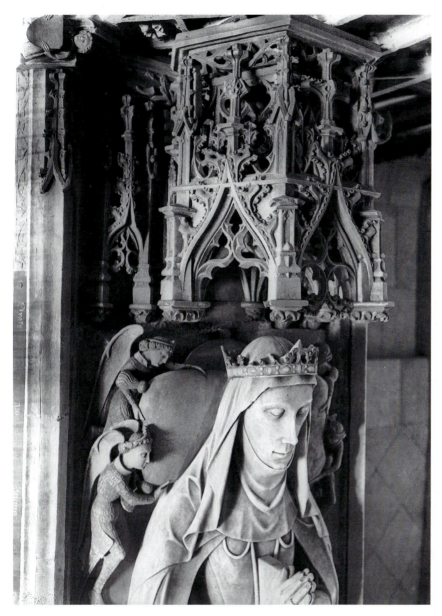

83 The three-layered gablette over the head of Alice's effigy, Ewelme. The rich tracery pattern on the upper facet, which grows into leaves, is still undamaged.

About half-way along the length of the gablette, and running right round it, is a string course crowned by a line of inverted trefoil arch heads with foliage finials. This string course marks a division in the internal carving of the gablette. Below it the stone is gouged out to form a tierceron vault over the head of the effigy. But above it the outer layer of decoration is undercut to form an inner hexagon of reticulated tracery within the depth of the block. This is undercut in turn to leave a pendant swirl of foliage in the very centre of the gablette. There is also a string course of undercut foliage under the rim of the gablette. It runs down onto the top of the tomb and terminates to either

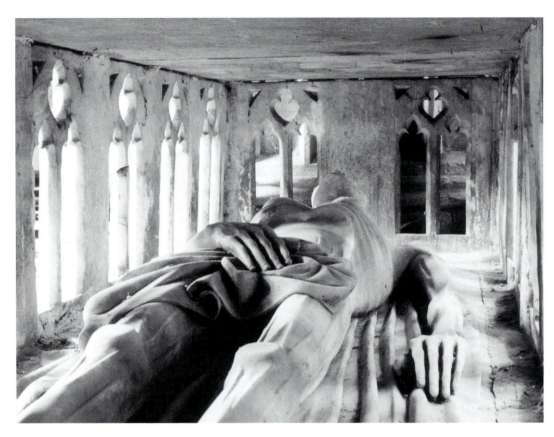

84 The enclosed cadaver effigy of Alice de la Pole at Ewelme, loosely wrapped in a shroud. The figure is cut entirely from alabaster and only its hair and mouth appear to have been painted.

side of the monument against the torso of a shield-holding angel. Beneath it and flanking the gablette on the top of the tomb is a pair of traceried arches with pinnacles on either side. These are miniaturized versions of the outer face of carving on the gablette itself.

The most memorable feature of the Ewelme monument is its cadaver, set beneath the tomb chest (see Fig.84). This macabre sculpture is unique on two counts. It is the only life-size sculpted cadaver of a woman that has survived intact in England[57] and the only cadaver in the country executed in alabaster. It portrays the Duchess's desiccated corpse lying naked in a shroud. This is tied together with a thong below the head and feet but has been opened to expose the corpse it holds. The figure lies in a conventional attitude with its legs stretched out together and its left arm by its side. The right hand holds a few folds of the shroud over its private parts.

This covering of nakedness is the only acknowledgement of the figure's modesty – every other feature of the body, even the shrivelled breasts, are open to the observer's inspection. Its skin is shrunk taut over the skeleton to create claw-like hands and feet, cruelly angular joints and a deeply sunken stomach. The neck, unpleasantly reduced from its natural size, arches up from boney shoulders to Alice's head. Her scalp has shrunk to pull the hair-line back from the face and her long hair is bound around the brow by a single

plaited lock. The face is lined and has sunken, but half-open, eyes. Within the gaping mouth are traces of red paint, added as a final ghastly detail. The only damage this cadaver has received is the loss of the end of its nose.

Painted above this effigy on the bottom of the tomb chest are three roughly executed paintings (see Fig.85). Above the cadaver's half-open eyes is an Annunciation scene (see Pl.vIII),[58] and above its feet, reversed so that it may more easily view them, the kneeling figures of St John the Baptist, pointing to the Lamb of God with the standard of the Resurrection (see Fig.86), and St Mary Magdalene, holding a palm and pot of nard (see Fig.87).[59] The eyes of the saints seem to be cast down to meet the cadaver's gaze.

These paintings are executed within the limits of marking-out lines incised into the alabaster and, with the exception of some pencil lines added to strengthen the features of the angel Gabriel, appear to be entirely unrestored. The figures are distinctive for their bottle-noses[60] and disproportionately large hands. They are built up out of blocks of colour, outlined and detailed in black. A palette of seven colours has been used and these are very sparingly mixed in some places to suggest modelling.

I have noticed while working in the church that most visitors never notice the cadaver – it is tucked right under the tomb chest and is almost entirely obscured by the narrow open-work arches around it. In this sense it is quite distinct from other such surviving effigies of the period, which are deliberately designed to be seen at once.[61] The cadaver's privacy seems an important aspect of the tomb's design: Alice's cadaver is not principally intended as a striking warning of the transience of earthly glory. Instead, it is a second corpse contemplating the paintings of saints above it.

Such images facing a cadaver are unique amongst surviving monuments. The closest comparable arrangement is described in 1439 in the will of Isabelle, Countess of Warwick. She directed:

> my image to be made all naked and no thyng on my hede but myn here cast backwardys, and of the gretenes of the fascyon [? fashion] lyke the measure that Thomas Porchalyn hath yn a lyst, and at myn hede Mary Mawdlelen leyng my handes a-crosse. And seynt Iohn the Evangelyst on the ryght syde of my hede; and on the left syde Seynt Anton, and at my fete a skochen on myn armes departyd [quartered] with myn lordys ...[62]

Though devotional imagery over cadavers is otherwise unknown, the practice of painting objects of devotion above images of the dead or the dead themselves was common. There is a wide variety of surviving examples to draw from: coffins painted on the inside with the images of the Virgin and saints, images in crypts above coffins (for example the Crucifixion painted in the crypt of Humphrey, Duke of Gloucester's tomb at St Albans),[63] images above tombs (on testers and canopies)[64] and facing effigies of the deceased in hearses.[65] For obvious reasons, one common subject in this position is the figure of the resurrected Christ, and this subject is alluded to at Ewelme by the standard above the Lamb held by John the Baptist. But otherwise the logic behind the choice of figures at Ewelme is an interesting subject for

85 St John the
Baptist's Chapel,
Ewelme: head of the
cadaver effigy of
Alice de la Pole. The
half-open eyes
contemplate the
devotional paintings
on the roof of the
cadaver space.

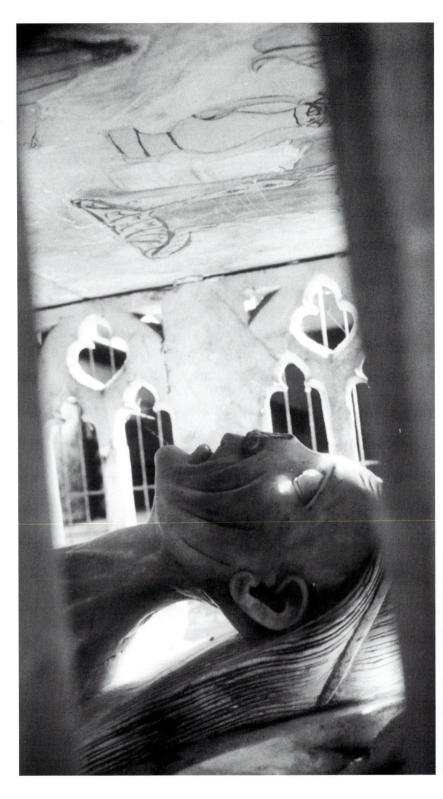

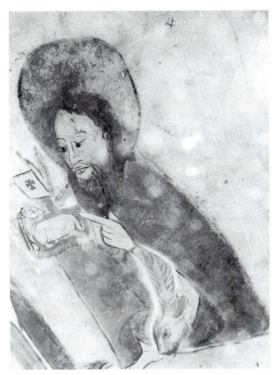

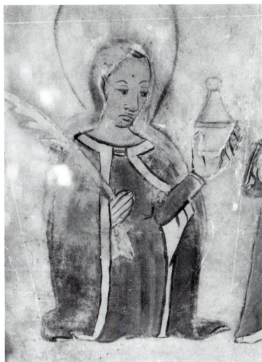

86 St John the Baptist's Chapel, Ewelme: painting of St John the Baptist on the roof of the cadaver space of Alice de la Pole's tomb. He holds the Lamb and the standard of the Resurrection.

87 St John the Baptist's Chapel, Ewelme: painting of St Mary Magdalene on the roof of the cadaver space of Alice de la Pole's tomb. She and St John also appear on the almshouse seal.

speculation. Sts John and Mary Magdalene were both popular patrons of almshouses and these two figures appear on the almshouse seal (see Frontispiece II).[66] Their appearance might suggest that they were deliberately chosen as being appropriate in the context of the almshouse chapel.

The pride of place given to the Annunciation above the cadaver's face may also be significant. The scene, in which the Virgin humbly agrees to bear Christ, encapsulates a central theme of the chapel's iconography – the Incarnation – and this fact should perhaps encourage us to understand the tomb, not as an isolated monument but as an iconographically integrated feature of the whole building it stands in. This might explain the privacy in which the cadaver lies: the effigy is not important as a warning to the living, but as a formalized statement of Alice's humility – referred to in the first of the chapel's painted inscriptions as the means to salvation – and the chapel around it a vision of the glory to which that humility would raise her.

The tomb may be dated closely on the basis of its gablette to between 1470 and 1475. Tomb gablettes vary a good deal in style and quality, depending on what the patron could afford. That at Ewelme is certainly one of the finest to survive anywhere in England, easily matching the standards set by those of the grandest comparable fifteenth-century commissions in alabaster: at Arundel on the tomb of the 5th Earl (ob.1416) and his wife (ob.1439), and at Canterbury on Henry IV's tomb.[67] Moreover, the ambitious three-layered

Ewelme gablette is strikingly different in design from either of these. Its vault is surprisingly restrained in a period when complex lierne patterns were popular in English architecture, and some of its details – such as the curvilinear tracery tailing off into leaves – very unusual in English design until the 1480s.[68] Other features, such as the oblong crocket forms and busily frilled foliage, are also very rare in English work, and the interpenetrating details of the buttress and pinnacle plinths are apparently without fifteenth-century English parallel at all.

Such features can, however, be found in German and Flemish work from the 1450s onwards, and it is evidently from this that the Ewelme canopy draws its inspiration. Yet though it is relatively easy to find Continental designs that incorporate these various features individually, none employs them together in a sufficiently similar manner to warrant a comparison. The idiosyncrasy of the Ewelme canopy is perhaps to be explained by its having been designed and executed by English craftsmen collating fashionable foreign details from pattern books. Other features of the tomb – the choice of material, the style of the angel panels on the chest and the overall feel of the work – would, despite its many eccentricities, certainly support an attribution to an English workshop.

But if the Ewelme tomb is English, how is it to be dated and where does it belong amongst the English monuments it matches so ill? As far as dating is concerned, it seems inconceivable that anyone except Alice herself would have commissioned such an unusual monument. It seems plausible, therefore, that the design predated Alice's death in 1475, possibly coinciding with the preparations she made for this in either 1471 or 1474.[69] This dating apparently creates problems of stylistic comparison with contemporary English work, but there is evidence that some of its features were in fact paralleled during the 1470s. The panelling on the canopy of Alice's tomb has already been compared to that found on William Waynflete's buildings, including Tattershall College. It is significant, therefore, that amongst the fragments of carpentry work that survive at Tattershall there is a panel from a screen decorated with Cromwell's rebus of a purse and carved with complex curvilinear tracery tailing off into foliage in the manner of the Ewelme gablette design. The date of this fragment can only be speculated upon, but work on the church was well under way by 1475, and the building was completed before 1482.[70]

Another commission which also possesses all the unusual features of the Ewelme gablette, but in a more modest way, is Bishop Stanbury's alabaster monument at Hereford (see Fig.81). As has been discussed, this is again connected with William Waynflete and may be dated post-1474. The sides of Stanbury's tomb chest have restrained curvilinear tracery with cusping (now much damaged) which grows into foliage. Around the rim of the tomb are oblong leaves, busily modelled in the manner of the crockets of the gablette arch canopy. There is even a suggestion of interpenetrating architectural detail in the way in which the canopy jambs of the tomb chest pass through

the upper plinth mouldings.

Stanbury's tomb and the Tattershall screen fragment together provide convincing parallels for the Ewelme gablette design in the mid-1470s, and suggest that the tomb was produced amongst the milieu of craftsmen working for Waynflete. Given the very close comparisons between the details of the Stanbury and Ewelme monuments, and their connection with Waynflete's work, it seems likely that both these tombs came from the same workshop. And a tentative case may also be put forward for suggesting that this was a London workshop. Of hitherto unrecognized importance is a surviving receipt in the Ewelme Muniments which identifies Alice de la Pole as commissioning a tomb in 1460 for her husband from two of the most prominent tomb-makers of the day: John Essex and Thomas Stephenes.[71] The document in question is a receipt acknowledging the final payment of £8 13s. 4d. towards a total sum of £34 6s. 8d. for 'certain marble stone' by John Essex, sold according to an indenture made between Alice's chaplain on her behalf and Thomas Stephenes. This receipt is labelled on the reverse 'Marmer [i.e. Purbeck] for my lordes tomb' and must refer to a lost monument, probably a very expensive brass, made for the Charterhouse in Hull, where William was buried (transcribed below as appendix IX).

That Alice commissioned her husband's tomb from these craftsmen does not prove that she employed the same men for her own monument in the early 1470s; indeed Essex had died in 1465. But it does demonstrate that she patronized the finest craftsmanship money could command, and the likelihood is that she commissioned her own tomb from the successors or competitors of these men. If the Ewelme tomb were from a leading London workshop of the day, it would explain both its quality and its idiosyncrasy of design. The curious combination of commonplace and unusual detail in the tomb would accord well with a good workshop adapting its methods to the needs of a particular commission in which some elements of the whole – in particular the upper effigy and gablette – were to be executed according to specially drawn designs.[72]

Has the Tomb Been Moved?

One physical detail of the make-up of the monument requires brief and individual notice. There is a vertical joint which runs from the top of the chest to the bottom of the cadaver space on both sides of the tomb. This joint coincides with two other decorative irregularities: it occurs at the only point along the long sides of the chest at which two mullions are coupled together and at which two angels dressed in the same manner appear side by side (see Pl.VI). The explanation for this feature must be that the tomb has been shortened by the removal of a single angel panel, and this is confirmed by a number of other details. First, it is actually possible to see the stumps of the arches for the missing canopy behind the doubled-up mullions. Second, the shortening of the tomb chest meant that the effigy slab no longer fitted the tomb, and the rim at the east end of the top of the chest has been dispensed

with, evidently in order to squeeze it on (see Fig.82).

This shortening of the tomb was necessary to make it fit under the canopy and even now it only just squeezes into the available space: not only are the plinth mouldings of the tomb canopy cut away to accommodate the mullions of the monument, but the angel figures and canopies at the ends of the tomb chest have had to be smashed away to fit them in. Why did this happen? It has generally been supposed that the tomb originally stood elsewhere in the church and that these alterations occurred when it was moved under the present canopy at a later date.[73] A variety of evidence has been cited to support this assertion, including a posited disparity between the style and competence of the carving of the tomb and of its canopy – supposed proof that the two were executed at different times. It has also been suggested that the existence of angel figures on the ends of the chest indicate that in its original position the structure was free-standing rather than crushed under a canopy.

But these arguments are not convincing. Not only were the tomb and canopy evidently designed together but, practically speaking, a move would not explain the shortening of the tomb: why go to the effort of constructing a new canopy that was too small for the monument it was intended to cover? In fact, there is only one convincing explanation for the strange state of the tomb, an error on the part of the craftsmen responsible for making it.[74] Two observations substantiate this hypothesis. First, the ends of the tomb were never fully painted. Since they are beyond the reach of the restorer's brush their piebald finish must be fifteenth-century and presumably shows that the need to shorten the tomb was recognized while the work of first erecting it was under way. Second, the alterations were conceived and executed in a manner that, from their tidiness, strongly suggests that the tomb-makers were involved.

On the face of it, the decision to remove a panel from the middle of the sides of the tomb is curious. Doing this both interrupts the pattern of feathered and vestmented angels and couples two mullions together, irregularities that presumably could have been avoided if the panels at the extremes of the chest had been removed instead. But this was not done because the craftsmen were working within two constraints. The tomb needed to be short enough to fit into the canopy, but it also had to be long enough to support the effigy slab, which could not be shortened without chopping off parts of the sculpture. The doubling up of the mullions gives the chest two more inches in length than it would have had if a whole panel had been removed from one of the ends, and this makes it just long enough to support the effigy slab.

Using doubled-up mullions to make up this critical space is yet more ingenious because the detail is actually drawn from the tomb's decorative vocabulary: it has previously escaped notice, but the angel panels on the ends of the tomb are divided up by doubled-up mullions as well. In other words, the method by which the problems of shortening the chest have been

obviated is consonant with the decorative design of the tomb and also with the skill and manner in which its makers, not later craftsmen, would work.

The heraldry of the chapel and the church

Both tombs (Alice's and the Chaucers') are decorated with sequences of coats of arms, part of an elaborate heraldic display that formerly filled the chapel and the church. Almost all of this has been lost, but its principal details may be reconstructed from antiquarian descriptions of the building. Numbers of such descriptions exist, but most are just interpolated re-copyings of earlier manuscripts, and upon scrutiny there are only three independently authoritative accounts which record the medieval display. Earliest amongst these are church notes made by the herald Richard Lee, Portcullis, on his Visitation of Oxfordshire in 1574.[75] Next to this in importance is an anonymous, undated and previously unknown account in a seventeenth-century hand, which survives as part of a collected book of papers in the Bodleian.[76] Thirdly, another herald, Anthony à Wood, also made notes on Ewelme between 1668 and 1681.[77] His notes are largely a compilation of other descriptions, drawing in particular from Lee and Leland's *Itinerary*, but they do contain some independent observations of value.

The descriptions of the heraldry in these three accounts broadly corroborate one another but each makes its own contribution to our knowledge of the lost decoration: the anonymous antiquarian, for example, is the only one to trick the complete collection of emblazons on Alice de la Pole's tomb. There are also occasional ambiguities and differences between the accounts which are difficult to reconcile. In at least one case, which will be discussed below, the most probable explanation for such differences is that of damage and repair to the glazing. Of the entire collection of heraldry these three accounts describe, the only fifteenth-century fragments to survive are to be found amongst the medieval glass located in the chapel's east window. Everything else is lost, repainted or replaced. What follows is an attempt to collate the contents of all three descriptions and reconstruct the complete display of heraldry as it appeared in the late fifteenth century.

The original sequence of shields on Thomas and Maud Chaucer's tomb is recorded by both Lee and Wood. With the help of an analysis of the heraldry on the Chaucer tomb by Greening Lamborn these may be reconstructed as follows.[78]

On the top of the tomb:

1 Gules, three roets or (Roet for Chaucer: this coat was adopted by Thomas Chaucer from his mother, and is used in the display to indicate both families)

2 Argent, a chief gules with a lion rampant queue-fourché or over all (Burghersh of Ewelme)

3 Roet (for Chaucer) impaling Burghersh of Ewelme

4 Roet (for Chaucer) quartering Burghersh of Ewelme.

On the sides working west to east:

5 Azure, three fleur de lys or (France) quartering gules, three lions passant guardant or (England) with a label ermine impaling Roet
6 France and England quarterly with a label argent with three roundels gules on each file (York) impaling or a cross engrailed sable (Mohun)
7 France and England quarterly in a bordure gobony argent and azure (Beaufort); Lee records a cardinal's hat over the emblazon, identifying it as Cardinal Beaufort's
8 York impaling gules a saltire Argent (Neville)
9 France and England quarterly in a bordure gobony ermine and azure (Beaufort of Exeter)
10 England with a label argent (Brotherton for Mowbray) impaling Neville
11 Beaufort (as 9)
12 Or, a chevron gules (Stafford) impaling Neville
13 Argent a fesse indented of three points gules (Montague) quartering or an eagle vert beak and legs gules (Monthermer) impaling Burghersh of Ewelme
14 Gules a fesse and six crosslets or (Beauchamp of Warwick) quartering checky or and azure a chevron ermine (Newburgh)
15 Or three roundels gules and a label azure (Courtenay) impaling Beaufort in a bordure gobony argent and azure
16 Montague and Monthermer quarterly impaling Mohun
17 Montague and Monthermer quarterly quartering Neville with a label gobony argent and azure
18 Azure a fess between three leopards faces or (de la Pole) quartering Burghersh of Ewelme
19 Quarterly argent and gules fretty or a bendlet sable over all (Despenser) impaling Burghersh of Ewelme
20 Mohun impaling Burghersh of Ewelme
21 Neville impaling France and England quarterly with a label ermine
22 Or a lion azure (Percy) quartering three luces rising argent (Lucy) impaling Neville
23 Barry argent and azure a bendlet gules (Grey of Rotherfield) impaling Burghersh of Ewelme
24 Gules two leopards – for lions passant – argent (Strange) impaling Burghersh of Ewelme.

All three antiquarian accounts record the emblazons painted on the hood-stops to the arcade arch over the tomb. The shields facing onto the chancel, and set beneath sculpted helmets with unicorn crests, bore the arms:

25 Roet (for Chaucer) quartering Burghersh of Ewelme
26 Roet (for Chaucer)

On the south side, facing into the chapel, were:

27 Burghersh of Ewelme, carried by a bust of St Catherine. She is depicted holding her wheel or roet, the heraldic charge of the Roet and Chaucer family arms

28 Roet (for Chaucer) impaling Burghersh of Ewelme, carried by a bust of Mary Magdalene with her pot of nard. This saint was probably chosen as Maud Chaucer's namesake and patroness.

In the windows of the Chapel of St John there appeared:

29 Burghersh of Ewelme
30 Roet (for Chaucer) impaling Burghersh of Ewelme
31 Roet (for Chaucer) quartering Burghersh of Ewelme.

In the east window of the chancel Lee recorded:

32 Roet (for Chaucer)
33 Montague quartering Monthermer impaling Burghersh of Ewelme
34 de la Pole quartering Burghersh of Ewelme
35 Burghersh of Ewelme.

The anonymous antiquarian and Wood both note quarterly France and England in place of 32 and list the arms in the glass in a different order. But Lee's arrangement has a convincing symmetry to it – Alice's familial coats flanking her two principal marriages – and the discrepancy between these descriptions probably results from undocumented repairs made to the glazing.

The anonymous antiquarian records in the two-light west window of the almsmen's chapel:

36 de la Pole impaling Stafford
37 France and England quarterly with a label of three points impaling Neville.

He also records 'in the south window at the east end':

38 Roet (for Chaucer)
39 France and England quarterly with a label of three points impaling ... [the manuscript indicates that the charge is illegible or lost]
40 Roet (for Chaucer) impaling Burghersh of Ewelme.

This latter series of shields is possibly different from that recorded by Wood 'in a south window of the church':

41 Roet quartering France and England quarterly [sic – this blazon is tricked]
42 Roet (for Chaucer) impaling Burghersh of Ewelme
43 France and England quarterly with a label of three points impaling Neville.

Although both Lee and Wood list ten shields on Alice de la Pole's tomb, only the anonymous seventeenth-century account records all the emblazons. It describes these as 'held by angels whose wings are expanded and robes

painted in various colours' and it even draws one of them. On the south side
the display differed from the re-painted series of coats which appears today.
From west to east there appeared:

44 de la Pole quartering Burghersh of Ewelme impaling England and
 France quarterly
45 de la Pole impaling Burghersh of Ewelme
46 Or a lion rampart gules (probably de la Pole)[79]
47 Montague quartering Monthermer impaling Burghersh of Ewelme
48 Chaucer
49 France and England quarterly with a label of three points impaling Roet
50 de la Pole quartering Burghersh of Ewelme
51 Roet (for Chaucer) impaling Burghersh of Ewelme.

On the north side of the tomb from west to east:

52 Roet (for Chaucer) impaling Burghersh of Ewelme
53 de la Pole impaling Stafford
54 Montague and Monthermer quarterly impaling Mohun
55 de la Pole quartering Burghersh of Ewelme
56 Roet (for Chaucer) quartering Burghersh of Ewelme
57 Burghersh of Ewelme
58 de la Pole
59 de la Pole impaling Franch and England quarterly.

Lee also noted in the church – or possibly in the Manor House – though it is
not clear where:

60 'Pooles quarterings'
61 de la Pole impaling Burghersh of Ewelme supported by an antelope
 proper 'of a brownish colour, with the hornes tail members and collar Or
 and a lyon Or.', of which he supplies a drawing.

This heraldic display in the church must belong to two periods – the 1430s to
1440s when the building was remodelled by William and Alice, and the 1470s,
when Alice de la Pole commissioned her tomb. But all the elements of the
display blend together to trumpet the antiquity and connections of Alice and
the Chaucer family, as is apparent if the names of those celebrated are
indicated on a family tree (see Fig.88). There was nothing particularly
unusual in such vast displays of heraldry on funerary monuments and
chantries in this period, but this one at Ewelme is remarkable on two counts.
First, the Chaucers are only celebrated through the arms of the families they
married into – Roet and Burghersh – even though Geoffrey Chaucer, Alice's
grandfather, is known to have used his own coat of arms. The explanation for
this undoubtedly lies in the fact that the Chaucer coat was not thought
sufficiently grand to appear in the chantry of this newly successful family.
Second, this display seems to go out of its way to emphasize only the most
important connections that the Chaucer family had.

The self-aggrandizing tenor of the display is most readily apparent in the heraldry on Alice's own tomb. This celebrates the familial arms of Roet (for Chaucer), Burghersh of Ewelme and de la Pole individually (48, 57, 58) and, in their simplest forms, the relationships between them (45, 50, 51, 52, 55, 56). The two royal connections of these families are also recorded – Alice's uncle, John of Gaunt's marriage to Catherine Roet (49), and that of her own son, John de la Pole, to Elizabeth Plantagenet (44, 59). So too is Alice's marriage to the Earl of Salisbury (47), and the marriage of William's parents (53). The parents of Thomas, Earl of Salisbury, are not included, however: he didn't get the title from them, but from his uncle William, Earl of Salisbury, who is recorded in the heraldry (54). Another interesting omission is her comparatively inconsequent first husband Phelip, who rather pathetically fails to make the display. The self-consciousness of the selection and its historicism is further suggested by the inclusion of Or a lion rampant Gules (46). This may have been an old de la Pole coat of arms, although it never appears to have been used by William, his parents or his grandparents.

The furnishings and decoration of St John's Chapel reflect the many highly sophisticated concerns of patronage that might underlie the construction and furnishing of a chantry chapel – from the desire to trumpet ancestry and political connections, to the need to secure salvation. In devotional terms the chapel at Ewelme presents what are apparently two quite distinct and contradictory impressions of fifteenth-century religion. In one corner Alice's grotesque cadaver suggests, at first sight, a sterile obsession with death and decay, but in the public iconography there is a spirit of triumphalism and glory in the Name of Christ. Both these themes need to be reconciled if we are to understand the spirit of chantry devotion. Their connection is explained in the quotation from Philippians that opens the chapel's iconography: it was Christ's humility in becoming man, and through his degradation at the Crucifixion, that he triumphed. The cadaver is a symbol of the humiliation which Alice believed was the path to her own glory in heaven, her decaying image pathetically imploring the intercession of the onlooking saints and observing the Virgin's own act of humility at the Annunciation. Alice, however, did not intend that her soul should reside with her cadaver. It was but a means to the real end of her existence. She intended to join the choruses of angels in the glory of Heaven which she so publicly and exuberantly depicted in the chapel around it. In these terms this chapel's evocation of decay is not rooted in morbidity, but in faith in the ultimate triumph of Christ.

88 Arms celebrated
in the heraldic
display of St Mary's
Church, Ewelme.

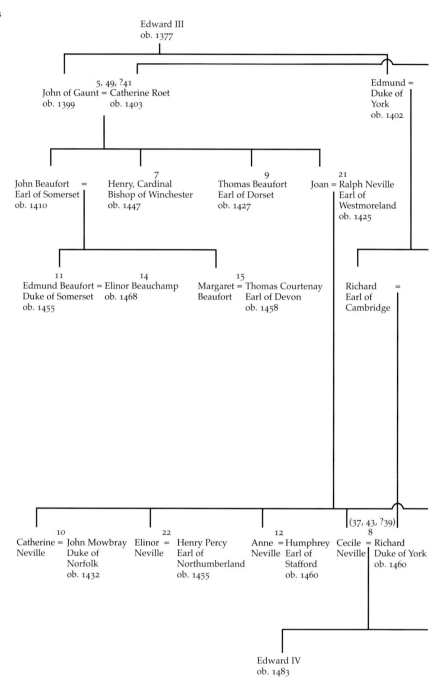

Edward III
ob. 1377

5, 49, ?41
John of Gaunt = Catherine Roet
ob. 1399 ob. 1403

Edmund =
Duke of
York
ob. 1402

John Beaufort =
Earl of Somerset
ob. 1410

7
Henry, Cardinal
Bishop of Winchester
ob. 1447

9
Thomas Beaufort
Earl of Dorset
ob. 1427

21
Joan = Ralph Neville
Earl of
Westmoreland
ob. 1425

11
Edmund Beaufort = Elinor Beauchamp
Duke of Somerset ob. 1468
ob. 1455

14

15
Margaret = Thomas Courtenay
Beaufort Earl of Devon
ob. 1458

Richard =
Earl of
Cambridge

10
Catherine = John Mowbray
Neville Duke of
Norfolk
ob. 1432

22
Elinor = Henry Percy
Neville Earl of
Northumberland
ob. 1455

12
Anne = Humphrey
Neville Earl of
Stafford
ob. 1460

(37, 43, ?39)
8
Cecile = Richard
Neville Duke of York
ob. 1460

Edward IV
ob. 1483

1, 26, 32, 38, 48
Sir Paon Roet

Michael de la Pole = Katherine
ob. 1389 Wingfield

John Burghersh = Maud Kerdeston
ob. 1349 ob. 1349

Philippa Roet = Geoffrey
 Chaucer
 ob. 1400

Bartholomew = Henry
Lord Burghersh Bishop of Lincoln
ob. 1355

58, ?46

20
John = Joan
Lord Mohun
ob. 1375

23
Maud = John,
Lord Grey
of
Rotherfield
ob. 1375

Bartholomew
Lord Burghersh
ob. 1369 =

2, 27, 29, 35, 57
Sir John = Ismania
Burghersh | ob. 1420
ob. 1391

19
Elizabeth = Edward,
ob. 1409 Lord
 Le Despencer
 ob. 1375

36, 53
Michael = Katherine
de la Stafford
Pole, ob. 1419
Earl of
Suffolk
ob. 1415

6
Edward = Philippa
Duke of Mohun
York
ob. 1415

16, 54
Elizabeth = William
Mohun Montague
 Earl of Salisbury
 ob. 1397

24
Maud = John, Lord
Mohun Strangeways
 ob. 1397

3, 28, 30, 40, 42, 51, 52
Maud Burghersh =
ob. 1436

4, 25, 31, 56
Thomas Chaucer
ob. 1434

13, 33,
47
Elinor Holland = Thomas Montague =
 Earl of Salisbury 2nd
 ob. 1428

45,
61
Alice Chaucer
ob. 1475

18, 34, 50,
55
= William de la Pole
3rd Duke of Suffolk
 ob. 1450

17
Richard Neville = Elinor Montague
Earl of Salisbury
ob. 1460

Richard III
ob. 1485

44, 59
Elizabeth = John de la Pole
 Duke of Suffolk
 ob. 1491

John de la Pole
Earl of Lincoln
ob. 1487

Edmund de la Pole
Earl of Suffolk
ob. 1513

Conclusion

A medieval almshouse and the modern world

If only to satisfy the reader's curiosity, it is worth making some final remarks about God's House today. As has frequently been mentioned, the buildings at Ewelme continue to house an almshouse and school, which still function under the original endowment made over to the foundation by the de la Poles in the fifteenth century. The story of how this has come to pass would be fascinating to relate in detail but it would demand another book. Even in outline, however, the history of this institution is a remarkable one and provides, particularly in its later stages, a portrait of English society and politics to rival a Barchester novel.

Quite how the foundation escaped suppression at the Reformation is not clear but it was probably as a result of the fact that the manor of Ewelme was in royal ownership from the early sixteenth century. The last de la Pole Earl of Suffolk, Edmund, was executed by Henry VIII in 1513, after languishing in the Tower of London for seven years. Edmund was a direct claimant to the English throne through his mother, the sister of Edward IV, and his execution was the most effective means of ridding Henry VIII of an unwelcome Yorkist rival. At his death all the de la Pole family estates were appropriated by the Crown. Amongst them came Ewelme and, as part and parcel of this, the patronage of God's House. The foundation was valued by the King's commissioners in 1526 (when it was estimated to be worth £64), but it was not assessed in the *Valor Ecclesiasticus* of 1535 and it survived the various rounds of dissolution.

Of the impact of the Reformation on God's House little can be said with certainty. The sixteenth-century history of the foundation is ill-documented and such papers as do survive from this period provide few insights into its affairs. In institutional terms the foundation continued to function in exactly the same form as it had done before the Reformation, with a Master, Teacher of Grammar and thirteen poor men. But the daily life of the community must

have been transformed by the religious changes of the period. With the prohibition of prayers for the dead and the abolition of the Mass God's House was bereft of its central devotional purpose and practice. It was left a fortunate but anomalous survivor from the wreckage of the Reformation.

As a wealthy institution, however, the foundation was not to be passed over indefinitely. In 1617 James I decided to augment the salary of the Regius Professor of Medicine at Oxford by attaching the Mastership of Ewelme, with its stipend, to the post. A few years later, in 1628, after a royal commission was appointed to correct certain unspecified abuses in the institution, this arrangement was made permanent, and it has continued to the present day. In consequence the Master of Ewelme has, for more than 350 years, been an absentee with no previous knowledge or connection with the place, and this circumstance has benefited and prejudiced the foundation by turns ever since.

For much of the seventeenth century the workings of the foundation remain obscure, but there are clues from surviving accounts as to various continuities of practice from the late Middle Ages. In 1637, for example, a new set of seats was constructed for the community in the almshouse chapel, an indication that this was still serving as their particular place of worship and implying that some regular life of prayer continued. In the late 1660s there is also a record that the prolonged absence of the Teacher of Grammar, a certain Mr Everard, prevented documents from being stored in the medieval common chest designated for the purpose. This was because the chest was locked with three keys held by different members of the community, as the Statutes of c.1450 direct, and he had taken his key away with him.

Towards the end of the seventeenth century important changes become apparent. From the 1680s onwards it is clear that non-residence amongst the almsmen was officially licensed, although for a short while it involved a cut in salary. Similarly, in about the same period it seems likely that the Teacher of Grammar's post became a sinecure: in 1712 the then Teacher of Grammar, William Howell, lodged a complaint against the acting Master, a certain Dr Taplow, for forcing him to undertake duties not outlined in the Statutes. Precisely what these duties were is not clear, but it is implied from the insults exchanged that the real Master, who was by then living abroad, had previously excused Howell from any duties whatsoever.

Aside from illustrating the state of the foundation in this period, Howell's dispute demonstrates that God's House was still legally governed by the unreformed medieval founders' Statutes, despite the fact that the regulations they contained were at almost total variance with the reality of daily life there. This situation, not properly rectified for a further hundred years or more, was common to numbers of surviving medieval institutions in the eighteenth century and the quarrel at Ewelme is representative of several similar disputes elsewhere. Like many other medieval foundations, God's House at Ewelme also grew very rich in this period: its medieval endowment had appreciated exponentially in value, a change from which all the members of

the community benefited according to their degree. The Teacher of Grammar, still usually resident at Ewelme, took the opportunity of having his house modernized in 1774 at the expense of the foundation. Had the Master and the whole community of almsmen been resident, there can be little doubt that the entire complex would have been similarly treated at this time.

In 1817 the Crown put the manor of Ewelme up for sale and it was bought by the Earl of Macclesfield. By virtue of his ownership of the manor he became patron of the foundation, a position enjoyed by his successors to the present day. Shortly afterwards, in 1822, a certain John Kidd acceded to the post of Master of God's House. He became passionately interested in the history of Ewelme and over the 1840s was responsible for a thorough restoration of the almshouse chapel. Although the rigour with which he systematically recreated the medieval interior of the chapel is perhaps regrettable today, it is impossible not to be impressed either by the result of his work or by the scholarship that it reflects. He also produced several valuable studies of the Muniments, including a concordance of accounts that records the contents of some lost documents from them.

Shortly before this, in the 1830s, the then Rector of Ewelme, Dr Burton, restored the church and, reputedly, the school building also, which was by now derelict and ruinous. He apparently undertook this latter project with the intention of re-establishing a working school at Ewelme, but when Burton died in 1836 his plans were not pressed forward. The Teacher of Grammar's post, meanwhile, remained a sinecure and in 1866 was allowed to lapse. The last incumbent, George Faithful, lived on his benefice in Leicestershire and rented his school building, now fitted up as a house (apparently at the common cost of the foundation), to the curate of the parish, Mr White.

The affairs of the poor men in this period would be an interesting subject for research. It would appear that from the eighteenth century the Minister had become responsible for overseeing the day-to-day life of the community and directed prayers within the almshouse chapel every morning and evening. This state of affairs probably persisted into the nineteenth century, but since at least half of the poor men were now permanently non-resident it is possible that even this practice had lapsed. In financial terms the men did well, possibly extremely well, as members of the community. Aside from any working income – and several poor men evidently did earn a private salary – they not only received two shillings per week from the foundation but also occasional disbursements of cash from surplus receipts. In the 1850s the Rector of Ewelme attempted to discover what their actual income was, only to be met with reluctant and evasive answers.

But such a state of affairs was not to last. There was a growing sense that the administration of the foundation was neither satisfactory nor acceptable and in 1850 the Charity Commissioners recommended that several changes be made to it. Nothing practical seems to have happened in consequence, however, and in 1860 the Court of Chancery issued directions for reforms as part of a new scheme for the management and regulation of the almshouse.

In accordance with the Court's directions, the salary of each poor man was regularized at nine shillings per week and extensive repairs were undertaken to the almshouse. After the death of the last Teacher of Grammar in 1866 work went ahead slowly to re-establish a school at Ewelme. This project was a catalogue of disasters from first to last and took several years to complete.

These changes in fact failed to answer all that had been demanded by either the Charity Commissioners or the Court of Chancery and in 1892 the Rector of Ewelme, H.J.Simcox, published a pamphlet calling for further reforms. In this he inveighed against the absenteeism of certain Trustees of the foundation and insisted that the Master should be resident. The school, he argued, was of little value considering the proximity of other good schools, and should be closed so that its funds could be disbursed as scholarships. As for the almshouse, he felt that the religious dimension of the foundation should be restored and the condition of the poor men altered. They should be forbidden to work, be provided with distinctive gowns and be served by a nurse.

Nothing came directly of Simcox's suggestions, but the following decade witnessed changes which answered some of his demands. In the late 1890s extensive repairs were made to the quadrangle, which had stoood untouched for over thirty years, and alterations were made to improve the living conditions within it. Amongst other things a wash house was built and new drains were constructed. This was the first of several major restoration projects, which have continued into the twentieth century, intended to make the medieval cottages in the almshouse meet rising modern living standards. At the same time money was set aside for the employment of a nurse and a chaplain to serve the community, although only the former was finally appointed.

In their present form the almshouse and school are independent institutions functioning under the aegis of the Ewelme Trustees, a body constituted in 1953 by order of the Charity Commissioners to administer the foundation. Over the last hundred years the school, which provides primary education within the state system, has passed through several subtly different phases, in accordance with the many changes in education on the national level. As well as being represented on the board of the school, the Trustees offer scholarships for local children. The almshouse, meanwhile, now accepts both men and women, married, single and widowed, into its community. Their housing is now divided between the ancient quadrangle – remodelled in the 1970s as a series of six flats with an enlarged Master's Lodgings – and another modern almshouse further down the village street.

ENVOI

Meanwhile the lord of the beleaguered and endangered castle lay upon a bed of bodily pain and mental agony. He had not the usual resource of bigots in that superstitious period, most of whom were wont to atone for the crimes they were guilty of by liberality to the church, stupefying by this means their terrors by the idea of atonement and forgiveness; and although the refuge which success thus purchased

was no more like to the peace of mind which follows on sincere repentance than the turbid stupefaction produced by opium resembles healthy and natural slumbers, it was still a state of mind preferable to the agonies of awakened remorse.

Walter Scott, *Ivanhoe*, Chapter xxx

Late-medieval religion is still in the process of rescue from a critical and deeply unsympathetic English historical tradition. Whether in the colourful prose of Scott or the considered scholarship of Wood-Legh, chantry devotion is presented, at the last analysis, as a religion of the dead run by the living – a way in which the wealthy sought to purchase Paradise.

In this book I have tried to present a rounded portrait of an almshouse and chantry foundation in fifteenth-century England, and to contribute thereby a fresh understanding of these institutions. My aim has been to show how chantries engaged with the living world, answering its needs rather than sapping its resources. In practical terms God's House was conceived not simply as a memorial to the dead, but as a living celebration of familial pretension and power set within the context of a great dynastic residence. Its function as an advertisement of political might is particularly apparent in the surviving architecture and furnishings at Ewelme, which have been tailored in all sorts of surprising ways to suit the particular needs of its patrons. Their analysis in this study highlights the immense value of physical remains in their own right as historical evidence, a value which is still all too often ignored or even disdained by historians.

In religious terms it has been argued that chantry devotion was not necessarily a selfish, privatized form of Christian practice – rather that while God's House was specifically created to answer the spiritual needs of its founders, this did not preclude it from serving the larger Christian community. Its value to the community was an essential part of its purpose: by providing a haven of Christian life it offered its brethren an opportunity to save their souls and, at the same time, to celebrate Divine Service which, generation after generation, would redound to the benefit of all people, living and dead, including its founders. In bringing souls to salvation, chantries were understood to be actively supporting individuals in every stage of a passage which stretched from their birth through life and Purgatory to the seat of Judgement. The living and the dead had different needs, but prayer could help both simultaneously, and a dead founder was therefore by no means its only spiritual beneficiary.

As originally conceived, God's House at Ewelme represented a supremely practical form of religion, capable of embracing concerns of piety, patronage and politics, which our contemporary world, with the sharp distinctions it has chosen to draw between them, finds difficult to reconcile.

The appendices

The Ewelme Muniments: an introduction.

The Ewelme Muniments: an introduction

The Ewelme Muniments are essentially a collection of business documents gathered together by the foundation over a period of five and a half centuries. This book has only used a fraction of this remarkable archive, which would prove an equally fruitful source for the study of the social and religous history of subsequent periods. Despite their importance, Ewelme's medieval documents remain little known and can only be read in the original, or in selective (and sometimes inaccurate) transcriptions. These appendices present transcriptions of several of the more important documents within them. (See the note in the Bibliography, below, on these documents and their present locations.)

The composition and provenance of the medieval Muniments

The vast majority of the medieval documents in the Ewelme Muniments relate directly to the almshouse and its affairs, and the collection includes accounts, deeds, court rolls and so on. The earliest of these documents drawn up by the administration of the foundation survive from the mastership of William Marton (appointed in 1455), but deeds, manor accounts and court rolls from the almshouse estates survive from the fourteenth century onwards. These must have been passed on to the foundation by the de la Poles with the endowment.

Alongside such items relevant to the almshouse administration, are several documents which appear to have no direct connection with the foundation at all. By considering briefly how they come to survive at Ewelme it is possible to date several of the most important of these and to throw light on how the remainder of this collection was constituted. The documents in question are as follows:

1 A 3 – a grant of land in Altofts (Yorks.) dated 1360

2 A 7 – rent rolls from Gristhorpe and North Clifton in Lincolnshire dated 1384

3 A 8 – a bond from Thomas Bylton, vicar of Tickhill, and Thomas Bilton, a merchant of York, to Ellias Sutton, dated 1396

4 A 9 – papers relating to the above bond dated 1404

5 A 29 – a tripartite indenture relating to the appointment of John Stanground as Prior of Snape (Suffolk) by Alice de la Pole, endorsed London 26 October 1461

6 A 36 – a fifteenth-century transcription of deeds relating to the ownership of Appulby in Lincolnshire by a certain John Langton; it is addressed to 'the mighty and noble John, Duke of Suffolk' and must date therefore from the late 1450s onwards

7 A 37 – an estimate by Hawe of Occold for the remodelling of the chancel of Wingfield Church under the direction of Alice de la Pole (undated)

8 A 40 – a receipt for money paid towards the cost of 'Maremer for my Lordes tomb stoon' by Alice's chaplain Simon Brailles, dated 10 January 1460

9 A 41 – detail of a fee farm owed to Alice de la Pole, a copy of a document dated 8 October 1461

10 A 42 – an agreement with the Prior of the Hull Charterhouse dated 1 October 1462

11 A 44 – two receipts for payments received by Lord Hastings from Alice de la Pole. In the first instance this was conveyed by the hand of Thomas Dey and in the the second by Simon Brailles; the receipts are dated 10 May 1462 and 7 May 1465 respectively

12 A 45 – power of attorney to Simon Brailles by John, Duke of Suffolk, to empower him to enter into various Lincolnshire manors, dated Wingfield, 5 March 1464

13 A 47 – a collection of inventories and receipts for goods from Ewelme Manor dated 1466

14 A 48 – a series of undated letters from Alice de la Pole to William Bylton

15 A 49 – a bill for constructing a timber-frame house, cryptically entitled 'The Bylton thyng' and undated

16 A 50 – one of Alice's letters patent dated 3 May 1467 concerning a wardship, with a covering letter to Simon Brailles.

On the face of it these documents are hard to account for amongst the foundation's papers, but two figures might provide a key to explaining their presence. The first is Simon Brailles. He is identified as Alice's chaplain and household Treasurer in BL Ms. Egerton Roll 8779. This records, in evidence of his trusted position, that in one year he paid bills totalling £488 5s. 11d. on behalf of Alice under his own seal. The careful attention to detail that no doubt recommended him to his office is revealed in the roll itself: he not only corrected and signed his section of the account, but also carefully inserted his own surname 'Brailles' where the scribe had simply identified him as *Simonis*

Capellano. Four of the above listed documents dating to the period between 1460 and 1467 (items 8, 11, 12 and 16) are directly concerned with his affairs and must have belonged to him. Their passage to the Muniments may have occurred at Brailles's death, because the then Master of the almshouse, William Marton, was evidently a friend and both witnessed his will (dated 25 April 1469) and benefited from it (see p.125 above).

Given Brailles's importance within Alice's de la Pole's household, and the variety of business that these documents associated with him encompass – from arrangements for a wardship, to making payments for a tomb – he also seems the most likely figure to have possessed the other papers in the Muniments relating to family business. Not only is he (as a household administrator) the most likely figure to have drawn up and retained the Charterhouse agreement draft (item 10), but as an agent he would also have had interest in copies of other legal documents of relevance to his mistress and John de la Pole (items 6 and 9). Through his involvement with John de la Pole's estates (evidenced in items 6 and 12) the fourteenth-century papers relating to Lincolnshire and Yorkshire properties (items 1 and 2) might also be plausibly associated with him. So too would the draft agreement for the remodelling of the chancel at Wingfield (item 7) and the indenture relating to the appointment of the Prior of Snape (item 5). Since all the dateable fifteenth-century papers that have been associated with Brailles were written between 1461 and 1467 it seems likely that this whole collection (items 1–2, 5–12 and 16) is comprised of documents relating to his business over that period.

The presence of the remaining documents – items 3, 4 and 13–15 – in the Muniments is rather more difficult to account for, but one possiblity is that they belonged to a certain Robert Bilton (Bylton). I can offer no bibliographical details of this man's life, but the three letters written to him by Alice de la Pole (item 14) would suggest that he was a favoured member of the household based at Ewelme. His connection with the Manor might explain his ownership of the Palace's inventories and associated indentures. His surname might also suggest a connection with the otherwise mysterious items 3, 4 and 15.

In conclusion, a tentative case may be made for all the medieval documents at Ewelme having derived from four sources. The first is documents relating to the administration and ownership of the almshouse estates. Of these, the earliest were passed on to the foundation by the de la Poles at the time of its establishment. Second is the documentation generated by the almshouse administration from William Marton's accession to the mastership in 1455 onwards. Third, there is a collection of documents relating to the de la Poles' family concerns dating to between 1460 and 1467, which were in the possession of Alice's chaplain, Simon Brailles. Finally, there is a miscellaneous set of documents owned by a favoured member of the household, Robert Bilton, who was based at Ewelme.

The documents transcribed here

Every transcription in these appendices is headed by its catalogue number in the Bodleian Library (or at the PRO in the case of Appendix VIII) and is preceded by a short introduction. This gives a rough idea of the document's physical dimensions, the material on which it is written and any other details of interest, such as watermarks. It also presents any relevant information concerning the document in question and describes any special editorial conventions that may have been used in the transcription. Unless otherwise stated in the introduction, the following conventions have been applied:

1 Spelling, capitalization and punctuation (which includes /. and // symbols) are all as they appear in the original. The only exception to this rule concerns proper names, for which capitals have always been supplied.
2 Letters supplied in place of abbreviation marks have been printed within square brackets so that it is always clear, despite the expansion, what the document actually reads. Words have only been expanded where there are abbreviation marks in the original.
3 The expression of monetary denominations has been standardized throughout the transcription regardless as to how they appear in the document. The sum of five pounds seven shillings and six pence ha'penny, for example would be expressed in the transcription as £5 7s. 6$^1/_2$d .

A few other symbols have been used to help clarify the transcriptions:

1 Passages bracketed by arrows pointing up appear written above the lines of the text on the document: ^inserted^.
2 Passages that have been crossed out in the original are indicated with outward-pointing brackets like this: '<oh damn>'.
3 Illegible passages are marked '…'.
4 Where a reading is clear but incomprehensible to me it is followed by a question mark in square brackets, possibly with a suggested interpretation: 'gobbledygook [?]'.

All my own notes supplying suggested readings, omitted letters and so on appear in square brackets. Tentative readings of illegible passages appear, if at all, in square brackets as well.

Appendix I

The Statutes of God's House, Ewelme

Introduction

Despite the great many buildings and furnishings that have survived at Ewelme, relatively little could be known about the life of the foundation in the fifteenth century were it not for its Statutes. Written in English and largely compiled between 1448 and 1450, they outline in about 10,000 words what the foundation was; its conceived purpose; what it was endowed with; and its regulations: the duties of its officers and poor men; their wages; the rules by which they were to abide; the manner in which they were to be disciplined; and the system by which the house was to be administered. Such sets of statutes were drawn up for every religious foundation in this period as well as for some secular households and guilds (see the section 'Hospital, college and guild statutes', below). Judging from those that have survived, they could differ widely in length and form.

In order to use the Statutes as an historical source it is necessary to bear in mind that they were conceived as a legal document with a very particular purpose in mind. In essence, they are a contract between the patrons on one hand and the community on the other, describing in detail what each owes and expects in return: essentially an exchange of prayers for charity. But since no one doubted the willingness of the community to accept the charity, the real emphasis lies on what the de la Poles wanted to get out of the almshouse in return. They must not, therefore, be read uncritically as a description of day-to-day life.

THE COPIES OF THE STATUTES

The Statutes survive in two fifteenth-century copies which, apart from occasional variations in spelling, are identical in substance. The first – subsequently called the Charter Copy – is written on two large pieces of vellum. As its Latin preamble and postscript explain, the copy is a charter drawn up by the Archbishop of Canterbury to confirm the terms of the

foundation. It was common practice in this period to get papal, archiepiscopal or episcopal confirmation for religious foundations, although Ewelme is unusual in having acquired this so long after it was established.[1] Its preamble also explains that the then Master, William Marton, had brought the Statutes for reconfirmation at the instruction of the wills of the late founders. The Charter Copy is dated at Lambeth, 30 November 1480 and was originally sealed, but the seal is now lost.

The second copy is written as a book of twenty-eight folios (bound as two bifolios and three quires). It is $6^6/_8$ in x $9^7/_8$ in (16 cm x 25 cm) in size and survives in its contemporary stamped satchel leather binding. Amongst the stamps used on the cover is a double-rose design, a common decorative motif, but one which also appears on the counterpoise to the font in Ewelme Church and on Alice's signet ring. The binding would appear to be of mid-fifteenth-century date, but I have been unable to find any identical stamps on other books which might serve to date it more accurately or suggest a provenance.

Throughout, the text is evenly written in a single and distinctive Gothic hand with twenty-four lines to a page (see Fig.89). The script is very fine and profusely decorated with hairlines. Each paragraph or regulation begins with a lightly illuminated initial decorated by a web of red tracery lines flowing down the margin and has been numbered in a nineteenth-century hand. The pages were once copiously annotated but these notes were effaced at some stage in order to return the manuscript to a more pristine condition. What is legible of these annotations shows them to be in both English and Latin and in a wide variety of hands from the fifteenth to perhaps the seventeenth century. The annotation might suggest that this was used as a working copy of the Statutes, much as regulation LXXXVII directs: a set of the Statutes to be available to the community that they might read and understand them more fully.

Book copies of statutes appear to have been quite common in the fifteenth century although they vary in form from quires tied into booklets, as at All Souls College, Oxford, and Eton College, to bound copies such as that at Ewelme and Whittington's Hospital.[2]

DATING THE STATUTES

Neither of the fifteenth-century copies of the Statutes gives a date for their compilation, but it has always been assumed – probably correctly – that the text of the Statutes can be dated to between June 1448 and May 1450. Such a dating would accord both with the legal formula they employ – discussed below – and with their internal evidence: principally the fact that William de la Pole is described within them as both living and as Duke of Suffolk, a title he acquired on 2 June 1448, less than two years before his murder in May 1450. Nevertheless there are complications in dating them precisely. The Statutes were probably not drawn up at one time, and, although a version of the text was certainly in existence by 1450, it was altered at least once after this date. In order to understand these complications of dating it is necessary briefly to consider how sets of statutes were drawn up in this period.

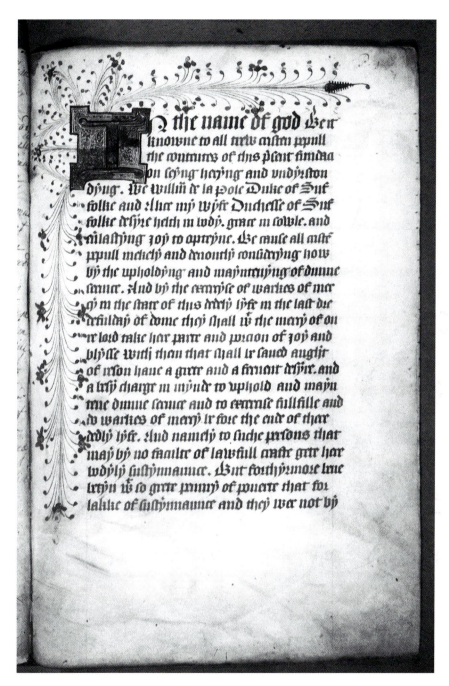

89 The preamble to the Ewelme Statutes. This book was probably produced in Oxford in 1456 after Thomas Benefaunt had reformed the Statutes. It preserves its original leather satchel binding stamped with double roses.

It is clear from the surviving statutes of other fifteenth-century foundations that it was typical for such documents to be drafted and revised several times, usually over a period of years, before they were finalized and sealed by the founders. The exact process of compilation varied between patrons and

institutions. Two examples roughly contemporary to Ewelme, however, illustrate the kind of process by which they were probably drawn up.

A glimpse of the very first stage of compilation can be seen in the surviving documentation relating to the foundation of Tattershall College (Lincs.). Before work on it had otherwise begun, its patron, Ralph Cromwell, set out his thoughts on the foundation in a preparatory document for the statutes. This is organized as a series of questions and answers, for example: '[question:] Whether he [Cromwell] will present the Master himself, or whether it shall be done by election? [answer:] He will present during his lifetime …' [179]. This document was evidently intended to be the basis for a formalized set of statutes, which would express the patron's choices in formulaic legal terms. Cromwell actually died on 4 January 1456, before the college had been established, and a formalized version was only drawn up by Cromwell's executors about ten years later, at some time before 1458–59.[3]

Even this formalized version of the Statutes probably went through a series of revisions, as is shown in the case of the statutes of All Souls College, Oxford (granted licence in 1438), which were drawn up by Archbishop Chichele. If they ever existed, no 'questionnaire' drafts of the All Souls statutes have survived. There are, however, three different formalized versions, of which only one was dated and sealed – that of 2 April 1443. These versions were apparently drawn up one after the other, after the foundation had first begun to function. They are essentially identical documents, varying from one another only slightly in content and in detail. The explanation for this is that the first two were dry-run copies intended to be corrected in the light of the practical problems that arose in running the institution. When most of the teething problems had been dealt with, a final version was drawn up and sealed to give it legal weight and mark it out as being definitive.[4]

The internal evidence of the Ewelme Statutes therefore suggests that they were constituted in formulaic legal terms between the elevation of William de la Pole to the dukedom and his murder. Judging by the circumstances of other foundations, however, this does not preclude the possibility that the first steps in their creation took place many years previously, perhaps when William and Alice first decided to found an almshouse. This 1448–50 dating, however, is further complicated by evidence that the Statutes were altered subsequently in the 1450s. The circumstances of these alterations may shed light on the changing constitution of God's House and narrow our dating of the rendering of the text into its legal formula to the year 1450.

THE REFORMATION OF THE STATUTES

There are two entries in the Master's Accounts that make it clear that the Ewelme Statutes underwent revision at least once subsequent to 1450. In 1456, between 13 April and 16 May (judging by the neighbouring dated entries), Master William Marton went to Oxford to undertake a 'reformation of the statutes':

Item pro expensis Magistri Willmi Marton Oxon' pro reformacione statutorum *v.s*

Then between 28 May and 26 June, in the following account of the same year, a certain Dr Thomas Benefaunt was paid 20s. 'for his work in the reformation of the statutes':

@Item doctori Thome Benefaunt pro labore suo in reformando statuta xx.s

This reference to Doctor Benefaunt (alias Twynge), a prominent university figure, is intriguing because he was a contemporary of William Marton in Queen's College, Oxford – they were elected fellows of Queen's in 1438 and 1441 respectively.[5] Marton also served as Treasurer to the college in 1453–54, a post that Benefaunt had held only two years previously between 1450 and 1451. This fact makes it seem likely that it was through Marton that Benefaunt was called upon to reform the Statutes.

As for the entries themselves, their close proximity would imply that they relate to the same, rather than two different, 'reformations' of the Statutes. Perhaps William Marton visited Oxford in the first instance for a consultation on the work and to make a small advance payment for it. Unfortunately we cannot be sure what Thomas's 'reformation' of the Statutes actually entailed: the surviving fifteenth-century copies of the Statutes are identical in content and, since one is dated 1480, both must derive from Benefaunt's reformed document. As has been argued in Chapters 3 and 6, above, however, it seems probable that they included rewriting the section which dealt with the school, the Teacher of Grammar and his duties.

The large sum of money paid for Benefaunt's work might suggest that he extensively altered the Statutes, but this seems unlikely for reasons of internal evidence. There are a number of historical circumstances woven into the formula of the text which prove that the pre-1456 text was not being rewritten. John Seynesbury, the first Master, is described in the Statutes as if he had just been appointed, whereas we know that by the date of Benefaunt's revision he was in fact dead; the post of Teacher of Grammar is described as vacant whereas in fact by 1456 John Clifford had been recently appointed to it; and, as has been noted already, William is described as living and as sealing the document, whereas in reality he had been dead five years.

If Benefaunt had undertaken a major revision of the text, these are all details one would reasonably expect him to have changed, as was often done when foundation documentation was updated.[6] That he did not do so suggests that Benefaunt undertook minor revisions to an existing text, much as can be seen in the case of the revisions of the statutes of All Souls. The substantial sum of money he received in return probably reflects the high wages that a senior university figure could command. It may also include the costs of copying the new text fairhand; in fact, an identical sum of 20s. was paid by Eton College in 1452–53 'for writing a book of statutes and for corrections to the other book of statutes'.[7] Indeed there are good reasons for believing that the book copy of the Ewelme Statutes is the very text that Dr Benefaunt drew up. In order to understand why, a third medieval copy of the Ewelme Statutes, BL Ms. Harleian 113, must be introduced.

BL Ms. Harleian 113 is a rebound sixteenth-century book copy of the Ewelme Statutes. The manuscript contains thirty-three folios, of which the first two are pages scraped clean of a Latin text with illuminated initials. The last five folios are lined and pricked but blank. These folios at either end of the book contain a number of notes which date the manuscript. Folio 1 is cut from a scrap sheet which bears the trimmed jottings 'Universis et singulis Cristi fidelibus [cut off]' and 'anno H [cut off]'. This evidently refers to Henry VIII, because on the following folio there is a note 'Henricus octavis Dei Gratia' in the same hand. On the folio incorrectly numbered 31 recto a hand has added a note describing Henry VIII as Supreme Head of the Church in England, a title he assumed in 1534. The two additions seem to prove that the leaves of the book were cut after Henry VIII came to the throne (1509) and that the text was completed between 1534 and the King's death in 1547.

The most curious feature of the copy is that its text, written for the most part in a cursive early-sixteenth-century hand, clearly imitates the fifteenth-century book copy of the Statutes: it is identically arranged with twenty-four lines to a page, and each regulation begins with an illuminated letter which reproduces the spider-web lines of the Muniment version's decoration. The British Library copy also contains little sections of text written in a rather crude imitation of the distinctive Gothic script found in the Muniment's copy. The appearance of this imitative copy of the Muniment's book version of the Statutes in the early sixteenth century is a curiosity, and it is one circumstance which hints at the possibility that there never was a sealed version of the Statutes: if the book of the Statutes was the authoritative text it might explain the deference of this copy towards it. The circumstantial evidence for such a supposition is strong.

As has already been argued, it is clear that the Statutes were prepared sufficiently late for it to have been possible for William's murder in May 1450 to have intervened to prevent their sealing. If he never sealed them, Alice's well-testified devotion to her husband might easily have caused her to preserve the Statutes and to instruct Benefaunt in 1456 to reform them while preserving their original and anachronistic details. The document he produced then became definitive, but by reason of its anachronism and William's death, an unsealable version of the Statutes. Such a sequence of events would explain a number of the anomalies surrounding the Statutes: first, why no sealed version of the Statutes survived, or is recorded as surviving, in the Muniments of an institution that has never ceased to function to the present day; second, why archiepiscopal confirmation of the foundation was sought so late – the Charter Copy was a means of giving the unsealed Statutes legal force; and third, a point which has not yet been discussed, why there is no indication as to when the Statutes were sealed.

There are occasional examples of sealed sets of statutes without sealing clauses, although in the majority of cases one was included. But when a clause was included, it was universal practice to note the date and often the place of ratification. In view of this it is very curious that, although both fifteenth-

century copies of the Statutes include a sealing clause, neither provides these details. This is perhaps particularly strange in the case of the Charter Copy, where one would expect the authoritative sealed version – had it existed – to be presented for inclusion in the document. This was evidently not done, however, or we should have the information. It is tempting in view of all this to speculate that there never was a sealed copy of the Ewelme Statutes. If that was the case, Benefaunt's anachronistically phrased revision would have had to be adopted without seals, as the authoritative version of the Statutes – a fact which might have been remembered in the sixteenth century when this British Library manuscript was made.

The Ewelme Statutes are impossible to date precisely because they were certainly compiled and altered over a period of years. It seems likely, however, that a formalized version of them was drawn up between 1448 and 1450 and, if William's murder prevented their being sealed, most probably towards the latter date. This first version of the Statutes was then altered in 1456 by Dr Benefaunt but, perhaps in deference to William's memory, his alterations did not bring the document fully up to date, and the structure and content of the version that survives today is essentially that of the 1448–50 text. Because the book copy of the Statutes was copied as an authoritative version in the sixteenth century, it seems reasonable to suggest that it is the text Benefaunt was responsible for drawing up in 1456. It was never sealed, but its Statutes were given legal weight in 1480 by being drawn up as part of an archiepiscopal confirmation charter.

THE FORM OF THE STATUTES

The Statutes are expressed throughout in the first person plural, as if William and Alice were themselves dictating the details they contain. They open with a short preamble followed by eighty-nine regulations of very varied length. These begin on line 67. They conclude with a clause 'In witness of all this foresaid our seals to this present writing we have put'; though, as I have argued above, this may never have actually occurred.

Like most medieval documents, statutes tend to follow standardized formulae and the Ewelme Statutes are no exception. In content they share much in common, and occasionally even phrases or whole regulations, with other roughly contemporary statutes. But there are two sets of statutes that match them closely – the statutes of Whittington's Hospital in London, sealed in 1424, and the statutes of Ellis Davy's Almshouse in Croydon, sealed on 27 April 1447.

The relationship of the formula and structure of these three texts deserves brief consideration. Of the two, Whittington's are the closest to Ewelme's and, by juxtaposing two passages from the two texts, it is possible to illustrate their close similarities. It should be explained that the Whittington's Statutes describe a hospital for thirteen poor men with a poor man or 'Tutor', and not a priest, acting as its head, hence there is no mention of Divine Service. Whittington's almshouse was attached to a sister collegiate foundation and

both were established after his death by his executors. Here the Ewelme text is on the left, the Whittington one on the right:

In the name of God be it knowne to all trew cristen pepull the contentes of this present fundacion seyng heryng and understondyng. we William de la Pole Duke of Suffolke and Alice my wyfe Duchesse of Suffolke desyre helth in body. grace in sowle. and everlastyng joy to opteyne. Be cause all cristen pepull mekely and devoutly consideryng how by the upholdyng and mayntenyng of divine service. And by the excercyse of warkes of mercy in the state of this dedely lyfe in the last dredefulday of dome they shall with the mercy of oure lorde take here parte and porcion of joy and blysse with them that shall be saved aught of reson have a grete and a fervent desyre. and a besy charge in mynde to uphold and mayntene divine service and to exercise fulfille and do warkes of mercy be fore the ende of there dedly lyfe. And namely to suche persons that may by no faculte of lawfull crafte gete here bodyly sustynnaunce. But forthyrmore bene betyn with so grete penury of poverte that for lakke of sustynnaunce and they wer not by almesse relevyd they shuld lyghtly peryshe. This we devoutly consideryng we William and Alyce abovesayde have beldyt erecte and foundid an howse of almesse for two prestes and. xiij. pore men to dwell and to be susteyned in the same all tymes to come in perpetuite set and edified upon a certeyne grownde of oures perteynyng to oure maner and lordshyppe of Ewelme in the cownte of Oxenforde annexid un to the churche yerd of the parysh churche of Ewelme in the west syde of the sayde church beyng in the est syde of the sayde howse of almesse. But for more clere and playner fundacion and ordinawnce and stabiliment of the sayde howse and persones the whyche shall be susteyned fowndyd and relvyed in the same. The might of the fadir the wysdom of the son the goodness of the holy goste thre persones in oon godhede: humbly we beseche of his grace principally be oure helpe socoure and

Omnibus Christi fidelibus praesentium continentiam visuris vel audituris ... [the names of Whittington's executors] ... salutem et gaudium consequi sempiternum. Viri providi et devoti fervens debet esse desiderium et cura sollicita labilis vitae suae statum et terminum cum operibus misericordiae praevenire; et praesertium personis illis miserabilibus providere quibus penuria paupertatis insultat ac facultas artificio seu labore alio corporeo vitae necessaria quaerere dinoscitur interdicta ut in die tremendi judicii portionem accipiat cum salvandis. Quod devote considerans venerabilis mercator Ricardus Whittington antedictus cujus manus dum vixerat ad egenos et pauperos liberaliter et largiter sunt extensae de domo quodam elemosinae pro sustentacione perpetua pauperum hujusmodi post ipsius obitum ordinanda nos executores suos praedictos in lecto transmigrationis suae districtius oneravit suam nobis in hac parte voluntatem plenius dedurando. Nos vero voluntatem ipsius tam piam tamque salutiferam adimplere volentes pro viribus ut tenemur fundato prius per nos auctoritate sufficenti in ecclesia S. Michaelis de Riola London ... Fundavimus etiam juxta voluntatem supradictam unam domum elemosinae pro tresdecim pauperibus successivis temporibus imperpetuam moraturis et sustentaturis in eadem situam et aedificatam super quondam solo quod propter hoc nuper emimus in parochia S. Michaelis antedicti; scilicet inter dictam ecclesiam et murum includentem vacuum locum retro summum altare eiusdem ecclesiae ex parte australi ... Ad quorum quidem domus et pauperum fundationem ordinationem et stabilitationem ulteriores pleniores et clariores Dei Patris potentia, Dei Filii sapientia, et Spiritus Sancti clementia per nos primitus invocatis procedimus in hunc modum.

spede the whyche called in and aspired:
we procede in thys manere.

Ffyrst licence graunted and auctorite of the most noble Prince and lorde kyng Harry the sexte kyng of Engelond and of ffraunce ...	*In primis de licentia concessione et auctoritate tam serenissimi principis et domini domini Henrici Sexti, Regis Angliae et Franciae moderni ...*

Significantly, the overall structure of these two documents is also broadly the same: a preamble followed in order by a description of the royal licence, a description of the head of the institution, a description of its buildings, and so on. Their chief difference (aside from language, of which more below) is in length: the Ewelme Statutes are probably twice as long as the Whittington's and include substantial extra sections of text.

It seems very unlikely that the Ewelme text was copied from that of the Whittington statutes. Rather, the similarities of these two texts suggest that both institutions were looking to a common model for the form of their statutes, and that this model was expanded, added to or tailored to suit their respective needs. This conclusion is substantiated by the evidence of the Ellis Davy's Almshouse statutes. These also include a large number of identically phrased regulations to those of the Ewelme and Whittington's statutes, which again appear in a similar sequence in the overall structure of the document. These parallels are discussed in Chapters 5 and 7, above.

The similarities of the Ewelme Statutes to two texts, sealed respectively in 1424 and 1448, is clear substantive evidence for their suggested dating (completed by 1448–50). It would be interesting to know whether the model for these three texts was just a widely recognized formula or whether it was derived from the statutes of a particular prestigious foundation, and, moreover, whether the formula is a 'London-based' one. Whatever the case, it is revealing to see just how many of the beguiling minutiae of the Ewelme Statutes are actually drawn from the formula they employ.

THE USE OF ENGLISH IN THE STATUTES

The most striking contrast between the Whittington and Ewelme statutes is their respective use of Latin and English. This difference of language between two closely related sets of statutes indicates that Ewelme was breaking from the tradition it grew out of, a change which reflects wider trends in linguistic usage in this period. Until the fifteenth century all statutes of religious foundations were drawn up in Latin, and this language was to remain in use for collegiate institutions until the Reformation. It is clear, however, that from the late fourteenth century English enjoyed wide currency in the statutes of other corporate religious bodies, such as guilds.[8] The survival of English translations of Latin statutes at such places as Whittington's Hospital further suggests that beneath a concealing layer of official documentation English was also widely used in early-fifteenth-century almshouses. On occasion, the linguistic problems created by Latin statutes in almshouses are dealt with in official documentation: the 1425 statutes of the Hospital of St John the Baptist

at Coventry, for example, allowed the brethren to take their oath in English (rather than Latin) and explain that this is by reason of their poor education [660]. Nevertheless, the Ewelme Statutes are amongst the first sets of foundation statutes formally written in English and considering the emphasis they lay upon the almsmen understanding their contents this may not be a coincidence. From the 1450s onwards English became the rule for almshouse statutes. It was used, for example, in the case of Ellis Davy's statutes and also in the slightly later statutes of the Heytesbury Almshouse (c.1472).

ABOUT THE TRANSCRIPTION

The transcription conventions outlined on p.212 apply here.

The transcription that follows is arranged in two columns. The left-hand column is the transcription of the book's text with the pagination marked in it: for example /1/ for the end of page 1. These numbers are not folio numbers but refer to the page numbers written into the text at some later date. Folio numbers have been used, however, to indicate the location of notes in the pages at either end of the book. The lines of the transcription are numbered and I have also numbered each regulation in roman numerals. Punctuation in the manuscript is limited to full stops and colons. These serve almost any function, sometimes marking the end of a sentence, sometimes standing where a modern writer would place a comma. Though the marginal notes have been largely effaced I have reproduced those that are still legible, as well as all later underlining of the text, as can be seen for example on ll.84–9.

The right-hand column is composed entirely of notes to the text. Those in roman type are the legible notes from the manuscript, but the remainder, in italics, are my own and they summarize the sense of the adjacent passage in the Statutes. For more complex passages this is sometimes an attempt at a translation. I have also supplied headings in capitals to give a sense of the structure of the document.

The Statutes of God's House at Ewelme
(Bodl. Ms. DD Ewelme d.42)

Fo.1v – An entry to say that the book had been used as 'Item Y of evidence' in Chancery case 'Mary Townsend, Deforciant' in 1744.

Fo.2r – A text of the initiatory oath taken by the brethren and priests described in regulation LXXXV. It is written in a very clumsy hand which could be of almost any date, but the spelling, content and form make it look like a convincing copy of a fifteenth-century text. A number of interlineations and corrections have been made in an eighteenth-century hand which I have transcribed in italics. Here is the text, which begins with 'IHC', standing for IHS, the so-called Sacred Monogram of the name of Jesus:

[IHC]

Ye shall sweere by the co[n]tentte of thatt boke that ye shall treuly kepe and obs[er]ve to the best of yo[ur] power and connuyge all and singler thies statute w[ith] in thise boke p[er]teynge to yow ^*being agreable to goddes worde and the lawes of this realme*^ aft knowlege of them be Gifen to yow and not to dispise them and also to be contentt w[ith] all suche correccons accordynge to the said statutte . Also ye shall sweere that yf ye be puttowtt of this hows accordyng to the statutte thatt then ye shall not hereaft[er] labor p[ro]aire [?] or purchas any lordde lade or any other p[er]son or p[er]sons lett[ers] to rele*sase* remitt ^*or*^ extincte any p[ar]tt of correccons or punnyshmentte contrarie to the statute maide for the same . And also ye shall sweere thatt if heraft[er] ye be put owtt of this hows for ev[er] accordynge to the ordinances of the statutte that ye shall in no wyse labor or sew to come in aygeen ne vexe trebull or strife w[ith] any man<e> for the expulsion owtt of the same so helpe yow god <and all [a blank] sanctes> . and heyre ^*ye contentes of*^ the<e>ys boke

Fo.2v – Memorandum of a judgement given by John, Duke of Suffolk, that the Rector has responsibility for the repair of the so-called 'long wall'. This is a corrupt eighteenth-century copy of the same judgement that appears written in a sixteenth-century hand in BL Ms. Harleian 113, f.32 recto.

Fo.3r – The Statutes begin. They are written on both sides of each page.

At the end of the book, in the pricked but blank folios, the following notes appear: Fo.28v – This has the beginning of a setting of the response for the dead in plain chant '*Animi nostro domine speram non confunder …*'. On the recto of the same page is a record of the signature of a bill on 14 April of the twentieth year of Elizabeth I's reign [1578]. Scribbled in the top right-hand corner of the same side are four sets of numbers in different hands:

1, 11, 13, 15.
5, 6, 12, 13, 49, 59, 61, 85.

Interpolated into the above sequence are:

15, 50, 52, 79[?75]
49, 50, 51, 52, 53, 54, 57, 59, 61, 63, 69, 72, 81, 82, 83, 85, 87, 88.

On the last page of the Statutes there is an enormous (about 2" square) and very shakily executed signature 'SUFFOLK'. This is popularly believed to be that of John, Duke of Suffolk, but though it is certainly modelled on his signature it is far too clumsy and large to be his. The Harleian manuscript has several Suffolk signatures doodled onto its last page.

The text

In the name of God be it knowne to all trew cristen pepull the contentes of this p[re]sent fundacion seyng heryng and
5 undyrstondyng. we Will[ia]m de la Pole Duke of Suffolke and Alice

THE PREAMBLE, *addressed to all Christians*

William and Alice desire health in body, grace in soul and salvation.

my wyfe Duchesse of Suffolke
desyre helth in body. grace in
sowle. and ev[er]lastyng joy to
10 opteyne. Be cause all criste[n]
pepull mekely and devoutly
consideryng how by the
upholdyng and mayntenyng of
divine service. And by the
15 excercyse of warkes of mercy in
the state of this dedely lyfe in the
last dredefulday of dome they
shall w[ith] the mercy of Oure
Lorde take here parte and porcion
20 of joy and blysse with them that
shall be saved aught of reson
have a grete and a fervent desyre.
and a besy charge in mynde to
uphold and mayntene divine
25 service and to excercise fullfille
and do warkes of mercy be fore
the ende of there dedly lyfe. And
namely to suche persons that may
by no faculte of lawfull
30 crafte gete here bodyly
sustynnaunce. But forthyrmore
bene betyn w[ith] so grete
penury of poverte that for lakke
of sustynnaunce and they wer
35 not by /1/ almesse relevyd they
shuld lyghtly peryshe. Thys we
devoutly consideryng we
Will[ia]m and Alyce abovesayde
have beldyt erecte and foundid
40 an howse of almesse for two
prestes and. xiij. pore men to
dwell and to be susteyned in the
same all tymes to come in
p[er]petuite set and edified upon a
45 certeyne grownde of oures
perteynyng to oure maner and
lordshyppe of Ewelme in the
cownte of Oxenforde annexid un
to the churche yerd of the parysh
50 churche of Ewelme in the west
syde of the sayde church beyng in
the est syde of the sayde howse of
almesse. But for more clere and
playner fundacion and
55 ordinawnce and stabiliment of
the sayde howse and persones
the whyche shall be susteyned
fowndyd and relvyed in the
same. The might of the fadir the

All Christians know how, by maintaining Divine Service and performing Works of Mercy in their lives, they may be saved.

All people should therefore fervently strive to maintain Divine Service and perform Works of Mercy while they are still alive.

Considering this, William and Alice have recently constructed an almshouse to support worthy objects of mercy – men who have no livelihood and are abjectly poor.

The almshouse is to support two priests and thirteen poor men in perpetuity.

It has been built on the edge of the churchyard of Ewelme Church on land belonging to the manor.

So that the house may be better founded we, with the help of the Trinity, proceed in these Statutes as follows.

60 wysdom of the son the goodness
of the holy goste thre p[er]sones in
oon godhede: humbly we
beseche of his grace p[ri]ncipally
be oure helpe socoure and spede

65 the whyche called in and aspired:
we procede in thys manere.
ı Ffyrst licence graunted and *The King's licence for the foundation.*
auctorite of the most noble Prince
and lorde kyng Harry the sexte

70 kyng of Engelond and of
ffraunce. we /2/ woll and orden *The almshouse is founded in perpetuity*
principaully to goddes worshyp *principally for God's worship to the increase*
to the increce of oure merites that *of the de la Poles' merit.*
now at thys tyme be and shall be

75 and aught to be for evyr in
perpetuite in the sayde howse of *There shall be two priests and thirteen poor*
almesse dwellyng and susteyned. *men sustained in the house for ever. The*
ij. prestes and .xiij. pore men aftyr *priests and poor men shall be appointed at*
the hole discretion and good *the discretion of the subsequent guardians,*

80 consciens of the provisors *founders and patrons.*
funders and patrons of the sayd ij. prestes
howse in this present writyng
afterwardes to be rehersed to be
provided and admitted the which

85 dayly shall pray aftyr dewe *The duty of the poor men and priests is to*
oportunite of tyme for quikke *pray for the living and the dead.*
and dede as it shall be in this
p[re]sent wrytyng aftyrwardes THE MASTER
rehersed. of the whiche prestes *The first priest, to be called the Master, is*

90 oon principally to be preferred in *responsible for the temporal possessions of*
power and reverence we woll *the almshouse.*
that he be called maystyr of the
almesse house to whoos office it
shall long and perteyne the

95 goodis of the sayde howse the
whiche shall co[m] un to his
hondis well and trewly to
ministyr suche wyse that the
sayde goodes anymaner

100 disperclet he shall gadyr togeder
and thoo goodes I gett and
gadered to gedyr he shall to the
profet of the sayde howse safely
kepe. Also he shall be besy and *The Master's responsibility for the Christian*

105 doo hys trew dili /3/ gence that *life of the foundation.*
charite pees and rest be had and
kept amonge the bretheryn good *The Master as an example in his living to*
exsaumples of vertuys in his *the other members of the foundation.*
levyng and spekyng he shall

110 vertuysly and sadly shew to the
which forsaydde maystyr we
woll and ordeyne that the todyr

prest and all the pore men of the
sayde howse now p[re]sent and to
115 com in all thyngis the whyche
perteynyth to the honeste
worship and profyte of the sayde
howse that they trewly obey and
intende as it semyth in any wyse
120 that it is lefull and expedient.
Fothirmore wyllyng to the sayde
howse aftyr the forme of oure
sayde fondacion trewly to
p[ro]vyde at the begynnyng a
125 chaste preste in body discrete and
devowte in sowle that of good
begnnyng may grow and be
p[er]severant good continuaunce.
Therefore now first a clene preste
130 aftyr oure estimacion in gracious
lyfe beyng we put in to the sayde
howse and ordeyne to be mastyr
of the same comonly called and
named Syr John Seynysbery late
135 p[er]sone by long continuance of
tyme of the sayde parysh of
Ewelme. the whych preste to
oure purpose aftyr oure conceite
ryght apte we hafe p[re]fered and
140 /4/ ordeynyd and now at this
tyme we p[re]ferre and ordeyne to
be maystyr of the sayde howse of
almesse. cause and grete occasion
mevyng us to hys preferryng to
145 the sayde howse bifore a clerke
graduate is at this tyme for his
longe contynuede service and
attendaunce that he had in the
byldyng of the sayde chirche and
150 howse also.
II Also we wyll and ordeyne as
for the secunde prest that ther be
provyded a wele disposed man
apte and able to techyng of
155 gra[m]mer. to whose office it
shall longe and perteyne
diligently to teche and informe
Childer in the faculte of
gra[m]mer. P[ro]vyded that all the
160 childer of oure chapelle of the
tenauntes of oure lordshyp of
Ewelme and of the lordshypes
perteynyng to the sayde almesse
howse now p[re]sent and alle
165 tymes to com frely be taught

*The Master as the chief authority of the
founation to whose decisions all must defer.*

*That the foundation may thrive, the first
Master must be a man of unimpeachable
personal qualities.*

*One such man, in our opinion, and our
appointee, is Sir John Seynesbury, lately and
for a long while parson of Ewelme.*

*Sir John was the overseer of the building
work of both the church and the almshouse.*

THE TEACHER OF GRAMMAR
*The second priest is to be responsible for
teaching grammar.*

*He is to teach children of Ewelme and of all
the almshouse estates for free.*

w[ith] oute exaccion of any
Scolehire.

III Also we woll and ordeyne
that yf it so be the mayster be
170 absent in occupacions for the
welefare of the forsayde howse.
or in p[re]chyng of the worde of
god or lettyd by sekenesse or
odyr resonable causes: that
175 tha[n]ne /5/ the forsayde techer
of gra[m]mer say hys masse whan
he is disposed at suche an oure
that the pore men may be present
there at. And aftyr the same
180 masse say the suffrage of Deus
misereatur. as it shall aftyrwardys
be rehersed. And in the same
wyse hys evynsong in the church
before the forsayde pore men
185 with De profundis with the
suffrages therto perteynyng.

IV Also as for the forsayde .xiij.
pore men we woll and ordeyne
that one of theym wele disposed
190 in wysdome and discrecion be
called minister to whose office it
shall longe trewley to p[re]sent
errors and defawtes of the
forsayd pore men to the
195 mayst[er] w[ith] oute fraude or
gyle. and to ryng the comyn bell
to the service and suffrages as it
shall aftyrwardes be rehersed.

V Also we woll and ordeyne that
200 the sayde ministyr diligently take
hede that the dores and yates of
the forsayde almesse howse
nyghtly be lokked at dew tyme
assigned by the maystre.
205 Ffothyrmore for the fullfyllyng
and execucion of the forsayde
fu[n]dacion we actually p[ro]vyde
and put in to the sayde howse
.xiij. pore men clene and gracious
210 /6/ of lyvyng aftyr oure
estimacion of the whiche one
comonly named John Bostok we
p[re]fere and ordeyne to be
minist[er] of the pore men and
215 almesse howse forsayde. The
whych howse of almesse thys
wise by us fundid and of new late
edified w[ith] the free entryng to

*The second priest is to be the Master's
substitute, saying Divine Service during the
latter's absence.*

In absencia Magistri

THE MINISTER
*One of the poor men is to be chosen as
Minister, responsible for presenting the
faults of the others to the Master.*

*The Minister is to ring the almshouse bell,
and to act as a warden of the almshouse
buildings.*
*The Minister is to lock the almshouse gates
each night.*
Portam clausenda

*Thirteen suitable poor men have been
appointed and provided for the foundation.*

Minyster
Of these John Bostok is the first Minister.

THE ALMSHOUSE BUILDINGS

the same and goyng owte from
220 the same as towardis the seid
churche or othir weys
p[er]teynyng to the same howse
now of late tyme by us ordeynyd
with lyghtis wyndowis
225 chemeneys welle clostre Gutters
Swolous prevye Gardeyns wallis
Gatis with all othir comodites
and aysementis p[er]teynyng to
the same soo fully hole as they be
230 p[er]teynyd I hadde and edified at
thys tyme. how eu[er]e the sayde
howse lye or be edified at thys
tyme with his Gardeyns wallis
Gutters Swolous lying or beyng
235 up on any p[ar]tye of the
grownde longyng or p[er]teynyng
to owre maner and lordship
above sayde wee yeve grawnte
and by the tenure of this p[re]sent
240 wrytng with the kynges licens
and auctorite a bove sayde wee
assigne to the maistre and the
techer of gra[m]mer and pore
men of the same howse to have
245 and to holde /7/ all the sayde
howse of almesse with all the
comoditees and aysementis
forsayd perteynyng at thys tyme
to the same to the sayde maistre
250 and techer of grammer and pore
men and to theyre successouris
for herre dwellyng and
inhabitacion for evir with oute
any impeticion lettyng or any
255 occasion of us of owre Eyriss or of
oure assignes what soo evir they
be in pure and p[er]petuall
almesse wyllyng and ordeynyng
that the sayde howse be called
260 and clepid p[er]petually goddis
howse or ellys the howse of
almesse And that we both
coniunctly be verely beleved
named and take fownders of the
265 same perpetually.
 VI Also we woll that this present
wrytyng and ordynaunce verrely
shewe and signifie all tymes to
com that it is oure full and hole
270 will that the sayde maystre techer
of gra[m]mer and pore men and

Entries and access to the church.

The land on which the almshouse and its associated buildings and fittings have been constructed is assigned to the foundation.

We bequeath all this to the Master, Teacher and poor men jointly and their successors in perpetuity.

The almshouse is to be called GOD'S HOUSE *or* THE HOUSE OF ALMS.

William and Alice are to be jointly remembered as founders in perpetuity.

THE ENDOWMENT

This document is proof of our willing endowment of the priests and poor men of this institution with three manors, without

theyre successours for ev[er] more
have and holde of oure yiffte and
graunte to them and their
275 successours for ev[er]e in pure
and p[er]petuall almesse to her
sustenaunce and to bere othir
certeyn charges aftyrwardes in
this oure p[re]sent ordynaunce to
280 be rehersed .iij. maners /8/ with
theyre hole appurtenaunce.
Excepte thadvowso[n]s of the
Churches p[er]teynyng to the
seide maners to us and oure
285 heyres reserved. Of the which .iij.
maners one is cleped Ramruge in
Hamptshyre. the secunde.
Connok in wiltshire. the .iij^de. is
cleped mersh in the shire of
290 Bokyngham lyke as it appereth in
the dedes munimentis and
grauntes openly made of the
saide .iij. maners with their
appurtenaunces to the sayde
295 maystre and techer of gra[m]mer
and pore men to their successours
in p[er]petuite withoute any
impetycion lettyng or any
occasion of us of oure heyres or of
300 oure assignes what soo ev[er]
they be.
VII Also yf any time to come any
lorde or lady the which shall aftyr
oure dicesse reioyce and opteyne
305 the sayde lordshyp of Ewelme
p[re]sume to covetyse or malice
as god defende to hurte the sayde
howse of almesse and take away
from the same by any cause or
310 occasion any party or porcion of
the lyflode or grownde I
graunted and yeven to the sayde
howse by us. than we woll that
the Chaunceler of Englond beyng
315 for the ty/9/me and hys
successours. and the Tresorer of
Englond beyng for the tyme and
hys successours have full power
to take away from suche a sayde
320 covetous lorde or lady all suche
maner lyflode p[er]teynyng to
oure saide fundacion and to
restore it to the forsayde howse of
almesse ayeyne. and that the

their advowsons, in perpetual charity in
order that they perform certain offices which
are to be described.

The manors, given without their advowsons,
are Ramridge in Hampshire, Connok (now
Conock) in Wiltshire and Mersh (Marsh
Gibbon) in Buckinghamshire, as is recorded
in the almshouse deeds.

Should anyone try to steal these endowments
the then Chancellor and Treasurer of
England are empowered to restore them to
the foundation.

325 forsayde Chaunceler and Tresorer
beyng for the tyme by vertew of
thys p[re]sent wrytyng be speciall
protectours and defendours of the
same howse. And also be

As protectors of the foundation the Treasurer and Chancellor shall receive mention in the foundation's prayers for ever.

330 p[ar]teners of the suffrages and
preyeres of the sayde howse
p[er]petually.

VIII Also we woll and ordeyne
that the sayde Mayster and all

PROVISION FOR THE COMMUNITY
The Master's quarters and garden.

335 thoo maystyrs to come the whiche
shall be p[ro]vided aftyr hys
dicees to be maystyrs of the sayde
howse by certeyn p[ro]vision as it
shall afterwardes be rehersed

340 have and holde for their
habitacions and dwellyng places
such chambres hall kechyn and
gardeyns with all other
aysementes as at this tyme is

345 edified for hem withyn the
p[re]cinkte of the sayde howse of
almesse withoute any impetycion
lettyng or any occasion of any
partye./10/

350 IX Also we woll and ordeyne that
the forsayde techer of gram[m]er
and all thoo that shall occupey
the same office in tyme to com
have and holde for thayre

The scolers lodging
The Teacher of Grammar's quarters and garden.

355 habitacions and dwellyng places
suche chambres hall kechyne and
gardeyn with othir aysementis as
at this tyme is edifiede for hem
withyn the p[re]cinkte of the

360 sayde howse of almesse withoute
any impeticion lettyng or any
occasion of any partye.

x Also we woll and ordeyne that
the seyde minister and his

The poor men's lodging
The poor men's quarters.

365 successours and ev[er]y of the
seyde pore men and theire
successours have and holde a
certeyn place by them self within
the seyd howse of almesse that is

370 to sayng a lityl howse a Cell or a
Chambir with a chemeney and
othir necessarijs in the same. in
the whiche ev[er]y of them may
by hym selfe ete and drynke and

375 rest and sum tymes among
attende to contemplacion and
prayoure.

XI Also wee woll and ordeyne that the mayster of the seyde

380 howse for the tyme beyng receyve and take of the provent / 11 / ijs of the seyde howse for his pencion and stipendye termely .l.s. that is to say .x.li in the yere.

385 XII Also we woll and ordeyne that the forsayde techer of gra[m]mer for the tyme beyng receyve and take of the proventis of the seyde howse by the handes

390 of the maystre for his pencion and stipendie termely .l.s. that ys to say .x.li in the yere. <u>he beyng resident and fulfyllynge the charges langynge to hym</u> by the

395 statute.

XIII Also wee woll and ordeyne that the seyde minister and his successours shall receyve of the proventis of the seyde howse by

400 the handes of the mayster for his part porcio[n] and sustinaunce .xvj.dˢ. wokely that is to say .lxix.s. iiij.dˢ. in the yere.

XIV Also it is ordeyned that

405 ev[er]ich of the seide pore men and theire successours shall receyve of the proventys of the seyde howse for theire part porcion and sustinau[n]ce by the

410 handis of theire minister of the delyveraunce of the saide mayster wokely .xiiij. dˢ. that is to say .lx.s. viij.dˢ. in the yere. / 12 /

XV Also wee woll and stablisshe

415 that the seide Mayster and his successours shul have of the proventis of the same howse for theire necessarie costes and expenses. and for theire

420 servauntes in theire companye or by the seide maystres to be sent at alle tymes nedeful. for surveyng emprowyng letyng to ferme. arreryng and receyvyng of the

425 lyflode of the same howse. or for any othir occupacion doyng for the wele of the seyde howse aftyr the discrecion and conscience of the seide. maistres and of

430 thauditours of the same howse for

THE SALARIES OF THE FOUNDATION
The Master's salary.

The Teacher's salary.

The Minister's salary.

The poor men's salary.

The Master and his servants are to have their expenses paid while on almshouse business.

In ryding abroad

The Master's expense claims are to be regulated by him and the almshouse auditors.

the tyme beyng.

XVI Afftyr such seide fundacion
and induyng I ordeyned by us in
our p[ar]tye for the seide <u>maister</u>
435 <u>and the techer of gra[m]mer and
pore men and theire successours
we devoutly desyre that ev[er]ich</u>
of them in theire p[ar]tye be
funded in good an sadde lyvyng
440 in hym selfe and indued with
godly and spirituall occupacion of
very trewe trusty and devoute
dayli prayoure <u>in the whiche we
have grete trust and hope to oure</u>
445 <u>grete relefe and increce of oure
merite and ioy /13/ fynally.</u>
Therefore first and byfore alle
othir thyng and by cause that god
woll that man intende and desyre
450 principally soo to be demeyned in
his lyvyng that he may therby at
the last have and opteyne the
kyngdom of heaven. we woll and
ordeyne that ev[er]ich ministyr
455 and pore man and theire
succesours dayly in theire
uperysyng knelyng byfore theire
beddis shall say <u>.iij. pater nostirs
.iij. Aves and a Crede.</u> desiryng.
460 inwardly in theire sowlis that our
soverayne lord kyng of Englond
kyng Harry the sext <u>and wee
theire seide fownders</u> and all
othir cristen pepill mow soo be
465 demeyned in oure lyvyng that at
the last we mow have and
opteyne the kyngdom of heven.
<u>And for the same good intent
wee woll that the mayst[er] and</u>
470 <u>the techer of gra[m]mer shall say
dayli in theire uprisyng this
salme. Deus misereatur.</u>
XVII Also we woll and ordeyne
that ev[er]y feriall and werke day
475 sone aftyr .vj. at the clokke in the
mornyng shall with the comyn
belle of the seide howse by the
ordinaunce of the seide ministyr
a peele be ronge to mattyns
480 thanne aftyrwardis as it may
seme /14/ to the discrecion of the
maystir of the seyde howse. that
the seide pore men mow be araid

THE SPIRITUAL FOUNDATION

*All the inmates must be of good living and
endued with true, trusty and devout daily
prayer. It is to this that we trust to our relief,
and to the increase of our merit, by which we
hope for salvation.*

*To that end, because God wills that man
attempt to be so demeanoured in life that he
may come to salvation, so the first prayers of
the poor men when they get up are to be for
the good demeanour of the King and William
and Alice in their lives.*

*They shall offer three Our Fathers, three Hail
Marys and three Creeds wishing for this in
their hearts while kneeling before their beds.*

The Master
*To the same end the priests shall say the
Deus Misereatur when they get up.*

*The common bell is rung soon after six
o'clock on work and ferial days to warn the
poor men of Matins.*

*The poor men must array themselves in their
habits and proceed to the church when the*

and redy to com to churche. the
485 secunde pele I rong the maystre
shall procede and bygynne his
mattyns and continue to the ende
with prime and ouris in the seyde
paryshe churche of Ewelme.
490 XVIII Also wee woll and ordeyne
that at .ix^e. at the bell aftyr
rynggyng to the maystyrs mass
he shall in the chapell of Seynt
John Baptiste p[ro]cede to say hys
495 masse if he be wele disposed.
And at .iije. at the clokke aftyr
mete in the seide worke dayes .ij.
pelys I ronge with the seyde bell
he shall procede in the seide
500 church to hys Evensonge and
continue tyll compleyn be sayde.
Except the tyme of lentyn whan
aftyr the rewle of the churche
evensonge ys sayede a fore none.
505 lasse thanne for summe resonable
cause he be moved to say the
seide service or any partye therof
sumwhat rathir or sumwhat latyr
thanne in the seyde ouris. but
510 comynly and custumabely he
shall kepe the seyde ouris in
sayng of the seide service in
feriallis and werke dayes.
XIX Also we woll and ordeyne
515 that the holy /15/ dayes the seide
Maistre shall say his matyns and
evensonge in the chauncelle of the
seyde churche with the p[er]son
or his substitute if so be that they
520 be there present in dew tyme. so
that in no wyse for plesaunce of
lorde or lady or of any othir
persone neythir for any mede to
be hadde of any p[er]sone he
525 shall leve any wyse the seide
service to be unsayde in the the
seid churche byfore the seide pore
men in the seide werke dayes and
holy dayes in the seide dewe and
530 behofull tymes. but if he be let by
sekenesse or p[re]chyng of the
worde of god. or by visitacion of
ffadyr and modir. or any othir
resonable cause.
535 XX Also we woll and ordeyne
that the forseide techer of

*bell is rung a second time. Matins is
followed by Prime and in due time by the
other Canonical Hours.*

THE MASTER'S DUTIES

*At nine o'clock, if he can, the Master is to
say Mass in the Chapel of St John the
Baptist.*

*At three o'clock after two more peals on the
common bell he will go to the church for
Evensong and remain there until Compline,
except in Lent.*

*Offices must be recited at the customable
times, but there is to be some flexibility for
convenience.*

*On Holy Days the Master is to say Matins
and Evensong in the chancel with the parish
priest or his substitute – if they are there on
time – so that, unless reasonable
circumstances intervene, the poor men may
always hear these Offices at the correct
times.*

*The Teacher must join the Master and the
parson in their Offices on Holy Days.*

gra[m]mer in the holy dayes say
his divine service in the chauncell
with the p[er]son or his substitute
540 as it is byfore seide of the
maystyr.
 xxi Also wee woll and ordeyne
that if it so fortune in any tyme to
com the techer of gra[m]mer have
545 not ore .iiij. childer that actually
lernes gramer beside pettetes and
reders. that thanne he shall say
matyns and evensonge dayly in
the seide churche of Ewelme with
550 the /16/ seide mayster before the
seyde pore men.
 xxii Also wee woll and ordeyne
that every minister and pore man
forsayde and theire successours
555 withyn the seyde churche of
Ewelme whanne they mowe best
therto attende shall say dayly for
the most noble astate of oure
seide soverayne lord the kyng
560 duryng his lyfe and for the good
astatis of us theire seide funders
duryng oure lyves and for the
statis of all them that bene alive.
and for the sowle of oure saide
565 soverayne lord aftyr his discese.
and for the sowlis of oure both
fadirs and moders and all cristen
sowlis .iij. tymes oure lady
psawter. a psawter conteynyng
570 thryes .l. Aves w[ith] .xv. Pater
nostris and .iij. Credis lasse than
any of them be let with febilnesse
or any othir grete cause lawfull
and resonable to be appreved and
575 allowed as it shall be aftyrwardis
rehersed. or in lasse that it be
chauged in to sayng of oure lady
mattyns. with vij. psalmes and
letanie or sayng. Placebo and
580 dirge. with com[m]endacionis or
ellys w[ith] saying of diverse
nocturnis of the psawter or any
othir devoute redyng by the wille
as /17/ sent and assignement of
585 their seide fownders or by the
will and assent of the seide
maystyr the whiche shall have the
seide fownders power in this
partye.

*If there are less than four children actually
learning grammar the Teacher is to join the
Master and poor men at Matins and
Evensong every day.*

*All the poor men shall pray, at a time that is
convenient to them, in the church for the
good estate of the King, the founders and all
Christian people. When these are dead they
shall also pray for their souls, and those of
our parents and of all Christian people.*

*To this end they shall say the Lady Psalter
three times, containing fifty Hail Marys,
fifteen Our Fathers and three Creeds.*

*They may be exempted from this if they have
a reasonable excuse.*

*They may alternatively say the Our Lady
Matins with the Seven Psalms and Litany
OR Placebo and Dirge with Commendations
OR several Nocturnes of the Psalter OR
reading approved by the Master or founder.*

590 XXIII Also wee woll and ordeyne
that ev[er]y seide maystyr minister
and pore men ev[er]y day to come
the which may well doo it. and
ev[er]y holy day the techer of

595 gra[m]mer aftyr the saide masse
to be sayde by the seide maystyr
shall gadir them self to gedir
abowte the tow[m]be of our fadyr
and modir Thomas Chawcer and

600 Mawte his wyfe where they shall
say this psalme Deus misereatur.
with the comyn suffragijs used to
be sayde for the quyk w[ith] this
Collet. Deus qui caritatis. And

605 thoo of them which shall not
conne say it shall say .iij. Pater
n[ost]ris .iij. Aves and a Crede.
the which I done the Maystyr if
he be p[re]sent or the techer of

610 gram[m]er or the minister or one
of the brotheris shall openli and
distinctly say in the Englissh tong
duryng the lives of oure seide
soverayne lord and of us both.

615 God save in body and sowle oure
soverayne lord the kyng my lord
Will[ia]m Duke of Suf/18/folk my
lady Alyce Duchesse of Suffolk
his wyfe oure founders my lord

620 John theire son and all cristen
pepill the brotheris answeryng
Amen. And aftyr the dessesse of
oure soverayne lord and of us
both wee woll than the seide

625 psalme. Deus misereatur. And
the suffrage followyng be sayde
for thayme that shall succede
unto us as founders of the

630 forsayde howse for tyme of
theyre dedly lyfe and for all
cristen pepill.
XXIV Also such sayde to gedir
comyng wee woll and ordeyne to

635 be kept dayly aftir compleyn soo
that thanne De profundis shall be
sayde with the comyn suffragijs
folowyng of them the which shall
conne say it. And thoo the which

640 shall not conne say it. shall say
.iij. Pater nostris .iij. Aves and a
Crede. thys I done one of them in
maner afore specified shall say in

Every day after Mass everyone who can shall gather together round Thomas and Maud Chaucer's tomb. They will be joined on Holy Days by the Teacher.

They shall say the Deus Misereatur *with the common suffrages for the living and the collect* Deus qui Caritatis.

Those that cannot say these shall say three Our Fathers, three Hail Marys and three Creeds.

A prayer shall then be clearly recited in English.

In our lives the prayer shall be that God shall save the bodies and souls of the King, the founders, their son and all Christians.

The brothers shall answer aloud 'Amen'. After our deaths the same prayers shall be said for our successors as founders and for all Christians.

This gathering round the tomb shall also occur after Compline, but then the De Profundis *shall be said with its common suffrages. Those that cannot say it shall say three Our Fathers, three Hail Marys and a creed.*

The spoken English prayer shall be repeated,

Englissh tong. God have mercy of
645 the sowle of the noble prince
Harry the sext And of the sowles
of my lord Will[ia]m sum tyme
Duke of Suffolke. and my lady
Alyce Duchesse of Suffolke his
650 wyfe oure fyrst founders and of
theyr fadyr and modyr sowles
and all cristen sowles. And it
shall be answard openly /19/
Amen. Also we wolle that the
655 sowles of all thoo that shall
succede unto us as founders of
the same howse aftyr theyre
discesse be rehersed by name in
the forsayde bedis.
660 xxv Also lyke wyse wee woll that
the seid maystyr and techer of
gra[m]mer devoutly recomende
to god in theyre dayly mass the
saide astatis aftyr the
665 continuaunce of theire lyves with
a speciall Collet for quykke and
the sayde sowles with a speciall
Collet for dede excepte such
masses in the whiche such colletis
670 shuld not be sayde aftyr the
ordinall of Salysbery.
xxvi Also wee woll and ordeyne
that aftyr oure discesse the
maystyr and the techer of
675 gra[m]mer yerely kepe oure
anniversary with Placebo and
dirige and co[m]mendacion and
masse of requiem at the whiche
Dirige and mass we woll that the
680 minister and all the bredyr be
present in theire devocions fro the
begynnyng to the endynge.
xxvii Also we woll and ordeyne
that the anniv[er]sary of Thom[a]s
685 Chaucer and Mawte his wyfe
oure fadyr and modyr yerly be
kept af/20/tyr the fourme
aforesaide.
xxviii Also we woll and ordeyne
690 that both the forsayde prestes say
Placebo and Dirige with
Co[m]mendacions as oftyn tymes
as it is ordeyned by the rewle of
Salysbery to say the same.
695 xxix Also wee woll and ordeyne
that dayly in p[er]petuite at .ij.

this time for God to show mercy on the souls
of the above-said and Maud and Thomas
Chaucer and all Christian souls.

When they die, the names of our successors
are to be inserted into these prayers.

Except where the Use of Sarum prohibits, the
daily Mass should include a special collect
for the living above-mentioned,
recommending their estates to God, and a
special collect for the dead above-said.

William and Alice's anniversaries are to be
kept with Placebo and Dirige with
Commendations and a Requiem Mass, which
devotions are to be attended by the whole
community.

The anniversaries of the Chaucers are to be
similarly kept.

Placebo and Dirge with Commendations are
also to be recited as often as the Use of
Sarum ordains.

At two o'clock, after Nones, the common bell
shall call the poor men to the church where

aftyr none at tollynge of the
comyn bell the minister and all
hys breyr whiche may wele do it
700 gadyr thayme selfe togedyr in the
forsayde church and there the
minister or his substitute shall
say certeyn bedis the whiche
shall be assigned hym by the
705 maystyr for the good state and
welefare of the spirituall parte of
the churche and for the temporall
parte of the churche and namely
for us theyr fyrst founders and
710 oure successouris. Aftyr the
whiche bedis the forsayde
minister and all his bredyr
knelyng on theyr kneys shall say
.xv. Pater n[ost]ris. and .xv. Aves.
715 and .iij. Credis in worshyp of the
passion of oure lorde Ih[es]u
Criste and of the Joyes of hys
blessed modyr oure lady seynt
Mary. And for gostly releve and
720 succour of thayme that be
reher/21/se in the forsayde
bedys.
xxx Also suche sayd comyng to
gedyr wee woll and ordeyne to be
725 kept dayly at sex of the clok aftyr
none or sone aftyr from oure lady
day the An[n]unciac[i]on to
Myghelmasse day. And from
Myghelmasse day to Our Lady
730 Day the Annunciacion in wyntyr
seson sone aftyr Evesong. So that
the forseyd minister shal sey a
certen bedys assygnyd to hym by
the seyd maister for our sowles
735 aftyr oure discesse oure
p[ro]genytors. And successourys
sowlys and all cristyn Sowlys.
And thys done and endyt the
forseyd minister and hys bredir
740 shall sey knelynge .xv. Aves for
the everlastynge quiete And reste
of the sowles rehersyd in the
forseyde bedys.
xxxi Also lest that this spirtituall
745 fundacion and induyng in
spirituall occupacion and
prayoure in the minister and pore
mennes partye dayly to be
excersised by any occasion of

*the Minister or a substitute shall say
prayers, as directed by the Master, for the
well-being of the spiritual and temporal parts
of the Church and the founders and their
successors.*

*Then kneeling down they shall say fifteen
Our Fathers and Hail Marys and three
Creeds in worship of the Passion and the
Joys of Our Lady for the spiritual relief of
those prayed for in the previous prayers.*

*This should be repeated at 6 o'clock after
Nones or soon after between the
Annunciation and Michaelmas and after
Evensong over the winter.*

*The Minister shall say prayers appointed by
the Master for our souls, those of our
progenitors, our successors and all
Christians. Then the poor men shall kneel
and say fifteen Hail Marys for the peaceful
rest of the same.*

ENFORCING SPIRITUAL DISCIPLINE

750 evyll be lest and put a syde
therefore we woll and ordeyne
that noon of the sayde .xiij. pore
men shall absent hym selfe fro
saying of the sayde spirituall

755 prayers and suffragijs /22/ in the
sayde church neythir fro the
sayde divine service to be sayde
in the sayd church by the maystir
or hys substitute with owte

760 resonable cause to be appreved
and allowid before the maistyr or
his substitute.
XXXII Herefore wee woll and
ordeyne that yf it so be that any

765 of the forsayde .xiij. pore men
com late to the forsayde service
spirituall occupacion or prayours
that thanne the maystyr correcte
theyme by the with drawyng of

770 theyr wages // As if it so be that
any of theym be so necligent and
slewthfull that the fyrst psalme of
matyns be begon or he come in to
his stall that thanne he lese .jd.

775 And if any of thaym be absent to
the begynnyng of the fyrst lesson
that thanne he lese .ijd. And for
absens fro prime terce sexte and
neynth for ich of thayme .jd. Also

780 if any of theym be absent fro the
masse to the begynnyng of the
pistyll that thanne he lese .jd.
And if he be absent to the gospell
that thanne he lese .ijd. Also if

785 any of theym be absent fro
evensong to the ende of the fyrst
psalme that thanne he lese .jd.
And if he be absent to the
begyn/23/nyng of the ymne that

790 thanne he lese .ijd. And if he be
absent fro Compleyn .jd. And if
any of theym be absent fro the
suffrages to be sayde at .ij. aftyr
none and at .vj. aftyr none thanne

795 he lese for ich of theym .ijd. And
if he com late to the sayde bedis
that thanne he lese .jd.
XXXIII Also we woll and ordeyne
that yf the forsaide minister or

800 any of the forsaide pore men be
rebell in dede or in worde
agaynes the correccion of the

So that the spiritual foundation and devotion of the community may not be neglected, no poor man may absent himself from prayers without good reason and the consent of the Master.

The wages of the poor men shall be docked as follows if they attend services late.

A poor man is also to lose his wages for any insubordination in proportion to his crime, as the Master sees fit.

forsaide maystyr that thanne he
correct such a rebellyous man by
805 subtraccion and takyng away of
hys wages aftyr his discrecion as
the cause requireth.
xxxiv Also in noo wyse the seyde
minister and pore men shall
810 walke much abowte in the seide
parissh neythir with owte the
seyde parissh withowte a
resonable cause to be allowed as
it is afore seyde neythyr they
815 shall be in noo wyse maynteners
neythir smaterers of straunge
quarellis and causes not
p[er]teynyng to them.
xxxv Also wee woll and ordeyne
820 that none of the seyde .xiij. pore
men be oute by space of oon oure
fro the sayde church or churche
yerde or owte of the saide
almesse howse or gardine / 24 / or
825 closur p[er]teynyng to the same
with owte resonable cause and
licence of the maistyr.
xxxvi Also wee wyll and ordeyne
that if it so be that any of oure
830 sayde almesse men be movid to
go in pylgrimage or to vysyte
theyre freyndis or odyrwyse
Consyderynge that by theyre
absence the howres of prayour
835 shall not be observyd nor kept.
the devoc[i]on of the[m] lassid by
outewarde aquayntaunce and
worldly occupacions. theyre
seetys in the churche voyde and
840 unocupyed to dyshonore of the
almesse howse. that noone of
them go in syche occupacion
w[ith]out a resonable cause to be
approvid. and lycence of the
845 mayster. And that thay so goynge
a bowte not w[ith] standyng and
lycence for tyme of theyre
absence receyve no wagis of the
almesse howse.
850 xxxvii Also wee woll and orden
that iche of the forseyde .xij. pore
men have a tabarde of his owne
with a rede crosse on the breste.
And a hode acordynge to the
855 same with out the whyche abyte

Rebell ...
[Statutes xxxix–xliv were all once
heavily annotated.]

*The poor men shall not roam around the
parish or abet or become involved in quarrels
or matters that are not their business.*

*The poor men shall not leave the bounds of
the almshouse for more than an hour without
reason and the permission of the Master.*

*Even with permission and cause – such as
pilgrimage or the visiting of friends – absent
almsmen shall receive no wages. This is
because they shall not say their prayers,
because life in the outer world shall corrupt
the purity of their devotion and because their
empty seats in church will dishonour the
almshouse.*

*The dress of the poor men: each is to have a
hood and tabard with a red cross sewn on it.*

he shal not entyr the chirche in
tyme of prayors or divyne service
in payne of lesynge of hys wagys
after the /25/ discreci[o]n of the
860 mayster.

This habit must always be worn in the church.

xxxviii Also we wyll and ordeyne
that the minister and ev[er]i pore
man use contynuelly a rede crosse
on the brest of iche one of theyr
865 gounes.

There must be a red cross on all their gowns too.

xxxix Also wee woll and ordeyne
that if any of the forsayde .xiij.
pore men absent hym selfe fro the
sayde almesse howse a quarter of
870 a yere withoute licens of the
patron and fou[n]der beyng for
the tyme and withoute lycens of
the maystyr beyng for the tyme
that than he lese the privilege
875 libertees and exibycion of the
sayde almesse howse for ev[er]
more.

If a poor man leaves the almshouse for more than a quarter of a year without leave he shall lose his place in it.

xl Also we woll and ordeyne that
all tyme to com in the which the
880 minister and pore men shall be
abydyng in the sayde howse or
any p[ar]tye therof. they shall be
restfull and pesibill with oute
noyse or troubill of here
885 felowship withowte cryyng and
grete noyse makyng attendyng to
prayers or to redyng or to heryng
of vertuys lyvyng or ellis
occupied with honeste laboure of
890 here hondys kepyng them selfe
from jaynglyng and chydyng and
in speciall from fowle
bost/26/full and ribawdise
talkyng of thyng doon in here
895 dayes thanne afore passed.

The poor men must live peacefully without disturbing each other.

They must employ their time reading or hearing of virtuous living, praying or performing honest manual labour.

They must avoid wrangling, chiding and ribald reminiscence.

xli Also wee woll and ordeyne
that noon of them be incontinent
comynly dro[n]ke a gloton a
faitour a chider Brigous a
900 mo[n]ge his felowship a taverne
hawnter or of any other suspect
or un lawfull place.

The poor men must not be known for evil living.

xlii Also wee woll and ordeyne
that the privitees and the
905 cowncelles of the seide howse
shall not be talkyd outwardis by
hem to any strange p[er]sone in
sclawndire of the sayde howse or

They must be discreet and not gossip to outsiders about the doings of the almshouse.

any p[er]sone of the same.

910 XLIII Also the seide minister and
ev[er]y of the saide pore men shall
holde hem selfe co[n]tent with
such sayde pension and porcion
p[er]teynyng to hem of the
915 proventis of the sayde howse
such wise that noon of them shall
p[re]sume to begge or to take any
worldly rewarde at any tyme for
any thyng that he shall doo with
920 any bodly laboure with oute the
saide howse to any p[er]sone or
p[ar]tie dwellyng with oute the
saide almesse howse and in
speciall to any lord or lady of the
925 lordship of Ewelme here aftyr to
come. or to any of her
servau[n]tis. /27/

The poor men must be satisfied with their stipend and not increment it by begging, performing manual labour or taking service, especially service of the lord and lady of the manor or their servants.

XLIV Also neythir neygh to the
cloyster neythir abowte the well
930 neythir neygh any porch dore
p[er]teynyng to the seyde howse
shall any unclene watir or any
filth or any harlottrie be made put
or leyde the which shall in any
935 wise cause stenche or orrour and
furthirmore displesaunce
dissecion and debate.

They shall not foul the buildings in any way.

XLV Also wee woll and ordeyne
that the minister and pore men
940 kepe clene the closter and the
quadrate abowte the welle fro
wedis and all odyr unclennesse
and theyr gardeyns and aleis in
peyne of lesyng of theyr wages
945 aftyr the discrecion of the
Maystyr.

They shall keep the cloister, the quadrangle, alleys and gardens tidy and clean on pain of losing their wages.

XLVI Also wee woll and ordeyne
that the brothers of the seide
howse beyng holer in body
950 strenger and myghtier faver and
succoure and diligently minister
to them that be seke and febill in
all behofull tyme.

The able-bodied poor men shall help the decrepit.

XLVII Also we woll and ordeyne
955 that the forsayde maystyr nor the
techer of gra[m]mer nor none of
the forsayde pore men have
drawyng to hys chambre any
man[er] of woman by the which
960 likly suspicion or sclaun /28/ dyr
myght fall to the seyde howse of

No one is to take a woman into their chamber through whom suspicion and slander will fall on the house.

almesse.

XLVIII Afftyr such sayde oure
ordinaunce that the inhabitantis
965 and dwellers of the seyde howse
of almesse by us foundid flee and
voyde evil sclawndyr unhoneste
and the occasions ther of. wee
furthirmore procede and ordeyne
970 certayn ruellis of police.
governawnce within the saide
howse to be observed and kept in
lyke wyse and maner as it
followith.

975 XLIX Wee woll that the saide
Mayster and ev[er]y of hys
successours to com with in a
mo[n]the aftyr the first day of his
ministracion in the sayde howse
980 associet un to hym the techer of
gra[m]mer and two othyr felawis
more discrete of the saide howse
they shall make a full and a trewe
Inventorie indented in twoo
985 p[ar]ties of all the comyn goodis
notabill of the sayde howse such
wyse that the toon partie of the
seyde Inventorie shall remayne
with the seide maister. that other
990 partie remaynyng in the comyn.
Tresorie I ordeyned therefore. or
in the comyn. Coofirr undyr .iij.
keyes that it may be knowe in the
ende of ev[er]y yere /29/
995 evidently what state the seyde
howse stante in by a trewe
rekenyng and a cownte yerly to
be hadde in the ende of every
yere in some day thereto apte and
1000 oportune betwene seynt lukes
day and Cristmasse next
followyng.

L Also wee woll and ordeyne that
with in .viij. days aftyr the
1005 endyng and finishyng of the
seyde cowntes that they be
rehersed openly a fore the bredyr.

LI Also we woll and ordeyne that
yerely be made a peyr of
1010 indenturis in the which shall be
wrytyn dewly and trewly all the
p[ar]cels of the resaytes of the
lordship and lyfelod that
p[er]teynes to the sayde almesse

*By these rules the inhabitants of the
foundation may avoid evil, slander,
dishonesty and the occasions of these.*

THE ADMINISTRATION OF THE ALMSHOUSE

*Within a month of his appointment the new
Master is to take an inventory of the
common goods of the house before the
Teacher and two poor men.*

*It shall be indented, one part going to the
Master, the other to the treasury, which is to
be designated, or common chest.*

*The possessions of the house shall be
reckoned annually between St Luke's Day
(18 October) and Christmas (25 December).*

*These reckonings shall be recited before the
poor men within eight days of their
completion.*

*A pair of indentures shall be similarly made
recording the house's income from its
possessions.*

1015 howse of the which indenturs
oone p[ar]te shall be kepte in the
comyn huch and the todyr parte
shall remayne w[ith] the mayster.
LII Also wee woll and ordeyne
1020 that the sayde maystyr techer of
gra[m]mer and pore men have a
comyn huch and a comyn seall to
be kept in the same with chartris
privileijs and with such letturis
1025 and scripturis and with othir
tresoure expedient to be kept in
the same. which huch we woll to
be /30/ putt and kept in a secrete
and secoure place I odeyned
1030 therefore withyn the seide howse
of almesse. to the wich huch wee
woll that ther be .iij. div[er]se
keyes havyng .iij. div[er]se wardis.
of the which keyes oon shall be in
1035 the kepyng of the sayde maystyr
another in the kepyng of the seide
techer of grammer and the third
in the kepyng of the saide
minister.
1040 LIII Also noo p[er]sone of the
sayde howse shall presume to
kepe to gedyr att oon tyme of the
saide keyes two or .iij. neythir
p[re]sume to seall with the comyn
1045 seall withoute a fore knowlech
and assent of the more partye of
the sayde p[er]sonys and
brotheris of the sayde howse.
LIV Also the mony and the
1050 tresoure or ellys juellys of the
seyde howse to be broght furth
yerly aftyr the Counte of the
sayde mayster we woll that it be
kept with diligent attendaunce in
1055 the sayde huch.
LV Also wee woll and ordeyne
that in case that any of the pore
men of the sayde howse aftyr his
admission in to the same be
1060 promoted and growe clerely to
the some of. /31/vj. mark yerly
by tityll of heritage or any othir
wyse whereby he may
sufficiantly life duryng hys lyfe
1065 withoute the almesse of the sayde
howse he shall be meved fro the
same howse and anothir pore

There shall be a common chest in which the seal, charters, privileges and valuables of the house are to be kept. This chest is to have three keys and locks held respectively by the Master, Teacher and Minister and is to be kept in a safe place.

No one shall hold more than one key or use the seal without the consent of the majority.

All the money, jewels and treasure shall be annually counted and brought forth.

If a poor man receives a private income over six marks a year, he shall be replaced.

man shall be provided unto the
same.

1070 LVI Also yf itt be soo that any of
the seyde pore men be proferred
and augmentid in rentis or
temporall proventis casually
aftyr his admission to the some

1075 of v. marke or above the same
some shall be devided in two
evyn p[ar]ties withoute any gyle or
dysseyte that oon p[ar]tye shall be
put in to the comyn huch to the

1080 vaylle of the comyn p[ro]fett of
the same howse and the pore man
such wyse encresed shall have
that othir p[ar]tie with the
porcion of a pore man of the same

1085 howse to hym rathir assyned.*
LVII Also wee woll to be kept and
observed at all tymes to come in
mayster techer of gra[m]mer and
pore men of the seyde howse that

1090 aftyr any avoidawnce of them fro
the seide howse next p[er]sone
than[n]e to be take in to the same
have for his habitacion and
dwellyng the same dwellyng

1095 place of his immediate
p[re]/32/decessoure in whos
avoydawnce he shall be take in.
LVIII Also in lyke wyse wee woll
that they have and holde there

1100 places and setis in the saide
church as we have ordeynede
assynet and put them in
possession w[ith]oute any grefe or
lettyng of any partye.

1105 LIX Also such sayde posityf
policy gov[er]naunce by us
ordeyned wee: forbede and
charge in all wyse that noo
p[er]sone by the will and the

1110 assent of the seyde maystyr and
his successours the seyde techer
of grammer and his successours
the seyde minister and his
successours of the seide pore men

1115 and ther successours any tyme to
come presume to disp[er]cle
consume yeve and ley to wedde
the commyn goodis of the seide
howse. But we woll that ev[er]y

1120 of them doo his diligence to kepe

*If a poor man receives a single sum
exceeding five marks it shall be fairly divided
in two, one half going into the common
chest, the other to the said poor man, who
will continue to receive his stipend.*

[* The first vellum sheet of the Charter
Copy ends here.]
*Upon appointment to any office in the
almshouse, the new entrant shall have the
living quarters of the man he succeeds.*

*Likewise he shall take the place in church of
the man he replaces.*

*Under no circumstances are the common
possessions of the almshouse to be allowed to
be dispersed, consumed or fall into decay.
Rather everyone should seek to improve
them.*

augment or make them bettyr.

LX Also wee woll and ordeyne that the minister and all the pore men shall yeve or leve aftyr theyr

1125 deth to the sayde almesse howse such goodys as they have in tyme of theyr saide deth: thayre dewtees and dettes payed.

LXI Also we woll and ordeyne

1130 that alma/33/ner of howsyng walles and beldynges perteynyng un to the seide almesse howse be repaired and upholdyn of the comyn costes of the same.

1135 LXII Also wee woll and ordeyne that whos ev[er] of the seide .xiij. pore men be fownde in defawte in any of the seide vices and excesses or any othir such lyke

1140 them. or breker of any of any of [sic] the reuellis and statutis of this oure p[re]sent ordinaunce: we woll thanne that he be first by dew monicion and warnyng

1145 reprevid of his defawte by the sayde mayster. And yf such seide defawte be continued in such a sayde p[er]sone aftyr such seide monicion and warnyng than[n]e

1150 wee woll the secunde tyme that he be warnyd and undir nome by the sayd mayster bi fore the techer of gra[m]mer and twoo brotheris of the seide howse. And

1155 we woll that he be suspendid fro his seyde exhibicion as for a woke. And if his defawte be continued aftyr such saide twoo degrees of correccion: thanne wee

1160 woll that he be called by the seide maistyr byfore the saide techer of gra[m]mer and the more part of the seide pore men in to ther comyn hall ther to /34/ be undyr

1165 nome and reprevid of his defawte and to be private suspendid and put froo his saide porcion and exhibycion by the space of a month aftyr such sayde .iij.

1170 degrees of correccion if such a saide defawtes and a blamable p[er]sone woll not leve such a saide undir nome and .iij. tymes

All the possessions of the poor men are to pass to the house upon their death.

The cost of repair and upkeep of the buildings is to be met from the common funds.

DISCIPLINE

If a poor man breaks the rules laid down in these Statutes he shall first be admonished by the Master.

If he continues in his fault he shall be cautioned before the Master, the Teacher and two poor men and lose his income for a week.

If he still persists in the fault he shall be called before the same with more poor men and be admonished in the common hall. He shall also lose his income for a month.

expulcyons

If all these warnings fail to work a correction

reprevid defaute thanne wee woll
1175 that he be trowid take holde and
demed incorrigible obstinat and
froward amonge hys brotheryn to
be put owte of the seyde howse
for ev[er] by the mayst[er] which
1180 shall have sufficient power in thys
p[ar]ty with the consent of the
founder and proviso[ur] beyng
for the tyme.
LXIII Also yf the saide maystyr or
1185 techer of gra[m]mer be founde in
any of the seide poyntis defauty
by trew and diligent examinacion
and inquisicion such a day and
tyme as the sayde howse and the
1190 inhabitantis of the same shall be
visite by oure successouris in the
lordship of Ewelme thanne we
woll that such a saide defaute
mayster or techer of gra[m]mer be
1195 by such a saide visitoure warnid
and charged to ame[n]de and put
away hys defaute. And if he
co[n]tinue hys blamed crime and
defaute aftyr such a sayde
1200 monicion: thanne wee woll that
another / 35 / such a sayde
visitacion he be suspende and
p[ri]vate for his pencion by the
space of amonth to be receyved of
1205 the p[ro]ventis of the seide howse.
And aftyr such lesyng of his
pencion if he continue his
punysshed cryme: thanne wee
woll at the third tyme that he lese
1210 of his pencion to be receyved of
the proventis of the seide howse
as for a quarter of a yere. And yf
he aftyr punysshmentis now
forsayd be fou[n]de the .iiij[th]. tyme
1215 defectyf in his punysshid crymes:
thanne wee woll that he as an
obstinate incorrigible and a
froward man be put oute of the
saide house for ever.
1220 LXIV Also wee woll and ordeyne
that the forseyde techer of
gra[m]mer soo sadly and discretely
rewle hys scolers that none of
theyme be tedius noysum or
1225 troublus to the seyde place or any
of the inhabitantis ther in.

he is to be expelled from the almshouse as incorrigible.

The Master shall have power to do this with the consent of the founder.

If the Master or Teacher default in their responsibilities they shall be examined on the day that the then founders make visitation of the house.

On the first occasion a defaulter shall be cautioned and exhorted to mend his ways by the visitor.

If he continues, at the next visitation he shall be admonished and lose his wages for a month.

If he persists in the fault, he shall be admonished and lose his wages for a quarter of a year.

If all these warnings fail he is to be expelled from the almshouse as incorrigible.

The Teacher must ensure that his scholars do not disturb the house.

LXV Also wee woll and ordeyne
that wee both have full and hole
power duryng oure bother lyves

1230 and that p[er]sone of us langer
lyvyng to provide to the saide
howse maystir techer of gra[m]mer
minister and pore men in the
voydaunce of any such from the

1235 seide how / 36 / se by deth or any
other wyse.

We reserve to ourselves during our lives the
right of all appointments to the house.

LXVI Also wee reserve un to us
duryng oure both lyves and to
ev[er]ych of us lenger lyvyng

1240 power to exclude and put oute of
the saide howse such maystyr
techer of gra[m]mer minister and
pore men of the same as may be
founde incorrigible in any cryme

1245 or defaute aftyr .iij. degrees of
correccion in lyke wyse as it is a
fore rehersed.

We reserve to ourselves during our lives the
right of expulsion from the house.

LXVII Also that sufficiaunt power
by oure p[re]sente ordinaunce may

1250 remayne aftyr oure both discese
therfore wee woll fothirmore and
ordeyne that aftyr the discese of
us both that that persone which
shall reioice and opteyne oure

1255 lordship of Ewelme next aftyr us
and all other to come which shall
succede to hym in the seide
lordship for the tyme which they
shull Joye and occupye the saide

1260 lordship as lordes and ladyes of
the same shall be provisouris of
the seide howse and shall have
power to provide to the same of
master techer of gramer minister

1265 and pore men in the voidaunce of
any such from the seide howse by
deth or any other wyse. / 37 /

That someone shall have the power to enforce
discipline after our death, our successors as
lord and lady of Ewelme shall have right of
appointment to the almshouse.

LXVIII Also we woll and ordeyne
that aftyr the avoidaunce of the

1270 place of any pore man by deth or
any other wyse that ther be
provided and put in an odyr in
hys place within a month or as
sone as it may co[m]modiusly be

1275 if it so be the facultees of the seide
almesse howse be sufficient ther
to.

APPOINTMENTS TO THE HOUSE
The empty places of poor men must be filled
within a month if possible, and if the
almshouse has sufficient funds.

LXIX Also by cause wee devoutly
desire that in all tymes to come be

So that the Master is well able to exhort and
counsel the poor men for their salvation and

1280 in the seide howse abydyng an
able and a wele disposed mayster
in body and sowle sadly to
conseyll and exorte to vertuous
lyvynge the sayde pore men to
1285 her comforte and salvacion
therefore wee woll and ordeyne
that aftyr oure both discese in the
voydaunce of any mayster fro the
seide howse by deth or any other
1290 wyse: that a nother lerned man of
the Universite of Oxenford passed
xxx^ti. wintir of age if any such
may be goodly be hadde be
provided and put in to the same
1295 howse ther to serve receyve and
lyve as it is above saide. And in
cas that such a seid degreed man
may not lyghtly be hadde to this
purpos: than[n]e som other able
1300 prest be provided to the same
howse to live and receyve as it is
afore / 38 / seyde.
LXX Also be cause the foresayde
office of the mayster may be more
1305 acceptable un to worshipfull and
wellerned men: wee woll and
ordeyne that the forsayde
mayster may have and halde
with the seide office a prebend or
1310 a free Chapell or odyr benefice by
the which residens and kepyng of
the seide almesse howse be not
hurte nor lette. So that by no
maner of coulour fraude nor
1315 dissayte the residens in the
forsayde almesse howse be lesset
or di[m]mysyd.
LXXI Also wee woll and ordeyne
on the forseiyde wyse that the
1320 techer of gra[m]mer be cause he
shall yeve the more dew and
bettir attendaunce to dayly
informacion and the encrece of
connynge of hys scolers may
1325 have and holde with his seyde
office a prebend or a free Chapell
or odyr benefice by the which
reside[n]s and kepyn of his scole
be not hurte nor lette. So that by no
1330 maner of colour fraude nor
deceyte the residens in the
forseide scole lesset or dimysed.

comfort, he should be a learned man from Oxford University over thirty winters old.

If it is not possible to find one such, a good priest should be chosen.

So that the post is attractive to suitable men we will permit the Master to enjoy the income of another benefice or prebend provided that it does not interfere with his duties.

So that the post is attractive to the best men we will permit the Teacher to enjoy the income of another benefice or prebend provided that it does not interfere with his duties in the school.

LXXII Also wee woll and ordeyne that the forsayde mayster holde
1335 hym co[n]tent /39/ with the forsayde exhibycion with the condicions and circumstaunces afore declared. So that he shall not receyve of noon other party
1340 by way of coveunte [? covenant] no stipendie nor wage more or lasse for saying of any service or ministryng of any sacrament And in special for the p[er]son of the
1345 saide church or his substitute.

The Master must be content with his situation and income as it is outlined here and must in no way attempt to alter or increment them.

In particular the Master must not enter into an agreement with the parish priest or his substitute over provision of the sacraments.

LXXIII Also wee woll and ordeyne that aftyr the avoydaunce of the place of maystyr or of the techer of gra[m]mer by deth or any
1350 other wyse that ther be provided and put in a nother in the place beyng voyde as sone aftyr as it may co[m]modiusly be.

Upon the vacation of the places of either of the priests a substitute must be found with as much speed as possible.

LXXIV Also wee woll and ordeyne
1355 that after the avoydaunce of the place of minister by deth or any other wyse ther be chosyn a nother of the nombre of the sayde pore men yf any such be founde
1360 emong hem able to the saide office by the assent and no[m]inacion of the maister the techer of gra[m]mer and the more part of the seide pore men.

Upon the death of a Minister a new man should be appointed from among the poor men, by the nomination and assent of the majority of the poor men and priests.

1365 LXXV Also if noon be founde able to the saide nombre of pore men to take upon him the seide office of ministraci[o]n in tyme of any /40/ voydaunce of the same
1370 office thanne we woll that the p[ro]visour of the seyde howse have full power to provide a nother able p[er]sone to be minister of the seide howse aftyr
1375 knowlech I hadde of such a saide voidaunce.

If there is no suitable man in the house for the post, then our successors shall appoint such a one.

LXXVI Also wee woll and ordeyne that noo lepre wood man nor any other in fecte and holde with any
1380 intollerable sekenesse be admitted in to the seide howse. And yf any tyme to come any p[er]son of the seide howse aftir his admission to the same be
1385 infecte with lepre or any other

ILLNESS IN THE HOUSE
No mad, leprous or infected person should be admitted to the house, but if a poor man subsequently succumbs to disease he should be removed from it to a suitable place.

intollerable sikeness wee woll
thanne he be amoved that he
infecte nat his felawship
provokyng them to orrour. And

1390 that he so mevid and translatid to
any behovefull place receyve
duryng his life for his
sustenaunce of the p[ro]ventis of
the seide almesse howse the

1395 porcion of the pore man afore
assigned. So that not
withstondyng such seide
sikenesse wee woll that he be
taken and counted one of the

1400 nombre of the sayde pore men
and of the seide almesse howse
duryng hys lyf.

LXXVII Also wee woll and
ordeyne that if it so /41/ be the

1405 mayster or the techer of gra[m]mer
be infecte notably with any of the
forsayde intollerable sikenesse
that thay on the forsaide wyse
amevid receyve of the p[ro]ventis

1410 of the forsayde place the hole
pension afore assigned to
theyme.

LXXVIII Also ev[er]y pore man to
be provided and admitted to the

1415 seide almesse howse wee woll
that he be meke in spirit pore in
temporall goodys in such wyse
that withoute othir releef than his
owen goodis he shall not mow

1420 competently live. chast in body
and of good conversacion named
and trowid y broke in age or ellys
by other maner of feblenesse to
gete his livyng.

1425 LXXIX Also wee woll that thoo
pore men y broke with age or any
other manere ympotence to gete
lawfully her lyvyng the which
may be founde that of longe tyme

1430 have be tenauntes of oure
lordship above seyde and other
lordshipes and maners within the
Countes of Oxeford and Barke
shire perteynyng to the seyde

1435 lordship of Ewelme and such also
as ben broken in oure service
impotent to laboure to her
sustenaunce and thoo pore men

Though removed he should nevertheless
continue to receive a poor man's stipend and
be considered one of the brotherhood during
his life.

If either of the priests succumbs to disease he
should be removed from the almshouse to a
suitable place where, nevertheless, he shall
continue to receive his pension while he
lives.

All the poor men must be poor in temporal
goods and meek in spirit, unable to support
themselves.

Of these, such men who have been tenants of
the lordship of Ewelme in Oxfordshire and
Berkshire, men broken in service to us, or
men from the manors belonging to the
almshouse shall be given preference in
appointment to vacancies.

/42/ in speciall that be founde
1440 dwellyng tenauntes to the
lordshipes or maners of the
which shall ryse and growe the
lifelode with the which the seide
pore men shall be susteyned in
1445 the seide almesse howse be
provided and preferred and
admitted byfore other to the
seyde almesse howse whan any
place of the same be voide and
1450 destitute of a pore man.
LXXX And by cause that wee woll
that noo man be provided to the
saide howse of almesse withoute
that he be vertuous. Therefore all
1455 of them to whom of oure present
ordinaunce aftyr oure discese it
shall p[er]teyne to the sayde howse
to p[ro]vide any mayster techer of
gra[m]mer minister or pore man in
1460 any tyme to come wee pray and
beseche them most mekely and
devoutly and with all reverence
as wee mowe wee charge be fore
god as they woll answere at the
1465 dredeful day of dome all affeccion
and unordinate love. all
corrupcion of prayer and
temporall mede cesyng and put
away no prest but chaste and
1470 discrete. no minister but apte and
disposed to his office aforeseid.
no feynyd pore man but verely
pore /43/ and devoute as it is
sayde that they provide admitte
1475 and putt in to the saide howse.
LXXXI Also how be it that div[er]se
places of almesse have be y
founded of grete pite and
devocion to be rewlyd by many
1480 ryght and resonable rewlis and
statutis to thencrece of vertue in
the inhabitantis of the same and
to exclude vices from the same.
yitte for defaute of dew execucion
1485 of the same statutis and rewlis
and for defawte of dew
visitacio[n] and correccio[n] of the
brekers of hem: such seide
howses have bene by myslyvyng
1490 and necligence y brought to grete
hevynesse and at the last to grete

Because we wish all appointees to be virtuous we exhort those who shall come to appoint priests or poor men after our decease, that in mind of the Last Judgement, when they shall answer for any corruption of prayer and when all earthly comfort shall be of no account, only to appoint virtuous men to office.

Many almshouses have been piously founded and their rules well considered to help direct the inhabitants to virtue and protect them from vice.

However, for failure to follow these sensible rules, and without sufficient visitations to enforce them, many have run to ruin.

desolacion. This wee William and
Alice abovesaide consideryng
dredyng gretely that and thyse
1495 rewles p[re]sent statutes and
ordinaunces be nat execute. The
sayde howse by us y founded
and the inhabitantis of the same
yf they be founde brekers of hem
1500 be nat also corrected and
punysshid aftyr degrees of
punysshmentis a fore rehersed
the seyde howse of almesse shall
take a grete hurt and an
1505 untollerable desolacion. Therfore
to the voidaunce of so grete and
untollerable grief as now is
rehersed wee woll and /44/
ordeyne as by oure speciall
1510 ordenaunce that the sayde howse
of almesse be visited every yere
onys by the provisours and
foundouris of the sayde howse
beyng for the tyme if so be that
1515 thaym seme it nedefull and
expedient.

*For fear that this should happen here we
ordain that the subsequent founders make
visitation once a year, if they think it
necessary.*

LXXII And upon this wee woll
and ordeyn by this p[re]sent
wrytyng that the seide maister
1520 techer of gra[m]mer minister and
pore men be obedient to apere by
fore hym in thayre comyn hall
and to his inquisicion and
diligent examinacion of the
1525 maners and condiciouns of ev[er]y
persone p[er]teynyng to the seide
howse they shull trewly answere
and witnesse the trouth and in all
other maters p[er]teynyng to the
1530 seide howse of the which they
shull be examyned aftyr her
connyng and power.

*During a visitation the priests and poor men
are to appear obediently before them in the
common hall and answer their inquiries
truthfully.*

LXXXIII Also yf the mayster or
techer of gra[m]mer of the seyde
1535 howse aftyr certeyn degrees of
correccion p[er]teynyng to hym
be founde incorrigible as it is
afore seide in tyme and day of
visitacion of the seyde howse by
1540 the seide visitour: than[n]e wee
woll that he by the seide visitour
be excluded and put oute of the
seide howse of almesse for
ev[er]more and another able be

*If either of the priests is found incorrigible in
a fault by the visitor during the visitation –
after the manner already described – they
shall be expelled and replaced (see regulation
LXIII).*

1545 put in /45/ in the man[er] afore
rehersed by the same visitoure.
LXXXIV Also yf any of the seide
pore men aftyr certeyn seyde
degrees of correccion p[er]teynyng
1550 to hem be founde incorrigible in
tyme of the seyde visitacion:
thanne wee woll that he be
excluded by the seyde visitour
from the seide howse for ev[er]e.
1555 And that anothir pore p[er]son be
provided and put in into the seide
howse of almesse by the
p[ro]visour of the same within
certeyne tyme undyr the fourme
1560 afore rehersed.
LXXXV Also wee woll and
ordeyne that ev[er]y maister,
techer of gra[m]mer minister and
pore man of the seide howse of
1565 almesse in hys fyrst receyvyng to
the seyde howse be sworne be
fore the seyde pore men in there
co[m]myn hall that he shall trewly
kepe and observe thise present
1570 statutes and rewles p[er]teynyng
to hym aftyr oure p[re]sent
ordinaunce to hys connyng and
power so that he shall nat
conntempne hem ne despise hem
1575 aftyr knowlech y hadde of hem.
And wee woll that yt be
expressely rehersed in his oth
takyng that yf any tyme aftyr his
receyvyng to the seide howse
1580 /46/ he be corrected or put oute
from the same for his myslyvyng
he shall nat appele ne compleyne
lordes lettres or mayntenaunce of
other favour of any other p[ar]ty
1585 to gete or to purchace to reles
remitte or extincte the execucion
of any degre of the seide
correccion or punysshmentis.
Nor he shall not in case he be put
1590 a wey owte of the seide howse in
noo wise labour or swe [?sue] to
com in ayeen to the same. nor he
shall stryfe vexe nor labour no
ma[n]er therfore.
1595 LXXXVI Also yf any tyme to come
any lord or lady which shall aftyr
oure discese reioyce and opteyne

If any of the poor men prove incorrigible in a
fault after the manner already described, the
visitor during the visitation shall expel and
replace them (see regulation LXII*).*

All new priests and poor men are, upon
coming into office, to swear before the whole
community in the common hall that they
shall abide by the Statutes.

It shall also be specifically sworn that if they
are punished or expelled from the house for
transgressing the Statutes, they shall not try
to alleviate the punishment for their fault.

If he is expelled he must swear that he will
not labour to be readmitted.
(See p.223 for a text of the oath.)

If any subsequent lord or lady of Ewelme
malign these Statutes or attempt to change
them maliciously they are to lose all right to

the seide lordship p[re]sume to
maligne ayeinst this p[re]sent
1600 ordenaunce or p[re]sume or
attempte to dispute any statute or
ruell of this oure p[re]sent
ordinaunce to the enervacion and
destruccion of any poynte of the
1605 same as God deffende. Thanne
wee woll also and ordeyne that
such a lord or lady so to be
disposed ayeinst any poynte of
this oure p[re]sent wyll and
1610 ordinaunce have noo power
duryng their lyfe to provide for
minister ore pore man. But wee
woll that all such power remayne
in the seide p[ro]tec/47/touris for
1615 the tyme and the dayes of such a
sayde contrarius lord or lady to
any poynte of this oure p[re]sente
ordinaunce.

*interfere with the almshouse. Their
responsibilities will then devolve on the
protectors of the house – the Chancellor and
Treasurer of England.*

LXXXVII Also wee woll and
1620 ordeyne that this p[re]sent
fundacion and this oure
ordinau[n]ce and ev[er]y chapitre
and statute of the same byfore the
minister and pore men of the
1625 seide howse by the mayster and
techer of gramer of the same
ev[er]y quarter of the yere at the
lest distinctly be redde openly
and undirstonyngly be
1630 expounded. And we woll that the
fewe rewles y take oute of this
hole ordenaunce be redde ev[er]y
month ones by the maister or
techer of gramer such a day as the
1635 seide maister semes convenient
therto. Therefore wee woll that
the maister techer of gramer
minister and pore men of the
seide howse have a trewe copy of
1640 this present ordinaunce and of the
seide rewlis y take and drawe
oute of the same to be redde
amongis hem as ofte as they woll.
that the contentis and the
1645 chapitres of the same mowe the
more inwardly be co[m]mended
to here myndes.

*The Statutes are to be read before the poor
men by one of the priests at least every three
months.*

*They must be read clearly and expounded so
that they are understood.*

*Each month a few rules must be chosen from
the whole and read by one of the priests at a
convenient time.*

*There must be a copy of the Statutes which
may be taken out and read by the priests and
poor men at leisure in order that these rules
may be committed to their minds.*

LXXXVIII Fynally to speke in this
mater wee /48/ pray and hertely
1650 besech Maister techer of

*Finally we make heartfelt plea to all members
of this foundation now and for ever that they
live in charity with one another, serving and*

gra[m]mer Minister and pore men
now p[re]sent in the same howse
and all aftyrwardis to come that
they have and kepe amonge hem
1655 selfe continuell charite servyng
praysyyng and trewly to god and
to the p[er]sones and sowles
forsaide aftyr this present
ordynaunce so lyvyng porely and
1660 mekely specially in spirit in theire
conv[er]sacion in the seide hows:
that aftyr the state of this dedlely
lyfe they mowe com and inhabite
the howse of the kyngdome of
1665 heven. the which with oure lordes
mouth is promysed to all hem the
which bene pore in spirit. so be
yt.
LXXXIX And not withstondyng
1670 this present ordynaunce wee
reserve unto us as longe as wee
lyve or to that p[er]sone of us
lenger lyvyng playn power to all
thynges forsayde adde. to take a
1675 waye from the same. Also to
declare. correcte. and chaunge the
same. And with the forseiede
ordenaunces and statutes
dispense. and new statutes to
1680 ordeyne. In witnesse of all this
forsaide oure seales to this
present writyng wee have putt.

praising God for the people and souls mentioned in this ordinance. That by meekness, especially in spirit, they may be saved; because Christ himself said that the poor in spirit shall be saved. Amen.

We reserve the right to amend these Statutes as we see fit.

We affix our seals to this.

Appendix II

The annual Audit Accounts

The annual Audit Account was a simplified overview of the foundation's dealings over the year and intended as a statement of its financial position. According to the Statutes it had to be drawn up between 18 October and Christmas and presented to the community within eight days of its completion [XLIX and L]. The fair copy of the account was written on a single sheet of parchment, but in some cases a draft duplicate, written on paper, also survives. These drafts are sometimes heavily corrected and occasionally even the fair copy of the account has been rectified.

Despite such efforts, the Audit Accounts regularly fail to balance. With such fragmentary evidence to rely on it is not always possible to say why this might be the case. Sometimes it is clearly the result of mistaken arithmetic, but there may have been other more practical problems also which caused errors. The Audit Accounts were dated from December to December, but the Estate Accounts, which recorded the income from the almshouse manors, were dated Michaelmas to Michaelmas. Because many of the dues from the manors were paid in small irregular instalments throughout the year there may have been some difficulty correlating the two sequences of accounts and confusion in deciding what income to count in which Audit.[1]

That the Annual Audits were, to some extent, financial window-dressing is most strikingly shown in the case of the £20 loan made by William Marton from the common chest to John de la Pole, Earl of Lincoln, in the 1480s. Such a large sum must have been missed but it is not mentioned explicitly in the accounts until 1500–01.

The structure of the Accounts

The heading of each Account names the current Master and the number of the audit. It also dates the span of the account using regnal years and describes the days included at either extreme. In the 1460s the accounts usually begin

on the 17 December one year and conclude on the 16 December following. This timing may indicate that the presentation to the community was intended to take place just before the feast of Christmas, eight days later. The upper half of the document deals with the income of the house and is arranged under six headings. These appear in the following order: (1) the money kept in the common chest; then the income from respectively (2) Mersh, (3) Ramridge and (4) Connok; (5) the income from the goods of dead almsmen under the heading 'de camere', 'from the rooms'; and (6) the income from fines docked from the almsmen's wages.

There are occasionally extra items inserted to accommodate extraordinary income and by the sixteenth century there are two other regular categories – 'redditus terr[a]e' (profits of the land), which records the income from property bequeathed by the almsmen to the foundation, and 'vendicacione' (sales), referring to income from the sale of timber from the house's landholdings. Previously such income, when it arose, had been included under other categories. Beneath this series of entries is a total of the income of the house.

The second half of the document lists the expenditure of the foundation under various headings. These vary slightly in organization but they generally comprise the following in this order: the salaries of the two priests; the wages of the poor men; and the other expenses of the foundation, such as repairs and travel. Beneath this is the total expenditure for the year and then the balance of the account, which was placed in the common chest. Some of the sixteenth-century accounts follow a slightly different formula, but each provides essentially the same information in roughly the same order. To avoid confusion and to facilitate their use, the following tables do not reflect changes in the presentation of the annual Audit Accounts. The tabulation of their contents, however, does follow the essential layout that has been described, with a section noting income and a section noting expenditure.

Ewelme Annual Audit Accounts 1461–64

Muniment no.	A 35 B (1)	A 35 B (2)	A 35 B (3)
Account	17 Dec. 1461 – 16 Dec. 1462; Marton's 8th	16 Dec. 1462 – 16 Dec. 1463; Marton's 9th	16 Dec. 1463 – 17 Dec. 1464; Marton's 10th
In coffer	£31 16s 3¹/₂d.	£27 15s. 5d.	£32 13s. 6d.
Mersh	£12 6s. 10d.	£25 0s. 20d.	£21 17s. 8d.
Ramridge	£18 11s. 9d.	£15 13s. 5d.	£13 11s. 9d.
Connok	£22	£21 6s. 8d.	£22
Redditus terre	—	—	—
De camere	Simon the Labourer – 20s. John Saundesley – 8s. 10d.	John Pury – 7s. 9¹/₂.d.	Thomas Smyth – 4s.1¹/₂.d.
Fines	15s. 11d.	22s.	14s. 2d.
Sale of wood	—	—	—
Total income	**£86 19s. 7¹/₂d.**	**£91.16.11¹/₂d.**	**£91.0.14¹/₂d.**
Master's Salary	£10	£10	£10
Teacher of Grammar's salary	Clifford – 100s. Greene – 50s.	£10 (Greene)	£10 (Greene)
Poor men's salary of £39 17s.4d.	£36 12s. 0d. [less 364 days' pay]	£38 2s. 11d. [less 202.5 days' pay]	£37 2s. 6d. [less 314 days' pay]
Expenses	102s. 2¹/₂d.	20s. 6¹/₂.d.	27s. 8d.
Total expenditure	**£59 4s. 2¹/₂d.**	**£59 3s. 5¹/₂d.**	**£58 10s. 2d.**
Balance	£27 15s. 5d.	£32 13s. 6d.	£32 11s. ¹/₂d.
TOTAL REMAINING	**£27 15s. 5d.**	**£32 13s. 6d.**	**£32 11s. ¹/₂d.**

Ewelme Annual Audit Accounts 1464–67

Muniment no.	A 35 B (4)	A 35 B (5)	A 35 B (6)
Account	16 Dec. 1464 – 16 Dec. 1465; Marton's 11th	16 Dec. 1465 – 16 Dec. 1466; Marton's 12th	16 Dec. 1466 – 16 Dec. 1467; Marton's 10th
In coffer	£32 11s. ¹/₂d.	£44 5s.9¹/₂d.	£44 11s. 7d.
Mersh	£18 10s. 0d.	£17 5s. 6d.	£32 11s. 10¹/₂d.
Ramridge	£25 16s. 10d.	£18 4s. 10d.	£24 18s. 6d.
Connok	£22	£22	£22
Redditus terre	—	—	—
De camere	William Curteys – 10s. ¹/₂d. Nicholas Webb – 12s. 11d. Walter Maynword – 10s. 10d. Gerard Vespilian – 10s. 1¹/₂d.	John Martyn – 22s. Thomas Pekke – 12s. 7d.	William Chaumerleyn – 29s. 5¹/₂d. John Wodeward – 6s. 3d. Richard Laurence – 22d. Tot.£0. 37s. 6¹/₂d.
Fines	13s. 10d.	13s. 5d.	9s. 9d.
Sale of wood	3d. for the lop of an elm listed with *de camere*	—	Sale of ten loads of flint – 6s. 8d.
Total income	**£100 35s. 11¹/₂d.**	**£104 4s. 1¹/₂d.**	**£126 15s. 11d.**
Master's salary	£10	£10	£10
Teacher of Grammar's salary	£10 (Greene)	£10 (Greene)	£10 (Greene)
Poor men's salary of £39 17s. 4d.	£36 2s. 8d. [less 313 days' pay]	£36 2s. 8d. [less 313 days' pay]	£34 17s. 0d. [less 600 days]
Expenses	£0 27s. 6d.	£0 69s. 10¹/₂d.	£0 51s. ¹/₂d.
Total expenditure	**£57 10s. 2d.**	**£59 12s. 6¹/₂d.**	**£57 8s. ¹/₂d.**
Balance	£44 5s. 9¹/₂d.	£44 11s. 7d.	£69 7s. 10¹/₂d.
Total assets	**£44 5s. 9¹/₂d.**	**£44 11s. 7d.**	**£69 7s. 10¹/₂d.**

Ewelme Annual Audit Accounts 1467–1500

Muniment no.	A 35 B (7)	A 35 B(26 & 27)	C.2 EA 1 (1)
Account	16 Dec 1467 – 16 Dec 1468; Marton's 14th	16 Dec 1498 – 16 Dec 1499; Spence's 1st	16 Dec 1499 – 17 Dec 1500; Spence's 2nd
In coffer	**£69 7s. 10d.**	**£74 6s. 8d.**	**£78 3s. 11d.**
Mersh	£22 19s. 2d.	£31 2s. 0d.	£22 12s. 3d.
Ramridge	£15 7s. 0d.	£16 12s. 8d.	£20 0s. 5d.
Connok	£21 13s. 4d.	£19 0s. 0d.	£37 8s. 4d.
Redditus terre	—	8d.	23d.
De camere	William Payce – £0 13s. 11d.	John Tommys – £0 4s. 10d.	Thomas Raynolds – 12s. 11d. John Rose – £4 13s. 2d. John Okelay – 14d. John Eternate – 22d.
Fines	13s 4d.	17d.	11s. 6d.
Sale of wood		[cf. below]	£8 14s. 6d.
Other income	—	£0 16s. 11d. incl, Branwhait's 10s. bequest.	—
Total goods	**£130 14s. 7d.**	**£142 5s. 2d.**	**£173 0s. 23d.**
Master's salary	£10	£10	£10
Teacher of Grammar's salary	£10 (Grene)	£10 (Dawson)	£10 (Dawson)
Poor men's salary of £39 17s. 4d.	£34 0s. 22d. [less 676 days' pay]	£38 10s. 10d. [less 156 days' pay]	£37 2s. 8d. [less 313 days]
Expenses	£0 42s. 10$\frac{1}{2}$d.	£5 10s. 5d.	£7 15s. 0d.
Total expenditure	**£56 4s. 8$\frac{1}{2}$d.**	**£64 0s. 15d.**	**£64 17s. 8d.**
Balance	£74 9s. 10$\frac{1}{2}$d.	£78 3s. 11d.	£108 4s. 3d.
Owed	—	—	£13
Total assets	**£74 9s. 10$\frac{1}{2}$d.**	**£78 3s. 11d.**	**£121 4s. 3d.**

Ewelme Annual Audit Accounts 1500–04

Muniment no.	EA 1 (2)	EA 1(3) and (4)	EA 1 (6)
Account	10 Dec 1500 – 10 Dec 1501; Spence's 3rd	16 Dec 1501 – 16 Dec 1502; Spence's 4th	6 Dec 1503 – 6 Dec 1504; Spence's 6th
In coffer	£108 4s. 3d.	£92 19s. 7d. (£33)	£101 7s. 1d. (£33)
Mersh	£23 13s. 9d.	£12 5s. 9d.	£22 4s. 6d.
Ramridge	£21 2s. 2d.	£22 2s. 4d.	£15 16s. 5d.
Connok	£20 13s. 6d.	£23 19s. 8d.	£20 2s. 8d.
Redditus terre	20d.	16d.	3s.4d.
De camere	Richard Tailor – 10s. 11d John Crue – 4s. 9½d.	Richard Bolte – 26s. 7d. William Clerke – 11s. 1d.	Edmund Sampson – 27s. 5d.
Sale of wood	—	—	£3 11s. 6d.
Fines	21s. 6d.	16s. 11d.	15s. 11d. (£0 59s. 39d.)*
Total goods	**£188 12s. 6½d.**	**£152 3s. 3½d.**	**£200 12s. 2d.**
Master's salary	£10	£10	£10
Teacher of Grammar's salary	£10 (Dawson)	£10 (Dawson)	£10 (Stele)
Poor men's salary of £39 17s. 4d.	£38 11s. 8d. [less 154 days' pay]	£34 9s. 10d. [less 645 days' pay]	£39 4s. 6d. [less 67 days' pay]
Expenses	£4 0s. 15d.	£7 0s. 13d.	£10 19s. 11d.
Total expenditure	**£62 12s. 11d.**	**£61 10s. 11d.**	**£70 4s. 5d.**
Balance	£92 19s. 8d.	£90 12s. 4½d.	£97 5s. 9d.
Owed	£33	– (£33 debt) –	£33
Total Assets	**£125 19s. 7d.**	**£123 12s. 4½d.**	**£130 5s. 9d.**

* This year a certain Thomas Alwyn, described as 'late almsman', was fined 43s. 4d for having an income of more than six marks a year at the time of his admission.

Ewelme Annual Audit Accounts 1504–07

Muniment no.	EA 1 (7) and (8)	EA 1 (9) and (10)	EA 1 (13)
Account.	5 Dec 1504 – 5 Dec 1505; Spence's 7th	4 Dec 1505 – 4 Dec 1506; Spence's 8th	5 Dec 1506 – 5 Dec 1507; Spence's 9th
In coffer	**£97 5s. 9d.**	**£101 4s. 3d.**	**£101 17s. 11½d.**
Mersh	£24 12s. 10d.	£21 0s. 22d.	£21 19s. 4d.
Ramridge	£18 8s. 5d.	£19 10s. 6d.	£18 11s. 9d.
Connok	£22 0s. 12d.	£22 13s. 3d.	£23 7s. 8d.
Redditus terre	16d.	8d.	2s.
De camere	—	—	Thomas Cowper – 21s. 6d.
Sale of Wood	40s.	51s.	8s. 4d.
Fines	22s. 4d.	20s. 4d.	15s. 6d.
Total income	**£198 11s. 8d.**	**£201 0s. 22d.**	**£201 4s. ½d.**
Master's salary	£10	£10	£10
Teacher of Grammar's salary	£10 (Stele)	£10 (Stele)	£10 (Gregory)
Poor men's salary of £39 17s. 4d.	£39 3s. 4d. [less 69 days' pay]	£39 17s. 4d. [full]	£39 15s. 0d. [less 14 days' pay]
Expenses	£5 4s. 1d.	£6 6s. 6½d.	£5 5s. 5½d.
Total expenditure	**£64 7s. 5d.**	**£66 3s. 10½d.**	**£65 0s. 5½d.**
Balance	£101 4s. 3d.	£101 17s. 11½d.	£103 3s. 7d.
Debts	£33	£33	£33
Total	**£134 4s. 3d.**	**£134 17s. 11½d.**	**£136 3s. 7d.**

Ewelme Annual Audit Accounts 1507–13

Muniment no.	EA 1 (16)	EA 1 (22)	EA 1 (24)
Account	4 Dec 1507 – 4 Dec 1508; Spence's 10th	1 Dec 1511 – 1 Dec 1512; Spence's 14th	1 Dec 1512 – 1 Dec 1513; Spence's 15th
In coffer	£103 3s. 7d.	£119 4s. ¹/₂d.	£115 5s. 2d.
Mersh	£24 0s. 22d.	£22 15s. 2d.	£31 18s. 8¹/₂d.
Ramridge	£17 18s. 9d.	£21 10s. 9d.	£22 4s. 1¹/₂d.
Connok	£22 0s. 12d.	£22 0s. 0d.	£23 13s. 4d.
Redditus terre	16d.	16d.	16d.
De camere	—	*Nihil*	*Nihil*
Sale of wood	—	—	£0 100s. 10d.
Fines	£3 0s. 23d.	45s. 4d.	59s. 6d.
Total income	**£203 8s. 5d.**	**£187 16s. 7d.**	**£191 3s. 0d.**
Master's salary	£10	£10	£10
Teacher of Grammar's Salary	£10 (Gregory)	£10 (Gregory)	£10 (Gregory)
Poor men's salary of £39 17s. 4d.	£39 17s. 4d. [full]	£39 17s. 4d. [full]	£39 17s. 4d. [full]
Expenses	£6 18s. 0d.	£ –	£14 6s. 10d.
Total expenditure	**£66 15s. 4d.**	**£(£59 17s. 4d.)**	**£74 4s. 2d.**
Balance	£103 13s. 1d.	£115 5s. 2d.	£116 12s. 1/2d.
Debts	£33	– (£33) –	£33
Total	**£136 13s. 1d.**	**£148 5s. 2d.**	**£149 12s. ¹/₂d.**

Ewelme Annual Audit Accounts 1513–24

Muniment no.	EA 1 (26)	EA 2 (2)	EA 2 (3)
Account	1 Dec. 1513 – 1 Dec. 1514; Spence's 16th	2 Nov. 1522 – 2 Nov. 1523; taken by Master Umpton	2 Nov. 1523 – 2 Nov. 1524; taken by Master Umpton
In coffer	£116 12s. ¹/₂d.	£131 4s. 5d. (£9 13s. 4¹/₂d.)	£131 4s. 5d. (£12 3s. 4¹/₂d.)
Mersh	£22 13s. 5d.	£21 8s. 3d.	£23 5s. 7d.
Ramridge	£21 19s. 9d.	£21 6s. 9d.	£23 17s. 5d.
Connok	£23 13s. 4d.	£22 0s. 0d.	£22 0s. 0d.
Redditus terre	16d.	16d.	16d.
De camere	Thomas Coton & Galfridi Welsheman – 19d.	—	John Delaby – £6 13s. 5d.
Fines	49s. 4d.	55s. 5d.	18s. 9d.
Sale of Wood	—	a due of 40s.	—
Total income	**£187 10s. 9¹/₂d.**	**£79 5s. 1¹/₂d.**	**£88 19s. 10¹/₂d.**
Master's salary	£10	£10	£10
Teacher of Grammar's salary	£10 (Gregory)	£10 (Jacob Myles)	£10 (Jacob Myles)
Poor men's salary of £39 17s. 4d.	£39 17s. 4d. [full]	£39 17s. 4d. [full]	£39 17s. 4d. [full]
Expenses	£19 2s. 7d.	–	–
Total expenditure	**£78 19s. 11d.**	–	–
Balance	£108 10s. 10d.	–	–
Owed	£33	– ?£0 –	– ?£0 –
Total	**£141 10s. 10d.**	**£140 12s. 5¹/₂d.**	**£139 10s. 1¹/₂d.**

Appendix III

An almshouse inventory and an account

The first of these transcriptions is an indenture recording the contents of the common chest at Ewelme on the arrival of Master William Marton, on 1 February 1455. It was drawn up in accordance with Statute XLIX and is the first piece of administrative documentation from the almshouse to survive. The inventory proves that there was a common chest under three locks and is witnessed by the newly arrived Teacher of Grammar, John Clyfford, and two poor men, the former of whom is mentioned as being the first Minister in the Statutes [v].

The second transcription is from a quire of paper in a set of accounts recording the receipt of money from the almshouse estates. It is not clear why it was drawn up or who 'Edward Quarton' is, but it containts the only references to the school in the medieval Muniments.

EM A 39 (2)

An indented piece of parchment c.5.5in x 5.5in (14 cm x 14 cm)

@This indentur' made atte Ewelme on Sat'day the
first day of the moneth of ffebruar' the xxxiij
yer' of kyng harry the .vj. [1455] makyth mencion that
Marst' Willmᵃ Marton at his comyng first to
Ewelme toke the said Sat'day deliveraunce
of the kay of the comyn chest leying in the comyn
halle loken <ud> under .iij. lokys and the sayd
Sat'day founde in the comyn purse lokyn wᵗ in
the sayd chest in money – iij li. xij s. iiij d.
S. John Clyfford. John Bostok and Thomᵃˢ Welyn
ton beyng present.

ON A PAGE OF THE ESTATE ACCOUNTS (EM A 43 B, p.12)

Edwarde Quarton Expensis
+first for a peyne shone [pension?] at seynt Nicholas tyde [6 December] – iiij.d solut
+Item pro pectinac[i]one eor[un]d[em] – ij.d solut
+Item for hys com[m]yns fro hys com[m]ynge to Cristymas – vj.s solut
+It for a pounde candell – j.d ob[1]
+Item for the lavnder for the same tyme – ij.d
 Item for scole hyre
+Item for wrytyngs of hys bob [?] – viij.d
+Item for strawynge of the scole – ob
+Item for ynke – ob
+Item for a wex ca[n]del at ca[n]dilmasse [2 February] – ob
 Item paied to Willm[a] Secole for the com[m]yns of
Edwarde querton fro Cristynmasse day to
the xxvj[a] day of februarye that is to sey
the twysday next afft[er] seynt mathye day
and shrove Eveyn anno iiij[ti] Reg[em] Ed[wardi] iiij[ti] [1465]
for ix wek[2] – vj.s
Item for the lavnder for the t[er]m of the Anu[n]c[iation] of oure Lady – ij.d
@Item payed to Willm[a] Secole for the comyns of
Edwarde quarton for vij weke that is to sey
fro schrove evyn to est[er][3] ^this^ day that was the
xvj day of ap[ri]l <et in festu[m] Tibertij et Valerian>[4] – iiij.s viij.d
+Item for wad in Wynt [wood in winter?] – iiij.d
Item in expensis v[er]sus Oxon[iensis] – iiij.d

Appendix IV

Hawe of Occold's estimate for work to the chancel of Wingfield Church (EM A 37)

The following text is written on one side of a sheet of paper 6in x 17in (or 15 cm x 43 cm) in size and is endorsed on the reverse in a fifteenth-century hand 'Wyngfeld Channcell'. There is a section of a watermark on the left-hand edge of the sheet of the horns and cross from a head of St Antony's stag.[1]

The description that this document gives of masons precisely imitating earlier architectural details, such as windows and arcade designs, in the new work to the church at Wingfield is of great interest. Similar practices have previously been recognized in great churches: Westminster Abbey, for example, was completed over a period of more than two centuries to a fairly consistent architectural design. In such cases it would appear that the architectural coherence of the interior was the principal incentive for continuing to build in an antiquated style. Similar considerations may also have prompted imitative work on a smaller scale in other exceptional circumstances. The chancel of St Thomas of Canterbury's Church at Salisbury, for example, was extended and rebuilt by two different patrons to a coherent design after it partially collapsed in 1447 or 1448. In this project the two patrons (the Dean and Chapter of Salisbury and the parishioners) agreed to copy one another's work.[2] But the re-use of earlier designs in the context of a parish church and family chantry, which celebrated the ancestry of a family, would seem to have a particular significance, the more especially because the alterations described at Wingfield closely accord with those made by William and Alice to the church at Ewelme.

Dating the document

This document may be securely dated to the early 1460s for the following reasons:

First, with the exception of deeds and rent rolls the Ewelme Muniments comprise documents written exclusively after 1455, suggesting that this

document was written after that date. (This dating can be reconfirmed by the detail that Alice de la Pole is to foot the bill. For her to pay for alterations to her husband's family chantry while he was alive – that is pre-1450 – seems inconceivable).

Second, the watermark on the paper is identical to one found on an inventory dated to 1466 [see Appendix VII, A 47 (4)]. A slightly smaller version of this watermark – probably from the same source – also appears in the Master's Accounts (1455–62) and a document relating to another chantry in Hull (1462) [see Appendix V]. These watermarks would strongly suggest, though they do not prove, that this document was roughly coeval.

Third, most of the documents in the Ewelme Muniments relate to almshouse business and it seems important therefore to establish why this document has survived here at all. One possible explanation is that it belongs to a group of documents dating to between 1460 and 1467 that found their way into the Muniments through Alice's chaplain, Simon Brailles. The arguments for associating a group of documents from this period in the Muniments with Brailles have already been rehearsed in the introduction to the appendices, but the reasons for including this amongst them deserves enlargement.

In the first place, this document can, through its watermark, be convincingly atrributed to this period of seven years to which Brailles's documentation belongs. Secondly, this is one of three documents in the Muniments relating to de la Pole chantries and it would therefore form a natural group with them. The second is a draft of a charter organizing the erection of effigies of Alice and her husband at the Hull Charterhouse in 1462 and the third is a receipt for money paid by Brailles towards the purchase of William de la Pole's tomb in 1460.

As a trusted intimate of Alice there are good reasons why Brailles might have held all these three documents: the 1460s receipt because he was the figure involved in the agreement on behalf of the Duchess and the other two – which I would suggest are both drafts of formal agreements – because he dealt with the preliminary arrangements for the work himself. The agreements proper were recopied, sealed and retained by Alice herself.

If these documents do form a group passed to the Muniments through Brailles, as has been suggested, it would seem probable that they are roughly coeval and reflect an attempt by Alice to put the spiritual affairs of the family in order during the early 1460s.

THE TEXT:

Hawe / mason of Ocolte Estemed e Werks and
stuff undernethe specified at suche value as
herafter apereth

The Channcell of Wyngfeld to be lengthed xiiij fete

wt þe ^est^ wall/ and on þe southside to be made a newe
arche asmoche . and of þe same werkmanshyp / as
þe arche is of . þere my lordes fader and his moderes
tombe is now. / and þe same tombe to be remeved
into þe seid newe arche / in þe same forme as it is
now . And oure ladies chapell to be also lengthed
even wt the channcel and a newe wyndowe to
be made on þe south side of the same chapell agens
þe seid newe arche / And þe olde Est wyndowe yt
is now in þe same chapell . to serve agen in þe same
chapell in þe Est end as it doth now . The defawte
Rof to be repered / And in þe North side of þe seid
Channcell to be mad a new wynde <of þe sute of>
of þe same sute and forme þat þe wyndowe
on þe south syde <is> of the Channcell is of / And the
same channcell ^walles^ to be hyghed convenyently after
þe heghte of þe churche walles / And þeryne to be
made a clerestory wt vj convenyent wyndowes
on eyther syde of þe chancell . And a newe
gabell wyndowe of v lyght to be made in þe
same channcell / and þe vestrye þat is þere
to stonde stille as it doth. And a new boteris
to be made on þe south syde of oure ladies seid
chapell bitwene bothe wyndowes.

ffor þe whiche werke to be made of my ladies
stuff redy caryed to þe churche and wt all suche
syde stuff specified in þis bille / to be ordeyned redy at
my ladies cost The seid Hawe Estemed shulde shuld [sic]
stonde my lady þe workmanship in l mark

@Whereto he Estemed shulde nede xxxvij tonne
of Lyncoln shire stoon þe tonne at vj s. viij d. The cariage
of the tonne iiijs xix l. xiiij s. viij d.
@viij tonne of Brywelle stoon. þe tonne at v s. iiij d.
cariag of þe tonne v s. iiij l. ij s. viij d.
@x^ml Bryke þe ml v s. þe cariage of þe ml iij s. iiij d. iiij l. ij s. iiij d.
@xxiiij Chalder lyme at vij s. wt þe cariage fro Nedeham – viij l. viij s.
@C cartful Calyon [no entry]
@dygging and Rammyng of þe fondacion w^t grauell and Rames iiij l.
@scaffolds and herdells x s.
@Estrich bord for moolds ^iij Waynscott^ ij s.
@A water soo ^xvj d.^ and ij water paylles ^viij d.^ ij s.
@viij bolles for morter and stoon xvj d.
@iiij shoveles xvj d.
@xij bords for syntres ij s.
@sand with the digging and cariage xiij s. iiij d.
 @xlij l. viij d.
 Sume of all lxxv l. vij s. iiij d.

Tymber for þe Roffs
Carpentre
lead

Glasyng
yrne werke

Appendix V

The Hull Charterhouse agreement (EM A 42)

An indenture between the Prior and convent of the Charterhouse of Saint Michael in Kingston-upon-Hull and Alice, Duchess of Suffolk, 1 October 1462

Written on paper c.11.5in x 16.5in (29 cm x 42 cm) with a watermark of St Eustace's stag's head fourteen lines up from the bottom: a stag's head with a cross of five points between its antlers. There are two very similar watermarks of the head of St Eustace's stag which appear in the Muniments' late fifteenth-century paper documents and these are distinguished by their respective depictions of the stag's face. That found here has nostrils depicted as two circles at the very bottom of the head.[1] Identical marks appear in the Master's Accounts – for example on the covering sheet – and one of the late Ramridge accounts [EM A 33 (24)], a circumstance which may indicate that this document was written at Ewelme. The text of this document is all but obliterated in parts by water and the scribe, aware that he is writing a draft, has heavily abbreviated the Latin. These facts, combined with the many alterations and corrections made to the text, render it very hard to follow in places.

The damage to this makes a proper translation of it awkward to render, but the contents may be summarized freely as follows:

To all the Christian faithful to whom this written indenture shall come, Henry, Prior of the Carthusian house of St Michael beside Kingston-upon-Hull and the convent of the same, greetings in the Lord. The late William de la Pole gave to the late Prior, John Gannesfeld, and the convent in perpetuity the manor of Rimswell in the County of Yorkshire with its appurtenances on 2 December 1439, by licence of the King. Out of consideration of the devout and pious intentions between us and the late Duke and the venerable lady and princess, Alice, Duchess of Suffolk, his wife, we grant that one monk of the house shall, every Friday, during the life of the Duchess, read and say the Seven Penitential Psalms and a Mass with the office 'Reministere', celebrated specially for the good estate of the Duchess and her son, the prince John, now Duke of Suffolk. We grant, moreover, that from this time forward we will

celebrate in perpetuity the anniversary of the aforesaid Duke and also the Duchess, when she has died. Beyond this we agree also that in the near future we will have made two stone images, one in the likeness of the Duke and the other in the likeness of the Duchess, the which shall bear on the right hand a disk, in symbol of bread and fish, and on the left hand an ale pot, in sign of a measure. These images shall stand in an eminent place in the refectory of the said convent for ever. In the presence of these images, I, the aforesaid Henry, and my successors as priors of this house, or our procurator or our representatives if we are ill or indisposed, shall distribute two messes of drink, fish and bread in perpetuity to a maximum of two almsfolk, according to our discretion. That is to say to a man and to a woman, two conventual loaves, each weighing one and a half pounds, and two conventual measures of ale containing two quarts each. Conventual messes according to this form shall be made on Sunday, Tuesday, Thursday and Saturday, except in Lent and on Monday, Wednesday and Friday, when fish shall be provided. These messes shall now and for ever be the same as those of two monks, except on the days when the Carthusian rule demands abstinence from fish. On those days the poor shall not be deprived of their messes. In respect of our distribution of food to the two paupers they are to offer prayers for the souls of the Duke and Duchess, their ancestors, parents and all the faithful departed. If we fail in the discharge of any of the above duties we will pay £10 to the Duchess and her successors and forfeit the manor of Rimswell and its appurtenances as they have been described. In testimony of which thing we keep one part of this indenture, sealed by the Duchess, while the other part remains with her, sealed with the conventual seal, given in our chapter on 1 October 1462.

In the light of this curious arrangement it is a matter of particular interest that Alice herself may have made daily distributions of food to paupers during her lifetime. In the codicil to his will, written in 1427, her second husband, the Earl of Salisbury, directed that three paupers be brought to Alice every day and be given one mess of meat, one loaf and one quart of milk out of her own hands.[2] It was perhaps her familiarity with this practice that explains some of the fussiness apparent in the preparation of this document: the repeated redrafting of the precise manner in which the statues were to be shown with their symbols, and also the emphasis on the fact that the Prior himself should make the distribution.

Omnibus Xpi [Christi] fidelib[us] ad quos p[re]sens sc[ri]pt <p[er]ve> indentat' p[er]ven[er]int henric[us] p[ri]or dom[us] s[an]cti mich[aelis] ordinis Cartus[iensis] iux[t]a kyn[g]ston sup[er] Hulle et /1/ eiusd[em] loci convent' Salu[tem] in d[omi]no sempit' Cum <w> potens et ven[er]abilis nup[er] d[omi]n[u]s Willo dux Suff' per cart[am] suis feoffamenti ded[er]it concess[er]it /2/ et confirmav[er]it <nob[is] p[re]fat'> ^Johanis Gannsfeld nup[er] < d[ict]i dom[us]>^ p[ri]ori ^ d[ict]i dom[us]^ et convent' et successorib[us] <n[ost]ris> ^suis^ man[erium] de Rymeswell in Com[itatem] Ebor[acensis] cu[m] s[uis] p[ert]in[ensis] ac sexdeci[m] mes[suagij] xxᵗⁱ ^terr[a]e et^ qui[nque] /3/ bonat' terr[a]e centu[m] et octo acras et iij rod. pᵃti [?] xlᵗᵃ et ij acr' et d[imidi] pastur' et xxᵗⁱ solidat ... deni[er]at' [?] redd' cu[m] p[er]tin[ensis] in Rymeswell in relenamen' /4/ do[mus] [nost]ro p[re]dict' que de fundac[ione] autocessor[um] dic[t]i ^d[omi]ni^ duc[is] existit convent' ... ijᵈᵒ die decembr[is] a[nn]o [regni] [regis] H[enrici] . vjᵗⁱ post

conqu[estum] Ang[liae] /5/ decimo octano [1439]. licentia d[ic]ti Reg[is] p[er]
l[itte]ras s[uis] paten' ta[m] eidem duci ipsa p[re]fat' p[ri]ori et convent' fact'
p[ri]us concessa et optenta p[ro]ut in eisdem /6/ l[itte]ris paten' pleni[us]
contine[ss] quar[um] Dat' ap[u]d West[minster] viij die ffeb[ruarij] [ann]o regni
n[ost]ri xix ... Et sicut licentia Humfridi tu[n]c Comit Buk /7/ Hersi North et
Perch [?] ... p[re]fat' Duci <Suff> [quam] p[re]fat' p[ri]ori et convent' ... hit et
optent . De quo quid comite Buk et ... /8/ man[er]iu[m] et ten[en]t' p[re]dict'
inmediate tenent[ss] p[ro]ut in l[itte]ris patent' eisd[am] ... confect' pleni[us]
cont' quar[um] datu[m] est primo die Decembr[is] /9/ [anno] ^regni^ d[ict]i
Reg H[enrici] vj[ti]. post conq[estum] decimo octano [1439]. Nos p[refat]' p[rior]
i[n] convent[us] considerant pia[m] et devota[m] intenc[i]one[m] qua[m] erga
nos /10/ et successores n[ost]ras ^tam^ p[re]dic[tus] ^nup[er]^ Dux q[u]am
ven[er]abil D[omi]na et principessa Alicia ducisse ...^ ... ux[or] sua^ ... et
<hel> adhuc continus p[re]di[c]ta ducissa hel [?] Ex /11/ unanimi concensii
et assencii n[ost]ris concessim[us] p[re]fat' ducissa q[uo]d unus monachus
domus ... qualiut septi[ma] <dic[er]ij[?]> die ven[er]is durante /12/ vita
ip[s]ius ducisse dicet et leget septe[m] psalmos penitentiab[ilis] qu... psalmos
... ad hoc ordinat' et p[re]fat' dieb[us] celebrabit missas /13/ cu[m] officio
REMINISTERE spe[c]ialit' orando p[ro] dict' ducissa ac p[ro] bon[o] stato
eiusde[m] ducisse et ... principis johis nu[n]c Duc Suff filii sui /14/
Concessimus ecia [ie. etiam] p[ro] nob[is] et successorib[us] n[ost]ris q[uo]d
<post mort> a dat' p[re]sentia nos et successores n[ostri]s celebravim[us] ^...
et imp[er]p[etuu]m^ anni[ver]sarium die obitus Duc /15/ p[re]dic[t]i et
si[m]iliter temporib[us] futures imp[erpetuum] celebravim[us]
anniv[er]sar[ium] tam d[ict]i dux et p[re]fat' ducisse ... luce ip[s]a ducissa
mig[ra]verit. Et ult[er]ius /16/ concessim[us] p[re]fat' d[omi]n[a]e ducissa[e]
et her[edibus] suis [quo]d ego p[re]fat[us] p[ri]or ^aut succe[ssor] ...^ ad ...
[a space in the text] p[ro]x' futur' fieri /17/ faciem[us] duas [ymag]inisce
lapideas . una[m] ad si[m]ilitudine[m] ip[s]ius nup[er] duc' et a[ltera] ...
p[re]fat' duciss[a]e . <que>^Quar[um]^ quid[e]m ymaginum <portabunt>
uterq[ue] portabit /18/ <duos discos in manib[us]> ^in manu dextra unu[m]
discu[m]^ videl[icet] <unu[m] discu[m]> in signu[m] panis et piscem ... < ...
servisie imponend'> ^<intus>^ <inde> ^desup[er]^ ponend' Et in manu
sinistra /19/ s[im]ile una[m] olam in signu[m] servisie ^<intus>^
<inde>^desup[er]^ ponend' Qu[a]e quidem ymagi[nes] ... eri[n]t situat' in
refectorio <s> dom[us] sup[ra]dict[ae] in eminenciori loco eiusdem /20/
refectorij et ib[ide]m temp[or]ib[us] futur[is] inp[er]p[etuu]m sic existere et
stare absq[ue] ... ear[un]d[e]m seu alt[er]ius earum impost[er]um p[er] nos
p[ri]ores et coventu[m] aut /21/ successores n[ost]ros aliqualit faciend
Cora[m] quib[us] duabu[s] ymaginib[us] ego p[re]d[ict]us henri[cus]
^n[u]nc^ prior et successores mei p[rior]es eiusd[em] domus aut p[ro]cura=
/22/ tores ib[ide]m p[ro] temp[or]e existentes quando in sanitate et ad
libitu[m] n[os]trum p[re]sentes fu[er]im[us] sive aliquis alius honestus
servo[rum] n[ost]ror[um] in n[ost]ra /23/ absencia seu infirmitate cotidie
imp[er]p[etu]um <^ac dict' ymagines ponem[us] ^^et mutem[us]^^ in varis

convenientib[us] dict' duo ferc[u]la ^^potagij et^^ piscem ij panes
p[re]dict'^> distribuem[us] aut unus n[ostroru]m distribuet duob[us]
elemosina' maxime s[ecun]d[u]m descre[cion]em n[ost]ram /24/
indegentib[us] [?] Scil[icet] uno ho[min]i et un[a]e fe[min][a]e duas panes
conventuales utroq[ue] pane ponderente <ij lb>^j.p di.lb^ duas ollas
^plen[er]^ [ser]visie conventual' utraq[ue] olla /25/ continet unu[m]
potellu[m] <s[er]visie> duo fercula <sufficiens> potagij conventual' et duo
fercula p[ra]ndij conventual' similiter diebus dominicis . martio. jovis . et
/26/ sabbali iiij^or gen[er]a pisci[u]m seisionabilit coctarum et dieb[us] lune
Mercurij ... piscum si[mi]lit[er] coct' . Qu[a]e quidem fercula cotidie
imp[er]p[etuum] eru[n]t /27/ talia et si[mi]lia sicut fercula duor[um]
monachor[um] eiusd[em] conventus . Et ... p[er] eor[um] ordine ^c[er]te
dieb[us]^ abstinere tenentur <certe dieb[us]> a p[ra]ndis pisc[u]m /28/
Tamen dict' duo paup[er]es nullo die restringentur a suis solit ego
predicono p[ri]or et successores mei p[ri]ores eiusd[e]m domus seu pr[o]cur=
/29/ tores ib[id]em p[ro] temp[or]e existent' cotidie imp[er]p[etuu]m dict[er]
panes sui ... is quando in sanitate et ad libiti n[ostru]m /30/ p[re]sentes
ib[id]em fuerim[us] <dict' duobus paup[er]ib[us] distribuem[us] .Et in
ead[e]m distribic[ion]e in p[er]pet[uum] ... specialit' ad orand' p[ro]
a[nim]ab[us] dictor[um] duc et /31/ ducisse ac om[n]i autocessor[um] et
p[er]entu[m] eor[um] et om[n]i fidelit' defunctor[um] > Ante imagines
p[re]dict' ... convenientibus ponem[us] et mittem[us] /32/ aut alius
hone[stus] suor[um] n[ost]ror[um] causa infirmitate seu absencie n[os]tre
n[om]ine ... ^forma p[re]dicta^ . Et deinde ^ea^ distribuem[us] dict'
duob[us] paup[er]ib[us] eis /33/ [immig]entas specialit' ad orando p[ro]
[anim]ab[us] d[ict]or[um] Duc' et Ducisse ... [ac omni autocessorum et] ...
p[er]ent[um] et autocessor[um] eorum om[nium] fidel[iu]m defunctor[um] Et
insuper nos p[re]dict' /34/ p[rior] et convent[us] concedimus p[ro] nobis et
successoribus n[ostr]is p[re]fat' Ducisse et ... nunc p[ri]or et p[ro]curatores
aut aliquis successo[rum] n[ost]ror[um] p[rio]res et /35/ p[ro]curatores
eiusdem dom[us] decet[er]o remisse ut necligentes fuerim[us] ut fuerit in
aliqua p[a]rte <^p[re]dict'^ p[re]dict' divinoru[m] dicend[us] et aut>
p[re]dic[t]e distribuc[ion]is faciend' /36/ et inde p[re]...inti ...s
emendan[er]im[us] quod extunc tociens quociens nos <et>^aut^ successores
n[ost]ri talia remissa ^in eisdem on[er]ib[us]^ n[o]b[is]
negligencias/facerim[us] <q[uo]d> /37/ concedim[us] p[ro] nob[is] et
successorib[us] n[ost]ris p[re]dic[t]e Ducisse et her[edibus] suis soluere
eisdem no[mine] pene decem libras legal monet angli[ae] p[ro] qua qui[de]m
suma et tociens /38/ quociens ^sic foriffcam [?]^ bene licebit p[re]fat'
duciss[e] et her[edibus] s[uis] ^et eor[um] a?ttournat?^ man[er]iu[m]
Rymeswell <ac messuag> cu[m] terre p[ar]t' pastur[es] et redditib[us]
<cu[m]> ^ac^ om[n]ib[us] s[uis] p[ar]tem narare /39/ et discruig[er]e
districc[ion]es q[uis] sit captas penes se ut sua p[ropri]a bona et catalla
retinere quousq[ue] eisdem Ducisse et her[edibus] [suis] de eisdem panis sic
for[unt] unacu[m] /40/ dapius et expen[sis] ex et p[ro] ea causa

distrucc[ion]is hit [?] <et fact> plen[er]ie fu[er]it satisfact ac etia[m] <p> nos
p[re]dic[t]i p[ri]or et convent[us] p[ro] nob[is] et successorib[us] n[ost]ris
/41/ <plen[ar]> sup[er] consciencias n[ost]ras p[er]mittim[us] dic[t]e ducisse
et her[edibus] [suis] bon[um] et fidelit[er] ^…^ dicta onera ex p[ar]te n[ost]ra
faciend' et p[er]miplend' . In cui[s] rei testion[em] /42/ uni p[ar]ti huius
scripti indentati penes nos p[re]fat' p[ri]ore et con[ventum] residenti et
p[re]dict Ducissa sigillu[m] apposuit alteri vero p[ar]te panes p[re]dicano
Ducisse /43/ residenti nos p[re]fat p[ri]or et con[ventus] sigillu[m]
no[st]ru[m] co[mmun]e apposim[us] dat domo n[ost]ra capalar p[ri]mo die
octobr[is] anno d[omin]i M^mo CCCC^mo lxij anno /44/ qui r[egni] r[egis]
Rege[m] E[dwardj] iiij^to post conq[uestu]m ij^do.

On the reverse there appears the following:

A note of þe composicion betwene my lady duchess of Suffolk and þe prior
and convent of þe charterhouse at Hull of þe sustenance p[er]petually of a pore
man and a pore woman for þe maner of Rymeswell.

New Hospital
paup[er] et senex Johes Beanghorn
valens et potens Rc Grawngby – p[er] instancia johis hasting[es]
iuvenis s[ed] i[n]firm[us] Rbt Caunfeld – p[er] ult[ra] p[ri]ore
valens et potens Johes hermyte – p[er] ult[ra] p[ri]ore
valens et potens Th Marchall – p[er] Ma[gister] petru[s] nup[er] M[agister] ib[id]em
potens Will Malyard – p[er] instancia G Crysto et p[er] Ma[gister] nu[n]c
　　　　　　　　　　　　　null eorum tenetur d[omi]ni
Joh Hadelsey vic' de Hull
Sorores
xj unde v debil et sex iuvenes et fortas
nulla earum teneant d[omi]ne et una earum ^nuper^ recepta sine licencia d[omi]ne
voc[atur] Joha Mayre

Me[mora]nd[um] de Johe Campyon comorante p[er] le North ferye in Hull ^fidele^
tenente d[om]ine per xxxv anni debiliter et senex

Appendix VI

A dispute over stones from a stone wall (EM A 46)

Written on paper 9in x 12in (22 cm x 30 cm). No watermark is visible.

@Be hit to be remembyred that the vij day of August yn the yere of the reigne of the kynge Edwade the fawthe the syxte [1466] Syr John Boteler knyght came to Ewelm and there informyd my lady of Suff' that he had the stonys of a grete wall y takyn fro his manor of Berwewyk xx yeres afore passyd a more by oon Rasth at that tyme bying servant to my seide lady and the seide stonys where caryyd to the manor of Ewelm for the reperacon there off wiht owte licence of the seide Syr John or any of his officys to his grete hurt and upon the weche informacon my seide lady haht lete enquere to have verely understondyng of the trowght of the seide mater and upon the X day of August in the yere of the kyng aforseide at Ewelme oon Richard Wyse William Croke William Berewyk William Snelle William Webbe Harry Yonge of Berewyk aforeseide husbandmen William Rolffe of Roke William Bynt of Ewelm and John Wynbury of Ewelm husbondmen yn the presencs of Thomas Vernawyn William Stanley Nicholas Castell Jamys Bowre Sir Symond Brayles Syr William West John Wadehyll John Samnell and Sawnders Yonges ^serventis to my seide lady^ where examenyd yf they say any soche a wall stondyng upon the manor of Syr John Boteler at Berewyk aforeseide and the fforeseide Richard William William William William Harry William William and John seydyn feyhtfully that thay saye [? saw] sechhe a walle of stone stondyng at Berewyk but never siht the seide Syr John Boteler whas owener of the seide manor of Berewyk for there whas a grete wall stonyng there at Berewyk yn the days of oon Margrete Berewyk the wheche whas owener of the seid manor and yn the lyf of the seide Margrete the stonys of the seide walle where y solde to Thomas Chaucers esquyer and the delyverance of the seide ^stonys <whas> where^ made by oon Andrewis Sperlyng the wheche whas steward to the seide Margrete of the seide manor of Berewyk and by ooen Thomas a Bury servant to the seide Maragrete and that the stonys of the seide walle where y carryd to the reperacon of the churche of Ewelm and nat to the reperacon of the manor of Ewelme yn maner and forme as my seide lady whas informyd by the seide Syr John Boteler the seide vij day of August at Ewelm aforeseide.

Appendix VII

The Ewelme Manor inventories and associated documents (EM A 47)

This series of inventories, the bulk of which probably relate to preparations for some special event at the Manor in 1466, merits considerably more analysis than can be given in the context of this appendix. Long extracts from them have been published before but this is the first time that the entire collection has been transcribed in full. Apart from their importance in elucidating the design of Ewelme Manor they also provide many interesting details about Alice's personal possessions, including her chapel goods and the titles of some of her books. Perhaps most significantly of all they provide a glimpse of the extraordinary richness of the de la Pole tapestry collection and the manner in which it was hung, a virtually unique picture of a suite of domestic apartments in this period. Many of these subjects and some of the individual contents of the inventories are briefly discussed in Chapter 2. In the following transcriptions the commentary and annotation has been kept to a minimum. For a discussion of comparable material the reader can refer to two important studies: *The Bedford Inventories* and *The Inventory of King Henry VIII*, both listed in the Bibliography. The commentary to the latter work is still to be published, but the index to the volume of the transcription is arranged as a glossary of terms and is helpful in understanding some of the terminology used in the Ewelme inventories. Particularly useful are the sections on textiles (pp.504–5) and vestments (p.508).

EM A 47 (1)

Written on a single sheet of paper 12in x 16.5in (31 cm x 42 cm) in a close hand. A watermark in the shape of a letter P with a cross above it.[1] The items are organized into clearly defined paragraphs in the manuscript which are reproduced below.

THE TEXT

1. xj tapites of reed wurste [worsted] brought by Stanley for þe warderobe at Ewelme
whereof viij tapites eche contenyng xiiij yerdes Sma [summa] vxx xij yerdes
and iij tapites eche contenyng xij yerdes Sma xxxvj yerdes
[Summa] vijxx viij yerdes

2. Wherof in my lordes chamber fro þe beddes head toward þe windowe ij lytell
Tapites . Oon þerof ij yerdes in brede and þe oþer v yerdes Sma vij yerdes
3. Item on þe oþer side of þe bed j lytell tapite cont' iij yerdes and a half and dj quarter
4. Item an hooll pece of hangyng on þe chymeney side to þe steyre dore cont' xiiij
yerdes
[Summa] xvij yerdes dj and dj quarter

5. In my lordes ^utterchamber^ <withdraught> chamber on both sides of þe beddes
head ij lytell tapites . Oon of ij yerdes dj and dj quarter and þe oþer ij yerdes
[Summa] iiij yerdes dj and dj quarter
6. Item fro þe dore unto my lordes chamber ^ward[robe]^ to þe steyre dore . an hooll
pece of xiiij yerdes
7. Item j litell tapyte over þe same steyre dore of ij yerdes iij quarter
8. Item j litell tapite fro þe same dore to þe wyndowe of iij yerdes

9. Item in þe chamber over þe Ewerye fro þe beddes head toward þe chymney j tapit
of xj yerdes
10. In þe same chamber ende ayens þe cupbord j tapit of vij yerdes j nayll2
11. ffro þe other side of þe beddes side to þe dore. j tapit of <vj yerdes j quarter>
vj yerdes j quarter

12. Item þe Norserye3 j hooll tapite wt a slytte [a slit] ayen wtdraught dore of xiiij yerdes
13. Item bitwene þe beddes hed and þe closet j tapit of <v yerdes iij quarter> v yerdes
iij quarter
14. Item fro þe steyre dore to þe wyndowe a tapite of v yerdes iij quarter
15. Item devided. ij hooll peces of wurstede eyther of xij yerdes. Into vj cupbord
clothes and vj wyndowe clothes . Eche of þe same cupbord clothes contenyng in brede
ij yerdes j quarter and in lengthe iij yerdes. And of þe seide wyndowe clothes. iiij of
hem contenyng in lengthe iij yerdes dj. quarter larger and in brede j yerde dj. And ij
eyther of hem contenyng in lengthe iij yerdes dj. quarter . And þe on of j yerde iij
quarter brod . And þe oþer j yerde j quarter brod
[Summa] xxiiij yerdes

16. Item j pece of þe larger sort. devided in iij contenyng eqally Sma xiiij yerdes

17. Item þere leveth in þe warderobe an hool pece of þe lasse [lesser] sort contenyng
xij yerdes

Summa vijxx viij yerdes iij quarter j nayle

[on the reverse:]

Tapytes of Wurstede cutte into diverse Tapites coverynges ... cupbord clothes. And
wyndowe clothes in the month of ... [?August] in þe vjth yer of K. Ed þe iiijth

EM A 47 (2)

Written on two sides of a single sheet of paper 11.5in × 16in (29 cm × 40 cm) in a close hand. A watermark of an ox passant.[4]

The document lists groups of objects and brackets them together according to their provenance – whether they came from Ewelme, London or Wingfield. To clarify what comes from where the layout of the document has been slightly altered by the insertion of blank lines. These divide the blocks of goods brought from different places to create paragraphs. At the head of each paragraph the provenance of the items is stated.

The entire text is struck through with a thin line and a note at the bottom of the reverse reads 'The olde bylle canceled'.

The abbreviated form 'It' for 'Item' has been extended throughout here and arabic numerals added for facility of reference.

To judge from the text of this inventory it seems likely that the clerk who wrote it was following somebody else around the various chambers of the Manor House and taking dictation of their contents. This is suggested by the fact that many of the proper names in the text are garbled phonetic spellings, as though the writer has guessed at, rather than known, what he is recording. The knowledge of the clerk's companion, however, must have been impressive because he not only identifies the subject matter of everything he looks at, but also makes interesting judgements about its quality. He distinguishes, for example, between arras, counterfeit arras and tapestry hangings. In consequence we receive a nicely nuanced tour of the interior beyond the great hall, in which the contents of each room reflect its importance. We start in the great chamber, spendidly hung with arras, and pass through into the inner rooms of the house before moving back out through the chapel into the great parlour. Because the tour begins and ends with a semi-public room directly accessible from the great hall, it is probable that we are seeing the contents of two floors in a single range. What the two men probably did was walk along the upper floor towards the inner apartments. They then dropped down a storey when they came to the chapel with its two closets (perhaps one was set above the other), and then walked back on the ground floor towards the hall.

THE TEXT
Thys ys the stuff of bedys and hangyngs of chamburys at Ewelme there hanged in the monethe of August in the vj yere of kyng Edward the iiij[the] [1466]

In the gret chambure

[In margin] (of Ewelme stuff)
1. The bed of aras of Orchia selo[r] Tester and coveryng.

[In margin] (of stuf of London)
2. Item the long tapyte of aras of dame dehono' [de honour]
3. Item the Tapyte of aras of arcules To'nay.[5]

4. Item iij tapytes of aras of locus p[er]fecc[i]o[n]is

In the chambure of dj seyntes [demi seyntes]

[In margin] (of Ewelme stuff)
5. The bed of aras selor' tester and coveryng of bergerye
6. Item iij tapytes of the same sute
7. Item the tapyte of Tygrys of tapyserye

In the chambure of K.K.[6]

[In margin] (of London stuff)
8. The bed of [blank]
9. Item a tapyte of aras of gold of Arkenbaldus[7]
10. Item a nother tapyte of aras w[t] owte gold of <syvyl> civitas pacis[8]

[In margin] (of Ewelme stuff)
11. Item in the stede of a tapyte the koveryng of a bed w[t] cages and byrdys

In the chambure of apeclogges [sic][9] my ladies closet

[In margin] (of Ewelme stuff)
12. iij tapytes of cownterfete aras[10] of <hawy> hawkyng and hontyng

In the Gentylwomen closet

[In margin] (of Wyngfeld stuff delivered by James [Brussels[11]])
13. the longe tapyte of cownterfete aras of hontyng at the Boor'

In the chapell

[In margin] (of þe stuff of London delivered by James [Brussels])
14. a tapyte of aras of xv signes of the doom[12]
15. Item a tapyte of the <s> story of seynt Anna of Aras

In the gret parlo[r]

[In margin] (of þe stuff of London)
16. ij tapytes of aras ^of selke^ both of the seven sciences[13]

[In margin] (of þe stuff of <London> Ewelme)
17. Item in stede of a tapyte a coveryng of a bed of men and women pleying at cardn'

In the gret wardrape

[In margin] (of London stuff.)
18. lefte over Seint Laurence even [9 August] a tapyte of aras of gold of tygres
19. Item a nother tapyte of aras w[t] owte gold <of> de guerre
20. Item a bed of blewe clothe of gold selo' tester an coveryng of the same
21. Item a bed of blewe saten and browderd w[t] carantynes pakks [packs] and skeynes [skeins] selo[r] tester and coveryng of the same[14]
22. Item a bed of blew bawdekyne [baudekin] w[t] braynches and flowres of rede and whyte selo[r] tester and coveryng of the same
23. Item a bed of red cloth of golde of bawdekyne w[t] byrds selo[r] tester and coveryng of the same
24. Item a bed of red sendell embrowdered w[t] chayers and a myses selo[r] tester and coveryng of the same
25. Item a bed of red sarcenet embroweded w[t] my lords armes and hys creste and w[t]

Radiar. ky. da.[sic][15] sylo[r] tester and koveryng of the same

26. Item a bed of red clothe of bawdekyne selo' tester and coveryng of þe same

27. Item a bed of bawdekyne of clothe of gold paled w[t] whyte and reed selo[r] tester and coverynge of þe same

28. Item a bed of bawdekyne of red and grene warke . seler tester and coverynge of the same

29. Item a sperver of crymosyn damaske selo[r] tester and coverynge of þe same and frenged w[t] gold and sylk

30. Item ij bankeres[16] of tapcery werk w[t] men and wemen haw^k^yng and hontyng

31. Item a cupborde clothe of aras w[t] owte gold

32. Item vj kochenys of aras w[t] ymagerys w[t] owte golde

33. Item a square standarde and covered w[t] blakke lethure and bowden [bound] w[t] yrne w[t] ij lokys the oone lokke broken ^w[t] my lady^ and the key ^also^ w[t] my lady

34. Item a gret standarde of the chapell bownde w[t] yrne w[t] ij lokkys ^with my lady^

35. Item iiij pelowes of downe kovered w[t] fosteon of v quarterys long and in brede iij quarteys

36. Item ij square pelowes of downe coveryd w[t] fosteon [fustian] of iij quarteres every weye

37. Item a long kocheon [cushion] of fethurs coveryd w[t] whyte lethur of v quarterys long and halfe yarde brode

38. Item a koveryng for a presse of canvas of chekerwerke

39. Item iij koshens of clothe of golde upon rede saten . oon þerof long f [?] ij square

40. Item a long koscheon of blewe selewet and a square kosshon of the same

41. Item a long koscheon of red velvet and iij square kosshons of the same

[on the reverse of the sheet]

[In margin] (of London stuff.)

42. Item viij newe square kosshons of verdure

43. Item iiij Tapytes of totebonys <and a>

44. Item a bed of þe same selo' tester and coverlight

45. Item <x carpytes> ix carpytes wherof ij lange . and .v. of a myddell sorte . and ij smale

46. Item an olde broken tapyte of blak wurstede

47. Item vj federbeddes

48. Item a large gilt chalys [chalice] of London

49. Item an horn of yvory [ivory] of Wardelhous [sic]

[In margin] (þe stuff of Wingfeld delivered by James [Brussels])

50. Item þe gardovyande [garde-viande] of þe Ewerye lokked w[t] þe stuff þerynne þ[t] cam fro Wyngfeld

51. Item þe stuff of þe chapell þ[t] cam fro wyngfeld . þ[t] is to weten a crucifix w[t] Mary and John of silver . and ij silver basyns for þe awter . ij highe chandelrs of silver . an high chalys of silver . j pix of gold and j pix of silver . j pax brede of gold . ij cruettes of silver square . an holy water stoppell j holy water spryngell.

EM A 47 (3)

Written on two sides of a single sheet of paper 11.5in x 17in (29 cm x 43 cm) in a close hand. Watermark of an ox passant as on A47 (2) above.

Like the previous inventory, the form of this document suggests something of the circumstances in which it was drawn up. The contents are quite strictly

grouped, as if they are being unpacked after their journey from Wingfield. First there is a list of chapel goods such as altar dressings and vestments, all neatly arranged into categories, then a number of books.[17] These are grouped by the colour of their bindings – white, red and black - into three distinct sets. Of these the liturgical books, all bound in white, appear to be the only group covered according to their subject matter and purpose. The black- and red-bound volumes, although listed separately, seem to be a rather catholic collection of works including everything from saints' lives to romance. Following the books in the list is an image of St John the Baptist's head, which was probably cut in alabaster and used as a private devotional image. This seems likely to have been kept together with the books. On the back of the sheet there is another list of objects, all fabrics, which were possibly separately packed in another standard. This final group of objects includes tapestries and bed linen as well as a number of dressings for a cradle.

THE TEXT
Stuff brought from Wingefeld to Ewelme in a standard and þere by Robt Newell delivered xth day of September in þe vjth yere of kyng Edward þe fourth [1466]

1. Ffirst frounte and contrefronte of blu white and purpill velvet and damask paled embrowdred wt kk[18] of gold
2. Item a . leytron cloth of þe same sute
3. Item a chesible ij tonecles thre aubes. wt fanons stoles and parmes [?] of þe same sute. and wt amyts also
4. Item a corporas of þe same sute
5. Item a frontell of blu cloth of gold wt lymons
6. Item a fronte a contrefronte of rede cloth of gold. <of a> upon damask wt a frontell of <þe> rede cloth of gold of damask.
7. Item a fronte a contrefronte of rede cloth of baudekyn wt grehonds wt a frontell of þe same sute
8. Item a leytron cloth of rede cloth of baudekyn wt swanes
9. Item a fronte and contrefronte of rede cloth of baudekyn. of gold wt squorelles and birdes. wt a frontell of rede cloth of gold of velvet uppon velvet
10. Item a frounte contrefronte. and sele [? stole] of rede satyn embrowdred wt kardinals hattes[19]
11. Item a chesible. aube. stole. fanon and amys of cloth of ^red^ baudekyn of greyhondes
12. Item a chesible. aube. amys. stole. fanons of blu damask
13. Item a cape of rede cloth of gold of bandekyn wt birdes. orfreid wt russet cloth of gold of damask
14. Item ij corporas wt ij cases þerfore of rede cloth of gold of baudekyn
15. Item a corporas wt an olde case of rede baukyn
16. Item canope for hanging of þe pyx of rede and white cloth of gold of baudkyn wt birdes [In margin] (broken by my lady)
17. Item an oþere canope of rede cloth of gold of ba[u]dekyn wt alamites [?]
18. Item an oþere canope knytt wt stritram knottes of gold wt a botoner [?] aboven garnysshed wt perle
19. Item ij auter courteyns [curtains] of rede tarteren.
20. Item ij auter corteyns of white tartren
21. Item a taweill [towel] of boills for a patyne for þe auter embrowdred wt silk and gold. and frenged

22. Item vj auter clothes. and iij wasshing toweill for thans
23. Item two finale sup[er] altares covered wᵗ lynnen cloth
24. Item a sup[er]altare of red jasper stone garnisshed aboute wᵗ brode plate of silver and gilt wᵗ a cas[e] þerto of coᵇbeill [probably cuir-bouilli]
25. Item thre frontes thre contrfrontes. thre frontelles <of white v> ij chesibles wᵗ all þe parones manicles stoles and fanones longing to þe same ij chesibles also of white bustren with crossess flouere [flory] of rede Bukerham / and ^a^ veaill of <þe same sute> lynnen cloth wᵗ a grete crosse of rede Bukerham floueres
26. Item ij koveryngges for <cussyns> ij square <cussy> cusshons of rede and white cloth of gold of baudekyn wᵗ lyons. tasseld on þe corners wᵗ silk
27. Item x surplices for þe chapell / besides <iiij> ^ij^ delivered to my lady aforn at Westhorp and ^j^ sent from Westhorp. to London <to wha … > to wynde and covere in a crosse bowe of my Lords garnyshed wᵗ gold delivered to James Brussells . by Castell
28. Item <iiij> ij ^red^ curteyns of saddle blu tartron and an oþere of light blu tartron wherof ij ben of iiij bred' and þe iijᵈᵉ of iij bred'.
29. Item a masse boke covered wᵗ white lethur . Wᵗ a laton closp and þe oþere broken.
30. Item a large antifener noted covered wᵗ white lether and clospes of laton and gilt tasseld wᵗ silk and a <ref> regestre pynne of silver þerynne.
31. Item an oþere <at> antifenere noted covered in white lether wᵗ tasselles of lether closped wᵗ laton
32. Item an oþere antifenere wᵗ þe legende þynne covered wᵗ white lether closped wᵗ laton
33. Item ij large grailles [graduals] covered in white lether tasselld wᵗ silk and closped wᵗ laton
34. Item a boke for rectors covered in white lether closped wᵗ laton
35. Item ij lectornalles covered wᵗ white lether and closped wᵗ laton
36. Item a collectall boke covered wᵗ white lether tasseld wᵗ grene silk closped wᵗ laton
37. Item iiij processionalles ^ij^ covered wᵗ white lether and oon wᵗ rede lether
38. Item a large boke of priked songe bounden a[nd] covered in rede lether and closped wᵗ laton
39. Item a quaire of a legende of Ragge hande [? Legend of St Radegunde] covered in a solipell
40. Item a frensh boke of quaterfit Emond' [*Les Quatre Fils Emond*] covered in rede lether closped wᵗ tyssh of threde and laton
41. Item a frensh boke of temps pastoure <and> ^conteyng divers stories in the same^ vij <oþe bokes in þe same> covered in rede lether bosed and clasped wᵗ laton.
42. Item a frensh boke of le citee de dames covered wᵗ rede lether clasped wᵗ laton newe
43. Item a boke of latyn of þe morall Institucion of a prince conteynyng xxvij chapters covered in rede lether and clasped wᵗ rede lether
44. Item a frensh boke of þe tals ^of^ philisphers covered in blak damask bosed and clapsed wᵗ silver and gilt
45. Item a boke of English in papir of þe pilgrymage translated by domine John Lydgate out of frensh covered wᵗ blak lether wᵗoute bords
46. Item iiij clospes of laton and gilt wᵗout tissues
47. Item a seynt johes hede peynted wᵗ silver foill

[On the reverse of the sheet:]

48. Item ij tapites of aras. oon þerof thassawte [? the assault] damones and þe oþere a litle oon of men and women hawking
49. Item a coveryng of rede tapsterye wᵗ a lyon
50. Item a testure of the same sute

51. Item a pane of meanyner doubled w^t rede wollen cloth for a large bedde
52. Item a pane of meanyner doubled w^t crimosyn cloth for a cradell
53. Item an hede shete. of meanyner doubled w^t crimosyn cloth for a cradell
54. Item a materas of blu Bukerham for a cradell
55. Item x peires of shetes and ij pec' of a shete. y^t was broken wherof iiij peire woll s[e]rve for a while and the remenance broken and leide aside nomore to s[e]rve for shetes

[Below in a large hand written on the inverted sheet:]
Robert Newelme – Stuff of þe Warderobe caried fro Wingfeld to Ewelme <Robt. Newelme> in Sepetmber Anno vj^to E[dward]. iiij [1466].

EM A 47 (4)

Written on two sides of a single sheet of paper 9in × 12in (23 cm × 30 cm). Watermark of a St Antony's stag's head (identical to that on A 37).

THE TEXT
@Delivered by Alson Croxford ^at Ewelme þe xxj day of December in þe vj^te yer K. E iiij^he [1466]^ to [blank] .
1. ffurste a beryng shete of fyn lawne of ij hooll plight[es] of brode and þe nayll in lengthe
2. @Item j other shete of <þe same> ^lawne not so fyn^ for þe pane of ij holl plight[es] of brede and in length ij yerdes sauf half a quarter
3. @Item a swathyng shete of Reynes [Rheims]. eche conteynyng in lengthe an elle and half a quarter large and in brede a yerde
4. @Item a new ^beryng^ shete of gretter lawne ^for every day^ cont' in lengthe j elle j quarter and þe nayll and in brede ij elles j quarter
5. @Item a beryng mantell of <reed> ^crymosyn^ cloth of gold Tissu contenyng in length iiij yerdes and in brede above ij yerdes furred w^t Ermyne and powdred
6. @Item a pane of blew cloth of gold veluet contenyng in lengthe and brede square ij yerdes half scant furred w^t Ermyne and powdred
7. @Item an head shete of þe same contenyng in lengthe iij yerdes and a half a quarter large And in brede iij quarter sauf half þe nail furred w^t Ermyne <w^t Ermyne> and powdred
8. @Item a beryng mantell for every day of scarlet furred w^t minyver perfoilled [purfled] and powdred. ^w^t Ermyne^
9. @Item a pane and a headshete for þe cradell of þe same sute bothe furred w^t minyver

[On the reverse]

10. The seide Alson hath delivered at Ewelme þe seid xxj day of December for the tyme of my ladise lying inne a shete of lawne for þe gret bed contenyng in lengthe vij yerdes j quarter and in brede v <brede> hooll bred
11. Item a shete of lawne for þe cowche contenyng in lengthe v yerdes and in brede iij hooll bred
12. Item an head shete of lawne for þe cowche contenyng in lengthe iij yerdes and j quarter and half þe nayll and in brede ij holl brede

13. Item an oþ[er] shete of fyn lawn of v yerdes long and in breede iij hooll bredes

[In a bolder hand below and written upside-down:]

iij billes of certeyn stuff delivered by Alson Croxford into þe Norserye and j bille endented of stuf delivered by my lady Item j oþer bille

[Also reversed at top of sheet:]
Ffyn shete of lawne

EM A 47 (5)

A small sheet of paper 4.5in x 5.5in (11.5 cm x 14 cm). There is no watermark visible.

1. @Memorandum that after þe deliverance made by Alice Croxford to William Secole by endenture of iiij pelewes eche of hem an elle longe covered wᵗ fustyan and bered wᵗ lynen cloth. And of xij pelewes eche of hem a yerde longe covered wᵗ fustyan. And vj of hem bered wᵗ lynenn cloth and vj unbered . [space] There lefte in þe seide Alices kepyng viij pelewes Eche of elle long covered wᵗ fustyan beered wᵗ lynenn cloth.

2. @Also þere lefte stille in her kepyng viij pelewes eche of j yerde long covered wᵗ fustyan and beered wᵗ lynenn cloth.

3. @Also þere lefte in her kepyng ij lytell pelewes covered wᵗ fustyan bered wᵗ lynenn cloth eyther half yerd long.

4. @Also þere lefte in her kepyng þe vj beeres of þe vj pelewes delivered to Secoles unbeered.

5. @Also þere lefte in her kepyng iiij beeres þᵗ were made for þe iiij [blank] brought fro London by James Brussells

[On the reverse]

Summa of pelewes in A Croxford kepyng and William Secoles beside ^w^ þe iiij cusshons broughte by James fro London xxxviijᵗᵃ

Summa of beeres in A Croxford kepyng xxviijᵗᵃ

Summa of beeres in Secoles kepyng x

EM A 47 (6)

On paper with no watermark 3in x 4.5in (7.5 cm x 11.5 cm). Indented.

This indenture records the delivery of a valence for the seal of the font and two cushions. The font in question was probably that in the Manor House, rather than the church. William and Alice had received papal licence to erect such a font in 1438.[20] The mention of this font, and the various other baby's clothes mentioned in these inventories, may suggest that the preparations at Ewelme were connected with the baptism of one of Alice's grandchildren.

Delivered to James Brussells by my lady out of

her standard at Ewelme on Saint Cicelyes [Cecilia's] day
in þe vj yer of kyng Edward þe iiij [22 November 1466] for þe
valance of þe seell of þe font two longe
cusshones of read cloth of gold of damaske
Eyther of a yarde and a qrt [quarter]. sauf þe nayel long
and of þe hool brede of þe cloth.

Addendum

Amongst the transcriptions from the Ewelme Muniments printed by H.A.
Napier in his book, *Historical Notices of the parishes of Swyncombe and Ewelme*
(on p.129), is an excerpt from a document, now lost, which must have
belonged to this group of Ewelme Manor inventories. Amongst other things
of interest, it mentions two chairs of estate, one of wood covered in blue cloth
of gold and the other of iron upholstered in the royal colour of purple and
trimmed in fur. Both chairs had leather travelling cases.[21]

Napier's transcriptions are very selective, so it is possible that this is not
the whole text of the original, but it is worth reproducing what he printed in
full, breaking up the entries and numbering each for ease of reference:

Another inventory, written upon a sheet of paper without date or
endorsement, contains the following entries:

1. Item, a travas of purple tartren.
2. Item, 3 curteyns of green, and blu paled tartran.
3. Item 3 curteyns of blu tartran.
4. Item 3 curteyns of green tartran.
5. Item, a Chaire of tymber of astate, covered wth blu cloth of gold, and 4
 pomells of coper, and gilt, enamyled wth 99K. [sic][22] In a caas of lether
 thereto.
6. Item, a chaire of astate of yren, covered w[t] purpall satyn fur[d]. And a caas
 of lether thereto.
7. Item. 2 long cushions stuffd of fethers, covered with lether, eche 1 yerd 1
 quarter longe, and 3 quarters brode.
8. Item, a square Cusshon stuffd of fethers, covered w[t] lether of 3 quarters
 square.
9. Item, a grete red standerd ful of stuff, locked with 2 lockes, and sealed w[t]
 Stanleys seall, ye keyes in my ladies keping.
10. Item, a piere of covered basins of silver w[t] gilt roses in ye bothems, and
 skochons enamyld of my lords armes, which come from amending, from
 Henr. Crownyng.

Appendix VIII

Estimate of the materials of Ewelme Manor prior to its demolition (PRO Ms. E178/4404)

A single sheet of vellum *c.*30in × 12in (76 cm × 31 cm), slightly damaged in places. Some of the total valuations in this document seem miscalculated.

THE TEXT
The survaye of the remyns of the manor house of Ewelme within the moate there and art also of the buiyldings without the moat togethr with the barne and stable standing remoat from the sayde house together with the quantities of the yeerlie valewes of the ground called the manor closes adjoyning to the said house with the woods and … thereon growinge By vertue of His Magesties Commission from out of the counte of Oxford directed to us John Thorpe and Richard Stevens gent. taken there the twentieth day of maye in the yeere of the raygn of our soverayne Lord James by the Grace of God of England, France and Ireland the tenth and of Scotland the five and fortith [1612].

Sundry sortes of materyalls within the moate:
IT[EM] IN PRIMIS the out walls of bryke of the sayde house with the moat; all the building within utterlie wasted and decayed considering in square measure doores and windows deducted iiixx vj rodde at ij bryke thicke beside the filling at xx s. the rodde standynge amountethe to the some of lxvj li.

Tyle within the sayd moate three thousand valued at vj s. viij d. the M cometh to xx s.

Stone doores tenn valued at iiij s. the door and with an other cometh to the some of xl s.

Shree stoone arches xij fote wyde apeece value at iiij s. ^the arche^ cometh to the some of xij. s

Buttress of stoone ij conteyninge xxxti foote high apeece and ij foote broade and fifteen ynches thicke and six other small buttresses of ^þe^ same heighte one foote without the wall contayning CCXL foote valued at ij d. the foote comethe to the some of xl s.

Stone lights contayninge one c iijxx iiij with lanceheads ^and drippes ^ of diverse heights valued at iij s. iiij.d the light cometh to the some of xxvij li. vj s. viij d.

Fortie other lights conteyning x foote light apeece one with an other valued at x s. the light comethe to the some of xx li. d.

Hollowe creste of stoone rounde about the sayde house contayning ciijxx xvj foote valued at ij d the foote in the wall, cometh to the some of v li. xij s. viij d.

Vente and creste of stoon conteyning a C foote valued at ij d. the foote comethe

to xvj s. viij d.

Grounde table of stone round about the sayde house cont ciij^{xx} xvj foote valued at ij d ffoote in the wall comethe to the some of v li. xij s. viij d.

Stone Berketts or Parrells of chimneys cont V valued at v s. apeece cometh to xxv s.

Tymber indifferentlie sounde in the flower and roofe over the Parlour cont thirteen lodes valued at x s. the lode cometh to the some of vj li x s.

Roted timber lyeing in diverse places within the walls cont xiiij lodes valued at v s. the lode comethe to the some of lxx s.

Locketts of yron of sundry lengths cont CC in all wayeinge one MCCCC weight by estimacion valued at ix s. iiij d. the C weight comethe to the some of vij li. x s.

Uprighte barres of yron cont CIX one with an other all weyeinge by estimacion CCC ^xxxvij pounde^ weight valued at ix s. iiij d. the hundred comethe to the some of iij li. viij s. v d.

Checquer windows cont iij^{xx} xij lockette and barres seaven foote longe apeece by estimacion seaven hundred weight valued at ix s. iiij d. the hundred cometh to lxv s. iiij d.

Lockes and hinges iij payre all weyinge by estimacion xlviij pounde valued at j d. the pound comethe to the some of iiij s.

Two barrs of caste yron crossynge the hall weyinge by estimacion CCCCC weight val at ij s. iiij d. the C cometh to the some of xj s. viij d.

The barre, bolte and cheyne of the gate cont xij pound valued at j d. the pound is xij d.

Old lead uppon plattforme and one gutter by estimacion CCCC weighte valued at ix s. iiij d. the hundred cometh to the some of xxxvij s. iiij d.

Buildings yet standing without the moate:

One range of buildinge cont xj bayes xij foote the bay and xviij foote wide with a flore and the roof tiled – two stories hige with studd and spares j brike betweene in breadthe valued at iij li. the baye comethe to the some of xxxiij li.

One gatehouse xxiiij foote longe and xiiij foote wide, two stories highe open on three sides belowe tyled about valued at xx s. the bay cometh to the some of xl s.

One other range of brike building two stories highe, one floore throughout and tiled, in legnth iij^{xx}vj foote, in breadth xvij foote over and besides the house where in the Honour Courte is monethlie kept not here valued cont five bayes with V partitions of bryke valued at v li. the bay comethe to the some of xxv li.

One open gallerie of tymber and floored iij^{xx}vj foote in legnth, five foote wide, two stories highe with ashead roof valued at xj d. the foote comethe to the some of iiij li. vjs.

One gutter of lead iij^{xx}vj foote longe xviij ynches broade, and behinde the chimneys cont CC wayght valued at ix s. iiij d. the C cometh to the some of lvj s.

Upright barres xlvj and locketts iij^{XX} xij weights by estimacon CCCCiij^{xx} xij poundes valued at j d. the pound comethe to the some of xliij s. iiij d.

Hookes and hinges by estimacon lxxxvj pounde wayght valued at j d. the pounde is vij s. ij d.

The quantities and yeerlie valewes of the lands being about the house:

All with buildings consisteth on nyne acres three roddes of pasture grounde with the ponde and moat valued at xiij s. iiij d. the acre per annum comethe to the some of vj li. x s. per anum with at xx li. purchases cxxx li.[1]

Elme timber fortie lode valued at x s. the lode uppon the stemme comethe to xx li.

Fire wood iij^{xx} iiij lodes at iij s. iiij d. the lode uppon the stemme comethe to x li. xiij s. iiij d.

The Barne and Stable standing remoat from the house:

One Barne tenn bayes everie baye xij foote asunder, xxviij foote wyde without the side walls of timber boaurded xiiij foote highe from the ground pinnynge all tyled over valued at x li. the baye cometh to the some of C li.

Three hundred foote of ^grounde table and buttresses^ <creste> valued at ij d. the foote comethe to the some of l s.

One other barne called the court stable of viij bayes everie bay xij foote asunder and xxiiij foote wyde iij parte tyled the side walls viij foote highe at lx s. the baye comethe to the some of xxiiij li.

SUMMA TOT. LCXL li. - XIX s. -IIJ d.

Appendix IX

The receipt for stone for William de la Pole's tomb (EM A 40)

Written on vellum c.13in x 3in or 7cm x 32cm

Amongst the muniments is a receipt for the purchase of 'petre marmer' or Purbeck Marble for the tomb of William de la Pole. This is dated 10 January 1460, but records an agreement on the form of the tomb struck the previous year, presumably at the time that William's body was brought to the Charterhouse at Hull for burial (see p.10). No record of William's tomb survives and although this receipt could conceivably relate to a very ambitious monument combining the work of several craftsmen, it seems more likely that it records the commission of a vastly expensive brass.

Apart from its curiosity as a rare piece of documentation relating to tomb manufacture, this receipt is important for the figures it names. Thomas Stephens and John Essex were partners in several of the most prestigious tomb commissions of the period (see p.191 and p.324, footnotes 71 and 72). The role of Robert Chamberleyn in the transaction is unclear.

Noverint universi p[er] p[re]sentes nos Robertum Chamberleyn peautrer et Thomam Stephenes cop[er]smyth cives London' recepisse et habuisse die dat' p[re]senem de Simone Braillis capellano serviente d[omi]ne ducisse Suff. octo libras tresdecim solidos et quatuor denari[os] sterlingor[um] in plenam soluc[ion]em triginta et quinq[ue] librar[um] sex solidor[um] et octo denari[os] nobis debit' pro bargania cuiusdam petre marmor' p[er] Joh[an]em Essex marbeler et nos eid[e]m Simoni no[m]i[n]e d[i]c[t]e ducisse vendit' s[e]c[un]d[u]m formam cuiusdam indenture int[er] ip[su]m et nos inde confect' cuius dat' est primo die ffebruarij anno regni Regis Henrici sexti Tricesimo septimo de quibus quidui viij li xiijs iiij d ut predicatur recept' ffatemur nos b[o]n[um] et fidel[it]er fore solut' p[er] p[re]sentes sigillis n[ost]ris sigillat' dat' decimo die mensis januarij anno regni dicti Regis Henrici sexti tricesimo octavo.

[signed] Ffermory.

Appended to two strips of parchment cut horizontally from the bottom edge of the document are two seals in red wax. The first depicts an "R" set in an oblong field, the bottom one a bird between the letters "T" and "S" set in a circle with a rope border. The strip of parchment to which this latter seal is attached has a partly legible note in the same hand as the rest of the document which reads:
"...ecru... of my lady Suffolke."

and on the reverse a note in a different hand:
"Aquitaunce of þe maromer for my lords tomb stoon" [This is only fully legible under ultra-violet light.]

TRANSLATION

Let it be known to the world by this document that we Robert Chamberleyn pewtrer and Thomas Stephenes coppersmith, citizens of London, have received and have had on the given day from Simon Brailles, the chaplain serving her ladyship the duchess of Suffolk, 8l. 13s. and 4 d. in full payment of the 35l. 6 s. and 8 d. he owed to us for a bargain of certain marble stone by John Essex marbeler which we sold to Simon in the name of the said duchess according to the form of the particular indenture then made between him and us the date of which is the first day of February in the thirty-seventh year of the reign of Henry VI [1459] a certain 8l. 13 s. 4d. of which, as aforesaid, we confess to having received in goodness and fidelity by this document, sealed with our seals on the tenth day of tenth day of the month of January in the thirty-eighth year of the reign of the said king Henry VI [1460].

Notes

1 Chantry foundations in fifteenth-century England

1. EM A 21 and *CPR 1436–41*, p.80.

2. Most of Statute V, including this passage entitling the house, appears verbatim in the statutes of Whittington's Hospital, London [744–5]. The title 'God's House' was a very long-standing one for hospitals and probably refers to their charitable activities. See N. Orme and M. Webster, *The English Hospital, 1070–1570*, New Haven, 1995, pp.39–40. It may also refer to the idea that, as the Statutes say, the poor are promised the Kingdom of Heaven by Christ [LXXXVIII]: an almshouse is a terrestrial community of God. (See Appendix I for the text of the Ewelme Statutes.)

3. The best general survey of chantries in England remains K. L. Wood-Legh, *Perpetual Chantries in Britain*, Cambridge, 1965. See also G. H. Cook, *Medieval Chantries and Chantry Chapels*, London, 1963, a book that should long ago have been superseded, and the references below.

4. For a discussion of college foundations see A. Hamilton-Thompson, 'English Colleges of Chantry Priests', *The Ecclesiological Society*, vii n.s. pt. 2 (1943), pp.92–108; G. H. Cook, *English Collegiate Churches of the Middle Ages*, London, 1959; and – as an often hostile and limited treatment of the subject of patronage of chantries by the nobility – J. T. Rosenthal, *The Purchase of Paradise*, London, 1972.

5. The pre-eminent importance of prayer is made explicit in several sets of statutes. See for example Fotheringhay [304] or Eton [LXIV].

6. Statutes tend to specify that all charitable works are to be performed for the good of local people, servants of the founder's family and their successors, or those attached to the particular foundation's endowments. For example see Ewelme [II and LXXIX], and, nearly identically phrased, Heytesbury [298–9], Tattershall [182], and Fotheringhay [303].

7. For a case study of the hierarchy and structure of a parish see C. Burgess, 'Shaping the Parish: St Mary at Hill, London, in the Fifteenth Century', in J. Blair and B. Golding, eds, *The Cloister and the World: Essays in Medieval History in Honour of Barbara Harvey*, Oxford, 1996, pp.246–86. Parish guilds have received considerable recent treatment and several important new works by Duffy, Bainbridge and Barron are listed in the Bibliography. The standard survey remains, however, H.F. Westlake, *The Parish Guilds of Medieval England*, London, 1919.

8. *The Household of Edward IV, the Black Book and the Ordinance of 1478*, A. R. Myers, Oxford, 1959, pp.70 and 133–7.

9. William Worcestre, *Itineraries*, ed. J. H. Harvey, Oxford, 1969, pp.46–7.

10. See Appendix VII, EM A 47 (3), p.287, nos.29–38, bound as a set in white.

11. *The Household of Edward IV*, pp.66, 205, 214. For a recent treatment of earlier royal almsgiving see S. Dixon-Smith, 'The Image and Reality of Almsgiving in the Great Halls of Henry III', *Journal of the British Archaeological Association*, 3rd series, cliii (1999), pp.79–96.

12. M. G. Underwood, 'Politics and Piety in the Household of Lady Margaret Beaufort', *Journal of Ecclesiastical History*, xxxvii (1987), p.41.

13. M. A. Hicks, 'Chantries, Obits and Almshouses: the Hungerford Foundations 1325–1478', in C. Barron

and C. Harper-Bill, eds, *The Church in Pre-Reformation Society*, Woodbridge, 1985, p.128.

14. For a discussion of Eton's architecture see J. A. A. Goodall, 'Eton College and the Court of Henry VI', in *Medieval Art and Architecture at Windsor: Transactions of the British Archaeological Association Conference 1998*, forthcoming.

15. In some houses they were evidently publicly read in exactly the manner of statutes in religious institutions. See p.154, below.

16. Hierarchies of dress are a commonplace of all collegiate statutes. For a detailed description of meals see Eton [XVI].

17. Alongside other works listed here, recent studies of particular value include P. W. Fleming, 'Charity, Faith, and the Gentry of Kent 1422–1529' in A. J. Pollard, ed., *Property and Politics, Essays in Later Medieval English History*, Gloucester, 1984, pp.36–58; M. A. Hicks, 'The Piety of Lady Mary Hungerford (ob.1478)', *Journal of Ecclesiastical History*, xxxviii (1987), pp.19–38; and, by the same author, 'Chantries, Obits and Almshouses', pp.123–42.

18. P. Heath, 'Urban Piety in the Late Middle Ages: the Evidence of Hull Wills', in R. B. Dobson, ed., *The Church, Politics and Patronage in the Fifteenth Century*, Gloucester, 1984, pp.209–34.

19. For the most forthright attack on the conventional assessment of late-medieval religion see E. Duffy, *The Stripping of the Altars: Traditional Religion in England, 1400–1580*, London and New Haven, 1992. A less positive revision of it is eloquently voiced in C. Richmond, 'Religion and the Fifteenth-century English Gentleman', in R. B. Dobson, ed., *The Church, Politics and Patronage in the Fifteenth Century*, Gloucester, 1984, pp.193–208.

20. See B. A. Kumin, *The Shaping of the Community: the Rise and Reformation of the English Parish Church, c.1400–1560*, Aldershot, 1966, pp.159–67 and Clive Burgess's important series of studies, which are listed in the bibliography.

21. See in particular C. Burgess, 'For the Increase of Divine Service: Chantries in the Parish in Late Medieval Bristol', *Journal of Ecclesiastical History*, xxxvi (1985), pp.48–65.

22. The classic study is R. M. Clay, *The Medieval Hospitals of England*, London, 1909. See now too Orme and Webster, *The English Hospital*, and the works listed in the Bibliography by Rubin, Carlin, Gilchrist and Rawcliffe. The latter is also producing a study of the Great Hospital at Norwich.

2 The de la Poles and Ewelme Manor

1. E. A. Greening Lamborn, 'The Arms on the Chaucer Tomb at Ewelme', *Oxoniensia*, v (1940), p.80.

2. *Scrope and Grosvenor Roll*, ed. N. Nicolas, London, 1832, p.410.

3. Alice is described as being thirty-two at her mother's decease on 28 April 1436 (ibid., p.411).

4. For the most recent biography of Thomas Chaucer see *The History of Parliament: the House of Commons, 1386–1421*, vol.ii, eds J. S. Roskell, L. Clark, and C. Rawcliffe, Stroud, 1992, pp.524–32.

5. Lydgate wrote a poem 'On the Departing of Thomas Chaucer'; this is printed, along with an introductory bibliography of books on Lydgate, in *Late Medieval Verse and Prose*, ed. D. Gray, Oxford, 1988, pp.60-2. His tomb is discussed below, see pp.169-75.

6. For details of Phelip's career see *History of Parliament: the House of Commons*, vol.iii, pp.71–4.

7. J. S. Roskell, *Parliament and Politics in Late Medieval England*, vol.iii, London, 1983, p.176.

8. *CPR 1429–36*, p.86.

9. William's career figures in all political histories of fifteenth-century England but principal amongst the sources relied upon here are L. E. James, *The Career and Influence of William de la Pole 1st Duke of Suffolk*, unpublished M.Litt. thesis, University of Oxford, 1979, and *CP*, xii (pt i), pp.443–50. William's own petition to the King on the occasion of his impeachment also provides an interesting, if superficial, autobiographical summary of his career, couched in the terms of a loyal toast; see *Rot. Parl.*, v, p.176.

10. For a family history and bibliography see R. Horrox, *The de la Poles of Hull* (East Yorkshire Local History Society, 38), Bridlington, 1983.

11. For a description of the castle, still very inadequately studied, see S. W. H. Aldwell, *Wingfield: its Church, Castle and College*, Ipswich, 1925, pp.31-4.

12. The history of this foundation is summarized in E. M. Thompson, *The Carthusian Order in England*, London, 1930, pp.199–204.

13. *Rot. Parl.*, v, p.176.

14. C. L. Kingsford, *Prejudice and Promise in Fifteenth-century England*, Oxford, 1925, p.149.

15. James, 'William de la Pole', pp.19–22.

16. See *CP*, xii (pt i), p.445.

17. *CP*, xii (pt i), p.446. The title of Marquis was rare and moribund since Richard II had first used it. It may have been given to Suffolk as a means of promoting a man who lacked the land holdings for a dukedom. See James, 'William de la Pole', p.78.

18. *CPR 1441–46*, pp.283 and 319.

19. She is recorded as having received the robes in 1433, 1435, 1437, 1439 and 1443. See H. A. Napier, *Historical Notices of the Parishes of Swyncombe and Ewelme*, Oxford, 1858, p.52. See also P. J. Begent, 'Ladies of the Garter', *The Coat of Arms*, n.s. vii (1989), pp.16–22.

20. B. P. Wolffe, *Henry VI*, London, 1981, p.182.

21. James, 'William de la Pole', pp.81–2. John's birth possibly succeeded several miscarriages, because as early as 1438 the couple received licence to erect fonts for the baptism of their own children in the manor chapels owned by them where, during their periods of residence, Divine Service and the Mass were celebrated daily. *Cal. Pap. Reg.*, ix, p.8.

22. Napier, *Historical Notices*, p.77, and *CP* xii (pt ii), p.384.

23. *CPR 1436–41*, p.455. For a recent discussion of the foundation of Eton see K. Selway, 'The Role of Eton College and King's College in the Polity of the Lancastrian Monarchy', unpublished D.Phil., University of Oxford, 1993.

24. R. Willis and J. W. Clark, *The Architectural History of Cambridge*, vol.i, Cambridge, 1886, p.401. For the construction of Eton also see H. M. Colvin, et al., *The History of the King's Works: the Middle Ages*, vol.i, London, 1963, pp.279–92, and J. Goodall, 'Eton College and the Court of Henry VI'.

25. H. N. MacCracken, 'An English Friend of Charles of Orléans', *Publications of the Modern Language Association of America*, xxvi (1911), pp.141–80.

26. Wolffe, *Henry VI*, pp.184–212.

27. R. L. Friedrichs, 'Ralph Cromwell and the Politics of Fifteenth-century England', *Nottingham Medieval Studies*, xxxii (1988), pp.15–16.

28. *CPR 1441–46*, p.198. William and Alice had also previously received reversion in 1441 of Humphrey's office of Warden of the New Forest (ibid., p.63).

29. *Political Poems and Songs*, pt ii, ed. T. Wright (Rolls Series, London, 1861) pp.224 and 229–31. A more remarkable expression of this hatred was the appearance in 1452, shortly after his death, of a window in the church of St Peter Mancroft in Norwich which depicted the Jew stopping the Virgin's funeral procession in de la Pole livery. I am grateful to David King for this information which is to be included in his forthcoming study of the glass in the church for the *Corpus Vitrearum* series.

30. *Rot. Parl.*, v, pp.177–82.

31. *PL*, ii, no.120. See also R. Virgoe, 'The Death of William de la Pole, Duke of Suffolk', *Bulletin of the John Rylands Library*, xlvii (1965), pp.489–502.

32. His will of 1448 requested that he be buried at Hull under a monument with a stone image of himself and his wife. See W. Dugdale, *The Baronage of England*, vol.ii, London, 1676, p.189. P. Hunt, (in *Fifteenth-century England*, London, 1962, p.114) says that a 1459 entry in the Chamberlain's Rolls at Kingston-upon-Hull notes payment for wine given by the Council to the Duchess when 'the remains of the late Duke of Suffolk were carried to the Charterhouse'. He gives no reference for this. The circumstance would correspond to Alice's commissioning of a tomb for her husband in February 1459; see below p.191. The College of Arms Ms. L.8., f.75 confirms that William was buried at the Charterhouse.

33. *Letters and Papers illustrative of the Wars of the English in France during the Reign of Henry VI*, ed. J. Stevenson (Rolls Series, no.22), vol.ii (pt ii), London, 1864, p.768.

34. *CFR 1445–52*, p.154. The grant, dated 8 May, has the appearance of being rushed because it explains that the fee had not yet been calculated, and would be set next Michaelmas.

35. J. Leland, *John Leland's Itinerary in England and Wales*, ed. L. Toulmin-Smith, vol.i, London, 1907, p.112, records that Alice's effigy at Ewelme wore the robes of a vowess. His comment may have been based on the lost paintwork on the effigy. See below, pp.183–4.

36. *Cal. Pap. Reg.*, x, p.472.

37. BL Ms. Egerton Roll 8779.

38. *CAD*, iv, p.26 (A 6337).

39. For details of the family's allegiances in this period see J. A. F. Thomson, 'John de la Pole, Duke of Suffolk', *Speculum*, liv (1979), pp.528–42.

40. For a discussion of one instance of this in a dispute over land see C. Richmond, *The Paston Family in the Fifteenth Century*, Cambridge, 1990, pp.234–41. A graphic description of John's strong-arm tactics is narrated in *PL*, iv, no.617. See also R. E. Archer, '"How Ladies ... who Live on their Manors Ought to Manage their Households and Estates": Women as Landholders and Administrators in the Later Middle Ages', in P. J. P. Goldberg, ed., *Woman is a Worthy Wight: Women in English Society c.1200–1500*, Stroud, 1992, pp.153–6.

41. *PL*, iv, no. 629.

42. *Epist. Acad. Oxon.*, xxxv, pp.326–7. The project may have seemed something of a family concern to Alice because her uncle, Cardinal Beaufort, had recently left 500 marks to it. See A. D. M. Cox, 'Account for Building the Divinity School', *Oxoniensia*, xxi (1956), p.49.

43. *Epist. Acad. Oxon.*, xxxv, p.369.

44. J. Catto and R. Evans, *The History of the University of Oxford*, vol.ii: *The Later Middle Ages*, Oxford, 1992, p.719.

45. *Epist. Acad. Oxon.*, xxxv, pp.303–4.

46. A critical edition of the text appears in *The Minor Poems of John Lydgate*, pt i, ed. H. N. MacCracken (Early English Text Society, e.s. cvii), 1911, pp.87–115. One fifteenth-century copy describes the poem as having been written 'ad rogatum Countesse de Suthefolcia' (ibid., p.87).

47. Almost certainly *The Pilgrimage of the Life of Man*, a translation from the French commissioned by the Earl of Salisbury, Alice's second husband, in 1426. See Ebin, *Lydgate*, pp.78–9. Another Lydgate manuscript associated with the de la Poles is a copy of *The Siege of Thebes* (BL Ms. Arundel 119). This contains William's coat of arms (de la Pole quartering Wingfield) in the opening initial.

48. See Appendix VII, EM A 47 (3), p.287, nos.39–45 and also C. M. Meale, '"... Alle the Bokes that I Have of Latyn, Englysch and Frensh": Laywomen and their Books in Late Medieval England', in C. M. Meale, ed., *Women and Literature in Britain, 1150–1500* (Cambridge Studies in Medieval Literature, 17), Cambridge, 1991, pp.134–5.

49. *PL*, v, no.795, dated 8 January 1472.

50. See Wolffe, *Henry VI*, p.348.

51. *CAD*, iv, pp.95–6 (A1118).

52. *CPR 1467–77*, p.417.

53. *Cal. Pap. Reg.*, xiii, p.550.

54. The Commons petition of 1450 actually describes William as being 'Late of Ewelme in the Countee of Oxonford' (*Rot. Parl.*, v, p.177).

55. Maud Chaucer died on 28 April 1436 but the writ of *diem clausit extremum* on her Oxfordshire estates was not issued until over a year later, on 2 May 1437 (*CFR 1430–37*, p.300).

56. Three pieces of information serve to substantiate this dating. First, the last surviving fragment of the Manor House bears close comparison (and was presumably therefore coeval) with the work on the second phase of construction to the foundation. This was under way in the late 1440s; see below, pp.99-108. Second, a disposition, EM A 46, records that on 7 August 1466 a certain Sir John Boteler claimed that a wall of his had been taken away 'xx yeres afore passyd a more' by Alice de la Pole's steward and that its stones 'where caryyd to the manor of Ewelme for the reperacon there off' (see Appendix VI). Alice inquired into this accusation and asserted that the stones had actually been removed long before by her father in the rebuilding of the church. She did not, however, question the circumstance implicit in the accusation: that work was under way on the Manor House about twenty years previously, that is in about 1446. Third, a royal licence was issued to William de la Pole to dig stone on 10 December 1444 at Hanley in the forest of Whitelwode in Northamptonshire (*CPR 1441–46*, p.326).

57. One claim is drawn up in relation to a legal dispute and is clearly biased (*Letters and Papers of Henry VIII*, vol.viii, pp.1101 and 1130) and the second is from a source which, impossibly, also credits Thomas Chaucer with building the almshouses; see Leland, *Itinerary*, vol.i, p.113. For a full discussion of this point see J. A. A. Goodall, 'God's House at Ewelme', unpublished Ph.D. thesis, Courtauld Institute, University of London, 1997, pp.161–4.

58. Leland, *Itinerary*, vol.i, p.113.

59. For a more detailed discussion of these buildings and their architecture see Goodall, 'Eton College'.

60. For Stonor see T. P. Smith, 'The Medieval Brick Making Industry in England 1400–50', *British Archaeological Series*, 138 (1985), p.7. As any visitor may judge, there is no fourteenth-century brickwork at Shirburn. Several of the authorities who have propagated this myth – including the *VCH* and Pevsner – were denied access to the building and have evidently mistaken brick alterations from the Tudor period onwards for original fabric.

61. For a discussion of early brick architecture see N. Moore, 'Brick', in J. Blair and N. Ramsey, eds, *Medieval Industries*, London, 1991, pp.214–20, and Smith, 'Brick Making Industry', pp.4–26. See also various works by Goodall in the bibliography.

62. For example, the chief figures at Tattershall were 'Baldwin the Docheman' and a certain Godfrey, who the accounts record was engaged from London, perhaps on his arrival from the Continent; see *The Building Accounts of Tattershall Castle 1434–72*, ed. W. D. Simpson (Lincolnshire Record Society, lv), 1960, p.21.

63. If a post-1439 date for Tattershall's tower is accepted. See J. A. A. Goodall, 'Tattershall Castle', *Country Life*, cxc, no.41 (10 October 1996), pp.50–5; and 'Eton College', n.48.

64. Quite apart from the familiarity which must have resulted from the proximity of the works to Windsor Castle, the accounts abound with formal and informal reference to courtiers. The first building account, for example, Eton College Mss. Col/BA/1 is addressed to James Fiennes, Squire of the King's Body, in a scribbled note on the front.

65. See Appendix VII. Note particularly pp.282–3.

66. S. McKendrick, 'Edward the IV: an English Royal Collector of Netherlandish Tapestry', *Burlington Magazine*, cxxix (1987), p.521. See also McKendrick's 'Tapestries from the Low Countries in England during the Fifteenth Century', in C. Barron, and N. Saul, eds, *England and the Low Countries in the Late Middle Ages*, Stroud, 1995, pp.43–60. I am indebted to Scot McKendrick for much information in the following discussion.

67. Appendix VII, EM A 47 (2), p.283, no.3. There is also a pastoral theme in the Chamber of 'demi seyntes' [?] and possibly one of judgement – with the subjects of Duke Arkenbold and the City of Peace – in the so-called Chamber of K.K., a name perhaps derived from the device used by Charles V of France (see the notes to Appendix VII).

68. Christine de Pizan, *The Book of the City of Ladies*, trans. E. J. Richards, London, 1983, pp.43–7.

69. Bodl. Ms. Wood D.14 f.51.

70. EM A 47 (2), p.284, no.12. Suffolk's use of the device is recorded in *Political Poems and Songs*, p.232, in 'The Death of Suffolk': 'Jac Napes [Suffolk] wolde one the see a maryner to ben, / With his cloge and his cheyn, to seke more tresour.' John A. Goodall also informs me that this device is recorded in *Wrythe's Garter Armorial*, no.213.

71. See Appendix VII, EM A 47 (2), p.284, no.21.

72. *CP*, xii (pt i), p.446.

73. At Tattershall Castle, Lord Cromwell, the Lord Treasurer, used the purse as a prominent decorative motif in the architecture, furnishings and glazing. For evidence of the latter see P. Hebgin-Barnes, *Corpus Vitrearum Medii Aevi Great Britain*, Summary Catalogue 3: Lincolnshire, London, 1996, p.332. The c.1450 glazing of Sir John Norreys's house at Ockwells Manor (Berks.) is also decorated with three golden distaffs, a symbol of his office as Keeper of the King's Wardrobe. See J. Stratford, *The Bedford Inventories*, London, 1993, pp.97–104 for a discussion of the use of arms and devices on a nobleman's possessions. Ewelme Manor may have had another room, the Chamber of K.K., named after a dynastic motif. These letters were used as a device by Charles V of France and the chamber may have become so known in consequence of Charles of Orléans' sojourn at Ewelme during his captivity. See the notes to Appendix VII.

74. 'In the church and manour house was to be seen Pooles quarterings and Poole alone impaling the chief lion ramp. with these supporters viz. on the right side of the shield an antelope proper, of a brownish colour, hornes, tail, members, and a collar with the tassell to it or. on the other side a lyon or' (Bodl. Ms. Wood D.14, f.51).

75. It has been suggested by Airs that this was a stairwell communicating with a fifteenth-century structure running southwards from the range on the foundations of the existing eighteenth-century extension; see M. Airs, 'Ewelme', *Archaeological Journal*, cxxxv (1978), p.280. But the structure looks too small to be a stairwell, and the only evidence for the existence of such a range, which neither the Bucks nor Buckler show in their drawings, are some fifteenth-century bricks at the base of the existing nineteenth-century walls. These might have come from anywhere.

3 The history of God's House

1. For a general discussion of chantry-foundation, its expenses and problems see E. F. Jacob, 'Founders and Foundations in the Late Middle Ages', *Bulletin of the Institute of Historical Research*, xxxv (1962), pp.29-46, and Wood-Legh, *Perpetual Chantries*, pp.30-64.

2. See the case of Sir John Fastolf's planned college at Caister (*PL*, iii, nos.340, 351, 385, and iv, nos.569-71). There were alternatives to amortization, for example the rolling enfeoffment of land at the Ludlow Hosyer's Charity Almshouse [235].

3. EM A 2. There may have been pressure to return alienated Church property to pious uses and this fact might help explain the choice of the Ewelme endowment as well. See Selway, 'The Role of Eton', pp.4-20, for a discussion of this in relation to Henry VI's foundations.

4. EM A 10-16.

5. A parallel instance of exchanges in preparation for an endowment can be seen in the case of Whittington's Hospital in London. In this instance the entire endowment was conveyed away by Whittington's executors, and then returned. Imray, in her study of the hospital, considered that this was done in literal fulfilment of Whittington's will but it was probably a means of reaffirming legal title; see J. Imray, *The Charity of Richard Whittington*, London, 1968, pp.20-2. A version of the same procedure can be seen in the case of All Souls College, Oxford, where the feoffees granted the endowment to the King, who then rededicated it back to the foundation; see E. F. Jacob, 'The Warden's Text of the Statutes of All Souls', *Antiquaries Journal*, xv (1935), p.420.

6. This business of securing a foundation's title to an endowment was often elaborately orchestrated. At Whittington's Hospital the deeds of the re-conveyed land were drawn up along with the statutes and licences for the foundation as an *Inspeximus* dated 12 May 1432 in the Patent Rolls and passed as an act of Parliament; see Imray, *Charity of Richard Whittington*, p.36. Archbishop Chichele also had all the documents relating to the Higham Ferrers foundation, including land grants, enrolled in the Patent Rolls (*CPR 1422-29*, pp.472-4). The dangers of not taking such precautions are exemplified in the case of Tattershall, where the foundation lost most of its lands after the death of its founder, Cromwell; see R. Marks, *Stained Glass of the Collegiate Church of the Holy Trinity at Tattershall*, London and New York, 1984, pp.18-19.

7. For details of the settlement of property on Maud after Thomas's death see *CCR 1429-35*, pp.335-6.

8. *CFR 1430-37*, pp.300 and 346 respectively.

9. *CPR 1436-41*, p.80. There are two Muniments copies; see EM A 21.

10. *CPR 1436-41*, p.78.

11. EM A 23.

12. EM A 21.

13. EM A 22. Two copies of a tripartite indenture survive.

14. EMM A 33 (5).

15. EM A 24 (1 and 2).

16. 'Primus compotus domus elemosinarie de Ewelme'; see EM A 31 (7).

17. There are several examples of communities being installed in temporary buildings or being established before work to their permanent buildings was under way. These include Tattershall College, where the community seems to have lived in temporary quarters for almost seventeen years (see Marks, *Stained Glass of Tattershall*, p.15), and Eton (see Willis and Clark, *Architectural History of Cambridge*, vol.i, pp.380-405). In the latter case the build-up of the community is also recorded in an account; see Eton College Ms. VR/A/3.

18. ' ... we actually provide and put into the said house thirteen poor men, clean and gracious of living after our estimation ...' (ll.207-11). See also Chapter 5, below. For the dating of the Statutes see the introduction to Appendix I.

19. See pp.130-31, below.

20. The preamble to the statutes of a training college for school masters at God's House in Cambridge written in 1439 lamented that 'over the est partie of the wey ledyng fro Hampton to Coventre, and so forth no ferther north than Rypon, lxx scoles voide or mo that weren occupied all at ones within l. yeres passed bicause that ther is so grete scarstee of maisters of grammar ...'; see A. F. Leach, *Educational Charters and Documents 598-1909*, Cambridge, 1911, pp.402-3.

21. The evidence of licences in this respect must be treated with caution. Some licences, like that for

Higham Ferrers [*CPR 1416–22*, p.441), specifically mention schools, but others do not, and this omission evidently did not preclude their foundation. The statutes of both Tattershall and Fotheringhay, for example, describe schools (in the former instance one which, like Ewelme's, gave education to local children [182]), but their licences only make mention of the number of choristers supported (*CPR 1436–41*, p.292, and *CPR 1408–13*, p.358 respectively). Very occasionally there is physical evidence also to suggest that chantry chapels served as schools when their licences make no mention of the fact. The Wilcote Chantry at North Leigh (Oxon.) is a case in point, contemporary with Ewelme. According to its licence, granted in 1438, it was to be served by two priests but no educational duties are described (*CPR 1436–41*, p.306). In the chapel itself, however, there are the remains of an alphabet in the glass, and the architecture incorporates a miniature stone bench – a curious combination which may indicate that the chapel also served as a school room. For a recent study of this chapel see K. Heard, 'Death and Representation in the Fifteenth Century: the Wilcote Chantry Chapel at North Leigh, Oxfordshire', unpublished M.A. thesis, Courtauld Institute, University of London, 1999.

22. V. Davis, *William Waynflete*, Woodbridge, 1993, pp.35–9.

23. N. Orme, *English Schools in the Late Middle Ages*, London, 1973, p.200.

24. See below, p.111.

25. The so-called 'School House' at Higham Ferrers was actually a Jesus Chapel; see *VCH Northamptonshire*, vol.ii, London, 1906, p.221. There was a similar arrangement at Long Melford, where an alphabet still survives on the Lady Chapel walls. For the inferred presence of a school at North Leigh see note 21, above.

26. Leach, *Charters and Documents*, pp.399–402.

27. Ibid., pp.378–9.

28. Davis, *Waynflete*, p.57.

29. Ibid., p.84.

30. See pp.11–12, above.

31. Davis, *Waynflete*, p.39.

32. By a contract dated 25 April 1484, Henry Alsbroke agreed to undertake the carpentry of the school for £26 13s. 4d. See *VCH Lincolnshire*, vol.ii, London, 1906, pp.483–4.

33. *Rot. Parl.*, v, p.177.

34. For Hull see Leland, *Itinerary*, vol.i, 50, and College of Arms Ms. L.8, f.75 lists the members of the family buried at Hull. Several tombs are documented or survive at Wingfield; see Aldwell, *Wingfield*, pp.25–8.

35. *CPR 1441–46*, pp.36–7. His associates were William, Bishop of Salisbury, Thomas Beckyngton, clerk, John Golafre and John Norrys, esquires, Thomas Pleasaunce, Philip Ripe, Hugh Mayn and Nicholas Goolde. This foundation was re-licenced on 20 February 1484 by another influential group of men, including William's son, John (*CPR 1476–85*, p.386).

36. *VCH Berkshire*, vol.iv, London, 1924, p.439.

37. M.J.H.Liversidge, '"Abingdon's right goodly crosse of stoone"', *Antiquaries Journal*, lxiii (1983), pp.315–25.

38. The work included the construction of a new rood screen, and the reglazing of the building 'with many fair and costly windows, wherin some of their names do yet remain [in 1627]'; see F. Little, *A Monument of Christian Munificence*, ed. C.D.Cobham, Oxford and London, 1871, pp.1 and 17–18.

39. *CPR 1441–46*, p.135. William Galyon was Mayor of Thetford.

40. *CPR 1446–52*, pp.180–1, dated 12 December. The endowment of the chantry was £8 a year, and of the hermitage 40s. a year. The other founders were John, Archbishop of Canterbury, William, Bishop of Lincoln, Humphrey, Duke of Buckingham, William Lovell, Ralph, Lord Cromwell, Ralph de Sudeley, Drew Barenteyn and Richard Quartremayns and his wife Sybyl.

41. *CPR 1436–41*, pp.78–9, dated 4 September 1437.

42. EM A 42. This gift was not actually put to use until 1462. See Appendix v.

43. See pp.11–12.

44. The elaborate south porch of the church displays the Burghersh arms (of Alice); the de la Pole arms quartering Wingfield (William's coat); and between these a coat of de la Pole quartering Burghersh

with supporters. The couple possessed the honour of Eye and in the circumstances seem very likely to have paid for this. Alice also gave money towards the church after William's death (see below, and note 49).

45. There is no written evidence of de la Pole patronage in this church, but the glass in the body of the building contained every variation of the de la Pole and Chaucer arms and included John de la Pole's differenced coat (Burghersh quartering de la Pole with an azure label), which dates the display post-1442; see Bodl. Mss Wood E.1, ff.93–4, and Dugdale 11. William and Alice owned the manor, and the prominence of this display probably indicates that they made a bequest to the church, along with three figures mentioned in inscriptions in the north aisle windows: Thomas Maunsfeld, Hugo Holkot, Robert Croxford and his wife Johana. Thomas Maunsfeld may have had connections with the Calais wool staple. See P. N. Newton, *Corpus Vitrearum Medii Aevi Great Britain*, vol.1: *Oxfordshire*, London, 1979, p.127. This was one of the principal sources of William's wealth. There is also mention of a certain Alice Croxford acting on behalf of Alice de la Pole – perhaps a relation of this couple. See Appendix VII, EM A 47 (4) and (5). Might there have been a jointly endowed chantry founded here?

46. On 25 April 1448, for example, a chantry of two chaplains was established to pray at the altar of St John the Baptist at the church of All Saints at Walshdale in Staffordshire by a certain Thomas Mollesley and William Flaxale; see *CPR 1446–52*, p.150. The chantry was connected with the Guild of St John the Baptist, a fashionable guild which included many influential figures (see *VCH Staffordshire*, vol.xvii, Oxford, 1976, pp.228-9), and perhaps the de la Poles were amongst them, because William and Alice are named in the royal licence as principal beneficiaries of the prayers offered by these priests.

47. There has been no full study of the surviving college buildings at Wingfield, but parts of them – the cloister and the remodelling of the great hall – date to the late fifteenth century and may be coeval with the extension of the chancel, which Alice undertook in the early 1460s. See below, pp.51-65.

48. EM A 42, transcribed as Appendix V and discussed on pp.273-4.

49. The donation towards Eye was made 'pro perpetuo memorial' habendum inter tenentes domine ibidem pro anima p'carissimi domini sui Willi nuper duc' Suff' viri sui ac pro bono statu' dicte johis filii eorundem'; see BL Ms. Egerton Roll 8779.

4 The architectural development of God's House

1. J. H. Harvey, *English Medieval Architects*, London, 1987, pp.336–7.

2. See below pp.169-75.

3. Transcribed in Aldwell, *Wingfield*, pp.96–107.

4. The soundboard of this has just been rediscovered and there are proposals to reconstruct the instrument. For a discussion of it see T. Easton and S. Bicknell, 'Two Pre-Reformation Organ Soundboards', *Proceedings of the Suffolk Institute of Archaeology and History*, xxxviii (1995), pp.268–95.

5. Aldwell, *Wingfield*, pp.38–9.

6. BL Add. Ms. 19092, ff.393–4.

7. T. Tindall-Waldridge, 'The White Friars, Black Friars and Carthusians of Kingston-upon-Hull', *The Hull Times*, July 1921, reprinted in Mallet Lambert Local History Reprints, extra volume xix (Hull, 1981), p.4. No source is cited by the author but the information must come from the corporation records. I am grateful to Fr David Grant for this reference.

8. BL Add. Ms. 6753, f.294.

9. BL Add. Ms. 19092, f.399(v). Two of the identifying inscriptions, *Thomas* and *Iohanna*, are still just legible.

10. Aldwell, *Wingfield*, p.97.

11. That the fourteenth-century fabric was preserved is suggested both by the fact that the aisle is of the same dimensions as the 1360s south aisle, and that the north aisle door has stacked wave mouldings, a distinctive feature of Sir John Wingfield's church.

12. That to the west of the north wall and that at the east end of the chamber. The latter has been moved from its original position, but the former stands in a 1360s wall (see below).

13. Transcribed in Aldwell, *Wingfield*, pp.26–7.

14. My interpretation and dating of this document differ from that proposed in B. Haward's *Suffolk Medieval Church Arcades*, Ipswich, 1993, p.378.

15. 'And in eche isle shal be wyndows of freestone, accordyng in all poynts unto the wyndows of the said quire, sawf they shal no bowtels [convex mouldings] haf …' L. F. Salzman, *Building in England, down to 1450: a Documentary History*, Oxford, 1967, p.506.

16. K. Heard, 'Death and Representation in the Fifteenth Century: the Wilcote Chantry Chapel at North Leigh, Oxfordshire', unpublished M.A. thesis, Courtauld Institute, London University, 1999, pp.17–20. For a discussion of the royal chantries see J. A. A. Goodall and L. Monckton, 'The Tomb of Humphrey, Duke of Gloucester', *Medieval Art and Architecture at St Albans: Transactions of the British Archaeological Association Windsor Conference 1999*, forthcoming.

17. It was moved between 1829 and 1836; see ORO Ms. DD. par Ewelme e.7, f.26.

18. For a description of these see Newton, *Corpus Vitrearum: Oxfordshire*, pp.91–6.

19. As it appeared in the Manor House, for example. See Bodl. Ms. Wood D.14, f.51.

20. BL Add. Ms. 36432, f.1208.

21. Newton, *Corpus Vitrearum: Oxfordshire*, pp.159–63.

22. Bodl. Ms. Wood E.1, f.215.

23. John 1:19–21.

24. Illustrated in H. Munroe Cautley, *Suffolk Churches and their Treasures*, London, 1937, p.190.

25. An inscription cut into the steps round the font calls for prayers for the souls of a certain Thomas Luce, his wife and his son Robert 'who caused this font to be made'. The dates of Thomas and his wife are not known, and there were two Robert Luces who were chaplains at Salle in the fifteenth century: one who died in 1456 and the other in 1489 (see W. L. E. Parsons, *Salle*, Norwich, 1937, pp.34, 85 and 98–9). It has always been assumed that the latter was celebrated on the font because seven-sacrament fonts, such as that at Salle, are believed to be a phenomenon of the 1460s onwards; see A. E. Nichols, *Seeable Signs: the Iconography of the Seven Sacraments 1350–1544*, Woodbridge, 1994, pp.304–6. But in some ways the former chaplain is actually a more likely patron: the church was extensively remodelled between c.1410–1440 and the font is likely to have been part of this work. See P. Cattermole and S. Cotton, 'Medieval Parish Church Building in Norfolk', *Norfolk Archaeology*, xxxviii (1983), p.263. This earlier dating would also ally it more closely with the Ewelme font, which is probably c.1440.

26. For an impression see EM A 13 (3). It may be a mark of Alice's patronage that the windows at Wingfield also formerly contained rose motifs; BL Add. Ms. 19092, f.392.

27. Physical evidence for such arrangements is ubiquitous in parish churches the length and breadth of Britain from the twelfth century onwards. For early examples of nave altars see churches such as Scawton (Yorkshire) or Castle Rising (Norfolk). Amongst the countless late-medieval examples of the form are Tattershall (Lincolnshire), Wellingham (Norfolk) and Patrishow (Brecknockshire).

28. Duffy, *Stripping of the Altars*, pp.110–13 and 157–60.

29. For a general discussion of rood screens see the works of A. Vallance or F. Bond, listed in the Bibliography. See also E. Duffy, 'The Parish, Piety and Patronage in Late Medieval East Anglia: the Evidence of Rood Screens', in K. L. French, G. G. Gibbs and B. A. Kumin, eds, *The Parish in English Life, 1400–1600*, Manchester, 1997, pp.15–32.

30. Other examples of ironwork in screens include the late-fifteenth-century aisle screens at St George's, Windsor, and at Sefton (before 1540). See C. Tracey, *English Gothic Choir Stalls 1400–1540*, Woodbridge, 1990, pp.47–58 and 60–1. The combination of iron with wooden tracery is unparalleled to my knowledge.

31. The screen obscured the rector's view of the chancel and it was here that 'the farming men, and that most disturbing element in every country congregation, the farming lads and boys, took their places, and the disorder that prevailed in divine service was very distressing' (ORO Ms. DD. par Ewelme e.7, f.19).

32. Ibid.

33. ORO Ms. DD. par Ewelme c.6, Item A. The faculty is dated 8 December 1924.

34. Ibid., Item B.

35. A loose note in ORO Ms. DD. par Ewelme e.7. The letter is undated.

36. The signature is the anagram 'C.T.W.O.', which probably stands for W. T. Cleobury, acknowledged for his drawings in A. Vallance, *English Church Screens*, London, 1936, p.vii.

37. The only surviving parallel for such decoration on a medieval screen of which I am aware is an

undated diaper pattern of the IHS monogram on a screen at Grundisburgh (Suffolk). If this is medieval it is probably fifteenth-century.

38. Napier, *Historical Notices*, p.55

39. Leland, *Itinerary*, vol.i, p.113.

40. Mr P. Bobby, who was responsible for the work, has kindly confirmed this and a few other details of the restoration.

41. MA, pp.20 and 29 respectively

42. Ibid., p.5.

43. Ibid., pp.1, 29 and 31.

44. This regulation appears verbatim in the Croydon statutes, 273–4 and Whittington's: 'Item statuimus et ordinamus quod quilibet ipsorum nunc tutoris et pauperum et successorum suorum habet unum locum per se infra dictam domum elemosinae; scilicet, unam cellam sive domunculam cum camino, latrina et aliis necessariis in qua levare debeat et cubare, ac solus divinae contempletatione vacare possit si voluerit [745]'. By this date almsmen generally appear to be privately lodged in this manner – as also occurred at Tattershall [176], where the surviving contract for the construction of the almshouse stipulates the construction of 'xiij several chambers to be made for xiij bedemen'. Exceptions to this rule occur at Higham Ferrers, where the surviving building was partitioned up into individual cells [78]; and Sherburn (probably a dormitory since no cells are mentioned). There is no description of the buildings at Heytesbury Almshouse.

45. The latter detail is based purely on the evidence of nineteenth-century drawings.

46. It is quite unusual for the statutes to make specific reference to the Master's Lodging – neither the Heytesbury nor the Sherburn statutes make mention of one. At Tattershall the Master was to have 'the principal chamber with the ones adjoining thereto' [182] and at Wynard's at Exeter the chaplain was to reside 'in loco sibi assignato facturus' [404]. The priest at Ludlow was also to live in the almshouse [236]. The specific apportioning of a master's garden is without parallel, though many institutions like Wynard's and Higham Ferrers evidently did have gardens (see below).

47. MA, p.16.

48. Ibid., pp.5, 15 and 19.

49. Ibid., p.20-2.

50. Ibid., p.20.

51. The Eton common hall, for example, was built for communal eating [LVIII].

52. This regulation is not paralleled elsewhere to my knowledge. Indeed, the only other compulsory manual work I have come across mentioned in statutes is the dressing of the garden at Higham Ferrers (see note 54 below).

53. The wall of the Teacher of Grammar's garden was repaired in 1461 (MA, p.19) which proves that the plots were walled.

54. Gardens are mentioned in only a handful of statutes and neither of those most closely related to Ewelme's – Whittington's and Ellis Davy's at Croydon – includes reference to them. Remark is made of a garden at Wynard's at Exeter [405] and at Higham Ferrers. In the latter the almsmen had to dress the ground in spring and those absent from the work forfeited 1d. per day [79]. At Sandwich the community had to work the fields: sowing beans, reaping corn and threshing it [20]. Gardens and their medicinal importance are also briefly discussed in C. Rawcliffe, 'Hospital Nurses and their Work', in R. Britnell, ed., *Daily Life in the Middle Ages*, Stroud, 1998, pp.58–9.

55. See Whittington's Hospital [745].

56. For more photographs and a discussion of this see C. Hussey, 'Ockwells Manor', *Country Life*, lv (1924), pp.52–60, 92–9 and 130–7. Hussey suggests a 1460s date for the hall but the figures that are celebrated in the heraldic glazing scheme, including William and Alice (not John de la Pole, as some authorities assert), would make a late-1440s date much more plausible.

57. See pp.32–3, above.

58. The lost almshouses at Tattershall also followed this form for example. The contract for their construction, dated 14 January 1486, is transcribed in *Report on the De L'Isle and Dudley Papers*, vol.i (Historical Manuscripts Commission), London, 1925, pp.175–6.

59. The Slough brickwork accounts are very fragmentary and none that survive mention Ewelme. But they do record sales of bricks; see for example the accounts from Michaelmas 1445–6 when 7,000 were

sold off to four individuals (Eton Mss. Coll/BA/7). There may be record of the brickworks set up to supply the work to Ewelme Manor. See J. Bond, S. Gosling and J. Rhodes, *Oxfordshire Brickmakers*, Abingdon, 1980, p.6.

60. The school-house bricks average about 8.8" long by 4.2" deep by 2.3" high and the quadrangle bricks about 9" long by 4" deep by 2.5" high.

61. See Smith, 'Brick Making Industry', pp.17 and 98–9. Perhaps closer in design than any listed here is a door at the rear of the Ridderzaal in The Hague.

62. For example the Gruuthuse in Bruges and Spaans Paviljoen in Veurne.

63. The Master's Accounts of 1461 make reference to the repair of 'muros latericeos in domo domini Johis Clifforde'. The reference to a 'house' and to brick walling suggests that this range is the one being referred to (MA, p.25).

64. Bodl. Ms. DD. Ewelme d.10. EA 5 (24). A sum of £307 3s. 9³/₄d. was spent, amongst other things, on 'additional building to and repairing the Teacher of Grammar's house …' in this year.

65. See L. Shekede, 'The School House, Ewelme, Oxfordshire: Conservation of the Wall Painting', unpublished report for the Ewelme Trustees dated 12 June 1997.

66. I have been kindly informed of this by Mr and Mrs George Cannon, who previously lived here.

67. The Master's Accounts do make specific references to entertainment – for example, the dinner for Sir John Norfolk and his servant in 1457 in MA, p.9. They also record the fact that there were a large number of visitors to the almshouse, and this would argue in favour of there being some facility for accommodating them.

68. MA, p.31.

69. H. K. Simcox, 'Suggestions for the Amendment and Improvement of the Scheme under which the Almshouse at Ewelme is now Administered', a pamphlet printed at Wallingford, 1892, p.6. A copy is preserved in the papers of Bodl. Ms. DD Ewelme c.109.

70. See EM EA 10 (123) and Ms. Top. Oxon a.8, f.63 respectively.

71. ORO Ms. DD. par Ewelme e.7, f.44.

5 Institutional life in the almshouse

1. For example the hospital at Abingdon; see pp.32–3, above. See the section 'Hospital, college and guild statutes', below.

2. Although the priest at Ludlow lived in the almshouse, he seems to have had no responsibility for supervising the community of poor men – this arrangement is unique to my knowledge.

3. This arrangement reflects the modest scale of the foundation, which had only seven men.

4. This entire description is repeated verbatim in the Whittington's Hospital statutes in reference to the head of that institution, a poor man entitled 'Tutor' [744], and these ideas about a suitable head of community find very similar expression in several other statutes. Variations of the same formula appear in the description of the Tutor at Ellis Davy's Almshouse [268 and 280]; the Chaplain of Wynard's at Exeter [404 and 405]; and the Master of Sherburn [7th page of statutes]. Even where this formula is not followed, the same ideas are rehearsed, for example in the description of the Master's post at Fotheringhay – his good personal qualities [274] and his powers [278–9], at Tong, 1404, and the Provost at Eton [VIII]. At Heytesbury his qualities are expressed negatively – he must not be a reveller and so on [291]. One interesting feature of all these descriptions is the explicit or implicit direction that the head of the institution should act as the sole figure responsible for the institution's temporal business – as if it is a task that the rest should be protected from. In the case of almshouses attached to collegiate foundations the responsibility for temporal possessions was always vested in the Master of the college.

5. This obligation is usually expressed in the form that the almsmen must hear the Offices: Wynard's at Exeter [406]; Ellis Davy's at Croydon [275] etc. At Heytesbury the Chaplain was to say Mass in different locations depending on how many of the almsmen were able to leave their beds [294].

6. Stipulations of age are comparatively unusual. The Master of the de la Pole Hospital at Hull had to be over thirty [715] and the priest at Westminster over forty-five and unbeneficed [146]. Demands for academic qualification are similarly unusual. At Tattershall there is a stipulation that the Master be a graduate [180] and, most elaborate of all, at Eton, he had to be an M.A. or B.A. in Theology or a Doctor in Canon Law and M.A., over thirty and be born in England [VII]. But the only other case in which a particular university is stipulated occurs in the statutes of Jesus College at Rotherham (1483), where the Provost had to be a B.A. in Theology from the University of Cambridge. See Leach, *Charters and Documents*, pp.426–7.

7. This is quite a common salary for such a figure. The same sum was paid to the chaplains of both Heytesbury and Hull [304 and 715] and to the chaplains of collegiate foundations such as Tattershall [183] and the second figure, the precentor, of Fotheringhay [273]. Masters, Wardens or Provosts of such institutions often received more: £13 6s. 8d. at Fotheringhay, £20 at Tattershall and £25 at Eton, though at Caister the Governor's salary was also £10.

8. At Heytesbury 20s. were to be allowed out of the house's income for the Chaplain's 'man or servant' [304]. Above and beyond the four or five college servants at Fotheringhay – including a cook, barber, and tailor – the Provost was allowed three horses and a servant at the expense of the house [286–7]. But the fullest description of servants is to be found at Eton, which amongst others, had thirteen poor youths between fifteen and twenty years old taken from other grammar schools. They were to serve as labourers, servants and bell-ringers, but were to be educated so as to take up holy orders by the age of twenty-five. Each fellow was to be served by one of these boys and the Provost by two. Beyond their commons and livery, which they received from the college, these boys were to be supported by their masters [x].

9. Many institutions also allowed their principal figure to hold other benefices – for example Tong [1404] and Tattershall [180], but at Heytesbury such a practice was utterly forbidden [293]. Evidently there was a concern that Masters and Tutors would not be present often enough. To avoid this, many statutes define holiday time – at Fotheringhay [283] and Tattershall [180] they were both limited to a month – or restrict periods of absence – a month at Heytesbury [291], three weeks and three days for the priest at Wynard's [405], six days for the Tutor at Croydon [276] and a lordly sixty days for the Provost of Eton [VIII].

10. For obvious reasons this is quite a common stipulation for such teacher-priests, for example, at Heytesbury [294], where the chaplain had to be 'a sufficient teacher of grammar'.

11. This concept of a free local grammar school seems to have been the norm for this kind of foundation, for example, at Heytesbury [294–5], where the education was free if the parents had an income of less than £10, and Tattershall [182], where the qualification for entry was, in the same form as at Ewelme, being a son of a tenant of the lordship or the lordship of the foundation. Henry VI could claim the kingdom as his 'locality', and so at Eton the foundation charter of 1440 grandiloquently states that the Grammar Master 'aliosque, quoscunque, et undecunque de regno nostro Angliae confluentes ad dictam collegium in rudimentis gramaticae gratis absque pecuniae aut alterius rei exactione debeat informare'; see *Correspondence of Bishop Beckyngton* (2 pts), ed. G. Williams (Public Record Office Chronicles and Memorials, lvi), London, 1872, p.281. In fact, however, the later statutes of Eton express a preference for students from the locality and associated estates, in just the same manner as other foundations [III]. Not all chantry schools were free. In the case of Wynard's Hospital, for example, the pupils were to be supported 'ad custus et expensas parentum et amicorum suorum' – presumably as a means of supplementing the priest's income. Edward IV's household Grammar Master seems to have offered free education for 'men and children of the court disposed to learn, if they be of ordinate masters within this court'; see *The Household of Edward IV*, pp.137–8.

12. Although the Master at Eton was to punish the boys for idleness and negligence, but not immoderately [XIV].

13. The salary of £10 seems to be a good, but not unusual, salary for a grammar master at this date; see N. Orme, *English Schools*, pp.156–8.

14. All institutions of this period had a deputy figure, principally by reason of the Master going away on house business. Because in most almshouses there was only one priest, the substitute was usually an almsman – described at Heytesbury for example as 'one of the poor men most discreet that may execute his [the chaplain's] office in all things till he return again' [292]. At Whittington's Hospital the Tutor is instructed to appoint a deputy during his absence in the same terms [746]. Westminster and Wynard's do not deal with the question of absence – most business was done for them by the college officers – though the latter does mention a key-holding almsman who was to be 'great in honesty', who presumably served the function of deputy [406]. Such positions are closer to the office of the Minister at Ewelme and will be discussed below. In large collegiate foundations, such as Eton, Tattershall, Tong and Fotheringhay, where the almshouse was subsumed within the college hierarchy, the Teacher of Grammar's position as deputy is analogous to that of a Vice-provost or Precentor, but their duties as deputies of colleges were in most respects quite different from his. At Croydon there was no deputy, so the Tutor was not allowed to be absent for more than six days in the year [276].

15. These directions are effectively identical to those of the Chaplain or Keeper at Heytesbury, who had to teach and run the almshouse [294]. By implication the Wynard's priest had to say all the Offices as well as teach because the poor men there were to hear all the Offices [406]. At Eton it is implicit in the statutes that the School Master had distinct religious duties from the fellows, otherwise his peers [xxx–xxxi]; indeed it was not even requisite that he be ordained a priest. In Edward IV's household the Master of Grammar was part of the Chapel Royal and, if he was a priest, also had particular religious duties; see *The Household of Edward IV*, pp.137–8.

16. There are no other instances of numbers of pupils determining religious duties, nor is the subject of

pupil numbers usually touched upon. Wynard's is an exception to this, where the statutes direct that 'tres pueros ad minus, quartor, quinque, sex, septem, octo, et novem ad maximum' were to be taught [406]. In college schools the number was possibly limited by the number of choristers stipulated in the statutes. But, on occasion, colleges evidently did teach more than the number of their choristers: at Tattershall their number was incremented by an unspecified number of local boys [182]. This Ewelme regulation seems further circumstantial proof that the school buildings do not match the school described in the Statutes. If there was a serious possibility that there would be so few students why was such an enormous building erected?

17. Orme, *English Schools*, p.60.

18. The term 'reders' is unparalleled in statutes, but the word 'pettetes' is often used of children in the first stage of their education. For example, the 1477 statutes of the Master of Ipswich Grammar School mention 'petytis vocatis Apesyes' – i.e. 'little ones called ABCs'; see Leach, *Charters and Documents*, p.422.

19. There is an evident preoccupation with the significance of the numbers of people who received charity from religious foundations. Almshouses in this period are regularly constituted with thirteen paupers, presumably significant as the number of Christ and the apostles – as at Eton [LII]; Tattershall [183]; Sherburn [5th page]; Whittington's [744]; and Tong [1404]. At Heytesbury there were to be twelve men and one woman to make up the number, and in some cases, such as Westminster [146] and Wynard's [406], the foundation's priest was the thirteenth figure. Multiples of the figure are also found, as at Hull, which had thirteen poor men and thirteen poor women [714]. The common alternative in smaller institutions was seven men, as at Caister [385] and Croydon [268]. One of the most remarkable cases of this interest in the numbers of paupers is described in the Fotheringhay statutes, where daily doles were to be made to different numbers of paupers every day: three for the Trinity on Sunday, nine for St Michael and the nine Orders of Angels on Monday; one on Tuesday, Wednesday and Thursday for St Thomas Martyr, St John and St Laurence respectively and five on Friday and Saturday for the Five Wounds of Christ and the five Glorious Mysteries of the Virgin [304]. This preoccupation with numbers, though not exclusive to almshouses, seems principally limited to them; the numbers of priests and clerks at colleges varies considerably.

20. This formula appears repeatedly in almshouse statutes of the period. For example: 'Pauperem vero quemlibet ad domum ipsam vel aliquem locum in eadem providendum, substituendum, et admittendum, talem esse volumus; viz humilem spiritu et bonis temporalibus unde competenter vivere possit alibi destitutum, castum in corpore, et bonae conversationis reputatum ...' [Whittington's, 745]. Similarly, 'We will that every poor man that shall be provided and admitted to the said house [be] destitute of temporal goods wherewith he might live else where, be[?ing] meek in spirit, chaste in body and of good conversation named' [Heytesbury, 298].

21. At Tattershall [179, as well as in the 1439 licence for the foundation, *CPR 1436–41*, 292] and Ludlow [238] the paupers could be of either sex, and at Hull the almshouse supported thirteen poor men and thirteen poor women [714]. Women were also often employed as servants in such institutions (see below) and, in the two sets of statutes that employ the formula used for Ewelme, specific provision is made for women: at Croydon women could be admitted as brethren at the discretion of the guardians [269] and at Whittington's Hospital there were to be thirteen poor men [744], but – again at the discretion of the guardians – 'unius vel utriusque sexus'. Because the Ewelme Statutes repeat the formula without specifically mentioning women – there were to be 'thirteen poor men after the whole discretion and good conscience of the provisors, founders and patrons of the said house' (ll.78–82) – it seems fair to assume that the constitution with men alone is deliberate.

22. Wives are not mentioned and the access of women into the almshouse was restricted [XLVII] (see below). It is hard to believe that celibacy was not normally expected – in the main, statutes certainly suggest that it was and at Eton an almsman would be expelled for marrying [LIX]. But it is interesting that at Heytesbury the decision to form a celibate male community is represented as a conscious choice on the part of the founder and that, by implication, other arrangements were known. Here poor men were to be accepted 'always provided that there be no man taken in to the said house, neither servant, nor tenant nor any other that hath a wife: for it was the will of him that first ordained the said house that no manner man that was married should be admitted into the said house' [299]. This passage may, however, be the result of an attempt to reform an almshouse which had slipped from the norm of celibacy, and Hicks (in 'Chantries, Obits and Almshouses', p.35) observes that married couples had lived at Heytesbury previous to its refoundation by Lady Hungerford. Hicks goes on to argue that the attribution of this stipulation to the original founder was therefore almost certainly untrue and that the exclusion of married couples reflected Lady Hungerford's personal preferences. Equally possible, however, and not exclusive of Lady Hungerford's devotion, is that these married couples had been accepted against the founder's wishes – as the document says – and that the statutes sought to prevent a relapse into this condition. At Westminster it was also expressly demanded that the almsmen be unmarried [146]. Occasionally college statutes allow for members of a community to be married, but only if there was nobody else suitable for the post; for example the organ clerk at Eton [X], who nevertheless could not live with his wife in the college [XLVIII].

23. This is the exact quantity of money paid to the almsmen at Whittington's Hospital 'pro victu, vestitu

et aliis necesariis' [746]. It was quite a high salary by the standards of the day, compared with 40s. a year paid for 'lyving, fyndyng and sustenacion' to each of the poor men at Caister and the 10d. per week paid to the poor men at Croydon. The salary at Ewelme, like that at Whittington's and Caister, was probably intended to cover all a poor man's living costs, and neither the Statutes nor the fifteenth-century accounts contain reference to communal doles of firewood and clothing that supplemented the much more modest payments typical of other almshouses in this period. The almsmen at Tattershall, for example, were paid a penny a day with the 'customary livery and fuel quarterly' [183] and the men at Eton 20s. a year with the same and commons [LVIII]. Those at Higham Ferrers received 7d. per week and cloth for a black gown every Christmas, as well as various communal payments: 5s. for their lamp, 3s. for a barber, 9s. for wood and 10s. for 'ffewell to wash them'[79]. It is not clear in some instances whether almsmen were paid at all: at Ludlow the paupers are only recorded as receiving the residue of 20s. distributed annually at the founder's obit, a liturgical anniversary of his death [238]. At Heytesbury the almsmen were supported on a communal weekly dole, the exact sum of which depended on the current price of wheat. If this dole is subdivided by the number of the brethren in the foundation, it works out at about 6¹/₂d. per person when wheat was at a 'normal price'. This sum was perhaps never distributed, but outlaid communally. It was supplemented each year with 3s. 4d. for a barber, 20 loads of wood [306] and gifts of clothing – two shirts, two pairs of hose and two pairs of shoes per year with a gown and hood every two to three years [304–5]. Wynard's almsmen had their salary of 7d. per week supplemented by charitable offerings [407] – a feature of the Higham Ferrers Almshouse too [77] – and the poor men of the de la Pole Hospital attached to the Charterhouse at Hull had their 8d. per week supplemented by an annual residue of 40s. distributed quarterly [716]. An interesting comparison to these salaries is the 13d. salary paid to impoverished members of the Guild of the Holy Trinity, Botolph's Gate, London, by the statutes of 1389 [69]. Tudor inflation had pushed an almsman's pay up to 2¹/₂d. every day at Westminster. It is interesting that three of the pure cash payments – at Croydon, Whittington's and Ewelme – all occur in foundations which share the same textual formula for their statutes. The salaries of the poor men in these foundations are all clearly related: at Ewelme and Whittington's Hospital the men drew identical sums, and at Croydon the Tutor and poor men tuppence less than the wages of their respective colleagues in the other two institutions.

24. Bodl. Ms. Rawl. B 400F, f.23.

25. At Westminster Almshouse for example it is stipulated that wages be distributed to the almsmen around Henry VII's tomb. For donor figures at Ewelme see also pp.77–9, above. Only two sets of statutes specify the timing of the payment of wages – Higham Ferrers (on Friday, [79]) and Westminster (after evensong on Saturday [146]). That both specify payment at the end of the week may suggest that this was the common practice.

26. For restrictions on work see below. Practically all almshouse statutes including Eton [LVII]; Whittington's Hospital [746]; Wynard's [406]; Ellis Davy's [285]; and Higham Ferrers [79] explicitly ban begging. At Eton [LVIII], Higham Ferrers [77] and Wynard's [406] there was to be a box for public charitable offerings. These were to be divided amongst the brethren. Curiously, in the latter instance, and at Heytesbury [298], where there was no such box, offerings could still be made by family friends to individual members of the house which the rest of the brethren had no claim to. In other words it seems to have been the begging, rather than the reception of extra charity, that was considered distasteful.

27. These two directions seem absolutely typical and are identically phrased in several statutes, although the sums of money vary – five marks at Whittington's [746]; four marks at Ellis Davy's [279] and Heytesbury [302]; and £4 – a reflection perhaps of Tudor inflation – at Westminster [147]. At Eton the sum of money is not stipulated, just the abject poverty of the almsman [LIII and LIX]. One man was expelled from Ewelme for having more money than was permitted (see p.139).

28. This instruction does not always appear but can be found at Heytesbury and Higham Ferrers [78]. In both these cases the almsmen are also instructed to bring their possessions to the almshouse when they arrive. At Higham Ferrers a considerable quantity was demanded of each man, including cooking utensils and bedding [77], but at Heytesbury you were simply to bring what movable possessions you had. Any cattle were to be sold and the profits halved between the owner and the almshouse on your arrival [301]. When they died Heytesbury almsmen had to give half of their possessions to the house 'for the health of their [own] souls' [303–4] – a direction which throws an interesting light on this gift as a charitable benefaction in its own right – and their clothing was distributed amongst the living brethren [305]. At Whittington's an almsman was permitted to write a will, but a greater part of the goods had to go to the house [746]. Almsmen at Eton had to bring their own garments, beds and bedclothes if they had them, but were supplied with them if they had nothing [LV]. All their property went to the almshouse when they died and they had to renounce all wills [LIV]. Restrictions on the disposal of property are by no means limited to almshouses – at Fotheringhay the Master had control over all wills [291].

29. It is often specifically stated that charitable provision is intended to serve local or, in aristocratic circles, familial needs. Ellis Davy's Almshouse was for the poor of Croydon [272–3], Whittington's for those from London [745] and so on. In the case of more aristocratic foundations such as Fotheringhay, the *hospitium* was to try to find those 'qui fuerint familiares seu tenentes dicti domini Edwardi

fundatris predicti ac progenitori eiusdem in villis seu dominiis de Fodringhay predicta Nassyngton et Yarwell dicto collegio adiacentibus' [303]. At Heytesbury 'all such persons as have been servants, or that shall happen to be servants, to the inheritors of the Hungerford's hereafter, that now be or hereafter shall happen to fall in poverty be preferred to the said almshouse before any other people' [299]. The Eton statutes show particular interest in helping servants of the college who had fallen on bad times [LIII].

30. This regulation appears verbatim in Whittington's [746], Heytesbury's [301–2], and Ellis Davy's [279] statutes. Sherbourne's 1434 statutes, which re-founded a leper hospital as a college and almshouse, supported two lepers in deference to its founder's directions, but they lived quite independently from the community (passim). Those put out of the house at Eton as a result of disease were to receive 12d. per week [LIX].

31. This instruction that the able-bodied should help the sick appears verbatim at Whittington's [746]. It appears likewise at Ellis Davy's [277] and Heytesbury [299]. At Whittington's and Davy's Hospitals, where women could be almsfolk, this duty is especially recommended to them. To quote the former: 'quod infirmis, debilibus et impotentibus sociis dictae domus cotidie seu consocios ejusdem sanos et potentes, et hoc foeminei sexus specialiter, si qui fuerint in eadem delegentissime succurratur et ministretur in opportunis' [746]. At Eton and Heytesbury the female servant was likewise especially recommended to the work (see below). Usually, where there were female servants in the almshouse, the work was placed in their hands alone: for example at Sherburn [7th page], Higham Ferrers [78–9] and Westminster, where there were three women over fifty years of age [147].

32. The description is formulaic; see for example Whittington [747] and Heytesbury [298] and so on.

33. The almshouses at Eton, Westminster, Higham Ferrers, Heytesbury, Hull and Sherburn all had female servants. Nor does this circumstance appear to be a fifteenth-century development: for example, as early as 1344 the statutes of St Julian's Leper Hospital at St Albans forbade women from entering the hospital but excepted 'good' women, and wives and sisters of members of the community [507]. Only collegiate foundations seem likely to have avoided women completely, but their prohibitions are usually phrased very similarly to those found in almshouse statutes. For women inmates see notes 21 and 22 above, in this chapter.

34. At the almshouse of Higham Ferrers the bedesmen gave the nurse meat to cook [79] and at St Bartholomew's, Sandwich, there was a common pot in which the food was prepared [19]. These latter statutes provide an unusually detailed picture of daily living arrangements.

35. This ban on reminiscences seems peculiar to Ewelme, but similar demands for good behaviour are found in the Ellis Davy's statutes [273–4] and those of Whittington's Hospital: 'Et volumus et ordinamus quod iidem nunc tutor et pauperes ac successores sui dum fuerint in praedictis locis, dominiculis, sive cellis suis, necnon in claustris, et caeteris partibus ipsius Domus Elemosinae quiete et pacifice, sine strepitu, vel turbatione sociorum suorum se teneat et conversentur, orationibus, lectionibus, sive manuum suarum laboris aut aliis honestis occupationibus insistentes' [745]. At Hull the poor men were to follow an honest profession in the afternoon [715].

36. At Croydon the clothing was to be dark or brown to befit the station of the wearer [276], and, no doubt for the same reason, it was to be 'de honesta forma et colore obscuro' at Whittington's [746]. In other cases habits were part of an almsman's income. For example the almsmen at Higham Ferrers were to receive enough cloth for a black gown each Christmas; and at Tattershall a livery was paid for quarterly. Such distributions precisely echo arrangements in contemporary secular households, where the different orders of staff were given cloth appropriate to their status. There are a number of examples of distinguishing marks on almsmen's clothing. At Heytesbury the men were to have 'gowns and hoods of white woollen cloth with "JHU.XRT" in black letters set upon their gowns upon the breast before and upon the shoulders behind' [305]. At Westminster each man was to wear a gown with a red rose scutcheon worth 20d. on it [146] – a reminder that such distinctive dress could also be treated like a servant's livery and an advertisement of a patron's largesse. A black cross was to be worn on the garments of the almsfolk of St John the Baptist's Hospital, Coventry [660], and at Eton Henry VI demanded that the almsmen wear a white cross on the right side of the chest, a fashion, we are told, the King had recently had recommended to him [LV]. The requirement for hoods as well as gowns at Ewelme is comparatively unusual. The explicit insistence that they be worn at church is only paralleled at St Julian's Leper Hospital at St Albans, where the brethren were to go to church 'capa clausa cum caputio induti' [486]. At Ewelme habits were evidently still in use in the eighteenth century and their last mention occurs in 1759 when a new set was ordered at the appointment of Dr Kelly as Master (see EA 5 (9)).

37. See p.78.

38. Fines were a feature of institutional life, and all statutes – of secular households, almshouses or colleges – describe such a system of docking wages or commons. These could be swingeing, as at Eton for missing the King's obit. But Ewelme has by far the most elaborate directions for this of any almshouse.

39. There are no exact parallels for the office of Minister in other foundations. His duties fall somewhere

between that of the senior almsman in an institution like Wynard's Hospital and the head of an almshouse like Croydon, Eton or Whittington's, where there was no priest. In the case of Croydon the Tutor was ideally to be elected by the acclaim of his fellows [271–2] but at Whittington's and Eton he was to be appointed by the Master or Provost of the College [745; LII]. At Higham Ferrers there was to be a senior almsman called the Governor, but it is not clear how he was appointed [77], and at Ludlow a head almsman, though his only duties were to ring the bell and lead a daily service of prayer [239]. Perhaps the closest comparison to the Ewelme Minister was the elected *hebdom* at Sherbourne [6th page]. See also note 14, above.

40. The option of an appointment to the office by patrons may also have existed at Ellis Davy's [271].

41. The Warden of the almshouse at Eton did exactly this [LII], but usually the head of the institution – the priest at Heytesbury and Wynard's or the Tutor at Croydon and Whittington's Hospitals – was solely responsible for fining. Several colleges had similar systems of fining to Ewelme. At Tattershall, for example, one college clerk was elected *prepositus* on 30 September each year to keep a note of absences of fellows and clerks and kept a tithe of the fines in reward for his labour [180].

42. Bells are not always mentioned in almshouse statutes – for example they are not mentioned at Croydon or Whittington's Hospital – though they were used at Westminster to summon the almsmen to morning and evening prayers [151 and 152] and at St Julian's Hospital at St Albans [486]. There was evidently a bell at Higham Ferrers, which is mentioned as being situated at the west end of the hospital. This was to ring at 6pm for half an hour to call the almsmen to prayer and bed [78]. There was also a fifteen-minute toll to call the Ludlow almsfolk to prayer once every day [239]. Colleges often have directions for bell-ringing, particularly at obits [Fotheringhay, 300]. Eton had bell-ringing clerks [x]. The only detailed instructions about closing doors at night are those for Fotheringhay, where the hours of closure are stipulated and the Master was to keep the keys [295], and for Eton. In the latter the warden was to lock the almshouse between eight and matins [LII]. There are separate instructions for the college gates [XLVIII].

43. The same salary as Whittington's Tutor [746]. At Ellis Davy's almshouse the Tutor received only 12d. – 2d. less than these men [275] – but since the almsmen's salaries there were also 2d. less than those of their Ewelme and Whittington counterparts, the sum is proportionately greater. The almsman priest at Westminster received 4d. per day as opposed to the 2¹/₂d. of his almsmen [146]. At Ludlow the head almsman was the only salaried figure in the community, receiving 2s. a year [239]. The Eton Warden seems to have received no extra pay.

44. For a general discussion of late-medieval accountancy in parish accounts see Kumin, *The Shaping of the Community*, in particular pp.82–102.

45. This responsibility is a commonplace, see for example Eton [XXXVII].

46. References to chests with three keys are ubiquitous but the identical descriptive formula to Ewelme's is used in Ellis Davy's [278] and Whittington's statutes [646]. Such chests are also found at Wynard's [407] and Tattershall [180]. Some foundations, like Heytesbury or Fotheringhay, actually had more than one chest of this kind. At Heytesbury there were three. One was kept under three keys and contained the vestments and instruments given by the foundress. This was housed under the altar of the chapel used by the almshouse in the parish church [295]. A second chest under two keys was also stored in the same place for the other vestments [302]. The third chest, described using the Ewelme formula, was to be kept in a secure place in the almshouse and was to contain the seal, charters, letters, privileges and treasure of the foundation [302]. Fotheringhay's system was yet more elaborate and included one chest with four keys [287–8]. At Hull the treasure and muniments were stored in the Carthusian monastery. The chest in which they were held is not described as being kept locked under different keys [716–17]. Perhaps in this instance such protection was not thought necessary, but the practice appears to have been so common that this seems unlikely.

47. For obvious reasons there are often elaborate instructions about holding keys. The three keys at Heytesbury, for example, were to be kept respectively by the foundress during her life (and a co-founder – if he outlived her – and then the Visitor afterwards), the Keeper or chaplain of the house and a worthy member of the parish [303]. At Whittington's the three keys were to be held by the Tutor, the senior member of the community and another trusty person from it appointed by the executors and, after their deaths, elected annually [746]. Variations on these arrangements also occur – at Wynard's the Mayor of Exeter was to hold one key [407]. Fotheringhay has particularly complex and rather fascinating instructions on this head and even the Master did not have keys to every chest [287–8]. In all these cases, having so many keys held by such diverse figures must have ensured that opening chests was a rare event and involved considerable ceremony, a security which must have made this system attractive to founders.

48. This formula is repeated with reference to the Tutor of Whittington's Hopsital: 'bona praefatae domus quae ad manus suas devenerint bene et fideliter ministrare dispersa congregare congregata servare et totam yconomiam ipsius domus in quanto bene poterit supervidere disponere vel ordinare …' [744].

49. The taking of inventories at the arrival of new heads of foundations in this manner is paralleled in several foundations. The exact formula found outlining this responsibility at Ewelme is repeated in

Ellis Davy's [280] and Whittington's [745] statutes. At Heytesbury the duty was elaborately conducted. The new priest had to take an inventory in the presence of two poor men, two priests from Heytesbury, the parish priest from Heytesbury, two trusty men chosen by the priests, the Dean of Salisbury (if he was around) and the foundress (or her representative). After her death her place was to be taken by a co-founder (if he outlived her) and then by the Visitor [292].

50. The inventory, EM A 39 (2), is reproduced in Appendix III.

51. MA, pp.15 and 21 respectively.

52. EM A 39 (1) and (3) respectively.

53. EM A 35 B (1).

54. MA, pp.30, 30–1, and 30 and 31 respectively.

55. Ibid., p.26.

56. For a study of the estates see J. Genet, 'Trois Manoirs anglais au XVième siecle: les domaines de l'hôpital d'Ewelme, étude économique et sociale 1442–1510', unpublished thesis for a Diplôme d'Etudes Supérieures, Paris, 1965.

57. MA, p.11.

58. EM A 35 A (5). Rede appears regularly in various accounts from 1465 onwards.

59. In 1461 he was farming the demesne of Ramridge; see EM A 35 A (1).

60. MA, p.6 and p.19.

61. For the first example see EM c.2 EA 1 (6).

62. EM c.2 EA 1 (9).

63. These terms appear to be used interchangeably along with 'patron' and 'guardian'.

64. This is an injunction repeated verbatim in many sets of statutes, including Whittington's [746] and Ellis Davy's [278].

6 The community

1. *CCR 1435–41*, p.335; *CCR 1435–41*, pp.91–3; and *CPR 1429–36*, p.449.

2. *CPR 1436–41*, p.166.

3. See pp.27–8, above.

4. Thomas Oldbury is described as rector of Ewelme on 6 March 1453, when he was granted a Papal Dispensation to hold an incompatible benefice along with it (*Cal. Pap. Reg.*, x, p.616). He took advantage of this to become vicar of Mildenhall (Suffolk), to which living he was admitted on 24 April 1453 (see *Univ. Oxf. Reg.*, p.1395).

5. EM A 38.

6. EM A 39 (2).

7. *Univ. Oxf. Reg.*, p.1238.

8. EM A 39 (2). See Appendix III.

9. EM A 35 B (7). See Appendix II.

10. See Appendix II.

11. MA, pp.2 (bis), 6, 11, 15 (bis), 16, 20, 21, 22, 25, 27 and 30.

12. MA, pp.1 (bis), 11, 12, 19, 20, 26 (bis).

13. MA, pp.2, 5, 9, 11, 16 and 22.

14. MA, p.25.

15. He received a long gown of crimson lined with black buckram along with a girdle of black silk with seven gilt bars; see *Somerset Wills 1383–1500*, ed. F. W. Weaver (Somerset Record Society, xvi), 1901, p.217.

16. Thomas Lee was admitted to the rectorship of Ewelme on 4 December 1467 and he held it till his

death in 1499. He had been principal of Edmund's Hall, Oxford, 1459–60. See *Univ. Oxf. Reg.*, p.1123.

17. CAD, V, 71 (A.10953), dated 20 October 1476.

18. CAD, V, 71 (A.10954 and 10955).

19. EM A 26. See introduction to Appendix I.

20. EM A 31 (25), (26) and (27) respectively.

21. These are numbered inversely EM A 31 (29) and (28).

22. *Oxf. Univ. Reg.*, p.1568.

23. EM A 31 (27). The information is collated from the main account and the *firmarius*'s account.

24. EM A 31 (24).

25. Curiously, this debt is not recorded in the earliest surviving subsequent audit accounts (for the years ending December 1499 and 1500), but only emerges in that closing December 1501 (see EM c.2 EA 1 (2)).

26. *Some Oxfordshire Wills proved in the Prerogative Courts at Canterbury, 1393–1510*, eds. J. H. R. Weaver and A. Beardwood (Oxfordshire Record Society, xxxix), 1958), pp.61–2.

27. EM EA. 2 (2) and (3). See Appendix II.

28. *Oxf. Univ. Reg.*, p.1742.

29. EM A 39 (2). See Appendix III.

30. MA, p.12.

31. MA, pp.19 and 25 respectively.

32. EM A 5 c (1) and a copy (2).

33. EM A 35 B (1).

34. *Univ. Oxf. Reg.*, p.448. The *Register* only says that the John Clyfford who rented the school may be the same man as the John Clyfford who was ordained. However the biographical details which will be outlined make the identification convincing.

35. See pp.27–8.

36. There are many instances both in statutes – for example, Whittington's named Robert Chesterton as the first Tutor [744] – and in foundation charters, see Higham Ferrers [*CPR 1422–29, 472–3*], and Tattershall [172–3]. In the case of Tattershall the names were revised in subsequent documents as men died. See also the introduction to Appendix I.

37. EM A 35 B (1).

38. EM A 35 B (14).

39. EM A 31 (24).

40. EM A 35 B (22).

41. EM A 31 (27, 28 and 29).

42. EM c.2 EA 1 (3) and a copy (4).

43. EM c.2 EA 1 (11) which reads 'pro quondam antiqo debit' domini nostro debit'.

44. For a transcription of this account see Appendix III.

45. The dating of EM A 35 B (16–21) is odd, but they seem to form a consecutive series.

46. The following Audit Accounts – EM A 35 A (1–7); A 35 B (8–25); c.2 EA 1 (1–4, 6–10, 13, 16, 22, 24 and 26); and c.2 EA 2 (2–3) – and Estate Accounts – A 35 B (1–7) and (26) – have been used in compiling this list. For the editorial conventions used in the transcriptions see p.212.

47. MA, p.25.

48. EM A 5 (b).

49. EM A 5 (c).

50. EM A 39 (2). See Appendix III.

51. EM A 33 (3) onwards.

52. EM A 33 (17).

53. EM A 31 (8) to (17) inclusive.

54. EM A 39 (2). See Appendix III.

55. MA, p.2.

56. MA, p.6. At Higham Ferrers 5s. was laid down annually for the employment of a barber [79] and at Fotheringhay it is specifically stated that one of the college servants was also to practise this trade [286]. Barbers are also mentioned in the Heytesbury [306] and Tattershall [181] statutes.

57. E. Prescott, *The English Medieval Hospital*, Melksham, 1992, p.2.

58. EM A 35 B (8).

59. It is assumed in these figures that no entry for deaths in the account of a particular year means that there were no deaths.

60. EM A 42. See Appendix V, p.277.

61. The first mention of *vacantibus* is in the 1511–12 account, c.2 EA 1 (22).

62. MA, p.32.

63. MA, pp.11 (bis), 12 (bis), 15 (ter), 16 (bis), 20 (bis) and 29.

64. MA, p.27.

65. EM c.2 EA 1 (6).

7 Devotion

1. See Chapter 1. Two representative analyses are Wood-Legh, *Perpetual Chantries*, and Rosenthal, *The Purchase of Paradise*, respectively.

2. This introductory passage is reproduced verbatim in the Whittingham statutes, with the difference that Divine Service is not mentioned; see pp.220–21 for the parallel texts. The explanation for this omission at Whittington's is that the almshouse there was attached to a college and had no priest of its own to celebrate Divine Service.

3. An easily accessible late-fourteenth-century work that outlines these ideas, for example, is Chaucer's 'Parson's Tale' from *The Canterbury Tales*. Passages from this have been quoted in the notes below to illustrate particular points. Amongst several recent works which treat the subject in the wider context of Christian belief and practice are J. Bossy, *Christianity in the West, 1400–1700*, Oxford, 1985, esp. pp.34–56, and Duffy, *Stripping of the Altars*, esp. pp.338–78. The theology of Purgatory is discussed specifically in relation to chantries in C. Burgess, 'A Fond Thing Vainly Invented: an Essay on Purgatory and Pious Motives in Later Medieval England', in S. Wright, ed., *Parish, Church and People: Local Studies in Lay Religion, 1350–1750*, London, 1988, pp.56–84.

4. See 'Parson's Tale': 'Of thilke Adam tooke we thilke synne original; for of him flesshly descended be we alle and engendered of vile corrupt mateere. And when the soule is put into oure body, right anon is contract original synne, and that that was erst but oonly peyne of concupiscence is afterward bothe peyne and synne. And therefore be we alle born sones of wrathe and of dampnacioun perdurable.' (Geoffrey Chaucer, *The Canterbury Tales*, ed. A.C. Cawley, Everyman edn, London, 1984, p.549.)

5. For a discussion of this see Burgess, 'A Fond Thing Vainly Invented', pp.61–2.

6. There are many contemporary descriptions of Purgatory. For a selection of these see Duffy, *Stripping of the Altars*, pp.338–40.

7. The terms of this distinction are not medieval. For example, Chaucer's Parson describes active satisfaction in two rather differently categorized terms. The first consisted 'most generally of almesse and in bodily peyne. Now been ther thre manere of almesse: contricioun of herte, wher a man offreth himself to God; another is to han pity of defaute of his neighebores; and the thridde is in yevyng of good conseil and comfort, goostly and bodily, where man han nede, and namely in sustenaunce of mannes foode.' The second he termed bodily pains, by which he meant 'wakynges in fastynges, in vertuouse techynges of orisouns' (see *Canterbury Tales*, pp.602–3).

8. Its devotional importance has been discussed by Duffy, *Stripping of the Altars*, pp.91–130, and in John Bossy, 'The Mass as a Social Institution 1200–1700', *Past and Present*, c (1983), pp.29–61.

9. *The Minor Poems of John Lydgate*, pp.110–14.

10. For a discussion of works of mercy as invocations of Divine Mercy see Duffy, *Stripping of the Altars*, pp.357–62. These ideas are famously expressed more than a century later in Portia's plea to Shylock, *The Merchant of Venice*, iv:i, 'The quality of mercy is not strain'd…'.

11. See C. R. Burgess, 'By Quick and by Dead: Wills and Pious Provision in Late Medieval Bristol', *English Historical Review*, cii (1987)', p.845, and Duffy, *Stripping of the Altars*, pp.360–1.

12. *The Minor Poems of John Lydgate*, p.105.

13. The *Ave* or Hail Mary used in the fifteenth century lacked the ending used today: 'Holy Mary, mother of God, pray for us sinners now, and at the hour of our death' (*Mon. Rit.*, iii, p.4).

14. See Duffy, *Stripping of the Altars*, pp.53 *et seq.* At Heytesbury the almsmen were even to be tested on their proficiency in saying them when they entered, and were to be punished (by fasting and fines) until they had them by rote [301]. Similarly, the almsmen at Eton had to be able to say and sing these prayers in the manner of a layman, or had to promise to learn them then on pain of being expelled [LVI]. The importance of these prayers also led to their treatment in didactic religious plays such as the Creed and *Pater Noster* Plays at York. See A. F. Johnston, 'The Plays of the Religious Guilds of York: the Crede and the Pater Noster Play', *Speculum*, l (1975), pp.55–90.

15. Judging by the statutes of other almshouse foundations, the use of the three prayers in these ways was universal practice. The statutes of Eton offer an extreme example of this vicarious devotion: almsmen did not always need to be present at services, but they had to be praying in the church, cloister or cemetery while they were going on [LVI].

16. For a discussion of the timing of the Offices see A. Hughes, *Medieval Manuscripts for the Mass and Office*, Toronto, 1982, pp.14–19.

17. *Mon. Rit.*, iii, p.112.

18. Ludlow is the sole exception to this. Though the priest did have to say a daily Mass here [236], the almsmen's attendance is not demanded at it. This omission may relate to the curious arrangements peculiar to this foundation whereby the almsfolk received no salaries and the priest appears to have had no responsibility for governing them.

19. For a particularly elaborate example see the collects stipulated by Wynard [406], or the great list of names to be remembered by the priest when he said Mass at Heytesbury [294] or at Whittington's [746]. The practice is a commonplace in chantry foundations of all kinds.

20. The statutes that demand this include Whittington's [746], St Albans [486], Coventry [660], Wynard's [406], Hull [715], Ellis Davy's [275] and Westminster [151–2].

21. These were Evensong and Compline at Ludlow, which the priest had to recite standing by the chantry altar while the Office was being said in the chancel [236], and Matins, Evensong and Compline at Heytesbury [294]. In a similar direction at Ewelme, the Master and the Teacher of Grammar were to say Matins and Evensong in the chancel on such days [XIX and XX].

22. The combination requested at Ewelme – three *Pater Noster*s, three *Ave*s and a Creed – is repeated at Croydon [275] and Heytesbury [299] and a similar demand was made in Whittington's statutes [746]. A night-time version of the same practice was perhaps observed at Higham Ferrers, where the poor men were to be called to bed by a half-hour peal of the bell and were to kneel at their chamber doors and offer unspecified prayers [f.78]. This is the only devotional direction copied into the seventeenth-century transcript of the 'original' statutes. At Eton, the almsmen were to cross themselves when they got up and say five *Pater Noster*s for the Five Wounds of Christ, five *Ave*s for the Five Joys of the Virgin and a Creed. This almsmen had to repeat this also before going to bed [LVI].

23. The practice is described at Heytesbury [299], Whittington's [746], Eton [LVI], Wynard's [406], Croydon [275] and Westminster [151], and in each case the details accord closely with one another. In all but the cases of Heytesbury (where four psalters were demanded: three for Joys of the Virgin – the Annunciation, Birth of Christ and the Assumption – and one for all Christian Souls), and Westminster (where the text is ambiguous) three psalters were to be said. For a discussion of this Marian devotion see Duffy, *Stripping of the Altars*, pp.256–65. The Eton statutes give a very interesting outline of this recitation. When the bell rang for Matins the almsmen were to go to the Crucifix in the nave of the church (presumably the rood, where they had stalls) and recite ten *Pater Noster*s for their sins against the decalogue, and five for their sins against the five senses. These prayers were to be so intermingled with *Ave*s and Creeds that a whole psalter had been said before Mass. The other psalters were to be said at the convenience of the almsmen in the church, cloister or cemetery. At Heytesbury, Croydon, and Whittington's the psalters were to be said, as at Ewelme, when it was convenient to the almsmen. Westminster and Wynard's both demanded more precise timings – at the former Our Lady Psalter was to be recited during the first Mass of the day and in the latter once at 11 o'clock and twice after lunch. It is also stipulated in the cases of the Wynard and Heytesbury statutes that, as at Ewelme, if the almsmen can do so, they should say, instead of the psalter, parts of the Office of Our Lady, the Seven Psalms and Litany, Placebo and Dirge with Commendations or nocturnes of the Psalter. At Eton [LVI] and Westminster [151] there are similar instructions.

24. For example see Heytesbury: 'We will and ordain that the said now poor men and woman and their successors every day, after supper, come together into the chapel of the said almshouse and say there together (they that can) for the souls of the above specified and for the souls of all Christian people the Psalm of *De Profundis* with the versicles and orisons accustomed to be said for the dead. And they that cannot should say devoutly for the same souls three Pater Nosters with as many Aves and a creed of the faith. The which so done and said, one of the seniors of the said poor men shall say openly in English "God have mercy on the souls of the noble knight Walter, sometime Lord Hungerford, Katherine his wife, and that noble knight Robert, late Lord Hungerford, and Margaret his wife, our founders" and all the poor men shall answer "Amen".' Identical ceremonies occurred at Whittington's [746], Wynard's [405], Croydon [276], and Westminster [152] and a very similar one at Sherburn [5th page]. At Ludlow six choristers were employed to perform this ceremony in sequence around two different tombs [237]. With characteristic eccentricity, the almsmen at Ludlow do not seem to have been involved in this. The Eton service was bound in with the evening devotions of the choristers [xxx] and is discussed below, see note 28 below.

25. But occasionally forms of this ceremony were performed several times – the priest at Wynard's had to recite an English prayer with the *De Profundis* on every occasion in the day that he entered the chapel [405]. At Fotheringhay a practice, perhaps related to this, is stipulated in the statutes: every time a clerk or chorister went to sing or read he had to kneel by the founder's tomb and say a *Pater Noster* and *Ave* for the founder [301–2].

26. The different statutes make various stipulations as to the timing of the service. Some, such as Wynard's [405], say that the ceremony is to be performed after Mass (in the morning), others, such as Whittington's [746] and Croydon [275], that it is to be performed either after Mass or else after Compline. But the service would seem most appropriate in the evening both because of the text of the *De Profundis*, and because Compline was itself associated with the grave. In the words of the late-fifteenth-century translation of *The Mirror of Christ*, quoted in *Mon. Rit.*, iii, p.67, 'For Compleyn betokeneth the ende of a mannes lyfe – and therefore eche persone oughte to dyspose hym to bedde warde, as yf hys bed was his graue.'

27. As at the leper hospital of St Albans [495]. Variations on the practice are documented in chantry chapels too. At Baroun's Chantry at Edinburgh, for example, founded in 1478, the priest was to exhort the people to say a *Pater Noster* and *Ave* before the Mass and afterwards to proceed to the founder's tomb still wearing his alb. There he was to recite the *De Profundis* and *Miserere Mei* and sprinkle the tomb with holy water. At Brydle's Chantry at Marlborough the priest was to turn to the congregation and address them with an English prayer for the founder; see Wood-Legh, *Perpetual Chantries*, pp.295–6.

28. At Eton all the community present in the choir after High Mass, the ninth hour and Compline were to stand before leaving the church. They were then to recite the *De Profundis* and, during Henry VI's life, a prayer was to be publicly recited calling for the repose of the souls of his parents and all the faithful departed. After Henry's death, his name and that of his Queen were to replace those of his parents. The same prayers were also to be recited after grace at the end of meals [xxx]. There were to be two services in the day when the whole community at Fotheringhay were to pray for the founder, Edward, Duke of York, and for Henry V. Both included the recitation of the *De Profundis* and, after the death of the founder, a public prayer that he rest in peace [294]. Edward was buried in the choir, so these ceremonies went on around him. His plain, black marble tomb slab was also to be made the centrepiece of another notable evening ceremony. This included the recitation of the Hail Mary by a single chorister while the rest of the community genuflected before the High Altar. The choristers were then to recite several prayers, including the *De Profundis*, while lined up to either side of his tomb. After praying for the founder the community filed out to supper leaving the choristers behind to sing various antiphons before certain altars [292–3].

29. For a discussion of the anniversary, see C.R. Burgess, 'A Service for the Dead: Form and Function of the Anniversary in Late Medieval Bristol', *Transactions of the Bristol and Gloucestershire Archaeological Society*, cv (1987), pp.183-211.

30. At Heytesbury [307] and Ludlow [237–8], for example, the directions for the ceremony include salaries to be paid to attendant priests, chaplains, bell-ringers and the sum to be laid out for charity and candles. Fotheringhay's statutes include similarly exact directions [299–300], as do those of Eton [xxxi]. Remembrance of the dead also took different forms. At Tattershall exequies were to be held at the end of every month for the founder, Cromwell, and all the Faithful Departed. This was above and beyond the demand that anniversaries be celebrated both for him on St Gregory's Day, and for a number of his friends on other days [181].

31. The details relate closely to those described at Westminster [151], Higham Ferrers [78] and Coventry [146].

32. The obligation to celebrate a daily Mass is always stipulated when the foundation includes a priest, as at Hull [715], Wynard's [405], Ludlow [235] or Heytesbury [294]. College statutes often expressly demand that Masters preside over High Masses, as at Tattershall [180].

33. Wood-Legh, *Perpetual Chantries*, pp.292–3.

34. These directions are based upon almost identically phrased regulations which appear in the statutes for the Croydon [286] and Whittington's almshouses [747]. At Heytesbury this formula is also used to describe the same practice [300, 307–8], but interestingly in this case it is also directed that the whole text be read publicly twice a year in the parish church [306]. Statutes were read in colleges too – for example at Tattershall [183] and Eton. In the latter case the recitation was preceeded by a Mass of the Trinity and followed by the examination of each member of the community for their observance of the statutes that year. Absence from this ceremony would result in the loss of commons and livery for a whole year [XLIII].

35. Underwood, '*Politics and Piety*', p.39.

36. Interestingly, these regulations do not appear in the Croydon or Whittington texts, but the use of oaths to bind members of a community to a set of statutes is common. It occurs for example at Heytesbury [298 and 307], Coventry [659–60], St Albans [477–8 and 508], Hull [717], and Higham Ferrers [77]. In colleges the practice is universal and often outlined in great detail. See Tattershall [182], Fotheringhay [270] and Eton [VI, VII, IX, X, XII and XIV]. The practice of oath-taking is also documented in households; see G. M. Woolgar, *The Great Household in Late Medieval England*, London 1999, p.30.

37. A similar formula is used to describe reasonable causes for absence in the case of Wynard's priest [405]. Most statutes do not seem to allow for any but the head of the community to go away for any length of time.

38. These are much tighter restrictions than those found in any other almshouse. At Heytesbury there was a time limit of a whole day's absence, but passage beyond the parish boundary was still only permitted with a licence [299]. The same restrictions were true of Ellis Davy's Almshouse [277] and of Whittington's Hospital [746]. In the latter instance there is also a regulation forbidding anyone other than the 'Tutor' going into the city or suburbs of London at night [747]. Regulations both about leaving the precinct and nocturnal outings are also found in some collegiate statutes, such as those of Fotheringhay [291 and 295]. Often the limits on movement are expressed in terms of geographic points beyond which the brethren may not pass. For example in the case of Wynard's almsmen: 'nullus eorum sic per dictam civitatem [Exeter], nisi ad ecclesiam cathedralem Sancti Petri, et ad ecclesiam Fratrem Minorum ac crucem de Southyng-heyes, nisi ex causa racionabili sit vagrans seu transiens ullo modo' [406]. The almsmen at Eton were forbidden to be more than a mile from the college or to wander into town during Divine Service [LVII].

39. An unusual regulation. The closest parallel is at Eton, where no almsmen were to be absent for more than fifteen days, on pain of expulsion [LIX].

40. See pp.91 and 308, note 44.

41. See pp.114 and 138.

42. For an example of its use in sermons see H. Leith-Spencer, *English Preaching in the Later Middle Ages*, Oxford, 1993, pp.69–70. The system is described in the statutes of many foundations, including almshouses such as Whittington's [747], Davy's [281–3], Sherbourne [6th page], and Higham Ferrers [77 and 78], as well as at Fotheringhay College [290].

43. This, or a very similar procedure was followed in all almshouses, though the figures who formed the visiting body varied depending on the circumstances of the foundation. Often the figures were local dignitaries – members of the city authorities or ecclesiastics – as at Ludlow [235], Wynard's [407], Croydon [270 and 284], Heytesbury [295] and Whittington's [747]. In case a particular responsible individual neglected their duties, some foundations invoke the intervention of several other people. For example at Hull the founder's family were to have first right of deposition, then the prior of the adjacent charterhouse, and failing these the mayor and archdeacon [717].

44. This regulation appears verbatim in the Croydon statutes [273].

45. This identical peroration is found in several almshouse statutes including those of Whittington's [747], Heytesbury [308] and Ellis Davy's Almshouses [286–7].

8 The Chapel of St John the Baptist

1. In the Vulgate the passage actually reads 'Nec enim est aliud nomen sub coelum …'.

2. The bill for this work survives; see EM d.10 EA 10 (65).

3. ORO Ms. DD. par Ewelme e.6, ff.9–10. One is now in the possession of the Ashmolean Museum at Oxford.

4. See also various 1821 views by Buckler in BL Add. Ms. 36373, ff.13 and 15–17, and, from the 1790s, BL

Add. Ms. 15545, ff.166–74.

5. J. Skelton, in his *Antiquities of Oxfordshire* (Oxford, 1823–25, Ewelme Hundred, p.6), wrote, 'In the ornamental tiles, with which the floor is paved, are several heraldic devices intermingled with others of ornamental character.'

6. See BL Add. Ms. 36373, f.21.

7. For a discussion of this point see below pp.169–74.

8. See R. W. Pfaff, *New Liturgical Feasts in Late Medieval England*, Oxford, 1970, pp. 62–79, for a discussion of this feast's history.

9. There is evidence for this association, for example, in the fact that the first cornice quotation in the chapel was later used in the Jesus Anthem, a devotion to Jesus; see E. G. C. Atchley, 'Jesus Mass and Anthems', *Transactions of the St Paul's Ecclesiological Society*, v (1905), pp.168–9.

10. The days of the Octave of the feast which did not fall on saints' days were all dedicated to different aspects of the Name of Jesus. Their titles and reading reflect its potency in these different ways: *de constitucione* on the second day; *de sanctificatione* on the third; *de descriptione* on the fifth; and *de praenunciatione* on the sixth; see BUS, iii, 642–6 and 657–62.

11. A common topos in medieval literature and art. For example, *The Golden Legend* by Jacobus de Voragine (vol.v, ed. F. S. Ellis, London, 1900, pp.197–8) in describing angels says: 'Some be in the hall royal … and accompany always the king of kings and sing always songs of gladness to his honour and glory: Sanctus, sanctus, sanctus, blessing and clearness and wisdom.'

12. Voragine, *The Golden Legend*, vol.v, p.195.

13. M. Glasscoe, 'Late Medieval Paintings in Ashton Church, Devon', *Journal of the British Archaeological Association*, cxl (1987), pp.182–90.

14. For example BUS, iii, 622, 628, 630, 631, 659–60, 667–8, 681–2 and 684.

15. Gabriel's words are 'And behold you will conceive in your womb and bear a son, and you shall call his name Jesus.' (Luke 1:31).

16. BUS, iii, 659–60.

17. BUS, iii, 617.

18. As is recorded, for example, at Durham; see *Rites of Durham*, ed. J. T. Fowler (Surtees Society, cvii), 1902, pp.33–5.

19. *Minor Poems of John Lydgate*, p.100.

20. Similar ideas are described in Voragine's *The Golden Legend*, vol.v, p.197. Angels could also inflame and illumine devotion (ibid., vol.v, p.194).

21. See Appendix VII, EM A 47 (3), p.287 no.47. For a discussion of these see W. H. St John-Hope, 'On the Sculptured Alabaster Tablets called St John's Heads', *Archaeologia*, liii, pt ii (1890), pp.669–708.

22. The liturgy for the Feast of the Birth of St John the Baptist repeatedly treats the saint as a type of Christ. The parallel and complementary circumstances of their birth, for example, are set out in the Matins readings of the feast (see *Mon. Rit.*, iii, 340–2). This liturgy also repeatedly alludes to the name of John in responses and readings (see *Mon. Rit.*, iii, 340–54 passim). It is interesting in the context of the chapel's iconography that John's execution was treated as a type of the Passion and his head on a salver compared to the consecrated host; see St John Hope, 'Alabaster Tablets called St John's Heads', pp.704–5. For John's humility and the analogy with the nine orders of angels see Voragine, *Golden Legend*, The Nativity of St John the Baptist, *passim*. (The latter analogy is omitted in some versions of the legend.)

23. A fragment of an early-sixteenth-century hanging with diaper decoration survives at Winchester College; see W. G. Thomson, *A History of Tapestry from the Earliest Times until the Present Day*, 2nd edn, London, 1939, pp.152–4. Elizabeth Cleland has also kindly brought to my attention various other examples of the form, including two undated fifteenth-century tapestries in the Musée des Arts Décoratifs in Paris, one of which has alternately coloured monograms in a similar pattern to that at Ewelme. She also pointed out the use of a personal monogram and rebus in the parclose hangings of a c.1505 painting of Chevalier Philip Hinkaert at his devotions; see A. Arnould and J. M. Massing, *Splendours of Flanders: Late Medieval Art in Cambridge Collections*, exhibition catalogue for the Fitzwilliam Museum, Cambridge, 1993, pp.42–3.

24. A. Vallance, *English Church Screens*, London, 1936, pp. 13–15. For Alice de la Pole's patronage of the church see pp. 57–63 above.

25. The church was rebuilt between 1430 and 1460; see Haward, *Suffolk Medieval Church Arcades*, p.237.

26. The celure at Southwold is repainted, but pre-restoration drawings from the Society of Antiquaries, London (Fox Collection, Box 24), are reproduced in Vallance, *English Church Screens*, p.16.

27. For a drawing of this see Society of Antiquaries, London, Fox Collection, Box 24, f.31. Voragine in *The Golden Legend* (vol.v, p.194) speaks of angels as deserving praise because they remind men of the Passion of Christ.

28. I am indebted to David King for sending me some of his unpublished work on the Salle glass, in which he convincingly demonstrates that the chancel was glazed in this year. There has been some confusion over the inscriptions in the glass, which give the date of the chancel's completion as 1440 (not 1450 as some authors have been misled to understand by a mistaken antiquarian transcription), under the patronage of the then rector, William Wode.

29. Leland, *Itinerary*, vol.i, p.112.

30. EM d.10 EA 10 (63).

31. Greening Lamborn, 'The Arms on the Chaucer Tomb', pp.80–1.

32. Bodl. Ms Wood D14, f.50.

33. For a discussion of Alice's work at Wingfield see p.62 above. Sir John Fastolf, by his will of 3 November 1469, undertook similar changes to the tombs of his parents (*PL*, iii, pp.154–5). I am grateful to Richard Marks for making me aware of an another contemporary rebuilding of a parental chantry and its tombs by the terms of Lord Cromwell's will, which he has briefly discussed in his 'The Re-building of Lambley Church, Nottinghamshire, in the Fifteenth Century', *Transactions of the Thoroton Society of Nottinghamshire*, lxxxvii (1983), p.88.

34. John, Duke of Bedford's effigy at Rouen was boxed in a wooden case that was only removed on special occasions; see J. Stratford, *The Bedford Inventories*, London, 1993, pp.32–3. Philip Lankester has pointed out to me a similar practice at Chichester, where the tomb of Bishop Sherborne (ob. 1536) was only exposed on special days. See Tummers, H., 'The Medieval Effigial Tombs in Chichester Cathedral', *Church Monuments*, iii (1988), p. 26.

35. See C. Wilson, 'The Medieval Monuments', in P. Collinson, N. Ramsay and M. Sparks, eds, *Canterbury Cathedral*, Oxford, 1995, 476–81.

36. Colvin et al., *History of the King's Works*, ii, p.884. For the Exeter tombs see B. Cherry, 'Some Cathedral Tombs', in M. Swanton, ed., *Exeter Cathedral*, Crediton, 1991, pp.161–2.

37. Colvin et al., *History of the King's Works*, i, p.290.

38. P. Lindley, 'The Great Screen of Winchester Cathedral II', *Burlington Magazine*, cxxxv (1993), p.799. He attributes the chapel to the designer of the great screen, which he suggests was completed by c.1476.

39. The construction of the church was well under way in 1475; see Marks, *Stained Glass of Tattershall*, p.22.

40. Lindley, 'The Great Screen of Winchester Cathedral II', pp.805–7. See also his 'The Great Screen of Winchester Cathedral I' *Burlington Magazine*, cxxxi (1993), pp.604–17, figs.9 and 11.

41. One other tomb – that of Sir Henry Willoughby (ob.1528) at Wollaton (Notts.) – succeeds in combining a chest and cadaver by cutting openings through the chest between the figures of weepers into the cadaver space.

42. This restoration occurred in 1791–2, when £94 9s. 6d. was paid to a certain Mr Bingley for unspecified work; see EM d.10 EA 10 (41). It probably included the reconstitution of several small breaks on the effigy with putty. The lost heads of five angels were also replaced at this date: one on each side of the chest and three on the figures supporting the effigy. All the repairs to the effigy are recorded in an 1840 engraving: see G. and T. Hollis, *Monumental Effigies of Great Britain*, pt i, London, 1840, p.58.

43. The evidence that the coloration is faithful to the original scheme may be summarized briefly as follows. First, the ends of the tomb are beyond the reach of the restorer's brush and their details still bear paint which must, therefore, be original. The paint at the ends of the tomb confirms all the main elements of the renewed scheme on the sides of the monument. Second, it is possible to see the shadows of overpainted patterns on the monument. This is true both on the angel plinths, painted as a flower-strewn lawn, and the wings of the angels, shown with peacock-feather eyes. Both details are commonplaces of painted alabaster from the period and the over-painted decoration is probably medieval therefore. For a detailed discussion of this see Goodall, 'God's House', pp.259–69.

44. F. Cheetham, *English Medieval Alabasters*, Oxford, 1984, p.27.

45. The standard work on alabaster monuments is A. Gardner, *Alabaster Tombs of the Pre-Reformation Period in England*, Cambridge, 1940. He discusses and tabulates the incidence of weepers on tombs; see pp.13–21 and 88–103.

46. Such as the Chellaston workshop, which has been widely discussed; see for example W. H. St John-Hope, 'On the Early Working of Alabaster in England', *Archaeological Journal*, lxi (1904), pp.230–2; Gardner, *Alabaster Monuments*, pp.4–6; and Wilson, 'Medieval Monuments', pp.501–2. For recent considerations of workshop practices see C. Ryde, 'An Alabaster Standing Angel with Shield at Lowick – a Chellaston Shop Pattern', *Derbyshire Archaeological Journal*, xcix (1977), pp.36–49, and 'Alabaster Tomb Manufacture 1400–1430', *Derbyshire Miscellany*, xii (1991), pp.164–77; and N. Ramsay, 'Alabaster', in J. Blair and N. Ramsay, eds, *English Medieval Industries*, London, 1991, pp.32–6.

47. Feathered angels appear in freestone on Bishop Beckyngton's tomb at Wells (built by 1451) and in restored figures on Bishop Fleming's tomb at Lincoln (ob.1431). Alabaster feathered angels appear on Sir John Vernon's tomb (ob.1545) at Clifton Campville (Staffs.), and on alabaster tombs of unidentified figures at Much Marcle (Herts.), Abergavenny (Gwent) – in an Annunciation scene – and at Bishop's Cleeve (Gloucs.).

48. For a summary of Stanbury's career see *Registrum Johannis Stanbury*, ed. A. T. Bannister (Canterbury and York, xxv) (1919), pp.ii–vi.

49. The evidence for the construction of the monument by Stanbury's executors after his death is as follows. First, his will, dated 5 February 1472, reveals that his burial-place was not yet established, and by implication, therefore, that his monument was not constructed; see *Registrum Johannis Stanbury*, pp.vii–ix. Second, it would appear that his funerary arrangements were entirely supervised by his executors: his chantry chapel was described as being 'newly completed' by two executors in 1490. Significantly, this document also describes the chapel as having been erected beside his existing tomb in the south choir aisle, which must therefore have pre-dated it; see ibid., p.xi.

50. This pattern is now broken, but for its original state see T. Dingley, *History from Marble*, vol.i (Campden Society, xciv) (1867), p.cxxxvi.

51. Leland, *Itinerary*, vol.i, pp.112–13.

52. Ibid., p.112.

53. J. Bertram, '*Orate pro anima*: Some Aspects of Medieval Devotion illustrated on Brasses', *Monumental Brass Society*, xiii (1980–85), p.329. Female effigy figures with rosaries appear in late-fifteenth- or early-sixteenth-century alabaster monuments at Harewood (Yorks.), and Llandaff (Glamorgan).

54. The only other female figure portrayed wearing this is the widow of Sir Robert Harcourt K.G. (ob.1471) at Stanton Harcourt (Oxon.).

55. M. C. Erler, 'Three Fifteenth-century Vowesses', in C. Barron and A. Sutton, eds, *Medieval London Widows 1300–1500*, London, 1994, pp.165–6.

56. Henry IV's alabaster effigy at Canterbury, otherwise a much more typical sculpture of its kind, may also reflect an interest in portraiture; see Wilson, 'Medieval Monuments', p.502.

57. A female cadaver effigy is described in the 1439 will of Isabelle, Countess of Warwick (see below). There are surviving fragments of others (for example at Beetham in Cumbria) as well as several surviving brasses. These are discussed, and all known examples of the form in England and the Continent listed, in M. Norris, 'Later Medieval Monumental Brasses: an Urban Funerary Industry and its Representation of Death', in S. Bassett, ed., *Death in Towns: Urban Responses to the Dying and the Dead, 100–1600*, Leicester, 1992, pp.195–209 and 248–51. A few continental examples of female cadaver sculpture also survive, such as that of the magnificent early-sixteenth-century tomb of Margaret of Austria in the Eglise de Brou, Bourg-en-Bresse, France. Female cadavers appear in other contexts too, for example in an illustrated fifteenth-century collection of religious verse, BL Add. Ms. 37049, f.32v. Here there is a tinted drawing of a lady's tomb exposing the rotting female corpse it contains. The image has a moralizing verse about the corruption of earthly beauty beneath it and faces the opening of a verse disputation between the body and worms.

58. This depiction resembles Cheetham's type D alabaster representations of the scene, produced from c.1430 until the 1470s or later; see Cheetham, *English Alabasters*, p.162.

59. Mary Magdalene is unusual, but not unique, in that she carries a palm. A labelled fifteenth-century figure in a window at Mells in Somerset, for example, also shows her with this attribute.

60. A detail which looks back to an early-fifteenth-century style of drawing exemplified in Master Thomas of Oxford's windows at New College, Oxford, and at Winchester (c.1400). For a discussion of this glass see J. H. Harvey and D. G. King, 'Winchester College Stained Glass', *Archaeologia*, ciii (1971), pp.149–77.

61. Archbishop Chichele's tomb is a particularly good example of this. It is positioned to serve three audiences – the public as they progressed round the choir to the shrine, the monks and the archbishop; see Wilson, 'Medieval Monuments', pp.477–8.

62. *The Fifty Earliest English Wills*, ed. F. J. Furnivall (Early English Text Society, o.s. lxxviii) (1882),

pp.116–17.

63. For example, several mid-fourteenth-century painted coffins survive at Notre-Dame in Bruges. For a discussion of the painting in Duke Humphrey's sepulchre, which is probably connected to an illustration in his psalter, see J.A.A. Goodall and L. Monckton, 'The Chantry of Humphrey, Duke of Gloucester', in *Medieval Art and Architecture at St Albans: Transactions of the British Archaeological Association St Albans Conference* 1999 (forthcoming).

64. One example roughly contemporary to Ewelme is the picture of the resurrected Christ on the canopy of the Clopton tomb at Long Melford, Suffolk, probably built c.1480.

65. See Wilson, 'Medieval Monuments', p.487.

66. In the seal John the Baptist also carries the standard of the resurrection but Mary does not bear a palm frond. For an impression of the seal see EM A 27.

67. The other fifteenth-century examples of gablettes are: Bishop Stafford's tomb at Exeter Cathedral (ob.1419); the Lowick tomb made c.1419–20 (Northants.); 'Dean Husse's' tomb in the Calixtus Chapel at Wells Cathedral – actually that of Precentor Boleyn (ob.1471 or 1472), as is shown by N. Ramsay in 'Imagine my surprise …', *Friends of Wells Cathedral*, 1988, pp.12–14; an unattributed tomb at Flamstead (Herts.); the tomb of Lord and Lady Botreaux (ob.1391 and 1437 respectively), North Cadbury (Somerset); an unidentified tomb at Abergavenny (Gwent); and, probably sixteenth-century, the tomb of Sir Richard and Lady Croft (he died in 1509) at Croft in Herefordshire. This has a gablette set vertically above the heads of the effigies. Bishop Stanbury's tomb may have lost a gablette.

68. Hitherto, the earliest dated example of curvilinear tracery of this type has been the screen for Edward IV's tomb at St George's, Windsor. For a reassessment of this see J. Geddes, *Medieval Decorative Ironwork in England*, London, 1999, pp.261–72.

69. See p.12.

70. See Marks, *Stained Glass of Tattershall*, pp.22–6. Illustrated in F.H. Crossley, *English Church Craftsmanship*, 2nd edn, London, 1947, fig. 109.

71. These men also worked on the Beauchamp tomb in St Mary's, Warwick, and were called to advise Henry VI on his proposed tomb; see Harvey, *Medieval Architects*, p.101. For a consideration of the involvement of Stephenes and Essex with Series B brass manufacture see R. Emmerson, 'Monumental Brasses: London Design c.1420–85', *Journal of the British Archaeological Association*, cxxxi (1978), pp.66–7.

72. For a discussion of the potential complexity of tomb-workshop practice see P. Lindley, '"Una Grande Opera al mio Re": Gilt-bronze Effigies in England from the Middle Ages to the Renaissance', *Journal of the British Archaeological Association*, cxliii (1990), pp.120–3.

73. See J. A. Dodd, 'Ewelme', *Transactions of St Paul's Ecclesiological Society*, viii (1920), pp.194–206.

74. There are other instances of craftsmen making mistakes of this kind, for example at Tong (Salop) on the tomb of Sir Henry Vernon (ob.1515) and his wife. Here the ends of the tomb are unfinished and the canopy was cut away because the fit was too tight.

75. Bodl. Ms. Wood D.14, ff.49–51 and 89.

76. Bodl. Ms. Rawl. D.807, ff.175–6.

77. Bodl. Ms. Wood E.1, ff.211–15.

78. Greening Lamborn, 'The Arms on the Chaucer Tomb at Ewelme', pp.81–4.

79. This shield is recorded in some fifteenth-century armorial rolls as a de la Pole coat; see *Dictionary of British Arms: Medieval Ordinary*, vol. i, eds D.H.D. Chesshyre et al., London, 1992, p.132.

Appendix I The Statutes of God's House, Ewelme

1. Another parallel case is the confirmation of Magdalen College, Oxford, by Pope Sixtus IV in 1481, thirty-three years after it was first incorporated; see H.A. Wilson, *University of Oxford College Histories*, London, 1899, pp.6–7 and 34.

2. Imray, *Charity of Richard Whittington*, pp.107–8.

3. Marks, *Stained Glass of Tattershall*, p.18.

4. See Jacob, 'The Statutes of All Souls', pp.420–31.

5. *Univ. Oxf. Reg.*, pp.217 and 1238.

6. See for example Magdalen College, Oxford (Wilson, *Oxford Colleges*, pp.6–7); Tattershall [172–3]; and Higham Ferrers [*C.P.R. 1422–29*, pp.472–3].

7. Eton College Ms. Audit Roll, 1452–53.

8. See *English Guilds*, ed. L. Toulmin-Smith and L. Brentano (Early English Text Society, o.s. x, 1870), pp.2–123.

Appendix II The annual Audit Accounts

1. Kumin, *The Shaping of a Community*, pp.88–9, discusses the similar problem of errors in churchwardens' accounts.

Appendix III An almshouse inventory and an account

1. The letters 'ob' here and below are an abbreviation for 'obulus', a halfpenny.
2. This requires some explanation. 'Shrove Even' was 26 February in 1465 and St Matthew's Day Sunday the 24th and the Tuesday following the latter therefore the 26th.
3. Easter Day fell on 14 April in 1465.
4. This has been struck out because the feast of Tibertius and Valerian fell on 14 April (Easter Day) rather than on 16 April in Easter week.

Appendix IV Hawe of Occold's estimate for work to the chancel of Wingfield Church

1. The head is similar to that of Briquet, *Les Filgranes*, vol.iv, Geneva, 1907, 14152, but there is a different style of cross set between the antlers, comparable to that of 14163.
2. I am grateful to Tim Tatton-Brown for bringing his work on this church to my attention. He has discussed St Thomas's and reproduces the text of the 1448 agreement relating to the rebuilding work in 'The Church of St Thomas of Canterbury, Salisbury', *Wiltshire Archaeological and Natural History Magazine*, xc, 1997, pp.104–7.

Appendix V The Hull Charterhouse agreement

1. Similar to Briquet, *Les Filgranes*, vol. iv, 15054.
2. Gough, *Sepulchral Monuments*, vol. ii (pt.ii), 92. The reception of the poor into a private house is a practice described occasionally in wills, but more usually in those of men than of women; see P. Cullum, '"And hir name was charite": Charitable Giving by and for Women in Late Medieval Yorkshire', in P.J.P. Goldberg, ed., *Woman is a Worthy Wight: Women in English Society c. 1200–1500*, Stroud, 1992, p.191.

Appendix VII The Ewelme Manor inventories and associated documents

1. Similar to Briquet, *Les Filigranes*, vol. iii, 8785.
2. A nail is a measurement of two and a half inches.
3. This room appears again in the accounts of repairs made by Henry VIII. Bodl. Ms Rawl. D.777, ff.130–34.
4. Similar to Briquet, *Les Filigranes*, vol. i, 2782 and 2784.
5. I am grateful to Scot McKendrick for pointing out that the subject of this arras was probably the Tourney of Hercules, in which Hercules and Theseus were vanquished by Amazon warriors. The story is treated in Christine de Pizan's *Cité des Dames*, a copy of which was also in Alice's possession at Ewelme (see Inventory EM A 47 (3), p.287, item 42 above). It is possible that all the tapestries in this room represented female themes.
6. 'K.K.' is the symbol of Charles V, King of France; see J. Stratford, *The Inventories of John, Duke of Bedford*, Society of Antiquaries of London, 1993, p.333. Might this name be a reference to him? See also EM A 47 (3), p.286, no.1, above.
7. This must have been a particularly magnificent piece woven with gold. It probably showed the judgement of Duke Herkenbold, who slew his nephew from his deathbed as a judgement on the boy's misdeeds. Several versions of this theme still survive or are recorded, includng one associated with Rogier van der Weyden, which was made for the great hall of the Hôtel de Ville in Brussels. See Thomson, *A History of Tapestry*, pp.99–100. The juxtaposition of the story of Herkenbold to a depiction of the City of Peace may suggest that the hangings in this room illustrate models of good governance.
8. This subject of the City of Peace was also treated in Henry VIII's collection; see *The Inventory of King Henry VIII*, no.14047.
9. This must refer to the Duke's device of an ape's clog; see p.19 above.

10. A very early instance of the identification of a 'counterfeit aras', probably an indication of a high-quality piece not made in Arras; see McKendrick, 'Tapestries from the Low Countries in England', p.48.

11. A certain James Brussels is mentioned in EM A 47 (3) and (5) and this is presumably the same man.

12. See J.T. Fowler, 'The Fifteen Last Days of the World in Medieval Art and Literature', *Yorkshire Archaeological Journal*, xxiii (1915), pp.313–37, for a discussion of this popular fifteenth-century subject.

13. This subject is also recorded in Henry VIII's collection; see *The Inventory of King Henry VIII*, no.12000.

14. These are symbols of the wool trade; see p.19 above.

15. Jenny Stratford has plausibly suggested that this is a garbled version of William de la Pole's motto, but what it is meant to read is not clear.

16. A banker, or cushion for the back of a seat.

17. There are numerous discussions of liturgical vestments, instruments and books. For a good example in relation to an inventory see W.H. St John Hope, 'On an Inventory of the Goods of the Collegiate Church of the Holy Trinity, Arundel, taken 1 October, 9 Henry VIII. (1517)', *Archaeologia*, lxi, (1909), pp.61–96. For a discussion of church books see H. Littlehales and H. Wordsworth, *The Old Service Books of the English Church*, London, 1904, and also F. Kisby, 'Books in London Parish Churches, c.1400–1605', in *Proceedings of the 1999 Harlaxton Symposium*, forthcoming.

18. See note 6 above. Could this be from Charles V's collection?

19. Presumably from Alice's uncle, Cardinal Beaufort.

20. *Cal. Pap. Reg.*, ix, p.8.

21. Napier rightly points to the Winchester Throne of Mary I at Winchester Cathedral as a unique, if much restored, surviving example of this type of chair. Chairs of Estate also appear in numerous royal Tudor portraits, for example, the anonymous portrait of Edward VI of c.1547 at the National Portrait Gallery. In this painting, as in many other depictions, the chair of estate is shown with decorative pommels on the arms and back, a point of comparison with the first of these Ewelme examples. Henry VIII's inventories also list numerous wooden and iron chairs with cases, as may be found in the Removing Garderobe; *The Inventory of Henry VIII*, nos.14144–6.

22. Napier suggests in a note that this is the number of Ks on the throne – as if someone would bother to count. But I think this is just a misreading of a symbol, perhaps KK again (see note 6 above).

Appendix VIII Estimate of the materials of Ewelme Manor prior to its demolition

1. This reading is unclear.

Hospital, college and guild statutes

Caister, Norfolk: Almshouse and College of St John the Baptist

The establishment of this foundation under the terms of Sir John Fastolf's will was ultimately frustrated by political and financial difficulties, but the correspondence of John Paston, the principal executor, provides an insight into the business of its creation. It was intended that a college of six Benedictine monks under a prior (later six secular priests with a Governor), and seven poor men be established in Fastolf's castle at Caister after Sir John's death. Details of the foundation are described in *The Paston Letters*, ed. J. Gardiner, London, 1986, vol.iii, nos.341, 351, 385 (p.148), 386, 393; and vol.iv, nos.564, 569, 570, 571, 601, 681.

Coventry: Hospital of St John the Baptist

The statutes, dated 29 March 1425, appear in W. Dugdale, *Monasticon Anglicanum*, vol.vi, pt.ii, London, 1830, pp.659–62.

Croydon: Ellis Davy's Almshouse

Ellis Davy's Almshouse in Croydon supported seven poor men. They were to live communally in an almshouse and attend Divine Service in Croydon's parish church. One of them was to be elected 'Tutor' and head the foundation. The statutes are dated 27 April 1447 and appear in G. Steinman, *A History of Croydon*, London, 1833, pp.54–6 and 267–87. They employ the same formula as the Ewelme Statutes.

Eton, Buckinghamshire: Royal College of St Mary

Perhaps the greatest religious foundation of the period. Founded in 1440 and subsequently linked to King's College, Cambridge, as a joint educational foundation. Its original statutes do not survive but the existing set was probably written in 1452–53 after the connection with King's and are directly inspired by the statutes of Winchester College. They describe a college with a Provost, ten priest fellows, ten chaplains, ten clerks, sixteen boy choristers, seventy indigent scholars, a school master, a deputy and an almshouse, as well as thirteen poor youths and other servants. Its statutes are printed in J. Heywood and T. Wright, *The Ancient Laws ... of King's College ... and ... Eton*, London, 1850, pp.477–625. Because manuscripts of this text seem as easy to get hold of as Heywood and Wright's transcription I have given the references to it by the statute numbers, which are common to both.

Exeter, Devon: Wynard's Almshouse or God's House

God's House at Exeter or Wynard's Almshouse was founded by William Wynard outside the south gate of the city. It supported twelve poor men and a priest, who was also to act as a teacher for between three and nine boys. The statutes, dated 20 January 1436, are reproduced in G. Oliver, *Monasticon Dioecesis Exoniensis*, London and Exeter, 1846, pp.404–7.

Fotheringhay, Northamptonshire: St Mary's College

St Mary's Fotheringhay was an enlarged collegiate foundation moved from the castle to the parish church in the town by Edward, Duke of York in 1415. It was to support a Master, a Precentor, eleven other chaplains, eight clerks, thirteen choristers and a *hospitium* for the poor. The statutes were compiled around 1415 and are transcribed in A. Hamilton-Thompson, 'The Statutes of the College of St Mary and All Saints, Fotheringhay', *Archaeological Journal*, lxxv (1918), pp.241–309.

Heytesbury, Wiltshire: Heytesbury Almshouse

Heytesbury Almshouse, for a chaplain (who was also to teach grammar without charge to locals), twelve poor men and a woman, was founded by Lady Margaret, Lady Hungerford and Botreaux, in place of an earlier almshouse for fourteen paupers first established by her father-in-law. The statutes are dated 20 February 1472 and appear in J. E. Jackson, 'Ancient Statutes of Heytesbury Hospital', *Wiltshire Archaeological and Natural History Magazine*, xi (1869), pp.289–308.

Higham Ferrers, Northamptonshire: Almshouse and College of St Mary and St Thomas of Canterbury and St Edward the Confessor

The College of St Mary and St Thomas of Canterbury and St Edward the Confessor at Higham Ferrers was founded by Archbishop Chichele. It was served by eight canons, eight clerks and six choristers and was granted royal licence in 1422. Chichele had the foundation publicly acclaimed by the populace of the town in 1425, at which date he appointed the first Master (CPR 1422–29, 472–3, and *VCH Northamptonshire*, vol.ii, 177). This institution incorporated an existing almshouse and school. A seventeenth-century précis of the almshouse statutes can be found in BL Ms. Lansdowne 846, ff.77–9. There is no firm evidence for dating these, but the contents of the transcription accord well with other fifteenth-century statutes. Moreover, the covering letter accompanying the transcription (on folio 76, dated 1669) says that the writer had found an original copy of the statutes from which to work – by implication a text of around 1425. The copy of the statutes used was certainly pre-Reformation, because the transcription also mentions the office of Warden, which the covering letter explains had fallen into abeyance since the suppression of the college. All but one reference to the devotional duties of the almsmen have been omitted in the copy, so it is useful only for considerations of day-to-day life. According to the statutes there were to be twelve men over fifty years of age and a woman to do the housework. One of the men was to be elected 'Governor' of the almshouse.

Kingston-upon-Hull: God's House

God's House at Hull was founded in 1384 by William de la Pole's grandfather Michael to support a priest with thirteen poor men and thirteen poor women. The de la Poles were closely associated with Kingston-upon-Hull and this hospital was situated beside the gate of the family's principal chantry foundation – the Hull Charterhouse of St Michael, which served as a family mausoleum. The Prior of the Charterhouse had rights of presentation and visitation over the foundation. The statutes are dated 1 March 1384 and appear in G. A. Hadley, *A New and Complete History of the Town ... of Kingston-upon-Hull*, Hull, 1788, pp.710–19.

London: Guild of the Holy Trinity, Botolph's Gate
The statutes are dated 1389 and are transcribed in H. F. Westlake, *The Parish Guilds of Medieval England*, London, 1919, pp.66–72.

London: Hospital at the Savoy
The foundation is discussed in R. Somerville, *The Savoy*, London, 1960, and D. Thomson, 'Henry VII and the Uses of Italy: the Savoy Hospital and Henry VII's Posterity', in B. Thompson, ed., *Proceedings of the 1993 Harlaxton Symposium*, Stamford, 1995, pp.104–16.

London: Westminster Almshouse
Westminster's almshouse was founded by Henry VII to support thirteen men, one of whom was to be an unbeneficed priest over the age of forty-five. There were to be three women over fifty to help with the housework. The statutes were enrolled in the Close Rolls on 16 July 1504: *CCR 1500–1509*, pp.146–7 and 151–4.

London: Whittington's Hospital
Whittington's Hospital, also called God's House, was founded by Richard Whittington's executors in conjunction with a college of five priests attached to St Michael, Paternoster Row. It was to support thirteen poor men, of whom one was to be elected as their head and entitled 'Tutor'. The statutes of this institution compare closely with those of Ewelme and are dated 21 December 1421. They appear in W. Dugdale, *Monasticon Anglicanorum*, vol.vi, London, 1830, pp.744–7. The statutes were sealed on 21 December 1424. J. Imray's *The Charity of Richard Whittington* (London, 1968) includes a transcription of a fifteenth-century English translation of the Latin statutes.

Ludlow, Shropshire: Almshouse of the Hosyer's Charity
The text of the statutes, dated 8 December 1486, appears in modernized English in *Catholic England: Faith, Religion and Observance before the Reformation*, ed. R. N. Swanson, Manchester, 1993, pp.234–41.

Newark, Leicestershire: Hospital and New College of the Annunciation
The statutes date to between 1355 and 1356 and appear and are discussed in A. Hamilton-Thompson, *The History of the Hospital and New College of the Annunciation of St Mary in the Newark, Leicester*, Leicester, 1937, pp.41–81.

St Albans, Hertfordshire: St Julian's Leper Hospital
The statutes are dated 1344 and appear in Thomas Walsingham's *Gesta Abbatum Monasterii Sancti Albani*, ed. H. T. Riley, vol.ii (Rolls Series, no.28), 1867, pp.483–510.

Sandwich, Kent: St Bartholomew's Hospital
A translation of an undated set of statutes appears in W. Boys, *Collections for an History of Sandwich*, Canterbury, 1792 (misprinted on the title page as 1892), pp.17–21. This presents a particularly detailed impression of the more practical aspects of almshouse life such as cooking, eating and so on. I would tentatively date the document by its contents to the late-fifteenth or early-sixteenth century.

Sherburn, Co. Durham: College and Almshouse
Sherburn College and Almshouse was a re-foundation of an earlier leper hospital. The new statutes of 1434 were drawn up by Bishop Langley and established a foundation comprising a Master, four chaplains, four clerks, two boys and an almshouse of thirteen poor men. There was also a small provision made for lepers in view of the founder's original intent. The statutes are dated 22 July 1434 and appear in G. Allan,

Collections relating to Sherburn Hospital in the County Palatine of Durham, Darlington, 1791. Eccentrically, this book has no page numbers.

Tattershall, Lincolnshire: Almshouse and College of the Holy Trinity
The College of the Holy Trinity at Tattershall was founded by Ralph Cromwell in 1439 to support the Master or Warden, six chaplains, six clerks, six choristers and an almshouse of thirteen paupers of either sex. There was also to be a free grammar school run by a hired clerk or priest. It was run for both the choristers and for boys from the lordship of Tattershall and the college's estates. The statutes were drawn up shortly before 1458–59 (see Marks, *Stained Glass of Tattershall*, p.18). An abridgement of the text, along with several other documents relating to the foundation, is reproduced in the *Report on the De L'Isle and Dudley Papers*, vol.i (Historical Manuscripts Commission), London, 1925, pp.170–85.

Tong, Shropshire: Almshouse and College of the Virgin and St Bartholemew
The statutes, dated 27 March 1411, are transcribed in W. Dugdale, *Monasticon Anglicanum*, vol.vi, pt.ii, London, 1830, pp.1404–11.

Wingfield, Suffolk: College of St Andrew
The statutes, dated 6 June 1362, appear in S. W. H. Aldwell, *Wingfield: its Church, Castle and College*, Ipswich, 1925, pp.96–107.

Bibliography

Primary source material

MANUSCRIPT SOURCES

This study has drawn on a wide variety of unpublished souces. Principal amongst these are the Ewelme Muniments, the collected business papers of the Ewelme foundation from the fifteenth century to the present day. With the exception of one fifteenth-century copy of the Statutes, all the medieval documents in this collection are now deposited at the Bodleian Library in Oxford.

For St Mary's Church at Ewelme, the diocesan and parish records held at the Oxfordshire County Record Office in Oxford have been of great value. These include correspondence relating to the parish, bills, architects' reports and drawings of the church furnishings, churchwarden's accounts from the seventeenth century and faculty applications.

The remaining unpublished material is held by a variety of libraries and falls into two broad categories: miscellaneous medieval papers and later antiquarian sources. Most of the former are associated in some way with the de la Poles or with Ewelme, but they also include such things as the building accounts in the Eton College Muniments. The antiquarian papers are of such a diversity of date and form that it would be useless to try to generalize about their content. They include descriptions of buildings, contemporary gossip about characters and places, drawings, records of decoration and heraldry, and historical notes. They vary greatly in value as sources and their character – for the most part – as jottings made for personal interest can render them complex to use.

The Ewelme Muniments (now at the Bodleian Library, Oxford)
Ms. DD. Ewelme a.i including Muniments A 1–10 (vol.i)
Ms. DD. Ewelme a.ii including Muniments A 11–14 (vol.ii)
Ms. DD. Ewelme a.iii including Muniments A 15–17 (vol.iii)
Ms. DD. Ewelme a.iv including Muniments A 20–3 (vol.iv)
Ms. DD. Ewelme a.v including Muniments A 24 and 27–33 (vol.v)
Ms. DD. Ewelme a.vi including Muniments A 34–43 (vol.vi)
Ms. DD. Ewelme a.vii including Muniments A 44–56 (vol.vii)
Ms. DD. Ewelme b.1 (Master's Accounts 1698–1791)
Ms. DD. Ewelme b.2 (1880s Catalogue of Muniments)
Ms. DD. Ewelme c.2. EA 1 (Audit and Estate Accounts 1500–14)
Ms. DD. Ewelme c.2. EA 2 (Audit and Estate Accounts 1516–1612)

Ms. DD. Ewelme c.109
Ms. DD. Ewelme c.114
Ms. DD. Ewelme d.1 (Dr Kidd's Accounts 1442–1850)
Ms. DD. Ewelme d.9. EA 3 (Audit Accounts 1628–1700)
Ms. DD. Ewelme d.9. EA 4 (surviving Audit Accounts 1701–50)
Ms. DD. Ewelme d.10. EA 5 (Audit Accounts 1751–1800 and 1841)
Ms. DD. Ewelme d.10. EA 7 (Charity Commissioners' order)
Ms. DD. Ewelme d.10. EA 8 (Ewelme Bills 1822–27)
Ms. DD. Ewelme d.10. EA 9 (Ewelme Bills 1828, 1830–36)
Ms. DD. Ewelme d.10. EA 10 (Ewelme Bills 1837–50)
Ms. DD. Ewelme d.41 (1456 copy of the Statutes)
Ms. DD. Ewelme d.42/1
Ms. DD. Ewelme d.42/2
Ms. DD. Ewelme a.8.R (plan of the almshouse)

At Ewelme
EM A 25 and 26 (a copy of the Statutes with archiepiscopal confirmation)

Ewelme Documents now in the Oxfordshire County Record Office, Oxford (ORO)
Ms. DD. par Ewelme b.8
Ms. DD. par Ewelme b.9
Ms. DD. par Ewelme c.5
Ms. DD. par Ewelme c.6
Ms. DD. par Ewelme c.6 items 'A' and 'B'
Ms. DD. par Ewelme c.13
Ms. DD. par Ewelme e.6
Ms. DD. par Ewelme e.7
Ms. Oxf. Archdeacon Papers Oxon c.68
Ms. Oxford Diocesan Papers b.111
Ms. Oxford Diocesan Papers c.653

Documents in the Bodleian Library, Oxford, other than the Ewelme Muniments

Fifteenth- to eighteenth-century manuscripts
Ms. Ash. 1137
Ms. Dugdale 11
Ms. Rawl. B.247
Ms. Rawl. B.400b
Ms. Rawl. B.400c
Ms. Rawl. B.420b
Ms. Rawl. B.400f
Ms. Rawl. d.777
Ms. Rawl. D 807
Ms. Top. Oxon e.263
Ms. Wood c.11
Ms. Wood D.14
Ms. Wood E.1

Nineteenth-century manuscript sources relating to Ewelme
Ms. Acland d.88
Ms. Don. d.140
Ms. Don. e.114
Ms. Don. c.90
Ms. Dep. d.226

Ms. Gough Oxon
Ms. Top. Gen a.5
Ms. Top. Gen a.11
Ms. Top. Oxon a.8
Ms. Top. Oxon a.21
Ms. Top. Oxon a.66
Ms. Top. Oxon b.75
Ms. Top. Oxon b.91
Ms. Top. Oxon c.521
Ms. Top. Oxon d.168
Ms. Top. Oxon d.479
Ms. Top. Oxon d.514
Ms. Top. Oxon e.220

Documents in the British Library

Fifteenth-century manuscripts
Ms. Harleian 113 (16th-century copy of the Ewelme Statutes)
Egerton Roll 8779
Arundel Ms. 119 (John Lydgate, *The Siege of Thebes*)

Sixteenth- to eighteenth-century antiquarian sources
Add. Ms. 6753
Add. Ms. 15545
Add. Ms. 19092
Add. Ms. 34896
Add. Ms. 36363
Add. Ms. 36373
Add. Ms. 36432
Add. Ms. 36439
Add. Ms. 37049
Add. Ms. 37180
Add. Ms. 42008
Add. Ms. 42018
Add. Ms. 42031
Landsdowne Ms. 846

Primary sources from other collections

Eton College
Mss. Coll/BA/1–10
Ms. 300
VR/A/3

Public Record Office, Kew
Ms. E 178/4404

Society of Antiquaries, London
Gardner's collection of tomb photographs
Fox Collection, Box 24

College of Arms Ms. L.8

Printed primary source material

Ancient Laws of the Fifteenth Century for King's College, Cambridge and for the Public School of Eton College, eds J. Heywood and T. Wright, London, 1850.

The Bedford Inventories, ed. J. Stratford, London, 1993.

Breviarum ad Usum Insignis Ecclesiae Sarum (3 vols), eds F. Procter and C. Wordsworth, Cambridge, 1882–86.

Briquet, *Les Filigranes* (4 vols), Geneva, 1907.

The Building Accounts of Caister Castle, eds H. Barnes and W. D. Simpson (Norfolk and Norwich Archaeological Society, xxx), 1952, pp.178–88.

The Building Accounts of Tattershall Castle 1434–72, ed. W. D. Simpson (Lincolnshire Record Society, lv), 1960.

Calendar of Close Rolls, London, 1892–1963.

Calendar of Fine Rolls, London, 1911–62.

Calendar of Papal Registers, ed. W. H. Bliss, London, 1896.

Calendar of Patent Rolls 1401–1509, London, 1905–16.

The Cartulary of St Mark's Hospital, ed. C. D. Ross (British Record Society, xxi), 1959.

Catalogue of Ancient Deeds (6 vols), London, 1890–1915.

Catholic England: Faith, Religion and Observance before the Reformation, ed. R. N. Swanson, Manchester, 1993.

The Chantry Certificates for Oxfordshire and the Edwardian Inventories for Church Goods for Oxfordshire, ed. R. Graham (Alcuin Club, xxiii), 1920.

Chaucer, Geoffrey, *The Canterbury Tales*, ed. A. C. Cawley (Everyman edn), London, 1984.

The Complete Peerage (13 vols), London, 1910–59.

Correspondence of Bishop Beckyngton (2 vols), ed. G. Williams (Rolls Series, no.56), London, 1872.

de Pizan, Christine, *The Book of the City of Ladies*, trans. E. J. Richards, London, 1983.

Dictionary of British Arms (2 vols), eds D. H. D Chesshyre, T. Woodcock, G. J. Grant, I. D. G. Graham, London, 1992–.

Dingley, T., *History from Marble*, i (Camden Society, xciv), 1867.

Dollman, F. T., *Examples of Ancient Domestic Architecture illustrating Hospitals, Bedehouses, Schools, Almshouses of the Middle Ages in England*, London, 1858.

Dugdale, W. *The Baronage of England* (2 vols), London, 1676.

— *The Antiquities of Warwickshire*, London, 1730.

— *Monasticon Anglicanum* (6 vols), London, 1830.

Educational Charters and Documents 598–1909, ed. A. F. Leach, Cambridge, 1911.

Ellis, R., *Catalogue of Personal Seals in the Public Record Office: Personal Seals 1*, London, 1978.

Emden, A. B., *A Bibliographical Register of the University of Oxford to 1500* (3 vols), Oxford, 1957–59.

English Guilds, eds L. Toumlin-Smith and L. Brentano (Early English Text Society, o.s. xl), 1870.

Epistolae Academicae Oxoniensis, ed. H. Anstey (Oxford Historical Society, xxxv), 1898.

The Fifty Earliest English Wills, ed. F. J. Furnivall (Early English Text Society, o.s. lxxviii), 1882.

Four English Political Tracts of the later Middle Ages, ed. J.-P. Genet (The Camden Society, 4th series, xviii), 1977.

Gough, R., *Sepulchral Monuments in Great Britain* (3 vols), London, 1786–99.

The History of Parliament: the House of Commons, 1386–1421 (4 vols), eds J. S. Roskell, L. Clark, and C. Rawcliffe, Stroud, 1992.

Hollis, G. and T., *Monumental Effigies of Great Britain* (6 pts), London, 1840–42.

The Household of Edward IV, The Black Book and the Ordinance of 1478, ed. A. R. Myers, Oxford, 1959.

Illustrations of the Occasional Offices of the Church in the Middle Ages from Contemporary Sources, ed. H.S. Kingsford (Alcuin Club, xxiv), 1921.

The Inventory of King Henry VIII, vol.i, ed. D. Starkey, London, 1988 (vol.ii forthcoming).

Late Medieval Verse and Prose, ed. D. Gray, Oxford, 1988.

Legends of Hooly Wummen, ed. M. S. Sergeantson (Early English Text Society, e.s. 107), 1938.

Leland, J., *John Leland's Itinerary in England and Wales* (5 vols), ed. L. Toumlin-Smith, London, 1907–10.

Letters and Papers illustrative of the Wars of the English in France during the Reign of Henry VI (2 vols), ed. J. Stevenson (Rolls Series, no.22), London, 1861–64.

Letters and Papers of Henry VIII (21 vols), London, 1862–1932.

The Minor Poems of John Lydgate, pt i, ed. H. N. MacCracken, (Early English Text Society, e.s. cvii), 1911.

Monumenta Ritualia Ecclesiae Anglicanae (4 vols), ed. W. Maskell, Oxford, 1882 (2nd edn).

Parochial Collections, ed. F. M. Davis (Oxford Record Society, ii, iv and xi), 1929.

The Paston Letters (6 vols), ed. J. Gardiner, London, 1986.

Political Poems and Songs (2 vols), ed. T. Wright (Rolls Series, no.14), London, 1859–61.

Registrum Johanis Stanbury, ed. A. T. Bannister, (Canterbury and York, xxv), 1919.

Report on the De L'Isle and Dudley Papers, vol.i (Historical Manuscripts Commission), London, 1925.

Rites of Durham, ed. J. T. Fowler (Surtees Society, cvii), 1902.

Rotuli Parliamentorum (8 vols), n.p., n.d.

Royal Commission for Historical Manuscripts, ninth report, London, 1883.

Sainted Women of the Middle Ages, trans. and ed. J. McNamara and J. E. Halborg, London, 1992.

Scrope and Grosvenor Roll, ed. N. Nicolas, London, 1832.

Skelton, J., *Antiquities of Oxfordshire*, Oxford, 1823–25.

Some Oxfordshire Wills proved in the Prerogative Courts at Canterbury, 1393–1510, eds J. H. R. Weaver and A. Beardwood (Oxfordshire Record Society xxxix), 1958.

Somerset Wills 1383–1500, ed. F. W. Weaver (Somerset Record Society, xvi), 1901.

Stothard, C. A., *Monumental Effigies of Great Britain*, London, 1817–32.

Sutton, A., and L. Visser-Fuchs, with P. W. Hammond, 'The Reburial of Richard, Duke of York, 21–30 July 1476', Richard III Society, London, 1996.

'Les Tombeaux de la Collection Gaignières', ed. J. Adhémar, *Gazette des Beaux-Arts*, 6e période, lxxxiv (1974), pp.5–192, and lxxxviii (1976), pp.3–128.

Voragine, Jacobus de, *The Golden Legend* (Caxton's translation of c.1470 in 7 vols), ed. F. S. Ellis, London, 1900.

William Worcestre, *Itineraries*, ed. J. H. Harvey, Oxford, 1969.

Secondary sources

Airs, M., 'Ewelme', *Archaeological Journal*, cxxxv (1978), pp.277–80.

Aldwell, S. W. H., *Wingfield: its Church, Castle and College*, Ipswich, 1925.

Archer, R. E., '"How Ladies … who Live on their Manors Ought to Manage their Households and Estates": Women as Landholders and Administrators in the Later Middle Ages', in P. J. P. Goldberg, ed., *Woman is a Worthy Wight: Women in English Society c.1200–1500*, Stroud, 1992, pp.153–6.

Armstrong, C. A. J., 'The Piety of Cicely, Duchess of York: a Study in Late Medieval Culture', in *England, France and Burgundy in the Fifteenth Century*, London, 1983.

Arnould, A., and J. M. Massing, *Splendours of Flanders: Late Medieval Art in Cambridge Collections*, exhibition catalogue for the Fitzwilliam Museum, Cambridge, 1993.

Atchley, E. G. C., 'Jesus Mass and Anthems', *Transactions of the St Paul's Ecclesiological Society*, v (1905), pp.163–9.

Bailey, B., *Almshouses of England*, London, 1988.

Bainbridge, V., *Gilds in the Medieval Countryside: Social and Religious Change in Cambridgeshire, 1350–1558*, Woodbridge, 1996.

Barron, C. M., 'The Parish Guilds of Medieval London', in C. M. Barron and C. Harper-Bill, eds, *The Church in Pre-Reformation Society: Essays in Honour of F.R.H. du Boulay*, Woodbridge, 1985, pp.13–37.

Begent, P. J., 'Ladies of the Garter', *The Coat of Arms*, n.s. vii (1989), pp.16–22.

Bertram, J., '*Orate pro anima*: Some Aspects of Medieval Devotion illustrated on Brasses', *Monumental Brass Society*, xiii (1980–85), pp.321–42.

Birchenaugh, E., 'The Prymer in English', *The Library*, 4th series, XVIII (1937–38), pp.177–94.

Blair, J., 'Henry Lakenham, Marbeler of London, and a Tomb Contract of 1376', *Antiquaries Journal*, lx (1980), pp.66–74.

—'English Monumental Brasses before 1350: Types, Patterns and Workshops', in J. Coales, ed., *The Earliest English Brasses: Patronage, Style and Workshops, 1270–1350*, London, 1987, pp.133–74.

Bobby, F. P., 'Ewelme Manor House', unpublished report for the Ewelme Trustees, 27 April 1973.

Bond, F., *Gothic Architecture in England*, London, 1906.

—*Fonts and Font Covers*, London, 1908.

—*Screens and Galleries in English Churches*, London, 1908.

—and B. Camm, *Rood Screens and Rood Lofts* (2 vols), London, 1909.

Bond, J., S. Gosling, and J. Rhodes, *Oxfordshire Brickmakers*, Abingdon, 1980.

Bossy, J., 'Holiness and Society', *Past and Present*, lxxv (1977), pp.119–37.

—'The Mass as a Social Institution 1200–1700', *Past and Present*, c (1983), pp.29–61.

—*Christianity in the West, 1400–1700*, Oxford, 1985.

Brunskill, R. W., *Timber Building in Britain*, London, 1985.

Burgess, C.R., 'For the Increase of Divine Service: Chantries in the Parish in Late Medieval Bristol', *Journal of Ecclesiastical History*, xxxvi (1985), pp.48–65.

—'By Quick and by Dead: Wills and Pious Provision in Late Medieval Bristol', *English Historical Review*, cii (1987), pp.837–58.

—'A Service for the Dead: Form and Function of the Anniversary in Late Medieval Bristol', *Transactions of the Bristol and Gloucestershire Archaeological Society*, cv (1987), pp.183–211.

—'A Fond Thing Vainly Invented: an Essay on Purgatory and Pious Motives in Later Medieval England', in S. Wright, ed., *Parish, Church and People: Local Studies in Lay Religion, 1350–1750*, London, 1988, pp.56–84.

—'London Parishes: Development in Context', in R. Britnell, ed., *Daily Life in the Late Middle Ages*, Stroud, 1988, pp.151–74.

—'The Benefactions of Mortality: the Lay Response in the Late Medieval Urban Parish', in D. Smith, ed., *Studies in Clergy and Ministry in Late Medieval England* (Borthwick Studies in History, i), 1991, pp.65–86.

—'Strategies for Eternity: Perpetual Chantry Foundations in Late Medieval Bristol', in C. Harper-Bill, ed., *Religious Belief and Ecclesiastical Careers in Late Medieval England* (Studies in the History of Late Medieval Religion, iii), Woodbridge, 1991, pp.1–33.

—'Shaping the Parish: St Mary at Hill, London, in the Fifteenth Century', in J. Blair and B. Golding, eds, *The Cloister and the World: Essays in Medieval History in Honour of Barbara Harvey*, Oxford, 1996, pp.246–86.

Carlin, M., 'Medieval English Hospitals', in L. Granshaw and R. Porter, eds, *The Hospital in History*, London, 1989, pp.21–39.

Cattermole, P., and S. Cotton, 'Medieval Parish Church Building in Norfolk', *Norfolk Archaeology*, xxxviii (1983), pp.235–73.

Catto, J., and R. Evans, *The History of the University of Oxford*, vol.ii: *The Late Middle Ages*, Oxford, 1993.

Cautley, H. Munroe, *Suffolk Churches and their Treasures*, London, 1937.

—*Norfolk Churches*, Ipswich, 1949.

Cavallo, A. S., *Medieval Tapestries in the Metropolitan Museum of Art*, exhibition catalogue for the Metropolitan Museum of Art, New York, 1993.

Charles, F. W. B., 'Ewelme Manor House', unpublished report for the Ewelme Trustees, 30 April 1974.

Cheetham, F., *English Medieval Alabasters*, Oxford, 1984.

Cheney, C. R., *A Handbook of English Dates*, London, 1970.

Cherry, B., 'Some Cathedral Tombs', in M. Swanton, ed., *Exeter Cathedral*, Crediton, 1991, pp.160–70.

Clapham, A.W., 'Three Medieval Hospitals of London', *Transactions of the St Paul's Ecclesiological Society*, vii (1911–15), pp.153–60.

Clay R. M., *The Medieval Hospitals of England*, London, 1909.

—*Hermits and Anchorites of England*, London, 1914.

Colvin, H. M., et al., *The History of the King's Works: the Middle Ages* (2 vols), London, 1963.

—*The History of the King's Works, 1485–1660*, vol.iv, pt ii, London, 1982.

—and J. S. G. Simmons, *All Souls, an Oxford College and its Buildings*, Oxford, 1988.

Cook, D. R., *Lancastrians and Yorkists: the Wars of the Roses*, London, 1984.

Cook, G. H. *English Collegiate Churches of the Middle Ages*, London, 1959.

—*Medieval Chantries and Chantry Chapels*, London, 1963.

Coulstock, P. H., *The Collegiate Church of Wimborne Minster*, Woodbridge, 1993.

Cox, A. D. M., 'Account for Building the Divinity School', *Oxoniensia*, xxi (1956), pp.48–60.

Cox, C., and W.H. St John-Hope, *The Chronicle of the Collegiate Church or Free Chapel of All Saint's Derby*, London, 1881.

Crossley, F. H., *English Church Monuments AD 1150–1550*, London, 1933.

—*English Church Craftsmanship*, London, 1947.

Cullum, P., '"And Hir Name was Charite": Charitable Giving by and for Women in Late Medieval Yorkshire', in P. J. P. Goldberg, ed., *Woman is a Worthy Wight: Women in English Society c.1200–1500*, Stroud, 1992, pp.182–211.

Daniell, C., *Death and Burial in Medieval England, 1066–1550*, London and New York, 1997.

Davidson, C., 'The Digby Mary Magdalene and the Magdalene Cult of the Middle Ages', *Annuale Medievale*, xiii (1972), pp.70–87.

Davies, R. C. H., 'The Chronology of Perpendicular Architecture in Oxford', *Oxoniensia*, xi/xii (1947), pp.75–89.

Davis, V., *William Waynflete*, Woodbridge, 1993.

De la Mare, A., *Duke Humphrey's Library and the Divinity School, 1488–1988*, exhibition catalogue for the Bodleian Library, Oxford, 1988.

Dixon-Smith, S., 'The Image and Reality of Almsgiving in the Great Halls of Henry III', *Journal of the British Archaeological Association*, 3rd series, clii (1999), pp.79–96.

Dodd, J. A. *A Historical Guide to Ewelme* (rev. edn), Bath, 1916.

—'Ewelme', *Transactions of St Paul's Ecclesiological Society*, viii (1920), pp.194–206.

Drewett, P. 'The Archiepiscopal Palace at Croydon: a Further Contribution in the Light of Recent Research', *Archaeological Journal*, cxxviii (1971), pp.162–5.

Duffy, E., *The Stripping of the Altars: Traditional Religion in England, 1400–1580*, London and New Haven, 1992.

—'The Parish, Piety and Patronage in Late Medieval East Anglia: the Evidence of Rood Screens', in K. L. French, G. G. Gibbs and B. A. Kumin, eds, *The Parish in English Life, 1400–1600*, Manchester, 1997, pp.15–32.

Easton, T., and S. Bicknell, 'Two Pre-Reformation Organ Soundboards', *Proceedings of the Suffolk Institute of Archaeology and History*, xxxviii (1995), pp.268–95.

Ebin, L. A., *John Lydgate*, Boston, 1985.

Emery, A., 'Cromwell's Manor at Wingfield', *Archaeological Journal*, cxlii (1985), pp.276–339.

—*Greater Medieval Houses of England and Wales*, vol.i: *Northern England*, Cambridge, 1996.

Emmerson, R., 'Monumental Brasses: London Design c.1420–85', *Journal of the British Archaeological Association*, cxxxi (1978), pp.50–77.

Erler, M. C., 'Three Fifteenth-century Vowesses', in C. Barron and A. Sutton, eds, *Medieval London Widows 1300–1500*, London, 1994, pp.165–83.

Faulkner, P. A., 'Archiepiscopal Palaces and Planning', *Archaeological Journal*, cxxvii (1970), pp.130–46.

Fleming, P. W., 'Charity, Faith, and the Gentry of Kent 1422–1529', in A. J. Pollard, ed., *Property and Politics in Later Medieval English History*, Gloucester, 1984, pp.36–58.

Fowler, J. T., 'The Fifteen Last Days of the World in Medieval Art and Literature', *Yorkshire Archaeological Journal*, xxiii (1915), pp.313–37.

Friedrichs, R. L., 'Ralph Cromwell and the Politics of Fifteenth-century England', *Nottingham Medieval Studies*, xxxii (1988), pp.1–21.

—'The Two Last Wills of Ralph Cromwell', *Nottingham Medieval Studies*, xxxiv (1990), pp.1–20.

Fryer, A., 'Monumental Effigies in Sculpture, IX', *Proceedings of Somersetshire Archaeological and Natural History Society*, lxix (1923), pp.6–29.

Gardner, A., *Alabaster Tombs of the Pre-Reformation Period in England*, Cambridge, 1940.

Geddes, J., *Medieval Decorative Ironwork in England*, London, 1999.

Gee, E. A. 'Oxford Masons 1370–1530', *Oxoniensia*, cix (1952), pp.54–131.

—'The Painted Stained Glass of All Saints Church, North Street, York', *Archaeologia*, cii (1969), pp.151–202.

Genet, J., 'Trois Manoirs anglais au XVIème siècle: les domaines de l'Hôpital d'Ewelme, étude économique et sociale 1442–1510', unpublished thesis for a Diplôme d'Etudes Supérieures, Paris, 1965. (A copy of this is deposited at the Bodleian Library, Oxford, Ms. Top. Oxon d.527.)

Gilcrist, R., 'Christian Bodies and Souls: the Archaeology of Life and Death in Later Medieval Hospitals', in S. Bassett, ed., *Death in Towns: Urban Responses to the Dying and the Dead, 100–1600*, Leicester, 1992, pp.101–18.

—*Contemplation and Action: the Other Monasticism*, Leicester, 1995.

Glasscoe, M., 'Late Medieval Paintings in Ashton Church, Devon', *Journal of the British Archaeological Association*, cxl (1987), pp.182–90.

Goodall, J. A. A. 'Thornton Abbey', *Country Life*, clxxix, no.40 (5 October 1995), pp.44–7.

—'Gainsborough Hall', *Country Life*, cxc, no.3 (18 January 1996), pp.38–41.

—'Tattershall Castle', *Country Life*, cxc, no.41 (10 October 1996), pp.50–5.

—'God's House at Ewelme', unpublished Ph.D. thesis, Courtauld Institute, London University, 1997.

—'Little Wenham Hall', *Country Life*, cxciv, no.21 (6 July 2000), pp.126–31.

—'Eton College and the Court of Henry VI', *Medieval Art and Architecture at Windsor: Transactions of the British Archaeological Association Conference 1998*, forthcoming.

—and L. Monckton, 'The Chantry of Humphrey, Duke of Gloucester', *Medieval Art and Architecture at St Albans: Transactions of the British Archaeological Association St Albans Conference 1999*, forthcoming.

Graves, C. P., 'Social Space in the English Medieval Parish Church', *Economy and Society*, xviii (1989), pp.297–322.

Gray, D., ed., *Late Medieval Verse and Prose*, Oxford, 1988.

Greening Lamborn, E. A., 'The Arms on the Chaucer Tomb at Ewelme', *Oxoniensia*, v (1940), pp.78–93.

—*The Armorial Glass of the Oxfordshire Diocese*, Oxford, 1949.

Hadley, G. A., *A New and Complete History of the Town ... of Kingston-upon-Hull*, Hull, 1788.

Hamilton-Thompson, A., 'Notes ... on a visit to Liddington Bede House', *Report of the Rutland Archaeological and Natural History Society*, xii (1915), pp.38–40.

—'The Statutes of the College of St Mary and All Saints, Fotheringhay', *Archaeological Journal*, lxxv (1918), pp.241–309.

—'English Colleges of Chantry Priests', *The Ecclesiological Society*, vii, new series pt 2 (1943), pp.92–108.

—*The English Clergy and their Organisation in the Later Middle Ages*, Oxford, 1947.

Hanawalt, B. A., 'Keepers of the Lights: Late Medieval English Parish Guilds', *Journal of Medieval and Renaissance Studies*, xiv (1984), pp.26–37.

Harriss, G.L., *Cardinal Beaufort: a Study in Lancastrian Ascendancy and Decline*, Oxford, 1988.

Harvey, J. H., *The Perpendicular Style*, London, 1978.

—*English Medieval Architects*, 3rd edn, London, 1987.

—and D. G. King, 'Winchester College Stained Glass', *Archaeologia*, ciii (1971), pp.149–77.

Haward, B., *Suffolk Medieval Church Arcades*, Ipswich, 1993.

—*Norfolk Album*, published by the author, 1995.

Heard, K., 'Death and Representation in the Fifteenth Century: the Wilcote Chantry Chapel at North Leigh, Oxfordshire', unpublished M.A. thesis, Courtauld Institute, London University, 1999.

Heath, B., *Medieval Clerical Accounts*, St Antony's Hall, York (Bothwick Paper, no. 26), 1964.

Heath, P., 'Urban Piety in the Late Middle Ages: the Evidence of Hull Wills', in R. B. Dobson, ed., *The Church, Politics and Patronage in the Fifteenth Century*, Gloucester, 1984, pp.209–34.

Hebgin-Barnes, P., *Corpus Vitrearum Medii Aevi Great Britain*, Summary Catalogue 3: *Lincolnshire*, London, 1996.

Hicks, M. A., 'Chantries, Obits, and Almshouses: The Hungerford Foundations 1325–1478', in C. Barron and C. Harper-Bill, eds, *The Church in Pre-Reformation Society: Essays in Honour of F.R.H. du Boulay*, Woodbridge, 1985, pp.123–42.

—'The Piety of Lady Mary Hungerford (ob.1478)', *Journal of Ecclesiastical History*, xxxviii (1987), pp.19–38.

Hildburgh, W. L., 'Iconographic Peculiarities in English Medieval Alabasters', *Folklore* (June 1933), pp.32–150.

—'An English Alabaster Carving of St Michael', *Burlington Magazine*, lxxxi (1947), pp.129–31.

Hirsch, J. C., 'Prayer and Meditation in Late Medieval England: Ms. Bodley 789', *Medium Aevum*, xlviii (1979), pp.55–66.

Horrox, R., *The de la Poles of Hull* (East Yorkshire Local History Society, no.38), 1983.

Howard, F. E., 'Screens and Rood-lofts in the Parish Churches of Oxfordshire', *Archaeological Journal*, lxvii (1910), pp.151–201.

Hughes, A., *Medieval Manuscripts for the Mass and Office*, Toronto, 1982.

Hunt, P., *Fifteenth-century England*, London, 1962.

Hussey, C., 'Ockwells Manor', *Country Life*, lv (1924), pp.52–60, 92–9 and 130–7.

Imray, J., *The Charity of Richard Whittington*, London, 1968.

Jacob, E. F., 'The Warden's Text of the Statutes of All Souls', *Antiquaries Journal*, xv (1935), pp.420–31.

—'Founders and Foundations in the Late Middle Ages', *Bulletin of the Institute of Historical Research*, xxxv (1962), pp.29–46.

James, E.A., 'The Hermits and Anchorites of Oxfordshire', *Oxoniensia*, lxiii (1998), pp.51–77.

James, L. E., 'The Career and Influence of William de la Pole 1st Duke of Suffolk', unpublished M.Litt. thesis for the University of Oxford, 1979.

James, T. B., *The Palaces of Medieval England*, London, 1990.

Johnston, A. F., 'The Plays of the Religious Guilds of York: the Crede and the Pater Noster Play', *Speculum*, l (1975), pp.55–90.

King, P. M., 'The English Cadaver Tomb in the Late 15th-Century: some Indicators of a Lancastrian Connection', in J. H. M. Taylor, ed., *Dies Illa: Death in the Middle Ages*, Liverpool, 1984, pp.45–57.

—'Contexts of the Cadaver Tomb in 15th-century England', unpublished Ph.D. thesis for the University of York, 1987.

—'The Cadaver Tomb in England: Novel Manifestations of an Old Idea', *Church Monuments*, v (1990), pp.26–38.

Kingsford, C. L., *Prejudice and Promise in Fifteenth-century England*, Oxford, 1925.

Kisby, F., 'Books in London Parish Churches, c.1400–1605', *Proceedings of the 1999 Harlaxton Symposium*, forthcoming.

Kreider, A., *English Chantries: the Road to Dissolution*, London, 1979.

Kumin, B., *The Shaping of a Community: the Rise and Reformation of the English Parish Church, c.1400–1560*, Aldershot, 1996.

—'The English Parish in a European Perspective', in K. L. French, G. G. Gibbs and B. A. Kumin, eds, *The Parish in English Life, 1400–1600*, Manchester, 1998, pp.15–32.

Lander, J. R., *Conflict and Stability in Fifteenth-Century England*, 3rd edn, London, 1982.

Lasko, P., and N. J. Morgan, *Medieval Art in East Anglia, 1300–1520*, exhibition catalogue, Norwich, 1973.

Latham, R. E., *Revised Medieval Latin Word List*, London, 1994.

Leach, A. F., *English Schools at the Reformation, 1546–8*, London, 1896.

—*Educational Charters and Documents 598–1909*, Cambridge, 1911.

—*The Schools of Medieval England*, London, 1915.

Leedy, W. C., *Fan Vaulting: a Study of Form, Technology and Meaning*, London, 1980.

Leith-Spencer, H., *English Preaching in the Late Middle Ages*, Oxford, 1993.

Lindley, P., 'The Great Screen of Winchester Cathedral I', *Burlington Magazine*, cxxxi (1989), pp.604–17.

—'A Neglected King at Ely Cathedral', *Burlington Magazine*, cxxxi (1989), pp.764–9.

—'"Una Grande Opera al mio Re": Gilt-bronze Effigies in England from the Middle Ages to the Renaissance', *Journal of the British Archaeological Association*, cxliii (1990), pp.112–30.

—(ed.), 'Gainsborough Old Hall', *Occasional Papers in Lincolnshire Archaeology*, 8 (1991).

—'The Great Screen of Winchester Cathedral II', *Burlington Magazine*, cxxxv (1993), pp.796–807.

—'The Medieval Sculpture of Winchester Cathedral', in J. Crook, ed., *Winchester Cathedral*, Chichester, 1993, pp.97–122.

Little, F., *A Monument of Christian Munificence*, ed. C. D. Cobham, Oxford and London, 1871.

Littlehales, H., and H. Wordsworth, *The Old Service Books of the English Church*, London, 1904.

Liversidge, M. J. H., '"Abingdon's Right Goodly Crosse of Stoone"', *Antiquaries Journal*, lxiii (1983), pp.315–25.

MacCracken, H. N., 'An English Friend of Charles of Orléans', *Publications of the Modern Language Association of America*, xxvi (1911), pp.141–80.

Marks, R., 'The Re-building of Lambley Church, Nottinghamshire, in the Fifteenth Century', *Transactions of the Thoroton Society of Nottinghamshire*, lxxxvii (1983), pp.87–9.

—*Stained Glass of the Collegiate Church of the Holy Trinity at Tattershall*, London and New York, 1984.

—*Stained Glass in England during the Middle Ages*, London, 1993.

McFarlane, K. B., *The Nobility of Late Medieval England*, Oxford, 1973.

McKendrick, S., 'Edward the IV: an English Royal Collector of Netherlandish Tapestry', *Burlington Magazine*, cxxix (1987), pp.521–4.

—'Tapestries from the Low Countries in England during the Fifteenth Century', in C. Barron and N. Saul, eds, *England and the Low Countries in the Late Middle Ages*, Stroud, 1995, pp.43–60.

Meale, C. M., '"… Alle the Bokes that I Have of Latyn, Englysch and Frensh": Laywomen and their Books in Late Medieval England', in C. M. Meale, ed., *Women and Literature in Britain, 1150–1500* (Cambridge Studies in Medieval Literature, 17), Cambridge, 1991, pp.134–5.

Miner, J., *The Grammar Schools of Medieval England*, Montreal, 1990.

Moore, N., 'Brick', in J. Blair and N. Ramsey, eds, *Medieval Industries*, London, 1991, pp.211–36.

Myers, J., 'Recent Discoveries at the Bodleian Library', *Archaeologia*, ci (1967), pp.151–67.

Napier, H. A., *Historical Notices of the Parishes of Swyncombe and Ewelme*, Oxford, 1858.

Newton, P. A., 'William Brown's Hospital at Stamford, a Note on its Early History and the Date of its Buildings', *The Antiquaries Journal*, xlvi (1966), pp.283–6.

—*Corpus Vitrearum Medii Aevi Great Britain*, vol.1: *Oxfordshire*, London, 1979.

Nichols, A. E., *Seeable Signs: the Iconography of the Seven Sacraments 1350–1544*, Woodbridge, 1994.

Norris, M., 'Later Medieval Monumental Brasses: an Urban Funerary Industry and its Representation of Death', in S. Bassett, ed., *Death in Towns: Urban Responses to the Dying and the Dead, 100–1600*, Leicester, 1992, pp.814–209 and 248–51.

Oman, C., 'Security in English Churches', *Archaeological Journal*, cxxxvi (1979), pp.90–8.

Orme, N., *English Schools in the Late Middle Ages*, London, 1973.

—*Education and Society in Medieval and Renaissance England*, London, 1989.

—'Schools and School Books', in L. Hellinga and J. B. Trapp, eds, *The Cambridge History of the Book in Britain*, vol. iii: *1400–1557*, Cambridge, 1999, pp.449–69.

—and M. Webster, *The English Hospital, 1070–1570*, New Haven, 1995.

Owst, G. R., *Literature and Pulpit in Medieval England*, Oxford, 1961.

Oxford Archaeological Unit, 'The School and School Master's House, Ewelme, Oxon.', unpublished report for the Ewelme Trustees dated January 1999.

Pantin, W. A., 'Medieval Priests' Houses in South-west England', *Medieval Archaeology*, i (1957), pp.118–46.

Parsons, W. L. E., *Salle*, Norwich, 1937.

Pevsner, N., *The Buildings of England: Nottinghamshire*, Harmondsworth, 1951.

—*The Buildings of England: Cambridgeshire*, Harmondsworth, 1954.

—*The Buildings of England: Buckinghamshire*, Harmondsworth, 1960.

—*The Buildings of England: Suffolk*, Harmondsworth, 1961.

—*The Buildings of England: Northamptonshire*, Harmondsworth, 1961.

—*The Buildings of England: North-East Norfolk and Norwich*, Harmondsworth, 1962.

—*The Buildings of England: North-West and South Norfolk*, Harmondsworth, 1962.

—and Harris, J., *The Buildings of England: Lincolnshire*, Harmondsworth, 1964.

—and Alexander Wedgwood, *The Buildings of England: Warwickshire*, Harmondsworth, 1966.

—*The Buildings of England: Berkshire*, Harmondsworth, 1966.

—*The Buildings of England: Hampshire*, Harmondsworth, 1967.

—*The Buildings of England: Yorkshire, The West Riding*, Harmondsworth, 1967 (revised by E. Radcliffe).

—and Sherwood, J., *The Buildings of England: Oxford*, Harmondsworth, 1974.

—and Neave, D. *The Buildings of England: Yorkshire, York and the East Riding*, Harmondsworth, 2nd edn, 1995.

Pfaff, R. W., *New Liturgical Feasts in Late Medieval England*, Oxford, 1970.

—*Medieval Latin Liturgy: a Select Bibliography*, Toronto, 1982.

Platt, C., *The Architecture of Medieval England*, London and New Haven, 1990.

Prescott, E., *The English Medieval Hospital*, Melksham, 1992.

Preston, A. E., *Christ's Hospital, Abingdon*, Oxford, 1929.

Ramsay, N., 'Imagine my Surprise ...', *Friends of Wells Cathedral*, 1988, pp.12–14.

—'Alabaster', in J. Blair and N. Ramsay, eds, *English Medieval Industries*, London, 1991, pp.29–41.

Rawcliffe, C., 'The Hospitals of Later Medieval London', *Medical History*, xxviii (1984), pp.1–21.

—*The Hospitals of Medieval Norwich*, Norwich, 1995.

—*Medicine and Society in Later Medieval England*, Stroud, 1995.

—'Hospital Nurses and their Work', in R. Britnell, ed., *Daily Life in the Middle Ages*, Stroud, 1998, pp.43–64.

—*Medicine for the Soul. The Life, Death and Resurrection of an English Medieval Hospital*, Stroud, 2000.

Richmond, C., *The Paston Family in the Fifteenth Century*, Cambridge, 1990.

—'Religion and the Fifteenth-century English Gentleman', in B. Dobson, ed., *The Church, Politics and Patronage in the Fifteenth Century*. Gloucester, 1984, pp.193–208.

Robertson, D. W., 'The Late Medieval Cult of Jesus and the Mystery Plays', *Proceedings of the Modern Language Association*, lxxx (1965), pp.508–14.

Rosenthal, J. T., *The Purchase of Paradise*, London, 1972.

Roskell, J. S., *Parliament and Politics in Late Medieval England* (3 vols), London, 1983.

Routh, P. E., *Medieval Effigal Alabaster Tombs in Yorkshire*, Ipswich, 1976.

Rubin, M., 'Corpus Christi Fraternities and Late Medieval Piety', *Studies in Church History*, xxiii (1986), pp.97–109.

—*Charity and Community in Medieval Cambridge*, Cambridge, 1987.

—'Development and Change in English Hospitals, 1100–1500', in L. Granshaw and R. Porter, eds, *The Hospital in History*, London, 1989, pp.41–59.

Rushforth, G. M., 'An Account of some Painted Glass from Leicester', *Archaeological Journal*, lxxv (1918), pp.47–68.

Ryde, C., 'An Alabaster Standing Angel with Shield at Lowick – a Chellaston Shop Pattern', *Derbyshire Archaeological Journal*, xcix (1977), pp.36–49.

—'Alabaster Tomb Manufacture 1400–1430', *Derbyshire Miscellany*, xii (1991), pp.164–77.

St John-Hope, W. H., 'On the Sculptured Alabaster Tablets called St John's Heads', *Archaeologia*, lii, pt ii (1890), pp.669–708.

—'On the Early Working of Alabaster in England', *Archaeological Journal*, lxi (1904), pp.221–40.

—'On an Inventory of the Goods of the Collegiate Church of the Holy Trinity, Arundel, taken 1 October, 9 Henry VIII. (1517)', *Archaeologia*, lxi (1909), pp.61–96.

—'The Heraldry and Sculptures of the Divinity School Vault at Oxford', *Archaeological Journal*, lxxi (1914), pp.217–60.

Salzman, L. F., *Building in England, down to 1450: a Documentary History* (rev. edn), Oxford, 1967.

Scarisbrick, J. J., *The Reformation and the English People*, Oxford, 1982.

Selway, K., 'The Role of Eton College and King's College in the Polity of the Lancastrian Monarchy', unpublished D.Phil. thesis, University of Oxford, 1993.

Shekede, L., 'The School House, Ewelme, Oxfordshire: Conservation of the Wall Painting', unpublished report for the Ewelme Trustees dated 12 June 1997.

Simcox, H.K., 'Suggestions for the Amendment and Improvement of the Scheme under which the Almshouse at Ewelme is now Administered', a pamphlet printed

at Wallingford, 1892.

Simpson, W., 'Herstmonceux Castle', *Archaeological Journal*, xcix (1942), pp.110–12.

Smith, T. P., 'Rye House, Herts., and Aspects of Early Brickwork in England', *Archaeological Journal*, cxxxii (1975), pp.111–47.

—'The Medieval Brick Making Industry in England 1400–50', *British Archaeological Series*, 138 (1985).

Stone, L., *Sculpture in Britain: the Middle Ages*, Harmondsworth, 1955.

Storey, R. L., *The End of the House of Lancaster*, London, 1966.

Swaan, W., *Art and Architecture of the Late Middle Ages*, New York, 1977.

Tatton-Brown, T., 'The Church of St Thomas of Canterbury, Salisbury', *Wiltshire Archaeological and Natural History Magazine*, xc (1997), pp.101–9.

Thompson, E. M., *The Carthusian Order in England*, London, 1930.

Thompson, W., *The Decline of the Castle*, Cambridge, 1987.

Thomson, D., 'Henry VII and the Uses of Italy: the Savoy Hospital and Henry VII's Posterity', in B. Thompson, ed., *Proceedings of the 1993 Harlaxton Symposium*, Stamford, 1995, pp.104–16.

Thomson, J. A. F., 'John de la Pole, Duke of Suffolk', *Speculum*, liv (1979), pp.528–42.

Thomson, W. G., *A History of Tapestry from the Earliest Times until the Present Day*, London, 2nd edn, 1939.

Thurley, S., *The Royal Palaces of Tudor England*, London, 1993.

Tracey, C., *English Gothic Choir Stalls 1400–1540*, Woodbridge, 1990.

Tristram, P., *Figures of Life and Death in Medieval English Literature*, London, 1976.

Underwood, M. G., 'Politics and Piety in the Household of Lady Margaret Beaufort', *Journal of Ecclesiastical History*, xxxviii (1987), pp.39–52.

Vallance, A., *English Church Screens*, London, 1936.

—*Greater English Church Screens*, London, 1947.

The Victoria County History: Northamptonshire, vol. ii, London, 1906.

—*Lincolnshire*, vol. ii, London, 1906.

—*Berkshire*, vol. iv, London, 1924.

—*Staffordshire*, vol. xvii, Oxford, 1976.

Virgoe, R., 'The Death of William de la Pole, Duke of Suffolk', *Bulletin of the John Rylands Library*, xlvii (1965), pp.489–502.

Ward, R.E., 'The foundation and functions of perpetual chantries in the diocese of Norwich c.1250–1547' unpublished Ph.D. thesis, Cambridge University, 1998.

Watts, J., *Henry VI and the Politics of Kingship*, Cambridge, 1996.

Westlake, H. F., *The Parish Guilds of Medieval England*, London, 1919.

Wieck, R. S., *The Book of Hours in Medieval Art and Life*, London, 1988.

Wight, J., *Brick Building in England*, London, 1972.

Willis, R., and J. W. Clark, *The Architectural History of Cambridge* (3 vols) Cambridge, 1886.

Wilson, C., *The Gothic Cathedral*, London, 1992.

—'The Medieval Monuments', in P. Collinson, N. Ramsay and M. Sparks, eds, *Canterbury Cathedral*, Oxford, 1995, pp.451–510.

Wilson, H. A., *Magdalen College, University of Oxford College Histories*, London, 1899.

Wolffe, B. P., *Henry VI*, London, 1981.

Wood, M., *The English Medieval House*, London, 1965.

Wood-Legh, K. L., 'Some Aspects of the History of Chantries in the Later Middle Ages', *Transactions of the Royal Historical Society*, 4th series, 28 (1946), pp.47–60.

—*Perpetual Chantries in Britain*, Cambridge, 1965.

Woodman, F., *The Architectural History of King's College, Cambridge*, London, 1986.

Woolgar, G. M., *The Great Household in Late Medieval England*, London, 1999.

Wright, H. P., *The Story of the Domus Dei of Stamford, Hospital of William Browne*, London, 1890.

Young, J., *Alabaster*, Nottingham, 1990.

Index

Page references in *italic* type indicate figures. The number 2 in parentheses after a page reference means that there are two separate references to the subject on that page.